The Critical Writings of
ADRIAN STOKES

Volume III
1955-1967

The Critical Writings of
ADRIAN STOKES

Volume III
1955-1967

MICHELANGELO
GREEK CULTURE AND THE EGO
THE PAINTING OF OUR TIME
COLDSTREAM AND THE SITTER
THE IMPACT OF ARCHITECTURE
PAINTING AND THE INNER WORLD
THE INVITATION IN ART
REFLECTIONS ON THE NUDE

with 37 illustrations

Thames and Hudson

© 1978 The Estate of Adrian Stokes

Library of Congress Catalog Card No. 77–84378

Printed in Great Britain by
Latimer Trend & Company Ltd Plymouth

Contents

Michelangelo

A Study in the Nature of Art

Author's note

The author acknowledges a very considerable debt to Professor Lawrence Gowing who was good enough to comment upon an early draft; to Professor E. H. Gombrich also, who so kindly read a later draft; to Mr and Mrs J. C. Palmes for their prompt and learned help; to his fellow-members of the Imago Group who discussed with him a part of the book.

His thanks are due to Mr Bernard Berenson and his librarian who accorded him the privilege to read in the Berenson Library, Settignano; to the librarian of the Warburg Institute, London; to Her Majesty the Queen for permission to reproduce drawings in the royal collection at Windsor; to the Trustees of the British Museum in regard to the reproduction of drawings in the Print Room. Acknowledgment is made to Messrs Cape for permission to reproduce the poem by Robert Frost on page 350.

First published 1955

PART I
Introductory

1 General Introduction

IT IS WISE TO INTRODUCE the reader with affability to an author's didactic purpose. In the present case, however, Michelangelo will hardly be mentioned: unfortunately, the introduction must help to shed on the further subject-matter a light which the book itself was designed to radiate. I must start with the dim light of abstraction, whereas the text that follows is at least more robust.

It was said before Freud that the child is father to the man. No one will have objected to so vague an insight. Similarly today, under the pressure of Freud, some of our more successful intellectuals have been crying *Angst, Angst*, making homely a content that could otherwise lead them to the unfamiliar. Their generalizations will appease or banish detail: and so, our compliance with the present actuality of infantine, crucial images will be no less unfamiliar than before.

Such matters do not disturb the reader in the sections that follow this. Part III discusses certain aspects of Michelangelo's poetry in the light of arguments developed in Part II which treats of Michelangelo's works in visual art. Part II is the difficulty, where I outline a theory concerning attitudes that determine the creation of form in the arts. The idea is simple: however, it is coupled with psycho-analytic conceptions both unfamiliar and subtle, though I do not attempt to convey their system, nor their refinement except occasionally with regard to the matter in hand. (I can only hope I have not subjected them to distortion in this way.)

Thus, this theory of form is tied up with psycho-analytic attitudes that may seem to have no bearing on art. Yet the alliance between some of the conclusions of this science and aesthetic experience has not occurred abruptly. Indeed, for more than twenty years I have emphasized the 'otherness' which now appears again, the 'out-thereness' of the work of art. A generic distinction I made between carving and modelling (1934 and 1937) has close connexions with the present theory. It is possible that the carving-modelling distinction was already

associated with the lengthy experience and study of psycho-analysis: if so, the influence was not overt: the one department of experience has not been applied summarily at any time to the other: on the contrary, aesthetic appreciation and a modicum of psychological awareness have gradually become inseparable; they mingle in the present book at the instance of Michelangelo's works. In the light of his art, I offer also some remarks about his life.

Having warned the reader, I must assure him that this is a book of aesthetic appraisal devoted to Michelangelo and humanist art, to an unique quality of humanist art. Unfortunately, it is impossible for me to attempt to support beyond the immediate text, to argue the validity of the psycho-analytic conceptions – some of them hotly disputed among analysts themselves – that are implicated. The reader with sufficient interest must refer to the literature of the subject, in particular to *Contributions to Psycho-Analysis* by Melanie Klein (1948) and to *Developments in Psycho-Analysis* by the same author and others (1952). Melanie Klein, Dr P. Heimann and R. Money-Kyrle are the editors of a compilation entitled *New Directions in Psycho-Analysis* (Tavistock Publications), to which I have contributed a tentative paper on form in art, presenting the theory of this book in more specific terms.

I have needed in rare instances to use psycho-analytic terminology. The following are the principal terms employed.

It is almost a common, though perhaps regrettable, usage to speak of 'guilt' in indicating the sense or feeling of guilt whether justified or unjustified . . . I have occasionally mentioned 'depressive anxiety' and 'persecutory anxiety'. The latter refers to the anxiety of being persecuted, the former to the anxiety caused by fear that what is good or loved may be endangered or lost, leading possibly to depression. (Fear of our own aggression is the prime factor in both cases.) The wide application of these alternatives originated in the work of Melanie Klein who traced them to the early months of infancy, to the first weeks in the case of persecutory anxiety. . . . It is possible that the word 'object' when applied to persons is a psychological usage: the expression 'internal object' or 'internal person', however, which I must use, requires brief comment. The feeding infant incorporates in fantasy both the objects that give him satisfaction and those that give him pain, as soon as he is aware of anything in the world to be outside. Thus there are built systems, corporeal in origin, of what is 'good' and what is 'bad', the mirror of our own inextinguishable hate and aggression: the well-known concept of the super-ego is based upon this complicated and enduring process of incorporation or introjection, alternating with projection. . . . I think that is all, except I now use descriptively Freud's adopted phrase, 'the oceanic feeling', the sense of oneness with the universe, which he derived, in one instance, from the feeding infant's contentment at the breast. . . .

Art, I believe, as well as love, offers us some share in the oceanic feeling. Yet,

with the phantasm of homogeneity, of singleness, the lover experiences in the beloved her singularity: she is the acme of emotive otherness, the essence of object. Now, this appreciation of the object's separate sufficiency united to a sense of identity with the pulse of things, prefigures, in my opinion, the sentiments that works of art in general stimulate in us, whatever their subject-matter or their occasion. 'An element of self-sufficiency' – I quote from p. 37 – 'will inform our impression of the whole work of art as well as of turned phrases and fine passages. The poem, the sum-total, has the articulation of a physical object, whereas the incantatory element of poetry ranges beyond, ready to interpenetrate, to hypnotize. Or perhaps precise and vivid images, an enclosed world, fed by metre, serve a sentiment that is indefinable, permeating, unspoken. Space is a homogeneous medium into which we are drawn and freely plunged by many representations of visual art: at the same time it is the mode of order and distinctiveness for separated objects.'

The combination of these two kinds of relationship with an object have special significance to the artist and to the aesthete. I refer on p. 350 to Wordsworth, to his care for the singularity of primrose or peasant, for an enclosed constellation of feelings which, none the less, inspire in him sentiments of pantheism. (But the humanist artist alone has valued equally with the oceanic feeling, the sense of an object's actual particularity.) That instance is of subject-matter rather than of form: his devotion to Form influences, sometimes determines narrowly, the artist's preference in subject-matter. The distinction between them is not hard-and-fast but only convenient. I shall employ the term, Form (with capital), in order to indicate briefly those many sensuous aspects that distinguish art as the crown of other symbolic systems.

The reciprocity of parts, the 'inner working' that causes a painting, though viewed but formally, to be much more than the sum of those parts, is conveyed to us in terms primarily of our sense-perceptions, in terms of vision and touch. Such communication is so pleasurable that we may enjoy it, Clive Bell affirmed, without conscious perception of the subject-matter. All the same, formal value does not exist apart from a particular subject or sentiment or function of the object, even in music and in ceramics: moreover the significance of the formal value issues from its own content, its own subject-matter, one so general as to be common to all art. I think that reciprocity, plasticity, rhythm, design, etc., are employed to magnify a self-sufficient object (notably other than ourselves even though it expresses also a narcissistic self-glorification): at the same time they are employed to surround us with a far different kind of object, to suggest an entirety with which we can merge. (All pattern stems from some identity in difference.) And, whereas it is obvious that texture, or the reciprocity of parts, primarily suggests the self-sufficient object, whereas the flow of rhythm or a giant plasticity may easily draw us into the homogeneous beatitude of the

oceanic feeling, I think it is impossible to tie a formal quality – the isolation is itself artificial – to one of these functions to the exclusion of the other: a pervasive theme embodies more than one unity: each formal quality has further function in the pulsation of the whole. A doubling of roles characterizes the masterpiece by which we experience the sensation of having the cake and yet of eating it without destruction, surfeit or waste-product. Form harmonizes this contradiction: it is the setting for the evocative ambiguities, for the associative collusion, of imagery: while serving culture and affirming outward things, it both provides and facilitates the echoing in all art of those urgent voices, deep in the mind, whose opposite, unmodulated, tones are nevertheless of one piece, whose character of condensation, when thus in company with distinctiveness, may contribute to the aesthetically deft or neat.

But though it be impossible to make a sure division, there is no difficulty in appreciating where the emphasis lies in any instance, or in a style, a period: indeed the history of art might be written in terms of an ever-changing fusion between the love for the self-sufficient object, fully corporeal in essence, and the cultural disciplines for oceanic feeling.[1] Renaissance art, of course, is always characterized by the joyful recognition of self-sufficient objects ordered in space: yet in other books I have tried to show, with the help of terms not altogether dissimilar from those I now use, the difference, in the placing of these accents, between the architecture of Luciano Laurana and Brunelleschi: on the one hand the emphasis upon objects, as if pre-existent, whose potentialities are uncovered in the guise of colour relationship, of surface texture and of the equal reciprocity of forms, to be valued for their inward glow like the distinct brother shapes which we discern in an evening light: on the other hand, movement, the suggestion of omnipotent flourish by means of a material that is itself no less subservient than clay, of an accent that cleaves us both from affinity and from separateness in order to recreate out of the material an all-inclusive stress with which we are one.

Here, and in the pages ahead, visible, tangible *objets d'art* provide the examples of aesthetic activity. Yet in poetry, for instance, image and metaphor similarly encompass mutual enhancement between sensuous units, culminating in a construction, in a Whole, that nevertheless refers beyond itself without breaking the entirety. This rounded aesthetic mode of treating subject-matter is employed upon a nexus of experience, of perception, thought and feeling, in the belief that the connexions thus created are no less poignant than those which underlie this Form or mode itself. Poetic 'truth' is not, of course, truth, but it has its own precision, detachment and, above all, an immediacy that offers us a particular congruity joined with a wider sentiment; a pattern, in short, of experience in the terms of something sensuous or physical. The pattern, I submit, requires both for its creation and for its appreciation, the amalgam of attitudes to what

is outside (and inside) us by which we merge with the world or contemplate what is other than ourselves. It is woven with the intertwined threads of these emotional relationships to objects: and thus, in the completed work, we view feeling as a full, sensuous, object containing a sensuous transcendent content: we are made aware once more of the primitive strength of the life-force in often harmonious union with the power of consciousness to define, to differentiate.

I apologize for these abstractions.

Art is symbol: the sprawling empire of symbolism radiates from the dream-world. From the angle of the symbolism of its subject-matter, art has often provided material for psycho-analytic study. But my governing theme is not of such kind. This book attempts to substantiate, in the person of Michelangelo, the distinctive character of art as self-expression or catharsis, what is called the Form, the mode of treating each subject-matter. If Michelangelo's greatness is brought into nearer view, I shall not have entirely failed.

In discussing Michelangelo's relation with his father and brothers (Part 1, Chapter 3), I have not referred to social and cultural values of the time. I am aware that even if the scholar of historical study cannot catch me treating as entirely personal to Michelangelo or to his family something which is better described in the terms of contemporary *moeurs*, he would still deprecate the abstraction and might invoke the incompleteness of our knowledge. Moreover, I select a small amount of evidence – it could be enlarged considerably without sharpening the point – from which wide conclusions are drawn. Having no belief in any novelist's inventions for behaviour and personality, I would fully share, for further reasons as well, the historian's distaste, were it not that I feel my summary of fact to be excused, and, in consequence, to be required, by a more massive appreciation of Michelangelo's art.

The achievement of an artist cannot be studied apart from the surrounding culture and the tradition in which he works. Today more than ever, the scholar-ship of visual art is absorbed (at the expense of general appreciation or even of the comparisons such as I make with our own art) in fixing the derivations (if easily handled) for each plastic form and iconographic theme. An aesthetic effect contains a long line, perhaps many lines, of precise antecedents: this is a fact often neglected by those who come from other fields to the study of an artist: hence, it is no wonder that the manners of art scholarship have become more and more academic. On the other hand there is the worth (to us) whose interpreta-tion, though it must be founded on this scholarship, cannot be pursued entirely in terms so narrow, whether we are considering the masterpiece or themes in which a masterpiece is embedded. The widest theme of all, the nature of art, has little attention now from those who explore most closely its manifestations.

Whereas there are powerful excuses for the neglect both of aesthetic speculation and of unusual sensibility, the study of art history, it is obvious, cannot be secluded in every case from a present understanding of human needs. I must therefore hope that this (by no means sporadic) attempt to discover certain fantasies that are common ground in the projection of Form, and then to relate how the genius of Michelangelo more than matched the great opportunities implicit in his tradition and in his time, may not be considered by scholars *ipso facto* as offensive.

Michelangelo has been fortunate in many of his students: all lovers of art are indebted to unimpassioned investigators of so fervid a field of human experience. I trespass at times on this well surveyed ground which, as I hope, from other places of the book persists in the middle distance. In regard to Michelangelo's poems which are so much less well known, my locus is rather different.

2 Synopsis of Michelangelo's life and known works
other than drawings and poems

NOT ALL STATEMENTS (nor omissions) even in so bald an outline are of equal validity: qualifications and references would be inappropriate in an *aide-mémoire*.

Michelagniolo di Ludovico Buonarroti Simoni was born on 6 March 1475: he died under three weeks before attaining eighty-nine years, on 18 February 1564.

He was born at Caprese, above the Valle della Singerna, a Florentine dependency where his father held the appointment of *podestà* or governor; the term of office finished less than a month afterwards. It is said that Michelangelo was put out to nurse with a woman at Settignano, above Florence, where the family owned a farm. His mother died when he was six. At ten he joined the Grammar School of a certain Francesco da Urbino. Granacci, six years older than Michelangelo, for long afterwards a friend, took him to the *bottega* or studio of Domenico Ghirlandaio where he worked. At the age of thirteen, Michelangelo joined the *bottega*, as pupil and helper (1488). The usual age for apprenticeship was ten: on the other hand the contract showed that Michelangelo would be paid a small wage. Probably at this time he made the extant drawings after Giotto and Masaccio. The contract was for three years: Michelangelo left, probably after a year, to study the collections of Lorenzo de' Medici, the Magnificent, in whose palace he was taken to live. Michelangelo executed a head of a Faun in antique style (lost). The sculptor Bertoldo was in charge of the collections. Lorenzo died in 1492.

This is thought to be the period of two marble reliefs by Michelangelo, the first in low relief, the second in high, the so-called *Virgin of the Stairs* and the *Battle of the Centaurs* (Casa Buonarroti, Florence).

Lorenzo was succeeded by his son, Piero. Michelangelo carved a *Hercules* (more than life-size) which was sold in 1529 to the French king, Francis I. It has been lost since 1713 with the abandonment of the garden at Fontainebleau in

which it stood. At this time also he carved a wooden crucifix for the Prior ot Santo Spirito who gave him permission to dissect corpses.

In 1494, observing the unpopularity of Piero (who was soon to be driven away), and doubtless believing a rumour that the French king might plunder the city, Michelangelo left Florence for Venice and Bologna. He lived over a year in Bologna at the house of a nobleman, Gian Francesco Aldovrandi. He was given the job of completing the tomb of St Dominic in the church of that name by carving two statuettes for the sarcophagus lid and one to stand near the shrine. He returned in 1495 to Florence where a new government, without the ruling Medici, had been formed under the influence of Savonarola. Another branch of the Medici family, however, were in some favour: Lorenzo di Pier Francesco de' Medici commissioned the carving of a boy St John the Baptist, now lost. Michelangelo carved also a small sleeping *Cupid* which later passed into the Gonzaga collection at Mantua (lost since the collection was sold to Charles I of England in 1628).

The *Cupid* had first been sold to a dealer from Rome: the artist went there himself in June 1496, to seek his fortune (which was unlikely to prosper in Savonarola's Florence). Cardinal Riario, who was living in the new Cancelleria palace, bought a marble block for Michelangelo. Probably this block was used for the *Bacchus* (Bargello, Florence) which Jacopo Galli bought, as well as buying a life-size *Apollo* or *Cupid* (lost). Galli served as intermediary of the contract for the marble *Pietà* of St Peter's (first chapel on the right). The other work of which there is mention in the first Roman period, was a cartoon (lost) for the *Stigmatization of St Francis*.

In the spring of 1501 Michelangelo returned to Florence until his second departure for Rome in the spring of 1505. He executed the marble *David* between August 1501, and March 1504 (Accademia, Florence), for the Opera del Duomo; he undertook to sculpt the twelve Apostles for the cathedral, commissioned by the Arte della Lana. Of these, only the *St Matthew* (Accademia) was started, probably in 1506. He had a commission also for fifteen statuettes to decorate the Piccolomini chapel in the cathedral at Siena. Four only were delivered, perhaps partly finished by assistants. It is likely that the Bruges *Madonna and child* (Notre-Dame) belongs principally to this period, three circular pieces also, or *tondi*, two in marble relief, the *Madonna Pitti* of the Bargello, the *Madonna Taddei* of the Royal Academy, London, and a tempera painting, the *Doni Holy Family* in the Uffizi, Florence. A bronze *David*, destined for a French marshal, was sent eventually to the king's treasurer, after being finished by B. da Rovezzano (lost). Together with the marble *David*, the most celebrated work of these extraordinarily fertile four years was the cartoon of the *Battle of Cascina* or the *Bathers*, a composition of more than life-size nudes for the proposed fresco in the Sala del Consiglio, Palazzo Vecchio. About 1516, this renowned design

was divided into many pieces, probably by the students who used to copy it. Some parts were sold, all were eventually lost. A grisaille at Holkham is the only surviving version that is plausible. The artist experienced an even more rapid destruction of his work in the over life-size bronze seated statue of *Pope Julius II* on which he had worked for more than a year, during his second visit to Bologna, whereas the Cascina cartoon had occupied him for a few months only. The bronze statue was destroyed upon the restoration of the Bentivoglio family to Bologna, less than four years after completion.

In the spring of 1505, Michelangelo was called to Rome by Pope Julius II in order that he might execute his (Julius') tomb in the new choir of the old St Peter's. Michelangelo then spent eight months in Carrara for the marble. The Pope seems to have lost interest in the tomb by the spring of 1506: he had decided to reconstruct the whole of St Peter's, using Bramante's plans. Rebuffed in demands for expense money, Michelangelo left Rome secretly for Florence the day before the ceremonial laying of the first stone. The Pope ordered the return of Michelangelo who replied that he could continue the tomb very well, indeed better, in Florence. After the Pope had sent a *breve*, after Michelangelo had received assurance of safety, at the end of 1506 he submitted to the summons to Bologna which Julius meanwhile had reconquered, appearing before the Pope, he wrote later, with a rope round his neck. Then followed the commission for the bronze seated figure mentioned above.

He returned to Florence in the spring of 1508: within a few weeks he was ordered to Rome by Julius to paint the vault and the higher parts of the side walls in the Sistine chapel. He executed this work in the subsequent four and a half years with the help of a few *garzoni*. Prophets, sibyls, nudes and scenes from Genesis are represented upon the vault; there is the figuration of other parts of the Old Testament for lunettes and spandrels, including the ancestors of Christ. The technique is fresco: when engaged on the ceiling, he worked on the scaffolding looking up and painting above his head, some 55 to 60 feet from the chapel floor. The length of the ceiling is 40·23 metres, the breadth about $13\frac{1}{2}$ metres. His previous experience of fresco painting is likely to have been small. The work was finished at the end of October 1512. It is probable that near this time Michelangelo made a cartoon of the *Pietà* which was used by Sebastiano del Piombo for his famous painting at Viterbo.

Julius died in February 1513: his heirs made a new contract for the suspended tomb. The original plan of 1505 had been for a free-standing shrine with more than forty large statues and reliefs. The contract of 1513 was for a wall monument, though of an even more ambitious scale. The contract of 1516 shows a modified version. Julius' heirs were particularly restive in 1522; Michelangelo thought of selling the executed work and of giving them the proceeds in repayment of the advances that had been made to him. In 1525 he suggested a further

modified plan which the heirs indignantly rejected: but the fourth contract of 1532 shows a modest plan; the site is now at San Pietro in Vincoli. (No doubt to humour the heir, the Duke of Urbino, Michelangelo made him a design for a silver salt-cellar and a little bronze horse in 1537 (lost).) It is possible that the *Victor* statue in the Palazzo Vecchio, Florence, was intended for the plan of 1532, though it is likely to have been carved some years earlier, together with the unfinished *Giants* or *Slaves* of the Accademia, Florence. The negotiations behind the contracts were partly triangular since it was Michelangelo's commitments with the Medici that prevented him from completing the tomb. Not that Michelangelo considered himself safe – Julius' dangerous anger was attributed also to his heirs – or excused in the matter, and he felt it necessary to make constant representations and rebuttals. The final contract belongs to 1542: largely the work of assistants, the monument we see today in San Pietro in Vincoli, was erected by the spring of 1545. As well as the *Moses* (moved forward and slightly raised in 1816), some of the stones of the 1505 and 1513 plans figure in the base. Michelangelo carved the *Leah*, already well advanced, and *Rachel* for this monument in 1542 and after. In the Casa Buonarroti, the British and Victoria and Albert Museums, there are eight small models, disputed in varying degrees, which are thought to be connected with figures for the Julian tomb.

To go back. After the death of Julius, Michelangelo was working in Rome between 1513 and 1516 on the contract of 1513: the *Moses* and the *Slaves* of the Louvre belong principally to this time. He had a studio at the Macello de' Corvi in Trajan's Forum, his property in Rome for over fifty years until his death.

In 1517 Michelangelo made models for the façade (with plentiful room for statuary) of San Lorenzo in Florence, at the behest of Pope Leo X. This project was no less prodigal than the Julius tomb and even less repaying, the cause of three wasted years, as he himself termed them, spent largely among the quarries and on the roads of Carrara and Seravezza. In 1520 the San Lorenzo façade contract of 1518 was suspended, probably owing to the huge expense. San Lorenzo was never to have a façade. In 1519 Michelangelo suggested that he should make a tomb in Florence for Dante's remains. In this year he began the marble *Risen Christ*, completed by two assistants, of S.M. sopra Minerva, Rome. An earlier version had been abandoned because of a black vein in the marble (lost).

From 1520-1, from 1523-7 and again from 1530-4, Michelangelo was working in Florence on the Medici funeral chapel at San Lorenzo and upon the Laurentian library adjoining the church. (Also the tribune for the relics, over the main door.) The chapel frames the marble tombs of two Medici dukes, Captains of the Church, below whose seated figures are their sarcophagi with back-to-back reclining figures of the *Times of the Day* upon the lids. In the

recess of the chapel's entrance wall, opposite the altar, there is a carved Madonna and child (the Medici *Madonna*) with two patron saints (the latter by assistants), figures executed for a double tomb originally designed for the same site. Tombs for the two Medici Popes, Leo X and Clement VII, were planned either for the church or the chapel precincts. Further statuary (*vide* the fragmentary model of a river god in the Accademia, and the Leningrad marble boy), as well as painting, were planned but not completed, except for a part of the cupola painted with decorations by Giovanni da Udine (whitewashed over).

Returned to Florence since 1512, the Medici party was again driven out at the time of the sack of Rome (May 1527): the republic was revived. While threatened by Pope and Emperor, the city put Michelangelo in charge of the fortifications and also of the block for a Hercules and Cacus or Samson and Philistine. (Possible clay model – it may well have been for the Julian tomb – in Casa Buonarroti. This project is not to be confused with another, near in time, for a Samson with two Philistines, of which there are several copies.) In July 1529, Michelangelo went to Ferrara to study the fortifications. With Alfonso D'Este in mind, who wanted a work from him, he painted the *Leda* (lost), of which there are copies. But first, in September 1529, fearing Florence would be betrayed, Michelangelo fled to Venice. He returned to Florence in November after the promise of a safe-conduct. The city surrendered in August 1530. After a short time of hiding, Michelangelo had to make himself pleasant to the Pope's delegate, Baccio Valori, for whom he carved the *Apollo-David* (Bargello). He drew a cartoon of the *Noli mi tangere* (lost) for the commander of the Imperial Army. He drew in 1532 or 1533 a cartoon for a *Venus and Cupid*. (The dilapidated cartoon in the Naples Museum is possibly the original.) Michelangelo made designs for fellow-artists, especially for Sebastiano del Piombo, and later for Marcello Venusti and Daniele da Volterra: scholars have associated many Michelangelo drawings with lost designs.

In 1534, at the age of fifty-nine, he left Florence finally for Rome where, as far as we know, except for a short visit to Spoleto at the time of a Spanish threat to the city (1556), he spent the remaining thirty years of his life. He was painting the *Last Judgment*, covering the whole wall above the altar of the Sistine chapel, from 1536–41. The *Brutus* bust (Bargello) probably belongs to this period, near the beginning of which he made friends with the exalted religious lady (of a circle and doctrine not untouched by the Reformation), Vittoria Colonna, the middle-aged widow of the Marquis of Pescara, who continued until her death in 1547, and after, to be of great importance to him. He made several drawings for her. At this time he was writing many poems: some of them are addressed to Vittoria Colonna, others to a young Roman nobleman, Tommaso de' Cavalieri, whom he had met in 1532.

From 1542–50 Michelangelo was painting the twin frescoes (each 6·25 × 6·61

metres) of the Paoline chapel in the Vatican. The *Epifania* cartoon of the British Museum is contemporaneous with the second of these frescoes.

Thereafter he devoted himself principally to architecture. Appointed in 1547, he remained until his death architect-in-chief of St Peter's: in the previous year he had taken on the completion of the Farnese palace and he had made the plans for the Capitol: he had also worked in the Vatican. In 1551 he presented the model to Pope Julius III for a palace.

The *Pietà* of the Duomo in Florence was carved between 1545 and 1555. (The artist mutilated it: Tiberio Calcagni restored and continued the work.) It is likely that the Rondanini *Pietà* was begun in 1555. The Porta Pia, the plans for the church of the Florentines in Rome (not executed), for the transformation of the Baths of Diocletian into the church and convent of S.M. degli Angeli, the plans for the capella Sforza in S.M. Maggiore, are the last architectural works of which we know.

Upon his death in 1564, Michelangelo's body was brought to Florence. A very elaborate funeral, decorated by the work of Florentine artists, took place at San Lorenzo in July. He was buried at Santa Croce in the parish where his family had long lived, and would continue to live until the middle of the last century.

Michelangelo was the second of five brothers. The elder brother, Lionardo (b. 1473), who is said to have been always delicate, became a Dominican monk. Defrocked, he fled from Viterbo to Michelangelo (in Rome) who gave the assistance for his return to Florence (1497). There is a mention of Lionardo as a monk in 1510: otherwise we know nothing of him, except that Michelangelo's grand-nephew said that the flight from Viterbo was due to Lionardo's partisanship for Savonarola who had recently been excommunicated. In adult life, and probably long before, Lionardo's monasticism gave over to Michelangelo the role of elder brother that suited him. It is remarkable that among the hundreds of extant letters of this close family there is no other mention of brother Lionardo, who probably died in Pisa soon after 1510.

Buonarroto, the first younger brother (1477–1528), worked in a banking firm, then in the woolshop of Lorenzo Strozzi, later with Giovan Simone (see below) as co-owner of a woolshop for which Michelangelo put up the money. Buonarroto held several public offices.

The next brother was Giovan Simone (1479–1548): he is said to have written some poetry.

The youngest brother was Gismondo (1481–1555). Family tradition has it that he was a soldier. Later, at any rate, he was working on the land, in no better circumstance (except for Michelangelo's help) than a peasant.

There is one mention of 'brother Matteo'. If this reference is indeed to a

sibling, then it is likely that Matteo was a son of Ludovico's, the father's, second marriage in 1485.

ABBREVIATED REFERENCES IN THE TEXT

F. = Carl Frey, *Die Dichtungen des Michelagniolo Buonarroti*. Berlin, 1897.

F. *Briefe* = Karl Frey, *Sammlung Ausgewählter Briefe an Michelagniolo Buonarroti*. Berlin, 1899.

M. = Gaetano Milanesi, *Le Lettere di Michelangelo Buonarroti coi Ricordi ed i Contratti Artistici*. Florence, 1875.

Tolnay = Charles de Tolnay, *Michelangelo*. 4 vols. Princeton University Press, 1943–54.

Wilde = Johannes Wilde, *Italian Drawings in the Department of Prints and Drawings in the British Museum. Michelangelo and his Studio*. London, 1953.

3 Michelangelo and his family

EXCEPT FOR THE NAME, marriage and death, nothing is known about Michelangelo's mother, who died when he was six (1481). As well as Vasari (1568), Condivi, Michelangelo's pupil, who published a short biography in the master's lifetime (1553), reports that Michelangelo was put out to nurse at Settignano with a woman who was the wife and daughter of stonecutters. Hence, these authors assert, Michelangelo used to remark that it was no wonder he became a sculptor. Condivi adds that possibly he was joking, or possibly he knew that a nurse's milk might well introduce a new propensity.[2]

It is important to understand that it was a new propensity from which Michelangelo was not unwilling at times in his old age to dissociate himself on other than religious grounds; new, in the sense that it was foreign to the pretensions of his family. The extant letters to his father and brothers do not mention any aesthetic value of his work, whereas they often refer to the hardness of his situation and to the money he earns. These aspects alone, of course, held the interest of his correspondents; they are anxious for him, and he is the family's chief breadwinner. Michelangelo wants his father's prayers as when he describes to Buonarroto, one of his younger brothers, the anxiety and difficulty about the casting of the Julius statue in Bologna, and the Pope's satisfaction with the model. The father had asked to be informed when he should say prayers for the casting. (M. pp. 71–3 and 76.) All such arduous work is undertaken solely in order to help the family, he likes to tell them (M. pp. 47 and 150: 'solo per aiutar la casa mia'). 'See that you keep alive', he writes to his father in 1512 at the time the Medici were returned to Florence and the father was fined. 'And if you can't obtain the earthly honours of other citizens, it's enough that you have bread and live well with Christ and in poverty as I do here.' Formerly the family had been a good deal richer: except for sometimes obtaining a small authority in government posts, the father would seem to have had no profession.

When Michelangelo was seventy-three, he wrote to his young nephew asking him to tell a priest not to address letters to Michelangelo, Sculptor, because he

is not known except as Michelangelo Buonarroti;[3] and if a Florentine citizen wanted someone to paint an altar-piece, he must find a painter; as for himself, he was never painter nor sculptor in the manner of keeping a shop. 'I have always looked to my dignity and the honour of my father and brothers. I have served three Popes but that was under compulsion.' (M. p. 225.)

I do not think it would be enlightening to say that Michelangelo was a snob. On the contrary, in view of the poor social status of the artist – a mere artisan – which he did much to alter, the fact that Michelangelo was determined to strengthen through art the pride and wealth of his family, is a measure of his huge belief in the reparative nature of aesthetic activity. He cared nothing for appearances:[4] though he became rich, he chose to live very simply in some degree of squalor: he preferred to be lonely. He continued to accumulate money for the family long after his father and two of his four brothers were dead. Though this 'saving' of the family was conceived in terms of restoring their position, it is obvious that the compulsiveness at work did not issue in the predominant need for social approbation. He paraded himself in letters and poems as the most miserable of men; he was also not slow to think and say that each of the close relatives was worthless. He felt persecuted by them. (The father on one occasion at least made use of Michelangelo's money without consulting him, but he was quick to share with Michelangelo the consequent anger, regret and alarm. (F. *Briefe*, pp. 16–19.) In regard to his unreliable and impulsive family, Michelangelo showed bitterness that is the measure, not so much of thwarted self-approbation, as of enslavement.

It cannot be said in the light of their letters that the family were not affectionate, though they were 'on the make', careless in the use of money furnished by Michelangelo, ready to ask a favour from him. All shared in the anxiety concerning each other's safety and health. Both the father and Buonarroto urge Michelangelo at different times to throw up his work and return to them: it would seem they were unable to make an important decision without his help. Even in offering advice, they are usually careful to stress that he, Michelangelo, is the wise one. Although narrow and idiosyncratic, the father is capable of showing humility, not in the face of his son's genius but of his prudence and business sense, even at the age of seventy-seven in connexion with a matter (the value of a farm) about which he, the father, probably with time on his hands, may well have been better informed[5] (F. *Briefe*, p. 175). We prefer the father, Ludovico, on the evidence of the letters to the favourite brother, Buonarroto, who died of the plague in 1528, it is said, in Michelangelo's arms.[6] Also Buonarroto, in spite of his two marriages, depended upon Michelangelo's judgment, eagerly fulfilled his commissions, identifying himself as closely with the Buonarroti interests.

The morose and tortured Michelangelo mothered and, indeed, fathered this

motherless, sisterless, narrow family. Ludovico, the father, married again, but women seem to have played little *open* part in the family stresses.[7]

The first point I want to emphasize in the matter of his family, is Michelangelo's prudence, his grip upon reality in spite of a great excess of temperament. Unlike pure visionaries, artists need, whatever the size of their wings, a good stance for the ground. They seek to dissipate the depression that encloses them, to restore, to revive; better than most, they have recognized the constancy of death.

Michelangelo was, of course, enslaved by his art in which he has restored the whole world. It happens that he was likewise enslaved by the family circle, however short the time he could give to them, however much with another part of his mind he resented the weight they put on him. Testimony comes in a letter to Buonarroto, probably of 1513. The letter's complaint is first of Buonarroto's extravagance. Michelangelo wants to know if he is keeping an account and he recalls an occasion when Buonarroto was in Rome and he had boasted of spending large sums of his own money: Michelangelo had not unmasked him nor, indeed, was he surprised, because he knew his brother only too well. 'If you have enough mind to be able to contemplate the truth, you would not have said: "I spent so and so of my own money", nor would you have come here to press me over your affairs after all that I have done in the past: you would have said instead: "Michelangelo knows what he has written to us, and if he can't do something to help at once, there must be some difficulty for him about which we know nothing: and we must be patient because it is useless to spur a horse who is running with all his might and more." But you don't know me and have never known me.' (M. p. 109.)

Nor have his biographers known him in this respect. It is usual to stress his generosity to worthless relations as well as his many other gifts, particularly to the poor. They overlook the manifest compulsiveness; they overlook the horse who is running with all his might, spurred invisibly by guilt, anxiety, the desire to restore, as well as by love. He had larger things with which constantly to occupy his mind; no one will have known it more clearly than himself. But the wide sublimation through art could not disengage him from the narrower field of undue apprehensiveness. It is never easy, in fact, it is finally impossible, to separate altogether love and affection from anxiety; yet we often recognize at once a strong degree of anxious superfluity.

Probably over a third of the extant letters, published and unpublished, that Michelangelo wrote to his father and brothers, must be dated between 1508 and 1512 when he was painting the Sistine chapel. There appears to have been a lull in the work between September 1510, after a section had been finished. (Pope Julius was lately departed for Bologna) and January 1511 (Tolnay, Vol. II, p. 111). On September 5th and again on the 7th, Michelangelo was awaiting payment

for what he had recently completed and an advance for the rest. He says he is moneyless since the Pope has left without having settled. Buonarroto is ill; Ludovico must provide for Buonarroto by drawing on Michelangelo's savings in Florence. And should Buonarroto be in danger, he himself would come at once, even though he would have to risk losing the money which, he thinks, should already have been paid over. 'Men are worth more than money', he concludes. (M. pp. 30 and 31.)

But the enslavement exceeded the demands of such love and undoubted generosity of mind. The relatives were not forbearing: they inflicted themselves upon the distracted artist. All three younger brothers, doubtless impelled by the appealing Italian compound of curiosity, family solidarity and self-interest, turned up in Rome to further their prospects in the early anxious years of the Sistine undertaking. Michelangelo writes to Buonarroto in October 1509: 'It seems to me you don't understand how I am situated here. . . . I shall do what I can. It seems that Gismondo is coming to expedite his business. Tell him not to take me into his calculations, not because I don't love him as a brother but because I can't help him in any way. I am taken up with loving myself more than others and I can't provide myself with the necessaries of life. I am in need, worn out and without friends, nor do I want any: nor have I the time to eat as much as I should; so don't let me have more troubles because I can't stand another ounce.' (M. p. 97.)

It is surely not strange that the prickly, unsociable Michelangelo in whom there was overwhelming anger[8] as well as his generosity or his fear, who was notorious for deep melancholy, should have become the cushion to mitigate the hard life of others. Nor is it strange that we find in the massive omnipotent proportions of many of his figures, a full measure of passive and patient receptivity.

There exists, of course, the other side, the resentment, the explosiveness, the contempt. More than a third of all the surviving letters are addressed to Michelangelo's young nephew, Lionardo, the son of Buonarroto: they were written between 1540 and December 1563, two months before Michelangelo died. He was attached to the nephew, not perhaps for himself but as the inheritor of the family. Yet on the whole, the letters reflect a profound irritation. Lionardo becomes 'them', that is to say, Michelangelo's father and brothers (mostly dead) who never asked him to spend money on himself. Thus, the old man writes to the nephew: 'About your rushing to Rome in such haste, I don't know whether you would have come so far if I were in the utmost poverty and lacking bread. It's enough to throw money about that you haven't earned. What a fear you have of losing the inheritance. . . . Yours is the love of a woodworm. If you really loved me, you would have written: "Michelangelo, spend the three thousand scudi on yourself: you have given us much and its enough: we care

more for your life than for your property." ' 'You all have lived off me now for forty years,' he adds in writing to this young man of twenty-six, 'and I haven't had even a good word from any of you in return.' (M. p. 187.) Two years earlier he had written to the unfortunate Lionardo who had come to Rome because of Michelangelo's severe illness: 'Don't my possessions in Florence suffice? You can't deny you are just like your father (Buonarroto) who drove me out of my house in Florence.'9 (M. p. 174.) Lionardo, in spite of Michelangelo's innuendoes, does not strike us an an unusually calculating young man. He appended as was his custom the date on which he received this un-addressed letter. Doubtless he was in Rome but was not allowed to make the visit which had been the object of his journey, undertaken, it is likely, at the instance of Michelangelo's friends.

This letter, in which the uncle tells the nephew not to appear before him, not to write to him any more, calls to mind a letter Michelangelo wrote to his father twenty-one years before (M. p. 55). Instead of *Reverendissimo* or *Carissimo Padre*, the missive opens with the one word, *Ludovico*. After arguing in a patient tone about a business matter concerning which he says he entirely fails to understand what else the (muddle-headed and accusing) father could want in the affair, Michelangelo goes on: 'If it is that you find my very existence tiresome, you have hit on a way to satisfy yourself and to return that key to a treasure which you say I command: and you will do well: after all, everyone in Florence knows what a rich man you are, how that I have always robbed you and deserve punishment: you will be applauded. So, tell everyone just what you please about me, but don't write to me any more because you stop me working.'

But it must be considered doubtful, even here, whether the bitter tone has precedence over the desire to calm the father's accusing fancies, to make amend even with ridicule. There is an extraordinary letter (M. p. 49) wherein a sardonic but desperate humility accompanies the expression of his own very strong feelings of persecution. 'Dearest father, I was astonished by the news of you the other day when I didn't find you at home: and now that I gather you are upset with me and say I have turned you out, I wonder the more. For I am certain that from the day I was born until now I have always had the intention both in big things and small to please you, and always the labours I have undergone were out of love for you. . . . It amazes me that you so quickly forget all this, you with your sons who have had me on trial for more than thirty years. And, of course, you know well that I have always schemed and done the best for you whenever opportunity occurred. How then can you go about saying I drove you away? Don't you see what harm you are doing me? Together with the other miseries I endure for other reasons, this completes my bitterness, and all this misery is the fruit of my love for you. You certainly repay me well! But

let it be as you say. I want to persuade myself that what I have always done is shameful and harmful: and so, as if I had done it, I ask your forgiveness. Try to forgive your son who has always lived badly and done all the evils that are possible in this world. Once again, I ask you to forgive me, the wretch that I am, and spare me the harm of your spreading the story that I drove you out. It hurts me more than you think. I am, you see, your son.'

The fear of losing each other, we have said, is the dominant emotional theme in the family letters. 'Men are worth more than money.' In the face of political dangers, Michelangelo writes, 'Be the first to flee' (M. p. 107). 'Think only of keeping alive' (and not about wealth), he urges his father. 'I wouldn't exchange your life for all the gold in the world.'[10] (M. p. 32.) Anxiously he tries to counteract with religious exhortation and common sense the father's patent persecutory fears whose opposite face sometimes seems to be a certain inconsequence. When the father is ill, though out of immediate danger, Michelangelo implores Buonarroto (who has already shown the utmost concern in telling Michelangelo) to make provision and to employ his wife in aid of Ludovico. He, Michelangelo, will make it up to all of them: the fount of all his effort had always been for the help of his father before he should die. (M. p. 132.) (It would seem he could never entirely convince himself that he has been successful: perhaps Buonarroto's wife could do better.[11]) He is very anxious – as he showed himself again over the deaths of his brothers – that if, by chance, there should be a relapse, his father would not lose the advantage of the last sacraments to promote his celestial living. 'I have always schemed to revive our family,' he wrote much later to his nephew, 'but I did not have brothers whom it was possible to raise up.' (M. p. 197.) The bitterness, I think, was more sorrowful than the usual feeling of failure to satisfy family pride. There had been insufficient proof for his own satisfaction that his father and brothers had exploited him successfully. He hated to be exploited and he knew them to be worthless: in any case, his feeling of persecution was very strong: even so, he preferred to make every anxious sacrifice in order to simulate an eternity for his family's motherless life, to secure their slipping existence. Nothing would be enough, nothing could convince him he had done enough, so profound was the melancholy guilt that centred on them, particularly on the father.

In the lines (F. p. 47) commemorating the death of his father as well as the death of Buonarroto some years before, he addresses his father saying that he will speak of his dead son first. To him the poet was drawn by love, to the father by duty. 'My brother is painted on my memory but you, father, are sculpted alive in the middle of my heart.' I take this wording literally: the very father, primitive as the stone, dwelt within him, a person to be instructed, still more to be placated, a persecuting as well as a persecuted figure, evoking nevertheless a certain pleasurable passivity in a host who may often have

desired to usurp the mother's place.[12] Ludovico is so immediately settled in heaven by the poet that some commentators have divined that Michelangelo is voicing heresy, that is to say, the denial of purgatory. 'In heaven,' he concludes, 'the holy love of father and son will grow. . . .' Thereafter he turned even more to religion, to a father embroiled not only with images of God but with those of the Saviour towards whom the last poems attest a deepening passive attitude. On the other hand, the death of his father seems to have released the full hatred of tyrants in his native land to which he never returned.[13]

It is part of my view that I assume the pressure (upon us all) of some such once-corporeal object which Michelangelo carried about with him, a figure he wooed, pacified, imitated,[14] nursed, even while the host performed similar conjuring tricks far more widely with the materials of the actual world, primarily on behalf of a maternal object through the sublimation, art. The broader restorative aim never ousted the narrower: the striking feature is their combination. A strong passive, as well as controlling and restorative attitude towards the narrower and nearer image was incorporated into the tensions of his art, whence there flowers an all-inclusive tortured mastery characteristic of his figures and of his own ideal self, his own self-mastery. Yet even the wrapt, furcate agent, God the Father of the Adam 'history', possesses a form and a position in regard to the lower half of his body which would not be inappropriate to a reclining *Venus* (plate 10). The bisexual congregation of the Sistine vault proposes a tremendous and overpowering strength: hence the *terribilità*.[15]

It is likely, apart from Condivi's assertion of beatings, that Ludovico had opposed Michelangelo's desire to be an artist; and that consent was forthcoming in the face not only of persistence but of an unique skill which seemed to promise gold. At the age of twenty-two, he is signing letters, *Michelagniolo, scultore in Roma*. The signature becomes notable eleven years later when he is *painting* the Sistine vault. Near the beginning of the task, he said that painting was not his profession (M. p. 17). Even after a large part of the ceiling had been finished with success, he pointed out in a burlesque poem (F. p. 7) that he was no painter. Yet the frescoes of the Sistine vault are generally recognized to be the most colossal feat known to pictorial art.

Michelangelo's humility rings no less truly than his pride. Except in the case of the first plan for the Julian tomb, of plans for the façade of San Lorenzo and for the Church of the Florentines in Rome – he was anxious that they should be executed – we do not know of any expression of real satisfaction in what he performed. Vasari stresses more than once Michelangelo's modesty as an artist. 'Michelangelo having been wont to say that if he had to satisfy himself in what he did, he would have sent out few, nay, not even one (sculpture).' Though masterful, he was subservient especially to the father within (in reality, it seems, an impetuous yet sometimes humble man). There was nothing forward-looking

nor expansive in these attitudes. On the contrary, he was led to demand some hypothetical, changeless condition of the once noble family, Buonarroti Simoni, in harmony with the conservative tendencies of his own deep melancholy: that melancholy served as a barrier to the corresponding elation, provided a certain detachment from unparalleled reparative feats in art, a certain pessimism that did not disallow the slow counterpart of omnipotent undertakings, the Julian tomb, the Sistine vault, the façade of San Lorenzo, the rebuilding of St Peter's, not to mention the taming of marble mountains.[16]

As long as it survives, the great work of art is the sole undiminished creation. Such an artist cannot easily tolerate his god-like stature. Many have failed when most was lying in their grasp, drowned by an ocean of illimitable achievement. Hubris for Michelangelo, whose success is perhaps the most individual and obvious of all, was not in question. Little as he valued his near-equals in art, he remained to himself the most wretched of men.[17]

I have wanted to make this point. Another reason for expatiating upon the Buonarroti is for their connexion with Michelangelo's patrons who will, of course, have tended to elicit from him some of the responses that had crystallized in the family circle. But if we now pass from Ludovico to Pope Julius, there is no need to examine Michelangelo's exchanges with this or with other potentates in order to assert that such powerful fathers could have been an important influence on his art: in short, that not only aesthetic sublimations irrespective of their context but the intrusion also of the mighty patron helped to enlarge to heroic size a homely anger, for instance, which may have once figured more directly during a family quarrel over a credit or the ownership of a farm. In the *Flood* scene on the Sistine vault we witness the chronic crises of brotherhood under the aegis of an old man. But the marble *Moses* with the huge knee, with horns, disposer of the fertilizing rivulets of cascading beard, has achieved a mastery (Freud) over the very tensions that have rocketed him into a super-human sphere. Even though he is dejected, self-mastery, the prime proof for Michelangelo of magnitude, impregnates the shambling bearded figure, for example with his arms akimbo on an elongated torso, in the bottom right-hand corner of the *Crucifixion of St Peter* (capella Paolina, Vatican (plate 22)).

Julius II, commissioner of the tomb and of the Sistine decoration, was Michelangelo's first Pope. Among recent writers, Frederick Hartt has stressed the importance to his work of Julius' personality. An opponent of the Borgias – Julius, four years after his accession, refused to remain in the Borgia apartments – he was, according to this view, the purveyor of a 'heroic and seminal' Christianity in which the Body of Christ, the phallic Rovere oak or acorn (Rovere was the family name) and the Tree of Life symbolism, were incorporated with Michelangelo's help into a personal mythology.[18]

At any rate, there is no need to doubt that the thunderous role that Julius,

already an old man, adopted with extraordinary ardour and energy upon his accession, fired Michelangelo's imagination, his terror no less than intransigence. In Julius' service he invented omnipotent forms that bestow an ideal activity upon what is corporeal, an ideal receptivity also, whereby ceaseless tension is married to an unbounded health unknown in the North.

It is not necessary for my purpose to relate the story of the Julian tomb, the chief external tragedy of Michelangelo's life: it dragged on for nearly forty years (with a little coda eight years after). An inspiration in the first place, the tomb became a stimulant of persecutory fears and of guilt. At the same time, he could not, under pressure, resist a novel undertaking if it were colossal enough. He feared to lose touch with a new persuasive patron of real power:[19] there accompanied the anxiety an attraction to the patron's profligacy which, while it inspired him, often wasted much of his time, as when he spent three years on the San Lorenzo façade among the quarries of Carrara and Seravezza. Until Michelangelo's interest was fully aroused, the patron had to go to some trouble with promises and reassurances to placate the artist's distracted temper, especially in regard to the abandoned Julian tomb and the accusations of the Julian heirs.

The Seravezza experience alone would have justified Michelangelo's ambivalent attitude to the paternal authority of the Medici: but it is obvious that there were deeper reasons for the alternation of republican enthusiasm with the utmost correctitude in his dealings with that ruling family. While he befriended the Florentine exiles in Rome, with a turn of events he was quickly carried into the train of perfect prudence, primarily out of fear, no doubt, which had prompted his various flights from Florence and Rome (he made the first when Medici rule was in danger), but also, I think, because some friendliness to the Medici, as well as servility and hostility, had been experienced in earlier days when as a youth he had lived for some years in the palace of the Via Larga, at first under the patronage of Lorenzo the Magnificent. Some thirty years later he stopped working in the Medici chapel in spite of new money offers by the harassed Medici Pope, Clement VII, fresh from imprisonment following the sack of Rome, became, instead of sculptor, the master of fortifications in the service of the revived republic. Not long after the city fell, Clement protected Michelangelo again.

We might have further insight into these events did we possess more knowledge of the year that Michelangelo spent in Bologna after his first flight from Florence in 1494, when he thought there was some danger that the French might advance on the city. He lived in the house of the Bolognese nobleman, Aldovrandi. Free of the paternalism of his home town, the young Michelangelo may well have exhibited in less tortured fashion his desire to please, to placate, to charm even, the undercurrent of the later gloom, touchiness and revolt.

It is no surprise that Leo X, the first Medici Pope, son of Lorenzo the Magni-

ficent, preferred to employ Raphael at his court. Leo spoke of Michelangelo as a brother, almost with tears in his eyes, since they were brought up together (in the Via Larga palace), wrote Sebastiano del Piombo to Michelangelo: 'But,' he added, 'you frighten everyone, even Popes.'[20] Leo is reported to have said of Michelangelo, 'He is terrifying, one can't get on with him.'[21] Ludovico, we feel, may have said the same. The unreliability of patrons, if only their un-punctuality in financial matters, often echoed the character of the father.

As time went on Michelangelo was fearful of his own crustiness in minor matters. His distaste for chatter and conventional compliments was not kept to himself: in the 1540s in Rome, he would sometimes ask his friend Luigi del Riccio to be polite on his behalf to an important person, or to return thanks for him (e.g. M. pp. 480 and 498).[22]

The final patrons were the Popes, who entrusted him with the rebuilding of St Peter's[23] as well as with the frescoes of the *Last Judgment* and of the Paoline chapel. When he was appointed architect-in-chief in 1547, he would not accept a salary for St Peter's: through the Pope's mediation he was now employed by God; and although for reasons of policy, his interests or properties in Florence in chief, he gave polite consideration to the entreaties of the ruling Medici, Duke Cosimo, although he hankered after his native town, even sometimes fooled himself about his return when writing to his nephew or to Vasari, he was mainly committed to the unruly job of supervising St Peter's, surrounded by enemies who tried hard to dislodge him. Dedicated at last to a single, ever-lasting Patron, he could at an advanced age surmount the intrigue that per-petually harries the life of an impresario. The beatified Ludovico had joined with his Maker, and so, with the earthly vicar. There could be little question of principal service elsewhere.

Michelangelo had left Florence in quest of the good father. The bad and dangerous Medici tyrant, Duke Alessandro, was left behind: within three days of Michelangelo's arrival in Rome, the Medici Pope Clement, for whom he had been working in the San Lorenzo chapel, died. Buonarroti republicanism was now much reinforced: it found expression not only in making common cause with the Florentine exiles in Rome but in his friendship during the earlier years with the reforming sect within the church of Vittoria Colonna. Yet he had been only a short time in Rome, while commanding the utmost favours of the new (though aged) Pope Paul III (who wanted to release him from arrange-ments concerning the Julian tomb that had been started by Clement), before he was planning to withdraw to a monastery near Genoa or to Urbino (Condivi) where he would be safe in the clutches of the much-feared Julian heirs.

On the other hand, prudent as well as panicky amid the uncertainties of patronage, during his Roman domicile Michelangelo would seem to have found, in the almost continuous Papal esteem, the possibilities of a positive

relationship, unusually humbled, as well as on rare occasions, familiar and perhaps contemptuous, through which his overcharged attitudes to paternal authority could become more bearable.

Vasari reports that Michelangelo said: If life, bestowed by God, is good, then his other gift, death, must also be good. Michelangelo's own life appears to have been a living death, except that his art is inexhaustible. Melancholy was too extreme for happiness; nor did it allow him, even when circumstances were favourable, to be always employed on his art: but melancholy was constructive inasmuch as it drove him largely to counteract his strong persecutory anxiety in favour of the mournful impulsion to repair, to restore, to re-create, in favour of a preferable (in his case an inspired) kind of 'madness'.[24] And I think that this is the meaning of his wry boast when he wrote to his old friend Fattucci, sending him some of his poems: 'You will say with truth,' wrote Michelangelo, 'that I am old and mad: I tell you there is no better approach to sanity and balance than to be mad.' (M. p. 526.)

MICHELANGELO

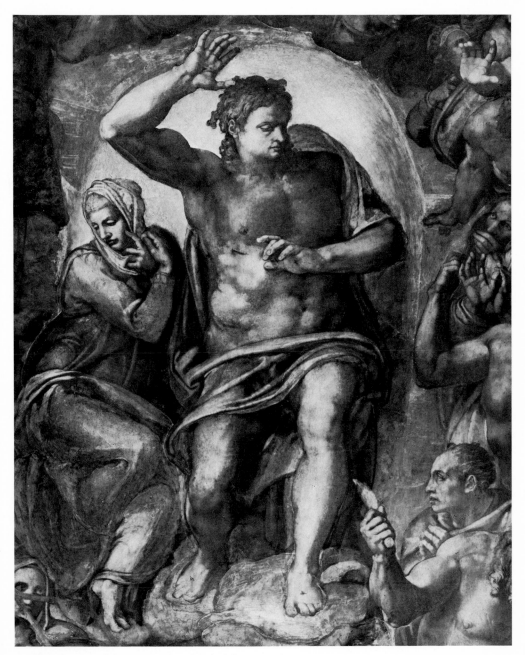

1 *The Redeemer and the Virgin Mary*, detail of the *Last Judgment*. Fresco

2 Pen and ink studies

3 Rapid sketch
in black chalk

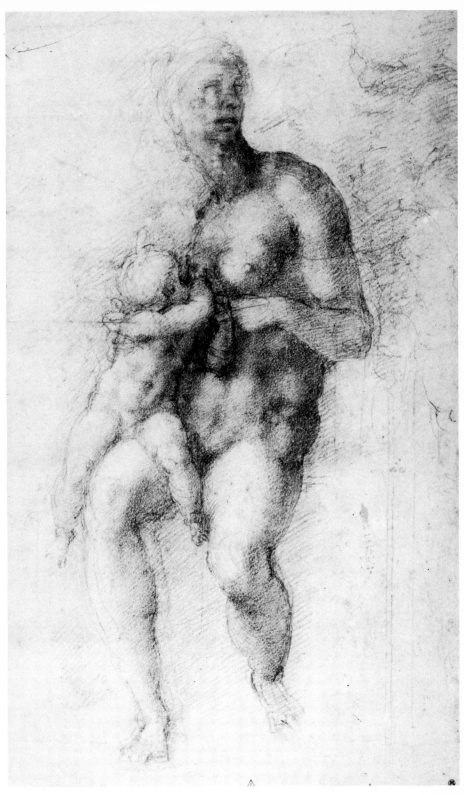

4 *The Holy Family with the Infant St John.* Black chalk

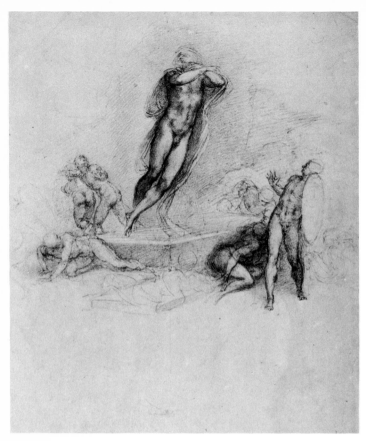

5 *The Resurrection of Christ*
Black chalk

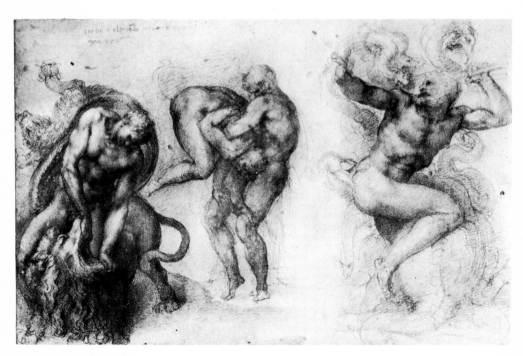

6 *The Three Labours of Hercules*. Red chalk

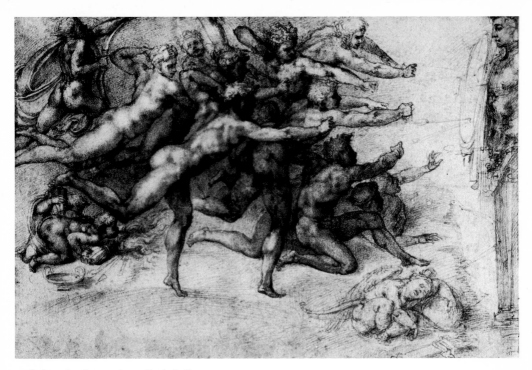

7 *Archers shooting at a herm*. Red chalk

8 *The Annunciation*. Black chalk

9 *The Virgin and child*
Black chalk

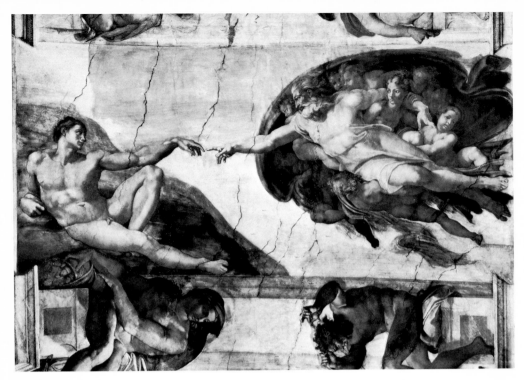

10 *The Creation of Adam*. Fresco

11 *God separating the sky (or earth) from water*. Detail of fresco

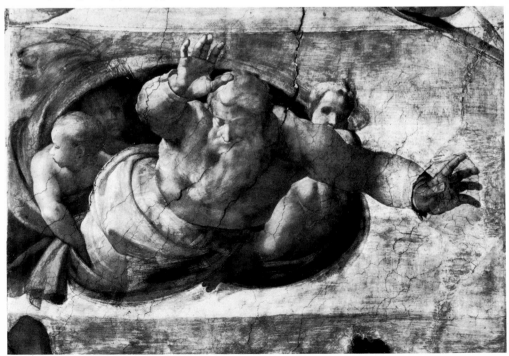

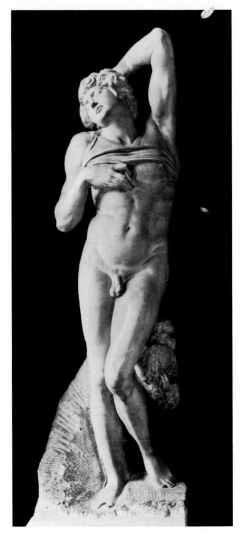 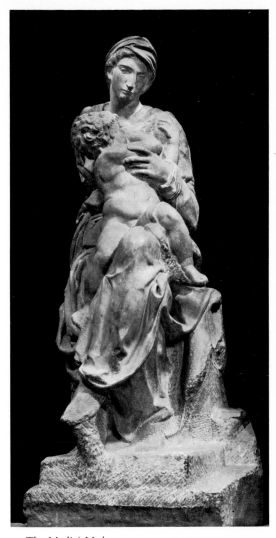

12 *Dying slave* 13 The Medici *Madonna*

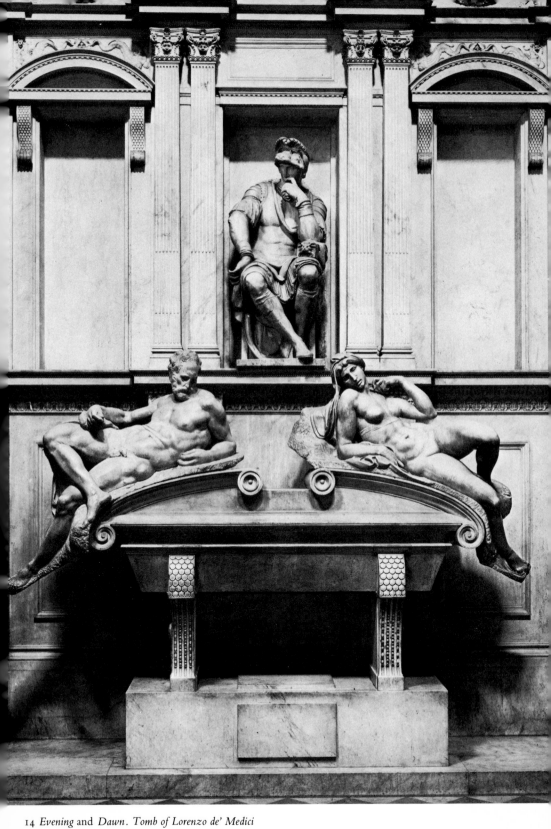

14 *Evening* and *Dawn*. *Tomb of Lorenzo de' Medici*

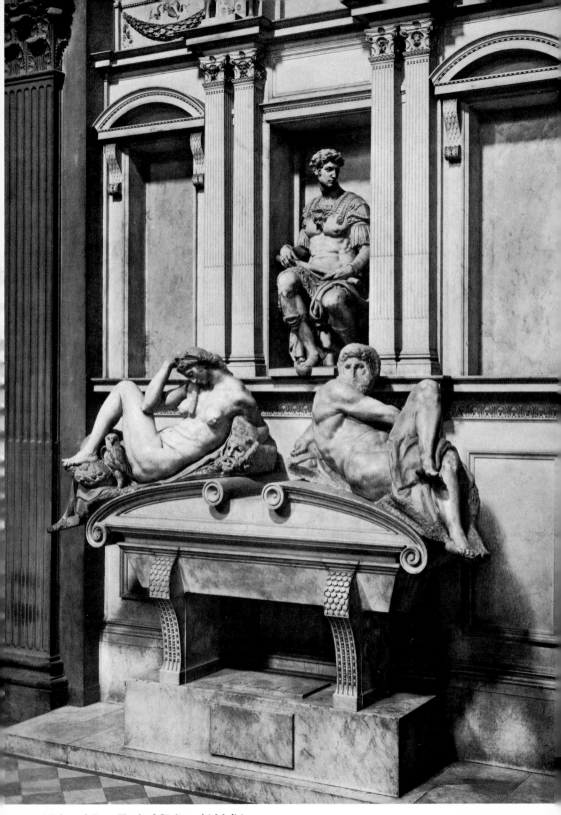

15 *Night* and *Day. Tomb of Giuliano de' Medici*

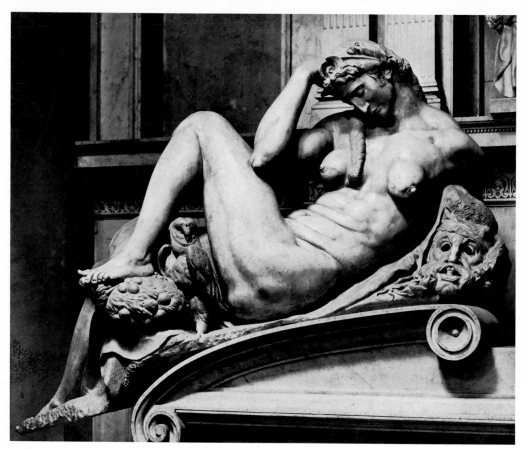

16 *Night*

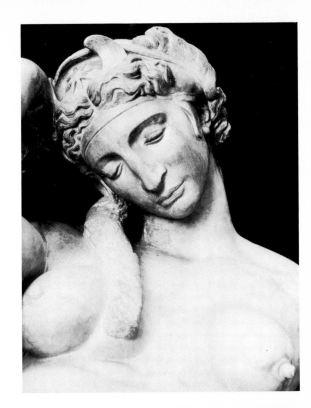

17 Head of *Night*

18 *Day*

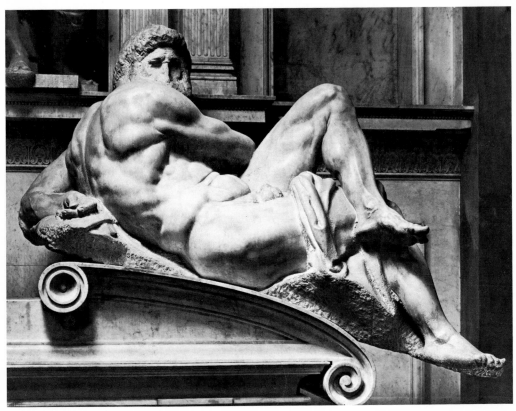

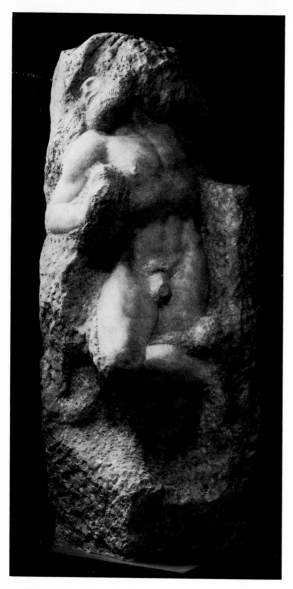

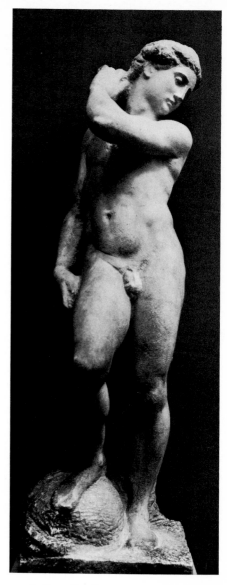

19 *Slave* or *Giant*. Unfinished

20 *Apollo* or *David*

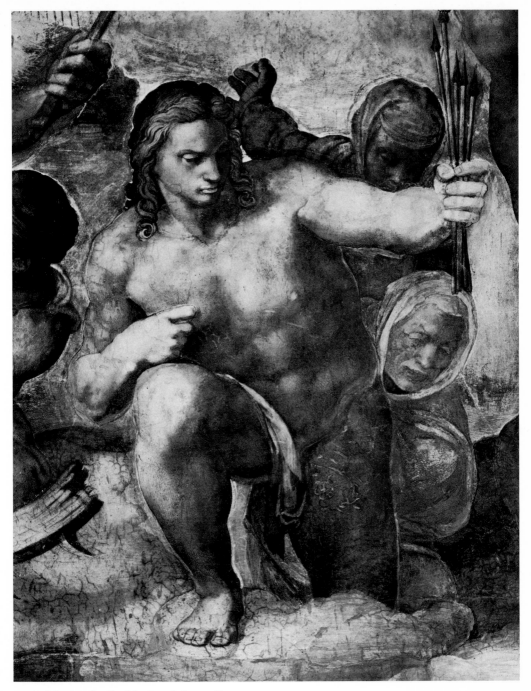

21 *St Sebastian*, detail of the *Last Judgment*. Fresco

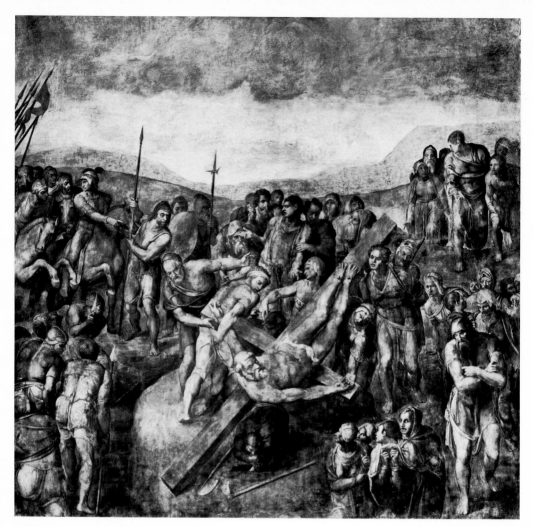

22 *Crucifixion of St Peter*. Fresco

23 The Duomo *Pietà*

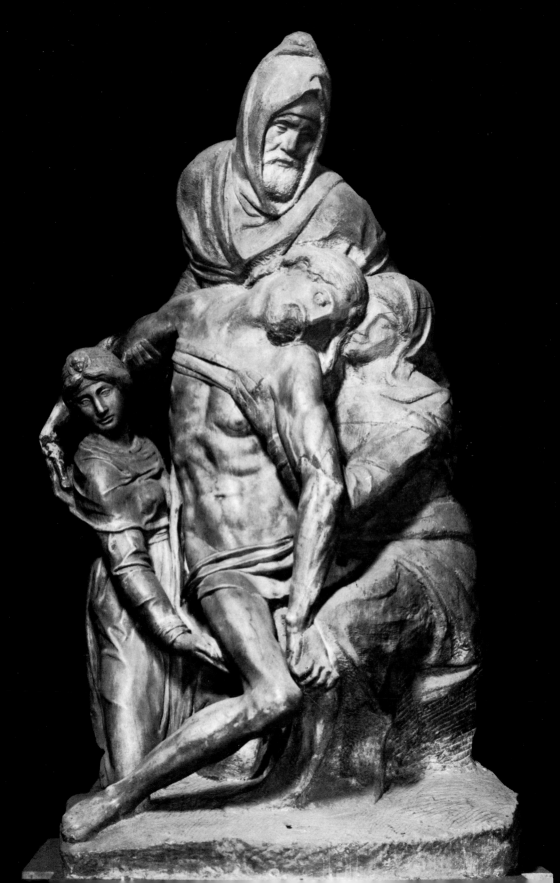

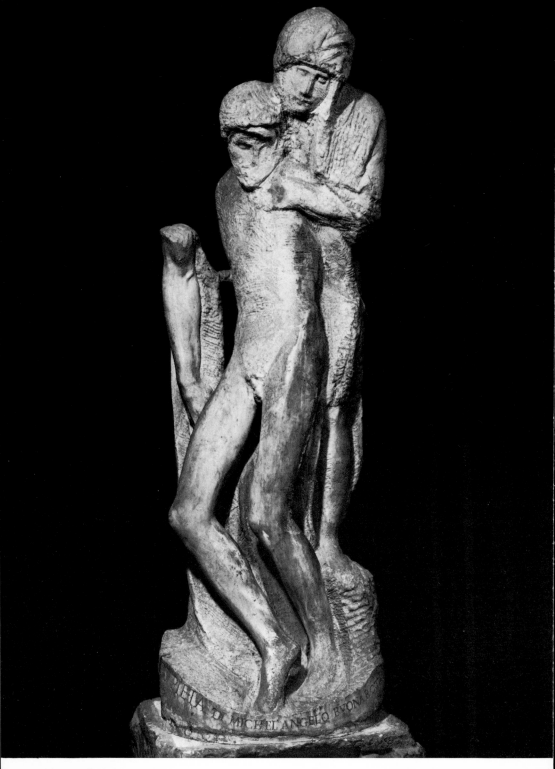

24 The Rondanini *Pietà*

PART II
Visual Works

IT IS LIKELY THAT IMAGES of the body belong to the aesthetic relationship with every object; emotive conceptions of physique are ancient in us; awareness of our own identity has always been based upon the flesh; the outer world of objects was conceived in the first place almost as an extension of our bodies. This early view, of course, bears no resemblance to an adult impression. But art tends to return some of the way back to the sources of feeling and perception. If we could put ourselves at the service of Michelangelo's genius, we should find that he illuminates strongly the compulsion in all art.

He was obsessed with fantasies of weight: he discovered in weight and movement imaginative media not only for depression and death but for the health of physical power. Momentum conquers, flows through complex attitude, the fount of all episodes, the massive idiom of self-mastery and self-possession. This weight, as well as the supporting naturalism of the early works, impels the spectator to exclaim over Michelangelo's figures that they are 'larger than life'. Plasticity, in particular of the male nude, had for some time been the principal target for Florentine figure painting and sculpture. If Michelangelo's works astonish us today, an impression got from them of crushing aside other art (as well as ordinary living) was stronger for his own time: in fact, there has not existed another artist who thus overpowered his contemporaries during a great age of art, magnified in stone the hidden fibres of any superlative strength they aspired to possess.

Plate 1 shows the Redeemer of the *Last Judgment*. He half rises: his arms are flails. Wide as an ape, with electrifying precision he ordains parcels of humanity to the distant zones. He governs in himself an ethereal density, the colossal weight which would belong even to a match-box were it filled with material from the centre of the sun: yet he is brisk, gymnastic; the order and disorder of the hair suggest a serpent-quick intelligence. . . .

The energy of this lavish flesh takes us unawares; we who are surveyors of Easter Island and of the dented meteorites of our own art.

33

Critics agree that Michelangelo's power is unparalleled, not only for the vigour of what he made the nude express (as a rule with the help of distortion), but in regard to his representational skill. Elements of tautology linger in both judgments, because it is not always apropos to differentiate during the Renaissance between skill, visual memory and genius. We cannot think that that situation is likely to recur: we do not feel that the musculature of the nude can again become the vehicle of a comparable significance. The reasons are many; cultural, formal, iconographic, some of which I shall discuss. But first there are even wider matters, useless as targets for scholarship in view of their vagueness; for example, the light, the climate of Italy and, in relation to them, the more profound sources of architectural stimulus. There is, for instance, a common sensation on reaching a Mediterranean country that an attendant oculist has slipped in lenses that clarify: an object even at distance is cleared of film: envelopment has sprung away. The distinctness, the palpability, seem to show that things are well. Ordinary Italian buildings offer us this bounty from their homogeneous walls pierced by apertures of an acute darkness, by a sable inner world inspiriting connective tissue, walls, tiles, cobbles, shutters. Michelangelo inherited not only the achievements of Giotto, Masaccio, Donatello, Antonio Pollaiuolo, Jacopo della Quercia, but more widely the Renaissance gusto for material seen with a clear lens, the passion for conceiving an individual physique however idealized by art, a particular scene however allegorical, as attainable, touchable. By means of the articulated nude he, in turn, contrived a touchable and heroic universe, a touchable homogeneous condition, the outcome of conflict. For, whereas aesthetic creativeness is rooted in the passion to obtain sensuous particularity for emotion, there supervenes an earlier experience whereby the world is one. Quattrocento art prized the newly-born, the *singular* object of the senses, yet singularity itself pointed to, or included, an all-embracing character: under the hands of fifteenth-century sculptors, the stone blossomed as if subject to the steadiness of *all* rooted living forms.

Though his achievement would have been impossible without the prevalence of so dynamic a conception in the previous century, Michelangelo modified the dominant Renaissance fantasy concerning the stone. As well as contriving so that a markedly individual shape should emerge, a near and loved thing such as the fifteenth century conducted to the light from a rich medieval soil, he partly re-interred the new-won finite world, no less than the antique, just dug from the Roman ground, in the homogeneous block. In saying this I have in mind not only the expressive lack of finish of the later sculptural works but also the High Renaissance shift from the Quattrocento enjoyment of outward things, in favour of more masterful organization. 'Michelangelo, the greatest of all naturalists,' wrote Wölfflin,[25] 'was also the greatest idealist. Equipped with all the Florentine gift for individual characterization, he was at the same time a

man who could most completely renounce the outside world and create solely from his own conceptions: he created his own world and it was his example – though not his fault – which chiefly led to the lack of respect for nature which was shown by the next generation.' And so, Michelangelo's inherited theme of the nude must be estimated as an emphasis upon the outwardness of the physical (the Quattrocento inheritance) and also as a generalization (of individual character or emotion) favouring a significance so comprehensive that any stone block is felt to be a parallel sign. Nevertheless he was the supreme carver or vivifier of material: he aligned modelling with painting. (Cf. p. 345.)

Antique art, to which Michelangelo greatly attended, is, of course, restricted, modest, less aggressive than his work. One will ask: of what is the Antique, the prototype; of anatomy, proportion, ideal beauty? Often it so served in serving more generally as a prototype of the aim of art. The fundamental lesson has surely been the one that Pater revealed in *The Renaissance* when he wrote of 'this ideal art in which the thought does not outstrip or lie beyond its sensible embodiment'. Classical visual art is concerned more directly than other art with the human form, the most sensible vehicle of feeling; with landscape, with architecture, as comments upon the inescapable presence of the nude. Thus, in sculpture, we are never distant from a notably physical presence or particularity in the service of an idealization, or even sometimes of a passionate mysticism that will not proceed beyond the bounds of undistorted embodiment. The result is an easy naturalism and a disciplined use of general terms.

If the definition fails to enclose even Michelangelo's recurrent adaptations of classical themes, it is not because he is not found there, but because he extends beyond. We shall often have met conflict conveyed in art with equal or even greater intensity, but we shall not find a parallel for his idealization that electrifies without disrupting a classical embodiment. It is Hercules, they are heroes whom he tortures: until his last works an extreme health contains and conquers the everlasting tension of which he made a nude the vehicle. . . .

Now, it is easier, surely, to find order in the stars than a permanent beauty of the flesh. Science leans towards the extinction of feeling, art towards beginnings that endure.

Plastic values, tactile values, we have been told, enhance the sense of life. But how are the aesthetic forms health-giving, life-giving? Certainly, perceptions will be flattered by their enrichment in the contemplation of art; but such partial flattery is nothing: messages from great art are not the means of a tremulous rejuvenation. There is something more precious than youth with which it may easily be identified; namely, the hope, the ideal, the comfort and self-esteem, whatever the forms it takes, without which we cannot be healthy: some hold on goodness whose sources were loved incorporated persons, as if

part of ourselves but not ourselves, *ingested from the outside world*; in the first place, therefore, physical objects; that body – the original attributes will have been transvalued almost beyond recognition – which many a suicide even, may want to preserve in destroying the enemy, himself.[26] . . . Works of art proffer a magical reassurance, as if a house were supported not only with defensive walls but with the nearby trilling of a nightingale. . . .

Michelangelo's drawings make us acutely aware of the body's articulation. As remembered impressions fuse, a state may arise that in a 'philosophical' form suggests the imprecise eroticism not uncommon in dozing. Though sharing the same root, this state is not in fact erotic in the popular sense. An identical, if less vivid, awareness of articulation may be had from all fine pattern, and particularly from architecture. Moreover, it is as if any physical need that such awareness must ultimately imply, embraced all others; as if, in a far-removed form, we experienced again the earliest goodness of the sensuous life, the blissful aspect of the mother's body (or part of it) co-extensive with an outer world which we incorporated (together with the bad), though afterwards retaining it without as well.

Also this retention without has provided a necessary idea of goodness: the desire for the good body, as expressed by art, is equally a desire for its *separate* persistence inside and outside ourselves, a quality I shall try to enlarge upon.

Meanwhile we are for the moment in the Uffizi, in a long gallery of classic nudes at which we look up, jostled by a crowd whose individuals are even rather repulsive to each other, sickening each other of the flesh. The sculptures, and paintings in adjoining rooms, the Florentine nudes among them, persist no less coolly in their appeal: they have little in common with even the most delightful members of the crowd who are uninteresting in this manner; that is to say, not immediately interesting in this manner, not so strikingly. Beyond the Uffizi, in many stretches of Florence, on the hills among olive terraces, still, level, lit arcades immemorialize the human frame; their thickness records firm integument, windows eye-sockets, cornices the uncontracted brow, ageless yet of each age. From the contrasting roughness of roof and of surrounding trees, plain plastered houses offer a ready image of the body in the manner of a nude revealed by the undercut drapery of surrounding figures in a fifteenth-century relief. A similar alternation comes to us now from every object. We glance at the terraces dominated by sleek cypress, or at the light from the chinks of the plumed cypress edge: we turn to the filigree olive trees and the drop between the levels. We turn once more to building: arches now provide a day-lit reassuring version of the entangled members in Michelangelo's *Centaur* relief: owing to a uniform emphasis on this façade, all surfaces and crevices are unusually manifest, as if attentive: shells on architrave, frieze or spandrel are ears: steps the grooves of the body that mount to the lips. Nevertheless, though

declared in terms of such analogies belonging to a more mature existence, here is the body for ever and the final face, not the dear, not the loathsome body, but an image of the flesh before repugnance has been brought into line, image of refuge, sustenance, sought with a relish we shall never surpass.

I suggest that the old richness is renewed by the imagery of contrasting textures, even though in the aesthetic result, texture may play only what is called a decorative role. The basic architecture of the visual arts depends upon the many alternations such as repose and movement, density and space, light and dark, that underlie composition, none of which can be divorced initially from the sense of interacting textures. Aesthetic appreciation has an identical root: it is best nurtured by architecture, the inescapable mother of the arts. Indeed, the ideal way to experience painting in Italy is first to examine olive terraces and their farms, then fine streets of the plain houses, before entering a gallery. As far as the streets are concerned a similar procedure can be recommended for Holland in preparation for Rembrandt and Vermeer. It is not a coincidence that what we now call Old Amsterdam was rising above smooth water in Rembrandt's day. Much existed on his canvas, in the character of the surface, before he started to particularize, to paint.

Now, if we are to allot pre-eminence in aesthetic form to an underlying image of the body, we must distinguish two aspects of that image, or, rather, two images which are joined in a work of art. There is the aspect which leads us to experience from art a feeling of oneness with the world, perhaps not dissimilar from the experience of mystics, of infants at the breast and of everyone at the deeper points of sleep. We experience it to some extent also from passion, manic states, intoxication, and perhaps during a rare moment in which we have truly accepted death; above all, from states of physical exaltation and catharsis whose rhythm has once again transcribed the world for our possession and for its possessiveness of us; but only in contemplating works of art, as well as nature, will all our faculties have full play, will we discover this kind of contemplation in company with the counterpart that eases the manic trend. I refer to the measured impact of sense-data that distinguishes the communicating of aesthetic experience from the messages of ecstatic or dreamy states: I refer to the otherness apprehended in the full perceptions by which art is made known. An element of self-sufficiency will inform our impression of the whole work of art as well as of turned phrases and fine passages. The poem, the sum-total, has the articulation of a physical object, whereas the incantatory element of poetry ranges beyond, ready to interpenetrate, to hypnotize. Or perhaps precise and vivid images, an enclosed world fed by metre, serve a sentiment that is indefinable, permeating, unspoken.[27] Space is a homogeneous medium into which we are drawn and freely plunged by many representations of visual art; at the same time it is the mode of order and distinctiveness for separated objects.[28]

Musical *ensembles* create perspectives for the ear: as well as the 'music', the enchantment, the magic, there is the *exactness* of rhythm, harmony, counterpoint, texture, and the enclosed pattern of symphonic shape, handy as a coin. We are presented with discipline, articulation, separateness, and with a blurring incantation that sucks us in, at the same time, gives us suck, communicates, however staid the style, a rhythmic flow. The strength of these effects will differ widely, but the work of art must contain some argument for all of them.

There is, then, in art a firm alliance between generality and the obdurate otherness of objects, as if an alliance, in regard to the body, between the positive rhythmic experiences of the infant at the breast and the subsequent appreciation of the whole mother's separate existence (also internalized), complete to herself, uninjured by his aggressive or appropriating fantasies that had caused her disappearance (though it was for one moment) to be mourned as the occasion of irreparable loss: there is the suggestion of oneness, and the insistence on the reality of otherness if only by the self-inclusive object-character of the artefact itself.

And so, these good and reassuring experiences, the basis of object-relationship, are used aesthetically as the cover for all manner of experience (i.e. they inspire conceptions of style even those predominantly hieratic or anti-corporeal and abstract, govern the treatment of subject-matter). This is the practical idealism of all art which says 'in order to live we must somehow thrive'. The artist is compelled to overcome depressive fantasies by making amend (often, as in the Renaissance, by presenting with an air of ease the surprising and the difficult), the amend that articulates together an all-embracing physical entity with bodily separateness, reconstructions of internalized good objects, threatened by the bad. Content, subject-matter, may be unredeemed; formal magic must rule over the pressures of culture. Obviously, art is not planned on tactics of avoidance. The artist has recognized our common sense of loss in a deep layer of his mind. Michelangelo, it is manifest, forged beauty out of conflict (not by denying conflict). The disguises of art reveal the artist; they do not betray him. It can less often be said of the activities of others.

These abstractions may not be so unfamiliar. The above conception of the Form in art has kinship under the modern dress with some well-known aspects of Renaissance theory, the emphasis on the human figure, on the proportions of the nude as the basis of all proportion including those of architecture; the welding of observation, of respect for the particularity of objects, set in space, with a mathematical or Neoplatonic homogeneity.[29]

Although the recalcitrant material of which the earth is made, possesses the highest degree of separateness from ourselves, it should now be clear that in the phrase, 'the homogeneous block of stone', there is implied an image of all-

inclusive *oneness* as well as of individual *separateness* so literally exploited by sculpture, especially by small pieces that we may handle. Absorbing Michelangelo's sculpture we seem able to fondle eternity in terms of physical tension and movement attributed to the nude.[30] The stress he achieves upon the absolute, comes to us from an object that stands well away from us even though we ourselves are subject to that all-embracing significance: and this is so not merely because the marble stands outside us but because Michelangelo's expressionist aim was for the most part subject to the self-sufficiencies of a classical style; because his exaltation of the nude was still largely based upon classical precept; because, in short, the heroic, naturalistic nude served as the vehicle of his longing for universal non-differentiation which so many have rediscovered in a less masterful form, by playing down the precise world of the flesh.

But if this is true, it is also true that we are very conscious of Michelangelo's romantic sense of conflict and of the reference that each form brings to the warmth of his attack upon the stone: whereas in the case of an opposite master, let us say Piero della Francesca, in the case of his love for separate particularity and exact position, we are first aware not of the artist's vital handling but of the intercourse between the forms on which he has insisted, and so, thus impersonally, of an autonomous yet personal world. It contains a calmer, less aggressive yet more concise conception of oneness, less compelling because unemphatic, by no means less noble. Even after allowing for the differences between the two periods from the point of view of art history, Piero, we feel, was not a restless man: he exalted wholeheartedly the out-thereness of things.

Michelangelo turned little to landscape and not greatly to the sublimities that entranced Piero of mathematical proportion.[31] Though science and art were close in the Renaissance, it could be said that Michelangelo was not by inclination a scientist, even in the broader sense, in spite of his enormous responsibilities as an architect. But that might be a misleading suggestion. He persevered with dissection though it tended to make him ill, at any rate in old age (Condivi). No artist, unless it be Leonardo, has equalled his perception of bodily structure in relation to every kind of movement, a knowledge of which his mind was most retentive.[32]

All have shared with him a very early, primitive identifying of sense-data with feeling: moreover, whether it leads to the exercise of art or to skill in other fields, deftness, dexterity, is from the earliest times the use of a vital rhythm that keeps the good object going and harnesses the aggression against it. The artist shows himself, generally in both respects, unusually tenacious. Michelangelo's subsequent development points to a power of memory and a grasp so long informed with intense visual images of actuality as the media for divergent emotions – the distinctive part is the (visual) artist's compulsive grasp of some exactitude, of structure, spatial disposition, weight: it separates him from the

mystic – that we have no compunction in accepting the legend of his draughts-man's virtuosity as a boy. He appears before history almost ready-made, it seems, in Domenico Ghirlandaio's *bottega* at the age of thirteen.

(For the most part I treat only of the less immediate sources of his art whose manifestations were, of course, dependent upon a thousand factors of his time. Had he the misfortune to be born in our own epoch, we might have possessed a variant Picasso, an equal artist of disorientated force.)

But in stressing Michelangelo's impersonal observation of the mechanics of the body, we must not seem to minimize the hallucinatory, the aggressive, appropriating side of the matter, more evident in his case than in the case of an artist such as Piero, or even Poussin with his enclosed world that provides a fencing to the masterful promptings of his temperament. Nevertheless, if Michelangelo's visions elbow, rather than persuade, ordinary existence into the road, it is not at the expense of his own aesthetic inheritance. Supreme initiator though he was, room enough remained for all supernal antics in the classical amplitude of that time: little need existed for the descent into what we now know as the subjectivity resulting from the weakness and confusion of styles.

The wonderful sheet of drawings in red chalk at Windsor of *The Three Labours of Hercules* (plate 6), an independent work of academic aim, probably a presentation sheet (Wilde), will serve as an example, by no means extravagant, for the Michelangelesque articulation and weight. It is especially revealing to remark stresses of this kind in so finished a drawing; for instance, the heavy thigh and back of Antaeus, a downward growing trunk, as it were, of which the leg below the knee is but a branching twig. The composition in the three episodes is markedly involuted. But the muscular stresses of these nudes, slow, inexorable, yet coiling, as we feel, to some attainable pyramid in harmony with the theme, link them with the tonicity that nourishes the fatalistic poise of the *Delphic Sibyl* or the *Moses*. Even from this drawing which emulates the antique, we derive the feeling that we are within the realm of the Sistine *Isaiah, Jonah, Joel*, or of the Sistine *ignudi* who have lifted themselves from the ruck of muscular torsion. *Daniel* and the *Libyan Sibyl* have these labours behind them: they are bastions who astonish us by their capacity to reign over their own voluminous thrusts. The Sistine *Eve*, most feminine of Michelangelo's nudes, is the princess of a people whose supporting toils are mirrored by the iridescent involutions of the serpent; by those thick spiralling elaborations on the surface of the tree, which cause Eve's body and her open face to appear the more succinct. In the expulsion on the right, the angel's flat triangular sword to the neck of Adam, a shape that answers dramatically to the stretched arms in the *Fall*, demonstrates the sharp future toil. . . .

Michelangelo exchanged guilt, fixation, depression for the dynamic if slowed-down bodies of contrite heroes with strength and more to match. With

gross pain just behind them, he showed that their brooding strength must build a huge reserve of matchlessness. He was, of course, incapable of avoiding optimistically such conviction, the basis and spring of his art; an arts upported by deep religion.

In the sculpture, heroic figures emerge from, yet relapse into, the homogeneous block. But before discussing Michelangelo's relationship with the stone, it will be useful to consider drawings: in executing even the studied *Labours of Hercules* to which I have referred, the draughtsman was not forgetting the tissue of stone. The limp, overpowered lion's mane, the lion skin foaming from the shoulders of Hercules in the first episode, the touched-in Hydra of the third, are like layers in the marble which Michelangelo often left chipped, allowing to the nude a heightened, smooth presence. The alternations of light-and-shade, we have said, while serving to articulate the figures, provide also a means of realizing textures. The technique of this drawing varies from stipple to hatches; *laborious* marks, we feel, whereby such figures of stress materialize, as if marks that record the carver's image of movement prised from the stone, were the close counterpart to the muscular effort he used in making them.

It has been said of late drawings especially, of a period when Michelangelo's touch had become unsteady owing to his great age, when his eyesight was defective, that he gradually worked inward from many corrections of contour lines, being compelled to narrow the form. However that may be, it was surely natural that he should start with breadth; so that there has come about by means of the *pentimenti* a suggestion not of distance but of the circumambient stone. Especially in old age the chalk in his hands tended to reproduce the preliminary scorings of the sculptor.

No one suggests that the work of Agostino di Duccio has any direct connexion with that of Michelangelo: and yet, in spite of their lesser gravity and weight, it is not absurd to be reminded of the reliefs at Rimini by a late drawing of a nude *Virgin and child* (plate 9) in the British Museum (Wilde 83), in preference to any other comparison other than further late drawings by Michelangelo himself. For it happens that although Agostino may be considered a mediocre artist in other ways, he was inspired by an intense and compulsive attention to the smooth-and-rough of the stone which sometimes inspires the artist to disclose forms that seem to undulate there, to provide us with a poignant image for the sense of universal growth. Many Michelangelo drawings, and particularly his paintings, of course, are noted for the sharpness and hugeness of their relief: it will therefore appear strange that Agostino, master of marble low relief, should be mentioned in connexion with him. Yet this very mature work, perhaps the latest surviving drawing, obtains the closest contact between mother

and child; and, just as the child is embedded in the mother, so she herself is embedded, it appears, in a homogeneous material which discloses her form, as might the adumbration of drapery.

My point is that if Michelangelo had not shared at times this quality of feeling with Agostino, he would not have been the greatest of sculptors and among the greatest of draughtsmen.[33]

The use of light-and-shade to suggest texture (smooth-and-rough) is well seen in the famous finished drawings of the *Archers* (plate 7) and of *Tityus with the Vulture*. We have in the first a wonderful pattern of great depth: the animus, so to say, in the anatomy of the figures in their rush to the right, would hardly strike our minds were the heads not matted like flowers upon long torsos and limbs. The arbitrary shadowing of some of the forms serves the same feeling. As for the *Tityus*, the recumbent body is clearly indebted to the feathered scales of the devouring vulture, as well as to the uneven rock and the gnarled tree. And surely the same mastery governs Michelangelo's crowd scenes – no other artist has had such success in suggesting turmoil, closeness, interlocking, accompanied by some separateness – in the *Centaur* relief, for instance, in studies for the *Worship of the Brazen Serpent*, in the *Symbols of the Passion* at the top of the *Last Judgment*, and so on; an intensity, a sweep, to which the Baroque artists, in spite of more sensational devices, aspired in vain. Michelangelo could supply contrast from the texture of each body; there was no need to relax a wider stress. We feel that he could evolve such scenes from scribbles with pen or chalk which enclosed islands of the paper; marks, together with the paper, soon represented actions of the human frame; not only pattern but potential rudiments of precise flesh. In this he would have differed only in degree from any other representational draughtsman. The sense of form expands from the sense of texture whose sharpness depends upon an unusual reactivation of the images for the bodily merging and the bodily separateness, defined above.

While there could be no better diagrams of the smooth-and-rough than Michelangelo's late carvings of the *Pietà* wherein the smooth body of Christ is backed or flanked by rougher supporting figures,[34] it will seem unusual to find the sense of this architectural dichotomy prominently displayed upon the Sistine vault. And yet, on returning to the Sistine chapel we are not so much overwhelmed anew by Prophets, Sibyls, Histories, that can scarcely be forgotten. There comes to the revenant a more permeating impression of the whole: he is gazing at the most successful decoration ever conceived: he notices an emanation of rosy light: each tempestuous figure has a place; there is large arrangement of light and dark, particularly the high lights on the centre of the painted arches and the jagged carry-in of light between Adam and the Creator at the top of the vault: little crowding results from so much figuration. Indeed, the Sibyls and Prophets, biggest figures by far, positioned at the top of the walls as

if supporting the vault, not only prevent the apex from appearing overcrowded, they assist also the fancy that this painted ceiling grows from the painted walls as might carved reliefs from their backgrounds. The white tone of the painted architectural framework dominates: but the impression is architectural because although vast surfaces are painted with figures, we viewers are subsisting none the less in the realm of aperture and projection, wall and void, of rough and smooth, the constant theme of architectural effect. We can justly compare the interplay between the bronze-coloured Medallions on the Sistine vault and its rectangular compartments (wherein the Medallions reappear in the forms of sun and moon), with the interplay on the Capitoline buildings, designed by Michelangelo, between pillars in association with giant pilasters, and the wide rectangular openings.

Many eminent Florentine painters and sculptors of the fifteenth, sixteenth and even seventeenth centuries were also architects. Vasari, himself an architect-painter, allows no fundamental difference between the visual arts. The root of all is what he calls *disegno* or drawing; but drawing in the sense of a power to elicit structure, to compose, to bind, to order, to harmonize differences, to proportion weight, to build.[35] No one will deny that the basis for this art was a thorough advertence to the human frame, to the nude, the bony structure, the balance, the protuberances, the cavities, the hair; a corpus of applied knowledge, however, which, thus extending the lessons of the human figure, unconsciously endowed with all these many dignities the ambivalent infantine experiences of orifice, crevice, enfolding embrace; of members that project, tautness and rotundity, of the hunger-filled and the contented mouth; in short, whatever sensuous experiences were primarily associated with the hard nipple, the milk and the soft continuous breast, as well as with the mother as a separate person.[36]

Now architecture, the more abstract of the visual arts, can afford to dignify those experiences with less disguise: there exists here a more profound significance for the phrase 'architecture, mother of the arts', a meaning applicable not only in Europe; and whereas entire commitment to the human proportions was rarely possible in practice, *disegno*, generally speaking, betrays its architectural root, the influence of houses in which men live.[37]

Deep emotional concern with buildings entails the predilection for a rectangular framework. (Pictures have always had architectural setting, whether frescoes or easel pictures with frames.) Even Michelangelo's *contrapposto* is based upon squareness in conjunction with circular forms. The more worked the drawing the clearer this becomes, at any rate in middle period and late drawings; for instance, the famous *Bacchanal of Children*. One will hardly fail to remark the strong rectilinear design – an entire block, as it were – of the *Epifania* cartoon in the British Museum, and the significance of the rounded heads. Or we may consider a collateral of the waistless Redeemer of the *Last Judgment*, the nude

Virgin with child (plate 4), (*The Holy Family with the Infant St John*, Wilde 65). The attitudes are complex, yet the robust columnar bodies leave another image on the mind, a suspended fleece weighted with gold. The conception is sculptural, and sculptural in the sense also of architectural, in the sense of alternations imposed upon an accurately divided block. Plate 3 is of an early sketch, perhaps from the time of the Sistine ceiling (Wilde). First the rectangle of the paper, then a nest of lines, supple as green twigs.

A late variant of this motif is the cat-like yet square palpability of the Fitzwilliam *Christ*, or the design for the *Christ and the Money-changers* (Wilde 78 recto). The *Last Judgment*, the leaden ballets of the Paoline chapel frescoes, particularly the *Conversion of St Paul*, demonstrate how rich and multiple was this theme. The centre explodes into rectangular depths.

Such themes are common enough: the point is the urgency and inspiration they receive from Michelangelo. Shifting the cube so that the longer side is vertical, Michelangelo drew versions of the resurrected Christ (plate 5), elongated, shot heavenward, the sketch for the soldier at the Resurrection in the Casa Buonarroti, the sketch there of the *Christ in Limbo*. (The motif was evolved much earlier; it is seen in a sketch for the *Raising of Lazarus* at Bayonne, executed for the use of Sebastiano del Piombo, about 1516.)

The stone is opened by the sculptor, robbed, restored, transformed. Sometimes in the late drawings we may feel that excoriation stops in favour of a Quattrocento caressing; that the pluckings-out of spiral and oval, womb-like, forms from the rectangular framework, cease. The form is good and unrobbed. . . . What rounded words this Virgin has from the angel at her ear. (Plate 8, Wilde 72 recto.) The square shoulders, the bent arm on the table top, the rectangular pattern of a soft, voluminous shape, seem effortless, glowing. There is often the same poignancy where Michelangelo has emphasized – as sometimes from the earliest days – the roundness of the head: though massive, it remains the more tender of his plastic inclinations. The well-woven words, as we feel them to be, at the ear of the Madonna suggest for the design a quality of contentment even, a mood in which Michelangelo may sometimes have come away from conversing with Vittoria Colonna. He depended on her highborn piety: doubtless in company with that dependence there existed the wavering belief that he, Michelangelo, put goodness into her: and it is likely that a rare conversational encounter of this kind was the nearest approach he could make to marital enjoyment.

The famous lines in Michelangelo's sonnet (F. p. 89) reveal the conviction that the sculptor projects no absolute form: his skill and imagination are needed to uncover something of the myriad forms the stone contains.[38] He removes the twigs which conceal a bird on a nest. (Cf. the basin which in the London drawing (plate 5) serves as the sarcophagus from which the resurrected Christ darts

up in flight, Wilde 52.) As well as fantasies of propinquity we may expect in the context of carving, fantasies parallel to those of exploring the inside of the mother's body, perhaps of snatching a future rival from her womb or of appropriating a fruitfulness that the aggressive infant cannot otherwise attribute to himself. The attack goes on in sculpture, blatantly, one might say, since it will not be mastered unless fully accepted. The form in the stone must first be released or stolen, then exalted. It is as if while discovering the whole, much longed-for object, the infant were able to perpetuate this vision by those very same aggressive fantasies, perhaps of robbing the fruitful womb, which have contributed to his sense of loss and to his need of making restitution. Art is what it is from the character of being an act of reparation that may employ the entire contradictory man. The sculptor controls a rich hoard, animates at the same time an obdurate dead material, a catastrophic avalanche, 'He breaks the marble spell' according to Michelangelo's sonnet; on the other hand, much of his sculpture seems to state that the outer stone is not to be considered as mere husk: it too has forms in embryo.

Even in early, more finished works, he chose to preserve some evidence of the original block: the tendency grew to leave surfaces uncut or roughly cut. The homogeneous block could be homogeneous in a manner he valued, whereas the particularity of any form prised out of it became, after a certain advanced point, less complete as it was 'finished'.[39]

In circumstances that might have entailed paralysing uncertainty, Michelangelo pressed on to solutions (aided by chance) of which the world remains in awe. Of his genius, the enduring strength of his vision, we can only remark feebly, tautologically, that his grip on life was thus strong. He valued in sculpture parts of the rough stone that will collaborate in revealing the particular nude; uncover the emotional process of searching the block; add to depth and vivification; allow the worked forms to suggest both emergence and shelter, a slow uncoiling that borrows from the block the ideal oneness, timelessness, singleness of pristine states.

I should have liked to offer a description of the *Madonna Pitti*; but photographs do not convey the saucer-like tilt – it helps to give the head great prominence – at the bottom of this circular relief, nor the varying treatment of the rim. Volume is attained by an extraordinary subtlety of levels and depths: the Virgin sits on a cube that appears to be cut from the original face of the stone (it projects beyond the inner rim, though not as far as the corresponding block of the Virgin's head), the receding planes of which have been left rough, in tune with the Virgin's arm. Different textures abound; they are part of the smoother neck and the leonine openness of the Virgin's face.

I will turn to the earlier *Battle of the Centaurs* relief. Tolnay has remarked that

45

with difficulty one distinguishes the Centaurs from the Lapiths, the males from the females. And there is certainly no question of victors and vanquished. He even uses the adjective 'homogeneous' for this timeless panorama of struggle. 'Joined to the material that has been carved and to each other, the figures appear to be ramifications of some organic entity.' (*Michelange*, Paris 1951, p. 15.) There is, then, a sense in which the relief confronts us with a single body: we are made to realize that the articulation of the many nudes is an articulation also of the homogeneous nature of the stone. Nevertheless the nudes are in conflict, though the passionate scene of horror is threaded with an ideal oneness: a composition of diversified, very palpable objects and movement joins company with the element of non-diversity. These together encompass the formal qualities that perpetuate the tension of the subject. Thus, the rough globes of all the participants' heads contrast with their smooth bodies and allow of that diversity of texture by which we arrive at a sense of the original body. It is no surprise that similar rough blocks, scraps of the top surface of the quarried marble, are weapons in the hands of two figures on the left, boulders for hurling; a touch that again brings homogeneity into the same orbit as conflict and difference.

Thousands of battle scenes have been executed in relief, especially in Roman times. The theme as such is not of moment, whereas the 'homogeneous' yet dire, even confused, pitting of limb against limb in Michelangelo's version, enlarges the ancient sensation of propinquity, brought to us through images inspired by texture that mediate as well between the artist and his material; for they are the *mise-en-scène* of the artist's formal constructions no less than of the aesthete's attentiveness.

Significant texture, of course, can rarely provide the first aim of the executed work: it is nearer a means of *rapport* with the medium and so, with art, than an end-in-itself. In view of our present-day genius for abstraction, for essence, in view of our corresponding rootlessness and iconographic poverty, we cannot expect otherwise than that many modern artists should be taken up with the quiddities alone; that aesthetes should be charmed above all else by messages sent to the workshop of aesthetic appraisal, provoking exquisite sensations of small stamina, stimulating aesthetic hunger. A proportion of the pleasure in each work is the pleasure of contact with the idea of art itself: modern art would suggest that we enjoy very close contact.[40]

The carver's stone is precious; his effects are therefore economical. Berenson has provided the best exposition in one sentence of Michelangelo's formal aims: 'A striving to pack into the least possible space the utmost possible action with the least possible change of place.'[41] Even so, the block itself will often remain recognizable.

46

In the Medici chapel, the huge back of the *Day* (plate 18) is half-turned towards us, a defiant pose of impossible discomfort, a furrowed bulk so rippling that we align our impression with topographic experiences, with mountain contours between cloud. The nearer arm is flung across a huge, restless girth; we see over the valleys to other ranges. However, at the same time we appreciate that those expanding planes are packed into astonishingly small room, never better than when we look at the photograph taken from behind the slab and see that this twisting bulk is backed by an emaciated, tapering block, the tight flesh, as it were, of a starving pregnant woman. (The description is more apt for the back of *Evening*: from this angle, *Dawn* and *Night* are the most beautiful.)

The imaginative and very skilful packing of the stone was often emulated in Baroque times but never surpassed. Although such works are meant to be viewed from the front, although their backs are false in Ruskin's parlance – indeed, much more often than not they are meaningless – I would suggest that the Allegories and the Dukes of the Medici chapel possess backs of the utmost significance, the outcome of an imaginative relationship with the stone and therefore of 'three dimensional conception' no less valid, at the very least, than those far different conceptions for which this term is priggishly reserved at present.[42]

The unpolished roughness of *Day*'s long head, at right-angles to the fluted flat pilasters behind, brings architecture into the service of his strength (plates 15 and 18). The narrow, deep niches with the Dukes they frame, afford a most wonderful experience of smooth-and-rough, the smoothness of ivory, the crystallizations of rock. Fluted and beaded architecture contrasts with the nude to which it is parent. Light from overhead keeps the faces in partial shadow, falls on the undulating planes of the bodies like sunbeams infused with the sea. . . .

There is a temper about the *David* that argues the dramatic economy of the marble whose story is well known. We learn that here truly was an emaciated block of unusual length and thinness, excavated at Carrara by Agostino di Duccio for a figure to be skied on the Cathedral (where thickness was of no consequence). He did not proceed with the work; the block was then mangled by the attempt of another artist. . . .

What genius to make of this poverty the vital thinness of a hobbledehoy (Symonds' word) with huge extremities, with a troubled, resolute glance; a thin-set giant, possessor of a reserve of strength. The stone's height, the statuesque poise, dramatize the young life which is shown coursing in vein and muscle. (The more truly felt image nowadays for so firm an elasticity would be a well-sprung car, in preference to the floating ease of an untaxed torso upon the hips, or the bend of the midriff above the stomach.)[43]

The movement forward of the *David*'s left thigh communicates both tension and pliancy. Knee and neck muscles, spaces between fingers and toes, the pubic hair, provide indispensable roughnesses to the composition. There is a bare elegance, perhaps Michelangelo's sole reference, entirely transformed, to the posturing which was, for him, a foreign characteristic in the Florentine art of the second half of the fifteenth century. (As the earliest drawings indicate, he sought out from the first the rectangularity of Giotto and Masaccio.) At the same time, both the *Bacchus* and the *David* exhibit the classical formula for achieving depth of planes: one knee forward, one foot back, the torso inclined gently backward, the head forward, the shoulders slightly hunched. Michelangelo's *contrapposto* is a transverse enrichment of classical pose: it demonstrates a whole figure, a whole person whom it was not easy thus to visualize intact: it corresponds to a need of emphasizing reunion within the object and within himself, of parts that have threatened to fling away their identity: each complication in the pose underlines a unifying power which has not been easily won; enchances the grip of the centre.

Although the first impression is of a tall, tapering figure, the depth of the seated Medici *Madonna* (plate 13) on the line of her foot is nearly half of the figure's height, and appears to be two-thirds. The many directions, the straddled infant's turning backward, the planes below the Virgin's vast lap and above, magnify this depth, whereas her inclined head bends forward at the summit. On one side there is a closed effect arising from the projection of knees and limbs carried down by the Virgin's crossed leg: the other side is open; there are bays formed by folds, a panorama of ridges and serrations capped by the dents of the Virgin's bonnet. A common impression will be that all this substance has suffered articulation slowly far beyond the centre.

Michelangelo was probably only sixteen or seventeen, and still the guest of Lorenzo de' Medici, when he executed the *Battle of Centaurs* and the *Virgin of the Stairs* reliefs. They show already the squareness, the monumentality, the restlessness, the search for the union of many planes. He substituted the whole figure of the Virgin for the usual half figure. She sits on a large rectangular block cut just below the original surface. The tilt of her right foot in the foreground plane adds to the surface differentiation both in regard to rough-and-smooth and in regard to depth: the overlap of her garment on to the block where she sits, contributes to the same effect, so too the Herculean infant's turned out arm and hand which we meet again in *Day*, in the seated Duke Lorenzo of the Medici chapel (plates 15 and 18) and in copies of the *Leda*. This gesture exhibits unease, in terms of the muscular restlessness attributed to great strength. The sibylline Virgin has been called a virago and her repose a form of suffering. Tolnay is doubtless right to interpret the heroic sadness in this Madonna and in the one at Bruges in terms of Fate; of visions of the

Passion. But we should ask ourselves why long after adolescence Michelangelo continued to enlarge upon that theme, why, in fact, viragos – though not in the sense of termagant – are the predominant feminine type in his work. The beautiful face of the *Madonna* at Bruges may remind us of the marble *David*. She has needed an element of bisexuality for her role as the artist conceived it. The question concerns this kind of heroism.

Michelangelo scorned incident and genre. A merely pretty mother or playful child set him no target. He showed his characters as subject to a 'universal' theme of which there were plenty in the current iconography.

We turn to his last extant works of sculpture, the *Pietà* in the Duomo at Florence (plate 23) and the Rondanini *Pietà* now in the Castello Sforza at Milan (plate 24). With death near, at the edge of the homogeneous realm of shadow, he was at last able to join elements that had once demanded a resistant strength to accompany their merging; or that had been represented as linked but disparate forces. (There is an early drawing in the Ashmolean at Oxford of *St Anne, the Virgin and the Christ child* which was probably executed in the context of Leonardo's cartoon of the subject, then on exhibition at Florence. The contrast between the tugging masses in the drawing with the Leonardo conception has often been remarked.) It would appear that between the shadow of the absolute merging into nothingness brought about by death, and the shadow of his long habit in religious as well as aesthetic expiation, Michelangelo could envisage more directly the participance of one being in another.

We have Vasari's word for it that Michelangelo himself figures as Nicodemus, the standing figure at the back of the Duomo *Pietà* (plate 23). He supports the right arm of the dead Christ and seems to be turning the corpse even more to the side of the Virgin who has Christ's head upon her check. We see Michelangelo, then, that most unaccustomed figure, in the exotic paternal role (more active than is St Joseph as a rule) of consigning the son to his mother. But nothing jars this deeply moving work;[44] deeply moving because, in a reversed form, we are able to partake, as was the artist in carving it, of an ideal reconciliation. So far from usurping the position of Nicodemus or of St Joseph – though perhaps that too *is* recounted here[45] – it is he, Michelangelo, who is the son once more, the child who sought to come between the parents, who longed to restore the father to the injured mother, to join them in harmony. But they are dead or overcome with melancholy: nevertheless, surrendering more direct uses of potency, he will stand behind them at the apex of the triangle, the puppeteer, the artist, for ever the grieving, resourceful child crying out for resurrection, forcing on the hard beauty that finally coagulates from the endless ceremonials of sadness. . . .

Michelangelo's mother died when he was six. One of the mainsprings of his adult life, we have seen, was to keep his father going, and his brothers came

within the orbit of the same compulsion which contributed largely to his extreme family pride. He fended for them all. Yet we will suppose that at the decisive stage of his emotional development it was also the father he wanted for himself, the mother's place. (A notably passive streak in so rebellious a character would make his attitudes unusually many-sided to his patrons, to Julius and to the Medici.) In the extraordinary Rondanini *Pietà* (plate 24) where an upright dead Christ is supposedly supported from behind by the Madonna standing on a higher level, there is the effect, none the less, that the second figure rides on the back of the first. Michelangelo's father had been dead for thirty years: but in a sense he was not allowed to die: corpse or no corpse, emaciated by death, growing dimmer every day, he was still the family's active principle to his son who had in fact supported him.[46]

At the last, in the Rondanini *Pietà*, heroic conquest was abandoned. One of the two basic images that inspire Form is paralleled here by the underlying content of the subject-matter. Ancient grief and depression calmly occupy the field in virtue of their paraphrase of death: but Michelangelo's Saviour will redeem and carry him: at the very last there is the first love, head by head, mouth at breast, an utterly forlorn contentment that merges gradually with the undivided nature of the final sleep.

I have thought it appropriate to refer to the final 'happy' phase at this point because it helps us to visualize one of the many alternatives of his temperament from which Michelangelo's art proceeded. A passive inclination to which he finally almost surrendered, albeit with a masculine austerity, contributed throughout his working life to the tension of his forms. A virile force was in control; for long stretches of his art, passive signifies encumberment and active, disencumberment. There is little sign, one might have said, before Michelangelo left for Rome in 1505 to work for Pope Julius, before the *Laocoon* came to light in January 1506, of that encumberment of his forms so evident in the *Julian Slaves* whose conception doubtless influenced the Sistine ceiling. Yet his journeying between encumberment and disencumberment was incessant: it will surely be agreed that no figure in the whole range of art affords so vivid an image of disencumberment as the marble *David*, disencumbered of clothes, of weapons other than the sling, disencumbered of the years. This nakedness, of course, belongs to the subject-matter and therefore to a thousand Davids, but Michelangelo adopted the poetic Renaissance conception with an unrivalled wholeheartedness: his still *David* of the turning head embodies disencumberment as never before nor since, not as a negative but as a positive state of earthy presence: disencumbered of cheers, of fame, even of the conquest which he has yet to perform. In this idealized presentation of a palpable, nerve-filled body, we encounter the classic synthesis between ancient experiences of what is

undifferentiated or absolute and ancient experiences of what is particularized, a conjunction that is part and parcel of the formal elements in every art. No wonder that in Florentine eyes so attuned a David became the image of political, everyday Freedom. Athenian statuary with a similar self-possessiveness had once provided the same thought.

We are bound, then, to attribute to the weight of Michelangelo's figures of early date – to the Cascina drawings, for instance – and to the huge energy that liberates them, the character of encumberment disenthroned: inheriting themes of naked energy; of brute strength from Pollaiuolo and Signorelli, Michelangelo transformed oppressive weight into the breadth and pumping power of the thorax especially, into muscles that renew themselves by partaking of bulk. The machine for crushing becomes the instrument for lifting, for release. Guilt, bad internal objects, are identified with the oppression of marble weight, redemption with an easing, but in a sense ever so stupendously muscular, that there are no overtones either of smugness or of romantic enthusiasm for striving *per se*. Faces are not contorted with suffering or effort; indeed, faces are of much less significance than torsos to the artist: many drawings, apart from the studies of movement, show this to be so, none more clearly than the careful design for the first carving of the Minerva *Christ*.[47] Thus, in the drawings especially, the human frame, rather than the features, represents the person; and often, it seems to us, the state of predicament in which Michelangelo passed his life, transubstantiated by this genius of great fortitude into an ideal condition of slow, perhaps cumbersome, disembarrassment. I have particularly in mind the four unfinished *Giants* (Slaves) who wrestle with their stones, with time, with eternity, in the Accademia at Florence (plate 19).

I am suggesting that in support of Michelangelo's sense of predicament and guilt there existed a state of uneasy passivity, known to us in terms of an oppressive weight which, however frightening, had at one time been partly welcome. One of the so-called *Slaves* or *Captives* of the Louvre, perhaps the most typical of Michelangelo's surviving major works, is bound, tied. (According to the first plan of 1505 for the Julian tomb, it seems that there were to have been sixteen of these prisoners as they are named by Condivi and Vasari.)[48] They are figures of passivity or suffering, and also of unusual strength. We are not made to feel that strength evaporates; though death will overcome it, the strength still shows, or, rather, the vision remains, as if coming from profound sleep. Indeed, while phantoms possess the *Captives*, a nightmare of pound-by-pound oppressiveness, their raised, bull-strong bodies translate some of this dependence into the slow particles of health. The so-called *Dying slave* of the Louvre is a relaxed image (plate 12). He submits tenseless to his dream, yet sustains with the huge, refulgent orbit of his form the vigilance of light. His beauty is the one of a sea-cave's aperture that allows and withstands

reverberating waves within. . . . These beautiful forms, foreign to self-pity or to sentiment, are the product of deprivation, surrender, revolt, enlisted by an idealizing yet naturalistic art.

In considering the St Sebastian of the *Last Judgment* fresco (plate 21), we first need to conjure up many Sebastians created in the previous century. As long as myth retains power, as long as the style of symbolic treatment remains approximate, art will grow swiftly from the soil of art. We cannot conceive Michelangelo's achievement except as a summit rising from the Renaissance, rising from all the creations of his period whether in a particular or in a general sense.

We have conjured up, then, a hundred fifteenth-century Sebastians, graceful, suffering, youthful, long-haired, tied to the tree. But here, on the Sistine wall, the arrows no longer impale his body: awaiting commendation he holds them in his hand. No longer tied and upright, he kneels in calm, relaxed expectancy. A tanned champion, he appears to be resting between the field events of a pitiless Olympiad. The episode of the arrows has become in our eyes an episode of training: their tips must have stimulated the giant body which has massively closed upon the wounds, which has closed, as it were, on a great deal of stimulus, shutting it in. The arrows have fertilized Sebastian: gigantic, muscular, of prodigious weight, he is yet full of spring, and somehow protected, clothed, muffled even, by his own sleek nudity, as an elephant by the wrinkled hide. The heroic proportions are so generous that we become aware that his body might suggest the agile cushion sometimes associated with superlative strength, with the loose-knit silence, for instance, of the catribe. Not that it is strong, this reference to the animal kingdom, in any figure by Michelangelo. On the contrary, his men and women of giant frame have a power of heroic intellect in place of the mobility of animals. If some suggestion of the leonine plays about the head of Eve in the Sistine *Fall*, and about the head of the *Madonna Pitti* (Bargello), it is a suggestion wholly subservient to the one of Amazonian strength: whereas, in contrast, the recumbent Adam of the famous *Creation*, fertilized by the finger of the Almighty whose gesture is authority itself (especially when compared with the more usual presentation of divine afflatus), possesses an enduring lassitude (plate 10). The fact is that virile creatures such as he and Sebastian are superhuman: without a trace of effeminacy they incorporate the female powers. Hence the *terribilità*.

And so, on the Sistine ceiling the anomaly of the issue of Eve from Adam's side, beckoned forth by the Almighty midwife, dissolves; and we realize with awe that the keen, the sublime, God the Father of *The Creation of Adam* controls about him an uterine mantle filled with attendants who clamber close, souls yet to be born, attributes as yet of his own essence (plate 10). In the history of *God separating the sky (or earth) from water* (plate 11), we see the attendants more deeply

ensconced in the inflated cloak from which only the upper part of his body emerges with taut, cylindrical simplicity. The features are those of Adam: hair, beard and hands flame with the bisexual creative strength which we readily identify with the imaginative urgencies that have governed the artist.

But what is the final evolution of the superhuman nudes? If we turn to the late Crucifixion drawings, to one at Oxford or at Windsor, we see in each a mourning attendant whose nudity is, so to say, of a quilted substance and dimension, more proper for an Eskimo matched for encounter with a polar bear. Among our thoughts associated with the appreciation of these superb and moving works of art, there may well be those which suggest that at the back of the long cycle of Michelangelo's heroic figures, behind the successful omnipotence (successful in art) to which no homage paid will ever seem sufficient, there lurks in corresponding strength a frightening image of the utmost brutality, an oppressive image of sheer weight that had overcome the child. So it seems, at any rate to the present writer who has been reminded of his subject by R. Money-Kyrle's account of observations by Roheim concerning the overmasculinity and underlying femininity of the men in some central Australian tribes, and concerning the emergence of that undying, infantile conception, the phallic woman.[49]

Michelangelo projected into art a heroic, constant movement that overcomes, or rather absorbs, depression and the state of being overpowered. There are many reasons why the Michelangelesque woman – she too must resist a mighty attack – needs to be indomitable, a seer, a prophetess who foreknows and overpowers evil by her own tragic scale. Whatever the ferment, she must possess the brooding calm of a fine youth, the marble brow, the generous, unsullied resignation, though she be Hecuba herself.[50] Drawings show many more ordinary possibilities, but that is the best of it, the Bruges, Pitti and St Peter's *Madonnas*, the *Delphic Sibyl*, the *Virgin of the Steps*. Later in life, swayed by the rustlings of renewed religion (and, perhaps already, of Vittoria Colonna) he conceived that archetypical Baroque actress, the Virgin of the *Last Judgment* (plate 1).

Night and *Dawn* in the Medici chapel had revealed the nature of the full depression about the woman (plates 14–17). They are carvings that make of depression itself, rather than of the defences against it, a heroic cycle; a statuary less of uneasy grandeur than of grandeur in unease, yet figuring an anguish not unreconciled with the formula of an antique river god's vegetative settlement. The women are inactive; there is no expressionist thrust beyond the material, nothing pointed; on the contrary, a great deal to distract us momentarily, sleep, fatigue, surfeit, a relaxed and slow awakening upon the perilous incline, fruitful images which soon broaden to an universal recognition, undisturbed by the

intensity that provokes rejoinder, of profound unrest. This feeling is unescap-
able: it comes to us through the sense of touch and the consuming eyes, from a
hundred sources that interweave, monumental composition, modelling, move-
ment, directional contrast and the rest. It finds the hidden depressive centre in
ourselves, but even did we not possess it, we should be aware that here are
great works of art, here an eloquence of substances that is read by the tactile
element inseparable from vision, by the wordless Braille of undimmed eyes.
On the other hand, such clamant evocations of hidden depression could not
reach us – our minds would be closed – were it not that they are conveyed in
the reparative, reposeful terms of art. Employing the oppression of death to
enhance the satisfactions of the lively senses, the artist can display an obsessive
grief or cruelty which he would have needed to hide were it not thus repaired
by the ideal relationships expressed in Form.

Generalizations are often symptomatic: it is the precise, the particular, the
primitive hurt that consciousness must keep at distance. 'I live on my death,'
wrote Michelangelo. . . . 'And he who does not know how to live on anxiety
and death, let him come into the fire in which I am consumed' (F. p. 31). The
state of mourning in which Michelangelo spent his life is akin to death where
death is conceived as the irremediable loss of what is good. The Medici chapel
is a burial chapel dedicated to the Resurrection: it expresses the act of mourning
and also the only answer to that condition, the re-instatement, the resurrection
of the lost good person within the mourner's psyche.[51] On opposite walls the
Capitani, idealized figures who have, as it were, sprung to their thrones from
the sarcophagi broken at the centre by the counterweights of the Allegories
upon them (plates 14 and 15), look in the direction of the marble *Virgin* (plate
13), towards that separate, all-sufficient object, the mother, the original object
once long ago attacked, destroyed and despaired of in the outside world. The
Allegories on the tombs below are not, of course, the hired mourning figures
of conventional necrology, but Times of the Day that in effect construe the loss
endured throughout the twenty-four hours, figures not only of loss, but, from
their very concatenation, of the restlessness, dissatisfaction and suffering that
keep loss fresh, just as the impact of these figures renews itself upon us.

PART III
The Poems

It will be objected that whereas it is hard to embrace the conscious motives of our friends, harder the characters of those with whom we are not acquainted, it is surely monstrous to attribute *unconscious* thoughts to a historical figure with small reference to what may be known of him from others or to the sayings about himself in poems and letters.

Certainly we need to discover all we can about an artist since, by and large, the perennial fascination of the life corresponds to a need arising out of closer aesthetic appraisal. The truism, however, must be insisted upon that neither the life nor the work of art would attract us were they not entirely based on foundations formed with materials that are identical with those we ourselves have used. Of the two constructions the work of art is the more simple, the more primitive, whatever the adopted style and aesthetic convention. In regard to Michelangelo, a paradox emerges for the present writer: he feels that his comments spring from psychological theory no more than from prolonged aesthetic sensation; he considers himself on surer ground when speaking in a general way of the hidden motivations in Michelangelo's art, to some degree shared by us all, than when grappling with the limitless complications of personality, or when judging behaviour subject to a thousand and one circumstances many of them entirely unknown, many of them strange to us; in spite of the fact that help is here at hand from eminent scholars who have long taken possession of a hoard of evidence which is probably more voluminous than in the case of any other visual artist except in our own time or in the recent past.

But the language of shape is older than the culture of personality. Art is ever founded upon the psychical tensions attaching to sensations, already at their height, it is plain, in early infancy when ungovernable fantasies tyrannize a most limited universe. The artist turns less far from them than do others. The handling of a material may not reflect an attitude of personality; but in figure art especially, it does allow of a sublimation for repetitive fantasies that were associated

with physical and, indeed, corporeal, form from the earliest times; as well as for many veneers of meaning accumulated upon a shape, the artist must forge a version for this sparse dynamic frame. We read with astonishment of the seven-year-old, almost destitute boy, Schliemann, who decided at this age to discover Troy: he eventually did so after fighting his way for some forty years. Had he been a sculptor of equal genius with Michelangelo, though it is unlikely that he would then have wanted to discover Troy, we might have seen or, rather, felt through our eyes, in some work of his, Schliemann's hand, a summary of the dominant power in so extraordinary a history, the warm meaning of which, except by analogy, is hidden from us.

With Michelangelo, unwittingly, it is true, to instruct us through aesthetic sensation, a nexus of the fantasies around which his genius was wrapped, seems near to the searcher, since he was so markedly individual an artist, a defenceless giant of our civilization. It is otherwise for his circumstances, culture, aesthetic heritage without whose felicitous turn and without their surviving relation with our own culture, that energy would not be conveyed to us in a comparable degree: such life-giving constructions form a vast metropolis difficult even to survey.

But let us seek out again the purlieus of Quattrocento art and culture from which Michelangelo drew life. We could now stipulate, *a priori*, as it were, that at the time of the great art of the Renaissance, culture in the widest sense bestowed on a whole variety of studies an uncommon union between what are more often opposing tendencies (harmonized, if harmonized at all, by the humanist artist alone), between deft observation and transcendental thought, between the exaltation of man and the hope of heaven, between flesh and soul, between health or normality and the magical, mystical, totalitarian propensities of mankind in the face of aggression, age, death, disease and disappointment. We have asserted that art always reconciles a not dissimilar antithesis; that some such union provides the essence of aesthetic value. But we cannot neglect the importance of philosophical rationalizations, along with many others, since they endorse or influence a period's aesthetic constructions, in an indirect, or, more probably, in a direct manner.

Now, neo-Platonism and any kind of thinking that, in effect, exalted Love, Beauty and the freedom of man's creative power, undoubtedly assisted aesthetic achievement. In *Neoplatonism of the Italian Renaissance*, N. A. Robb remarks that this particular doctrine could have been used just as well as a plea for asceticism: the author instances Girolomo Benivieni who, after conversion by Savonarola, collected his youthful love poems and published them with a commentary that interpreted the same imagery in a purely religious sense. But, on the whole, the neo-Platonists, moderate in the use of logic, without employing pantheism, tried to do away with, or to mitigate, medieval opposition

between Creator and created: on the one hand there are the urgent objects of the senses regarded in an optimistic manner, on the other the ideas or eternal models which justify the positive aspects of earthly things. Coluccio Salutati, one of the earliest Platonists, held, according to Robb, that God abides apart from the world in his own simple perfection and yet is present to the whole creation as an operative force. It is easy to see that since this kind of thinking, howbeit illogically, avoided, except in extreme cases, a pantheistic or truly stern and other-worldly outcome, since it idealized, though well within the Christian framework, a sanguine attachment to sensuous experience – it is easy to see that such rationalizations could be of service in furthering art: Renaissance art is unimaginable without this glowing philosophical bent of many patrons (Michelangelo himself, it must be remembered, passed some years as a youth in the house of Lorenzo de' Medici among his neo-Platonic circle.) For one thing, a temper of transcendence or ideality in combination with a firm attachment to the senses, made a bridge to the Antique world as then regarded, to Antique art; provided a spur to the enlargement of those monumental aims which we consider to be typically Italian, whereby mere naturalism and the representation of anecdote are surpassed or transcended. Again, far more generally, we discern in these doctrines, a rationalization of the dual passions fused by art, the love for the 'sensible' self-sufficient world combined with an extreme love for an all-embracing unity conveyed thereby to the senses; the *doppia Venere*, to re-apply a phrase of Michelangelo's.

But although visual art has not been so happily incited by culture in any other period of modern history, the effect was less ideal in regard to Italian love poems. The 'supernal' aspect of love was for the most part at the service of courtly trifling: the poet's concern with his medium, with the concise welter of his words, with urgent sensuous experience, was not vital enough to balance the load of conventional mysticism; whereas, in visual art, the immediate spur to the aesthetic rendering of sensation was as acute, or more acute, than the desire to discover wider connexions therein.

In spite of the humanist revolution, Italian lyric poetry remained the close inheritor of Provençal song and the *Stil Nuovo*: the main subject, as ever, was the prostrations before a (finally) inaccessible mother-figure, the courtly Christian love. Indeed, a case exists for asserting that Michelangelo's verse is a rough exercise in Petrarchan image and antithesis, a neo-Platonic elaboration of certain moods in Dante of whose work he was a notable student. It is undeniable that phrases as well as attitudes echo Petrarch or Dante; that some of the poems, more usually parts of them, exhibit the artificiality of poesy-making. On the other hand, few will deny that the cultural *moeurs* of those centuries, as well as the lyric imagery then prevalent, the conventional antithesis, even some exaggerated conceits, suited the expression of Michelangelo's temperament so

well, that we are acutely aware of his authentic voice in some laborious *fioriture* no less than in simple outbursts and sardonic burlesques, in fragments unprepared for other eyes. We are justified, I think, in abstracting the more laboured poems also – there are sometimes many versions – and the tenor of their imagery which reappears again and again, out of the literary-historical context, so as to consider them solely as prime reflectors of Michelangelo's temperament. More often than of their artificiality, the reader is conscious of great pressure, great sincerity, a violence, an unexpectedness in the use of worn-out convention.

Then again, I am not aware of tendentiousness in finding that the poems' imagery endorses the previous analysis of Michelangelo as sculptor and painter. That has been the sequence: hence the short references to the verses that follow. I must ask the reader to believe that no major conclusion of this study as a whole was ever based upon evidence abstracted from the poems, for many years unopened. As in the case of the life, it is the study of the visual art which emboldens me to interpret some patent aspects of material in the poetry.

Since the sensuousness was so nearly matched by an ascetic renouncing and religious trend, we must rejoice that neo-Platonism held the reins of Michelangelo's poetry, driving these horses along the road of the sonnet. 'His passion is rooted in an eternal paradox', wrote Robb: 'Visible things must be loved since they alone can recall the vision of pure beauty, but to see that vision and try to reveal it to men is to know that matter is forever at enmity with the spirit.' (Visible things must be loved not for any reason of theory, but because, as Michelangelo says over and over again in the sonnets, he is so enormously susceptible. Neither philosophic thought nor religious speculation in which Michelangelo was an amateur, could resolve the paradox; only art for which it can serve as the prime subject.)

Feeling to the full the pressure of death and decay, since he never renounced the nude, Michelangelo's aesthetic problem was more acute than the one of a Nature lover, of an artist equally religious yet nearer to the natural scene, who has escaped this far. Michelangelo's poems abound in expedients whereby the value of corporeal beauty should be preserved in transcendental form; and the same with love. The love of beauty, which, he says, was the endowment of his birth, appears at times to be synonymous with love *in excelsis*. There are almost no references in his poems (nor, of course, in his visual works) to tenderness. Love and beauty are incandescent entities with the coolly burning grip of radium: poem after poem speaks of the fire of love which consumes and destroys or, at best, purifies him of waste: and the poems themselves seem to burn with a cold incandescent ardour. In the sonnet numbered 55 in Carl Frey's edition (p. 42), we discover that the fire of beauty is more extensive than the love it may kindle: 'If I am not burnt up nor die because of your beauty, it is only because I perceive but a part of it.' Beauty is like the sun that inflames the

world while remaining temperate itself (F. p. 127): and he, Michelangelo, would be like the eagle who looks at a small part of the sun (F. p. 94). As well as serving in art as the instrument of reparation, beauty, it seems, or, rather, in this case, a terrifying content that lurks at the back of it (based originally on his own anal-sadistic aggressiveness), provides an instrument for scorching the guilty. Even the stone, we read in F. p. 190, has an internal fire which, if struck, may reduce it to lime so that in this way it can live for ever as a mortar which joins other stones; similarly the passion of love burns up his cold heart which, thus tempered or cleansed, will have become material worthy of the beloved.

The fierceness in this method of joining with another or in the merging with a whole, suggests the existence of a persecutory component, just as the early situation which incited the images of good objects was itself surrounded by thwarting situations, the provokers, therefore, not only of love but of hate, retaliation, guilt and the feeling of persecution. Death may lurk at the back of beauty: at any moment the good turns into the bad. Perfection itself signifies death (F. p. 157). . . . Projecting what is good without the stultification caused by mere denial of what is bad, the artist not only discovers a complex beauty that may include the bad, not only employs aggression in attack upon the medium for his constructive, reparative, purpose, he also plots so that the finality of decease to which instinct, the source of our aggression, commands us, shall lend the character of irreversibility to utterance.

But it may well be beyond the artist's power to achieve in actual situations, a tithe of the stability invented for their aesthetic counterparts. The most common subject with which Michelangelo could make a poem would appear to have been his own anxiety in connexion with the loved body. The burden of it all seems to be that he takes a hammering from physical beauty (in the poems from faces, always, faces, not bodies), a hammering so severe that it burns him up, purifies him in order that he may actively enjoy, it is hoped, eternal love and beauty. We cannot but acknowledge once more in these fiery, austere terms, so fierce yet so masochistic, the welding of active and passive components already attributed to his superhuman figures. But in the sonnets the passive element is paramount at the expense of any exertion to influence the beloved.[52] In F. p. 228, he is the rude model with which Vittoria makes a more acceptable image, taking away what is superfluous, filling in the gaps, moulding him with the strength of her love and interest, into better shape. In F. p. 106 we encounter a related imagery; since Vittoria has meanwhile died, the fashioning of his soul has been left incomplete. In a sonnet (F. p. 55) which displays an unusual sensuous fervour, the demand to be the shoes on which the beloved walks in bad weather, need not be remarked, nor the less fanciful passivity which dominates some of the final religious poems. (It is the coin, even today, of poetic piety.) In F. p. 232,

for instance, God is asked to send down light (perhaps the Holy Spirit) on His fair bride (the soul, perhaps the Church), so that in old age Michelangelo's heart should be warm and comforted. He complains in the same sonnet of an icy curtain between his heart and the heavenly fire of love. In F. p. 239 he says there is nothing viler than he himself would be without God. Without the divine fire – and this we may identify with his own creative gift – he felt not only abject, wicked and depressed, but also, as a corollary, it would seem, cold, frigid, though incessantly inflamed by physical beauty. 'Love made me a perceptive eye, and you he made light', he says in F. p. 97. On the other hand, in F. p. 130 he describes himself as his own counterfeit, wrapped in a darkness that serves best to define the loved one's brightness. There are four sonnets to explore darkness and the night. Illumination is then the enemy; and so vulnerable is night that even a glow-worm can do her violence. The image recalls the predicament of *Night* in the Medici chapel who holds a firestone in her right hand[53] (cf. Appendix 2); it recalls the imagined power of the infant as he first visualized such predicament issuing from his direct attacks, or from those he delegated. Night is scorned in this sonnet for such excessive vulnerability; in F. p. 82 she is praised for the gifts of sleep, of good dreams, of peace near to death.[54]

Whereas despair hides in the curtains of this peace, we are perhaps justified in ascribing to a line of F. p. 207, variation II, p. 463, that same precise confidence in a reparative act which may be discovered in connexion with the *Leda* (cf. Appendix II); *Per vagina di fuor veggio'l coltello*, the sheath tells of the shining blade within (physical beauty tells of heavenly beauty). We would attribute to this image a reversal of that central gloom connected with the sheath rent by the punitive blade. . . .[55]

In general, one has an impression from the sonnets that the poet harbours with anxious concern, with despair, with the need for constant renewal, with a fire, violence and susceptibility persisting into old age, the beloved, the good inner object, in whose reflected light alone he can live, as does the moon by the light of the sun (F. p. 128). Now, an image of the lover living in the terms of the beloved provided a common conceit to Renaissance poets. But we may well feel convinced in Michelangelo's case, as in the case no less of some Elizabethan poetry, that the indispensable, unconscious fantasy which mastered the infantile depression from time to time, was not far different from this same 'conceit'. Love and beauty, we have noted, were almost identical for Michelangelo, who, by projecting the beloved image, sought to rescue and to immortalize the physical world as well. This beauty, then, attributed by art to a projected image in relationship with the self, will partake of the attitudes, active and passive, which he has experienced in his dealings with the loved object within; and it will assume the dangers of the bad by which (in life) the good object is beset. Thus, the *Giants* of the Accademia emerge slowly yet irresistibly from

the stone, retarded by the night from which their heroism disentangles them.

A study of the madrigals, fragments and other pieces confirms the prevailing impression from the sonnets. The beloved is merely a power over the poet in virtue of an unspecified beauty of face or eyes: there are neither personal details nor a glimpse of satisfaction in love. We are assured repeatedly that the poet was made for this burning and for sorrow: and although he as often represents the unsupportable torture of unrequited love – a freezing and a burning together – yet he plainly says at other times that he feeds, however scrappily, upon that indifference. Nature does well, he says, in the tones of Petrarch (madrigal, F. p. 60), to unite such beauty with such cruelty, since one opposite is tempered by the other; and so, a little of the sweetness of your face serves to moderate my suffering, which, thus made lighter, renders me happy. . . . He emphasizes that he cannot surrender the suffering. But in madrigal, F. p. 173, of which there are three versions in Michelangelo's hand, he says he is in two parts, attached to heaven and to the beloved below. The division causes him to freeze and burn. He then suggests that whatever the dangers of undivided love on earth, he would then at least be one with himself. This is very unusual, since he generally seeks unity from the celestial love alone, at the same time finding reasons why the terrestrial love has some justification, even when viewed with the eyes of eternity.

An intense ambivalence causes the juxtaposition of heat with cold, of passion with frigidity. It is obvious that Michelangelo learned to distrust a situation where love could be requited; a situation that led to self-division. He says in madrigal, F. p. 187, that it would be more helpful were the beloved less gracious: an alliance of such beauty with such compassion blinds the beholder like the sun. In an incomplete sonnet, F. p. 109, we read of the eagle who not only has the power to look into the face of the sun (the beloved), without hurt, but can soar up to that height – a far superior satisfaction than the one of mere looking – from where the poet, did he attempt it, would inevitably fall to his ruin.[56] Madrigal, F. p. 225, is more specific: satiety precludes hope: he who never loses in a game is little implicated. Then follows a weak apology for the defeatist's choice: if the beloved were to give everything, it would not satisfy the infinity of desire. . . . The madrigal on page 186 of F. reveals the truth. He asks the beloved for a little favour but not too much: what helps another man, only annoys him: many prefer to have humble fortune. . . . (In this context and in many others we are made aware that for Michelangelo death is the other face of intimacy, just as in art, what is homogeneous or what is complete is the other face of the sensible object, the individual pattern.)

The madrigal addressed to his great friend, Luigi del Riccio (F. p. 174) speaks of the slavery he endures as the result of kindness: a form of robbery, he says. One is reminded of the sonnet, probably addressed to another benefactor,

Vittoria Colonna (F. p. 95), in which he argues without offence that thankless-ness is the humble and therefore polite return for beneficence. Even great beauty is like a killing weight (madrigal, F. p. 176) – we note especially the metaphor of weight in view of what has been said above – which, when distributed, would not harm a crowd: a flame concentrated on one spot could calcify a stone: water would then dissolve the stone, and it would be better for tears to dissolve me utterly than that I should burn of love, without dying. . . .

And so, in one sense the beloved burned, robbed and crushed Michelangelo: such would have been the outcome of most intimacy, the emergence of a per-secutory object constructed in the image of his own aggression. We wonder, then, at the strength of the hope and reparative power which fed the flame of his passion with constancy, made him generous though miserly to himself, cour-teous though persecuted, susceptible and humble though of an ingrowing turn of mind, touchy and in some ways self-contemptuous, sardonic and fierce though wrapped in fear, a supreme creator, believing in himself, who lived to a vast age though unusually committed to negation (cf. note 24). Love was burdened with the weight of the beloved, with suffering: he projected as his own this complicated element of attack, into the marble, on the Sistine wall, on paper.

The stock-in-trade of Michelangelo's poetry, we have said, is the Petrarchan lyrical inheritance: Love, Love's dart entering the heart through the eyes, tears, death. But when literary comment is exhausted, Michelangelo's harping upon death, his predicament between love and the good of his soul, his difficulty in distinguishing the good from the bad as well as in combining the good with the bad, the easy entry of the bad into the good, all are very notable. *Fra l'uno e l'altro obbiecto entra la morte* (F. p. 222). (He is referring to the danger for the soul from the obsession of love): 'Death comes between the partners of love.' Yet his suffering, he says many times (e.g. F. p. 124), is a condition of the beauty of the beloved. This conceit too, I think, can be taken in a wider sense than the intended contrast: we have plenty of evidence that the poet insisted upon his melancholy, his ugliness, his badness – *la mia allegrezza è la malinconia* – as a form of well-being, even of happiness (cf. F. p. 160), in so far as they belonged to the only solution possible in one so little blind, the solution by means of that acceptance or recognition which leads on to the restorative activities of art. Michelangelo, in fact, knew that his art depended upon his ability to stomach loss and death, his ability to mourn. This is not to say with certainty that had he been a less afflicted man he could not have been as great an artist. Probably, the danger was always present that he might topple over into complete, listless depression. There is no doubt that he had phases, long phases, when he was too distraught to work. . . . Unless overlaid and stifled, we all have sufficient

depression at the centre to spur us into continuous acts of restitution: there is room enough for great artists of an almost sanguine temperament, those who are blithe, those of exemplary orderliness.

One common aspect of dilemma might be summed up as follows in relation to Michelangelo. He was easily possessed and overwhelmed: he thus feared to lose himself: what was taken inside could soon become bad and appropriating: every good thing moved in company with one which was bad, conceived on the analogy of his own aggression, his own greed for the good object, his own anger in the way it frustrated him. These sentences may signify little or nothing. A few illustrations from the poems, however, will allow them a modicum of support. First of all, the good object and a mood of biblical omnipotence.

The sense of the sonnet, F. p. 197, probably addressed to Cavalieri, is as follows: I am more than usually dear to myself: ever since I have had you in my heart, I have felt myself to be worth more, just as the carved stone is of greater value than the block. And just as a piece of paper with writing or a design is of more significance than a blank page, so I have become of value now that I am a target pierced by your beauty. No, I don't regret the assault. On the contrary, the imprint has made me safe: I am like a man with a magic power: I am fully armed: (Cavalieri = Knight): fire, water, cannot overcome me: in your name I can give sight to the blind and with my saliva I can render all poison harmless.

In another poem addressed to Cavalieri (F. p. 128: much admired by Varchi as by Frey), Michelangelo says: 'With your feet I can carry weight.' He has his being in the beloved: just as the moon has light from the sun, so he possesses a borrowed light. A less comfortable accommodation of the good object may unwittingly be expressed in a madrigal (F. p. 167) addressed to Vittoria Colonna. The sense runs as follows: The empty mould awaits fulfilment from gold or silver liquefied by fire. A perfect work may be taken out of the mould by breaking it. Thus, with the flame of my love I can cause the shape of empty, unsatisfied desire for your infinite beauty, the heart and soul of my fragile life, to be complete. A beloved woman, far above me, comes down into me through channels so narrow (like those into which the liquid metal is poured) that to bring her out again it would be necessary to break me open to kill me. . . .

It may be objected that whereas this uncomfortable passivity (qualified by the outward passage of tears, cf. F. p. 5) lacks much suggestion of life and well-being, any awkwardness in the images is due either to our scanning them with too literal an eye, or to the nature of the conceit, to an unfortunate variation of a current theme. But suppose the violence of this poem's imagery were the fruit of clumsiness, it would not be the less revealing. Moreover, the violence is surely consonant with the poet's mention of his own death in the ultimate words. The reference is not only conventional, as we know from the majority

of the poems which reveal a deep-set depression that Michelangelo himself identifies with death's likeness. He felt empty and his hunger for the beloved was the ache to fill this void (cf. F. p. 111 which ends: Imprint yourself on my thought just as I make use as I please of stone and blank paper. Cf. also F. p. 120: Love commands not only that I feed on you yourself but on anyone whose face resembles yours). But even the good object, suffered with such passivity or entertained with such greed, can become the object of renewed anxiety: in fact, it may become the bad. Otherwise, why should love make him feel robbed, a frequent complaint? F. p. 5 in which he grieves that he is not master of himself, ends thus: O Love, what is this that enters the heart through the eyes: if for a time some of it comes out again (in sighs and tears), the rest goes on swelling inside?

This foetus becomes a source of persecution: the mode of impregnation is always through the eyes: there passes, F. p. 224 tells us again, in an instant to the heart by way of the eyes, whatever object (*obietto*) seems beautiful to them: 'And by way of this smooth, open and spacious road, there pass not a hundred but a thousand objects of every age and sex.' The poet fears to lose himself: he is now anxious over what he has taken in: all such heterogeneous importations threaten the equilibrium of his soul. . . .

The soul, of course, is now the old, original, good object, in contrast with these crowding newcomers who were thought to be supports, who may turn against the good object. It is not difficult to see that the distinction expresses an original doubt concerning the goodness of the good object due to the constant threat from the bad. We read in the tenth of some burlesque stanzas (F. 25–8 and 321): The whole of you enters me through my eyes (fount of tears) like a cluster of grapes thrust into a jar. This cluster, passed through the narrow neck, expands in the belly of the jar. And now that I have you inside me, it seems that you are my pith and marrow: hence I become larger, my body swells as does my heart with your image. I don't think you can get out by the way you came in: the torso is wide but the passage of the eye is narrow. (The version to which Frey gives priority is slightly different. It has the sentence: Your image which makes my eyes weep, grows within me after passing through the eyes.) . . . Part of another stanza is as follows: When air, opening the valve, is forced into a ball, the same air serves also to close the valve from within: similarly, your wondrous image which reaches the soul through the passage of the eyes, by the very manner that it opens them, by the same manner it closes itself within the soul. . . .

The impregnation, it is clear, is both pleasurable and a source of some pregnancy discomfort. Remembering the cluster of grapes forced into the receptive neck of the jar, we should, I think, remind ourselves that the infant seizes with his mouth, and in fantasy incorporates, the proffered breast, active

in voraciousness and greed. It is not, or rather, it is by no means solely, a passive experience. Any glee that may be expressed in the last lines quoted, has a counterpart in the preceding adumbration of awkwardness. The activity of greed tends to cause the good object to become a bad object, or rather, both greed, and anger at any frustration, summon up the image of a bad incorporated breast against which the good breast must be defended. One defence would be the denial of activity, a protestation of complete passivity, an attribution of badness to the self rather than to the object. The development of this and alternative defences will become exceedingly complicated: and whereas the artist restores, reconstructs the object by his creative work, he must continue to experience also in that defence, traces of the original greed, glee, loss and revulsion, now used to good purpose. The organ about which the processes centre is, of course, no longer the mouth: in the case of Michelangelo it became the eyes.

There are many passages other than those already quoted which express what must be called a genitalization of the act of seeing. Readers will doubtless consider this interpretation unacceptable: at the same time they would find it difficult today to overlook the emphasis upon the eyes. There is, of course, a harping upon the eyes as the windows of the soul, and the conventional usages of *occhi* or *ciglia* to indicate the face. (Except in one or two early poems, no other feature of the beloved has even a bare mention.) In Michelangelo's poems, these conventions are much exaggerated. What is unique (cf. F. Rizzi, *Michelangelo: Poeta*, Milan 1924) is the emphasis upon the poet's own eyes, first as a receiving agency, then as an active power whereby to engorge the beloved. Naturally, this second meaning is not openly averred: but, in spite of the passivity experienced, for instance, in the jar-cluster-of-grapes simile, quoted above, it is noticeable that not Love (according to the usual convention), but the loved body or its image enters into the poet. Now, other contexts show that he is by no means entirely passive in his attitude to the beloved body: indeed, the first of the jocular stanzas from which I have quoted, displays an exercise of control over the beloved, as follows: I believe I love with such faith that even were you made of stone I would be able to make you follow me, more than a step; even were you dead, I could make you speak, and if you were in heaven I would draw you down with complaints, sighs and prayers: but as you are flesh and blood, as you are among us, what limit can there be to expectation? . . .

Yet this active, omnipotent, manic mood passes at once with the transition from stone to flesh and blood. The next stanza (no. 2) begins:[57] I cannot do other than follow you: I don't regret a great undertaking of this kind: for you are not, after all, a rag-doll whose movements inside and out can be controlled. . . . When a day passes (no. 5) without my seeing you, I have no peace: and

then when I do see you, I fasten on to you as does a starving man to food, or as another behaves who feels an urgent need to empty his belly. . . .

The impression that after all he has treated the beloved in some part of his mind as a rag-doll, as *a puppet of his glance*, subject to the enormity of his every wish, is not reduced if we turn to the curious lines that Michelangelo wrote concerning the mechanism of his own eyes. (F. p. 98. Commentators feel justified in considering these lines to be a description of his own eyes because of the mention there of the yellow flecks that Condivi noted in describing Michelangelo's appearance.) Dobelli (*Michelangelo Buonarroti, Le Rime*, Milan 1932) suggests that the description is meant as a lesson or record of how to paint the eye. Even were it so – and it seems unlikely – we would remain equally aware of a certain complaisance, typical of scoptophilia, in the power to gaze so completely while the seeing eye shows little of itself. The fragment is as follows: The shadow of the eye-lashes, when the eye is contracted, does not impede vision, in fact it is free from one end of the socket in which it turns, to the other. The eye turns slowly beneath the lid, showing very little of its big globe: only a small part is visible of the fount of clear vision. The eye does not move up and down under the contracted eye-lid which greatly covers it; and the eye-lid since it is not raised, has a shorter arc, with the result that it is less wrinkled when thus stretched over the eye. The white of the eye is truly white and the black blacker than mourning clothes, were that possible; and the yellow flecks that dance between the lashes are tawny. Black, white and yellow occupy the whole socket. . . .[58]

The uses of the eye were especially for Michelangelo a substitute for potency. A sonnet, almost certainly addressed to Vittoria Colonna in her conventual retreat, runs as follows (F. p. 118): My eyes – possibly the 'inner eye' as Frey would have it – have the power to encompass your beautiful face, near or far: but my feet are forbidden, lady, to bring my arms and hands (the rest of my body) where my eyes can go. By means of the eyes the soul, the intellect, are able to ascend to you and embrace your loveliness: but the body, in spite of great love, lacks this privilege because it is heavy, mortal: and since I have no wings I cannot follow an angel in flight: I must satisfy myself with the power of vision alone. Alas! If you exert as much power in heaven as you do here, entreat and obtain that my body shall be changed wholly into one (great) eye, so that there won't remain any part of me which cannot enjoy you. (*Che non ti goda.*) . . .

There is thus described the renunciation of intimacy with so close a mother-figure in favour of long-distance enjoyment and control by the eye; in the very terms of the renunciation, in despair at the absence of wings for flight (sexual intercourse), a cry for the enlargement of scoptophilic pleasure, to embrace all bodily pleasures, all potency.

And so, in terms of the eye, of visual art, thus indirectly, yet always seeking refreshment from the torturing source, Michelangelo re-enacted with greater consistency, with supreme power, with less revulsion, the active and passive consummation of love as well as guilt, greed and their recompense. Harried with inner persecution and with melancholy, he remained susceptible and aware to the end: it is the first ground of his greatness. *Che chi vive di morte mai non muore*: 'He never dies who lives on that which deals out death.' (F. p. 40.) 'Who would think,' he wrote, probably when approaching seventy, 'that dried and burnt wood might become green again in a few days in the light of your beautiful eyes' (F. p. 150)? *I'me la morte, in te la vita mia* (F. p. 50.)

The refusals of intimacy to which, among other causes, an excessive sympathy impelled him, were not invariable. Thorny though he was, Michelangelo inspired not only respect but an affection he much valued in a faithful servant such as Urbino or in a tactful and unselfish man as Luigi del Riccio. The latter used to advise Michelangelo's nephew, Lionardo, in the making and timing of little gifts, delicacies, food and wine, which pleased the old man.[59] Since he lived in a considerable squalor[60] that matched his depression and his hardness to himself (he might otherwise have had to entertain his friends), gifts from his relatives and others were nevertheless a morsel of the honouring also due to him, a morsel which he could almost readily accept. He used even to visit del Riccio in the Strozzi Compagna villa and was twice prevailed upon to live out serious illness in the Strozzi house in Rome. Always emotional, he might welcome an old friend with tears of joy; but there was a severe limit to that intimacy, easily ruptured, at any rate for a time. Donato Giannotti, the respected associate both of del Riccio and of Michelangelo, described in his two dialogues about Dante[61] how that at the end of their discussions these close friends were unable to persuade Michelangelo to eat with them. He excuses himself on the grounds that he is more susceptible than any one else of any time: on every occasion that he is among those who are skilful, who know how to do or say something out of the ordinary he is possessed by them, indeed robbed by them (*et me gli do in maniere in preda*): he is no more himself:[62] not only the present company but any one else at the table would separate him from a part of himself; and he wants to find and enjoy himself: it is not his trade to have much delight and entertainment: what he needs to do is to think about death: that is the only subject for thought which helps us to know ourselves, which may keep ourselves united in ourselves and save us from being dispersed and despoiled by relations, friends, geniuses, ambition, avarice, etc.

He was about seventy at the time.[63] It is unlikely that longer, more undeniable court from the powerful has ever been paid to an artist in the flesh; yet he felt distracted from his own essence, even by those who were his worshippers.

As, notably, in the cases of the actors, Shakespeare and Dickens, there can be no doubt that the unusual lending of himself (which is also a control of the object) underlay his phenomenal technical command, versatility, and, indeed, originality. For the purposes of art he would initially feel less distrust of the object as he bent it to his will: yet, none the less, in spite of the extraordinary, never-dying warmth of his passionate feelings – extraordinary amid the persecuting fears – love, fascination, interest, entailed oppressive weight, spoliation, a shock to the organization of the ego. He wanted now to keep himself for death, for the undifferentiated, for a merging with what is entire. On the other hand, the separate person 'in his own right', objects good and bad, animate or inanimate, had won from him an overpowering response. (No art, he sometimes says, is sufficient return for the beauty of the object.) And so, he would ever be as the infant with the homogeneous world of the satisfying breast, and he would also be as the rather older infant who could restore, not only this good breast but the self-subsistent mother, the other person, the *whole* separate object whom he had in fantasy overpowered; and he would reconcile or fuse the two ambitions, making the one to serve the other. . . .

Such was the constant aim of a supreme artist, and such is the aim of all lesser artists too. Not many, however, will have employed in comparable degree under the aegis of the restorative aesthetic ideal, psychical trends which when arrayed in strength, must often preclude this lack of emotional simplification, this accessibility, preconditions of the creative refashioning that ends in art.

The superb simplicity or homogeneity of the greatest art which we enjoy as might a starving man a close-grained crust that links every working and sleeping moment, comes to us as an attribute of singularity. Wölfflin has remarked how extraordinary it is that *Dawn* 'for all her movement can be read as a single plane', that the Medici *Madonna and child* combining many tempestuous directions of attitude, give the 'impression of repose because the whole content is reduced to one compact, general form: the original block of stone seems to have been but slightly modified'[64] (plates 13 and 14). Though all these indications of movement are transverse, the Medici *Madonna* tapers like a tower with many ledges.

In the combination of the homogeneous with the individual or specific, we have the crux of Form in art, the creed of the artist's endeavour (for which I have indicated some compulsions). There are, of course, an infinity of methods other than Michelangelo's firm resolving of contrasted directions: but his particularly powerful combination of restlessness with repose provide a clear-cut text. All the same, the homogeneous quality is so well fused with the elaboration of an individual content that we cannot separate them. (For instance, both repose and movement speak of the distinctive object *per se*: everything will serve a dual function.) But in spite of the difficulties of analysis, we are well

aware in general that, on the one hand, a work of art is an epitome of self-subsistent or whole objects which can neither be superseded nor repeated, an epitome of particular and individual entirety; while on the other hand, striding in upon the presentation of the concrete, upon the rendering of experience in terms of touchability and the synthesis effected by the eye that perpetuate (in visual art) the image of a separated and outward *thing*, there comes the tendency to gain for such poignant particularity, connexions with everything else, connexions that blur, a kinship with the universe, a singleness that vibrates at its junction with the singular; there comes, maybe, the homogeneous experience of the 'oceanic feeling', of sleep, the prototype of death and disciple to the unmatched bliss of the infant at the breast: these contents too are communicated *in terms of the senses*.

Welded together, they underlie what we call Form in art; that is, they underlie the systems of completeness and harmony which interpenetrate with the many cultural aspects of specific subject-matter on which Form works; in the case of the Accademia *Giants*, for instance, not only their aspect as Cinquecento nudes but at the heart of the writhing, the theme of conflict in Michelangelo's life.

His figures became more massive and simplified after the early period, without the loss of complicated movement. This deeply-felt simplification rests on the naturalism of the *Bacchus* and *David* and Cascina cartoon, upon a rapacious yet self-lending observation, upon a grasp of attitude which is without parallel. He sought the utmost scale and intractibility to match the synthesis demanded of his emotion, the utmost carnality to feed his universal maxims, the utmost movement to represent repose, the utmost extensions to serve the centre of gravity. He offered to beauty the ideal settlement, his inherent conflict unified by the character of the marble block; he petrified the body's dynamics of which he was the master; he was of the body as magnificently as he was of death and of God; we soon come upon the genius forcing all the world of sense to serve this angry altar of the nude.

Appendices

1 A note on iconography

THE ARTIST IS MORE FAITHFULLY the child of culture, the substitute father and mother, than the rest of us, because he identifies his problems specifically with all that surrounds him. He has been set to serve cultural ideals: the work of art has been a comment as a rule upon the strength of myth and tradition to this end. A mature iconography was indispensable, a framework of articulation for the expressiveness of artistic style. Without this popular poetry to which a thousand approximations in the use of symbol will have contributed, the artist, bereft of an aesthetic *mise-en-scène*, finds himself free today to employ a less fully related symbolism, potent but transient: whereas the precision of art seems to demand that much-used symbolism should circumscribe a personal aspiration. And we do, in fact, still employ as the thinnest of frameworks, our long iconographic heritage, now outworn. Even so, our iconography tends more and more to become the iconography of the artist himself. Venus, or more likely, Oedipus, is a name only, a facetious name that figures in the catalogue. Hence a necessity, in some modern art, for the hustling, for the rather aggressive dragooning, of Form which must provide shape not only to the means of expression but also to what is expressed; hence our abstract art. (At least, that is one of the determinants. But, of course, all developments in art are over-determined.) And hence the short-lived styles, since the evolution of a systematic symbolism and of a durable style are interdependent processes.

These modern tendencies should not be regarded as regrettable, since we do not know their outcome. Yet it is likely that we must hope that the Machine Age will evolve an iconography and that machines will be domesticated by the imaginative, myth-making power of the community. At present, much of our surroundings suggest that machines have been imposed from without. The artist moves among his various selves: he feels rather blankly omnipotent; the more universal, and even the more personal, his symbols, the more disorientated do they appear to be. It would be unaesthetic to represent vitality by exhibiting a puppy on a leash, or any other piece of living tissue: not altogether

dissimilarly, the concentration upon the undoubted essentials of art, whether of Form or of expression, almost the only artistic modes now available, communicate as well as some aesthetic virtue, aesthetic loss; as well as defiance, the cleansing defect in all our lives. We know that true culture is profuse, cluttered with a mass of furniture: it is useless and irritating knowledge.

There has been little monumental art of consequence since iconographic detail began to slacken greatly. A mature iconographic tradition may be narrow, far too narrow: even so, it may, though exceptionally, in terms of a style, communicate to us hundreds of years later, though we have no knowledge except by analogy of its meaning, a beauty, an aesthetic, Form, amassed like folklore. In accordance with the definition of Form, such an iconographic system, whether we can interpret or fully isolate it or not, possesses the familiar air of particularity in combination with references that extend local flavours to cover all. On the other hand, in such a case we are probably unable to disentangle the personality of the artist.

It will be agreed that an endemic myth may offer to the genius an incomparable stimulus if he is allowed to treat of it broadly. For this reason alone, iconographic studies – and they are very extensive as the work of the Warburg Institute shows – have great importance in the understanding not only of art history but of the *desiderata* for aesthetic creation. Whereas the psychological basis of Form is invariable, a new way of presenting the Last Supper may be tantamount to a new formal conception, and vice versa. Scope for the artist's personality, varying with the character of the iconographic pattern (which is interdependent with what is called style) will be severely limited by an iconography so hieratic as to resist variation.

Such was by no means the case in the Renaissance, as everyone knows; yet iconographic reference was still meaningful, robust. We are likely to envy Michelangelo his opportunities when we learn, for instance, of his *David* that 'another source of inspiration which explains the accentuation of the difference of the two sides, right and left, one being strong and on guard, the other open and unprotected, is found in the symbolic sense given to the two sides as far back as antiquity. Antique myths explained the right side as masculine and active, the left as feminine and passive. . . . The Middle Ages has a theological interpretation: the right side is protected by God, the left is weak and exposed to evil' (Tolnay, Vol. I, p. 155). Tolnay describes the affinities that had grown up between the current conceptions of David and Hercules: more than one iconographic lineage is detected in Michelangelo's figure. How different, we exclaim, from the fancies by which modern artists hope to attach their conceptions to the recurring symbols that have stood the test of time.

The Renaissance reunited the classical motifs with the classical themes: in the Gothic age, the themes had had no classical treatment, and the classical

motifs were applied to Christian subjects (E. Panofsky, *Studies in Iconology*, New York, 1939). It follows that the motifs, reunited in the Renaissance with classical themes, brought with them a wealth of medieval iconography. On the other hand, some religious themes were given a classical imprint. Panofsky instances an equation of St John with Ganymede (the rise of Mind to God).[65] As far back as the troubadours there existed an attempt to reconcile *cupiditas* with *caritas*, comparable to the reconciliation of classical and medieval principles in High Gothic statuary and Thomistic theology (Panofsky).

The Renaissance was an age of elevated yet earthly and equivocal convictions. What a triumph it is that in Titian's *Sacred and Profane Love*, the fine, healthy nude symbolizes the Sacred Love, the clothed woman, the Profane. This iconographic theme is perhaps unexpected, but the pensive fullness of Titian's painting is very apparent. Similarly, we are well aware, without any precise knowledge of neo-Platonism, let us say, we are aware that many of Michelangelo's nudes are bemedalled with the light of an enamoured philosophy whereby guilt and other unconscious material achieves the air of epic poetry.

I am thinking of the presentation drawings for Tommaso de' Cavalieri which Michelangelo sent to him in the first year of his love. The correspondence shows how unworthy Michelangelo felt himself to look into those eyes, how presumptuous; and it was to honour Cavalieri, as a token of *physical* self-effacement, that he made first the drawing of Ganymede (copy at Windsor) borne aloft on the back of the eagle with the bird's neck stretched around the torso, expressive, according to Tolnay, of 'mystic union and rapture'. We may well feel today that propriety was never again to be less arduous. In this life giving presumption that beauty spiritualizes, iconographic luxuriance has played an important role. By and large, art requires of unconscious bents that they be poetized. There has never been a more careful vehicle than the Greek myths. Michelangelo's fear of presumption *vis-à-vis* Cavalieri led him to make for him three drawings of the Fall of Phaethon. (At least one is a rejected version, but all three were probably seen by Cavalieri, cf. A. E. Popham and J. Wilde, *Italian Drawings at Windsor Castle*, London, 1949. Wilde (1953) now considers the unfinished Venice version as the later.) Although Jupiter takes the place of Apollo, Phaethon's father, in hurling the thunderbolt that destroys Phaethon and his borrowed equipage, we know today beyond dispute that the primary meaning of this story expresses the male child's castration fear, the result, as he feels it, of his own presumption. Cavalieri figures more than once in Michelangelo's poems as the sun. It is he, too, the Rider, astride a now subservient eagle, who hurls Michelangelo to destruction (cf. the Febo di Poggio poems). One aspect of the relationship with Cavalieri, I would suggest, was Michelangelo's regard for him as a parent[66] calling forth the truly sincere expression of his own unworthiness to the boy. Even in this great ardour that revived the

ageing artist, we come upon the passive component of his passion, both pre-ferred and dreaded. The figure of Sensuality in the *Last Judgment* (for copies, cf. Wilde 97 and 98) sucks the fingers of one hand while the back of the other is pressed against the base of his spine. In the *Bacchanal of Children*, another presentation Cavalieri drawing at Windsor, expressive of infantine licence, we may see in the bottom left-hand corner the actions which both these gestures represent, treated directly yet nevertheless disguised in one case by their com-bination itself.

The Windsor drawing of the predicament of *Tityus*, yet another presentation to Cavalieri, doubtless symbolizes the agonies of sensual passion (Panofsky, Wilde, Tolnay). It should also be remarked that this pain is inflicted by so punitive a phallic emblem (the vulture), and we should remember this is con-templating the assault upon the stone herm in the famous *Archers* drawing (Windsor), plate 7, though the mood is different: the Herm receives imper-viously the manifold attacks of what is, we are made to feel, an irresistible power. 'I live off my suffering,' wrote Michelangelo. It was desirable that the stone, hacked by the sculptor, should give proof of the same irreducible kernel.

Michelangelo's *Bacchanal of Children* is the apotheosis of the putto theme, of unconscious passion and fury in an 'innocent' form, of the fruitful prisoners of civilized living to whom the artist, as gaoler, allows exercise in a rather less confined air. During the Quattrocento, putti were shown seething in marble relief, angels, daemons, or merely infantine incorrigibles. The Quattrocento enlarged the elemental role derived from the Antique so that we come to see it as the basis of profusion, as the broad acceptance of deeper psychical reality from which art springs. No matter that Michelangelo uses the putto here to demonstrate everything pernicious: his judgment did not exclude his gusto. But it will be different in the age of the Counter-Reformation into which he passed.

His work celebrated both the end of the Quattrocento and the beginning of several new trends in art, the most permanent of which, still pre-eminent today, we recognize, for its accent upon individuality-cum-infinite-longing, as the basis of Romantic styles. When culture is most subject to hierarchical restraints, the personality of the artist is least distinguishable. Art was richest, however, when the commanding influences, including a rampant iconography, were various, cross-grained yet sufficiently harmonious to avoid for a time the relaxation of a dominant tone.

The iconography of the Sistine ceiling stems principally from the Old Testament. The difficulties arise when commentators, dumbfounded by the novel, unified treatment of biblical characters, search for a master theme. However necessary it may be, such a search is likely to be less rewarding in the case of visual art than in the case of literature where this kind of literary criticism is naturally more at home. A complicated philosophical programme

accords ill with the need for contrast, proper to visual art, or even with the difficulties of fresco painting. Is it imaginable that the artist of the Sistine ceiling, confronted with the problems of the site, requiring a bold decorative effect from the whole, could have undertaken at the same time an iconographic programme that demanded cumulative philosophical references for every gesture of each figure? It is a commentary on the iconological science when so applied, that the most idyllic of all paintings, Giorgione's *Tempesta*, probably holds the record, in relation to its size, for volumes largely devoted to an iconography of every detail, whose sum in each case provides arguments proper only to a thesis.

That is an extreme instance: moreover, the painting requires iconographic interpretation. But I do not think there is further need for the philosophical variety in the case of the Sistine decoration. The access of strength brought recently by Tolnay (op. cit. Vol. II) to the school of interpretation that favours a neo-Platonic programme, whereby he interprets the gesture of the least attentive attendant putto, is not, in my opinion, sufficiently rewarding. There must be some difficulty in the consistency of lower and higher spheres as the basic subject-matter, when *all* is treated by the artist in a heroic vein. This difficulty is less apparent, perhaps, in the Sistine ceiling (although the *ignudi* present a hurdle) than in the Medici chapel: as Hartt pointed out in his review of Tolnay (*The Art Bulletin* 1950), according to his (Tolnay's) scheme, the very altar figures in the realm of Hades. (If the *Magnifici* tomb had been executed, the Virgin would have been placed on a level with the doors' tabernacles, rather higher than she is today, but not in Tolnay's celestial regions.) I find a similar difficulty in the great Panofsky's neo-Platonic interpretation of the earlier Julian tomb projects. The seated Moses on the platform would have had for Panofsky an expression of supernatural excitement enrapturing the soul of a super-man, whereas the *Slaves* or *Captives* below were to be the expression of animal nature. Is it churlish to comment that in fact the *Slaves* of the Louvre appear more spiritual than the *Moses* of San Pietro in Vincoli?

Partly so. We have seen that at this time the reparative function of art tends to ennoble all. It is likely there was at any rate a vague programme of the kind that Panofsky envisages. What we know of Michelangelo's inner struggle is consonant with the antithetical intimations of such programmes by Panofsky, Tolnay and others. In Michelangelo's largest works, neo-Platonic abstractions may have served as an exordium, exciting the vision of the artist. Even vague sentences of the patron, certain only of his importance, his personal myth, his culture, could sometimes have had a similar effect. Indeed, I incline as much, it will have been evident, to an emphasis on the culture and ambition of the patrons, on the attitudes of Michelangelo, as far as they may be discerned or deduced, towards those who commissioned him.[67]

2 The Medici Chapel

THERE MAY BE SOME READERS for whom it would not seem too far-fetched were it supposed that the antiphonal Allegories (plates 14–18) on each tomb in the Medici chapel imply among their other meanings a disrupted intercourse, that under this image Michelangelo harboured throughout life the evil done to the well-loved original object, the mother or mother-surrogate. His ways as a rule were not those of separation and denial: love summoned the thought of attack: the images projected by his art needed heroic encasement. At the same time there is evidence in his work of a profound belief in the beneficence of the masculine power,[68] in an overruling and forthright omnipotence which was not, however, employed for the mere denial of his inner problems (otherwise he would not have been an artist). Thus, he did not abrogate through this means the hurt associated by the infant with the parents in each other's embrace. On the contrary, he was able to sublimate and idealize this murderous scene with its own ferocious strength, when he carved in relief the *Battle of Lapiths and Centaurs*. Some thirty years later in the Medici chapel he created an ideal vision of the depressive root, the loss of the self-contained object, an event that was suffered before the image of destructive intercourse had hardened it. The phallic woman emerged fully from this last hideous scene, cluttered up, one might say, throughout the flaccid length of her body with a surfeit of destructive phalli to which her protuberances bear witness, and even her Gorgon hair. Such is the suffering, surfeited yet beautiful figure of *Night*: there is conveyed to us by means of the aesthetic sublimation both the sense of gross surfeit and of surfeit overcome. But in life as opposed to art, Michelangelo was unable to find for his emotions a formula whereby to accept the heterosexual embrace. He needed to turn from the hidden incalculable, uncounted evil within the woman (who lacked Vittoria Colonna's aristocratic manliness), to the measurable maleness of the male, to the good version of a vital source, which he served as if *he* were the woman to be cured by it: the scenes of frightful intercourse were within him.

And so, in the deeper layers of his mind, man is also woman for him, the good maleness and the cleansed creative woman, while the woman is the bad man, in the sense of enclosing within her a male putrefying power. Hence the coincidence of active and passive elements which Michelangelo idealized with such force in his art; hence the subjection to his father, whom he upheld by putting forth all his strength; hence the statue of the *Victor*, a young man who kneels on the back of a completely passive old man whose features have sometimes been roughly identified with those of Michelangelo himself. (It was proposed, immediately after his death, to use this statue for his tomb.)

Of course, the hope of a healing heterosexual intercourse was never entirely abandoned, nor the revolt, often practised – it gave rise to the central conscious conflicts of his life – from the tyranny of the father-figures whom it had been necessary to wed. Does not the hacked stone reveal a rejuvenated form; might there not be some white power that could overcome the ceaseless disruptive parental intercourse that went on within? Several copies of Michelangelo's *Leda* have survived. A tyro in these matters can sense that here the swan is an all-enveloping phallic symbol of singular power. Since Leda is of the stuff of the surfeited Night – the source for both is the same – one may add that the swan is meant to achieve the curative act which is felt to be beyond the power of any man. Night's predicament demanded it; Leda would give birth to the twin heroes, the Dioscuri.

The period of the Medici chapel and of the *Leda* when Michelangelo was in the early fifties, became a time of utmost depression and of physical exhaustion. It has been called his erotic period as an artist. War, the complications of his dealings with the Medici Pope, now in distress, the death of his brother Buonarroto, the weakness of his father followed by his death, the uncertainty of the times and of his own affairs, some personal danger even, enlarged this emotional constellation. He turned eventually to the reinforcement of the old defence. In 1534, he finally abandoned his beloved mother-city, Florence, now in the hands of the dangerous tyrant, Alessandro, and the unfinished Medici Chapel, for Rome, for the Popes, for Tomasso de' Cavalieri.

Greek Culture and the Ego

*A psycho-analytic survey of
an aspect of Greek civilization
and of art*

Acknowledgments

Thanks are due to Sir Maurice Bowra for permission to quote from *The Greek Experience* published by Weidenfeld & Nicolson; to Macmillan & Company in respect of *Greek Philosophy Part I, Thales to Plato* by J. Burnet; to Routledge & Kegan Paul Limited in respect of *Society and Nature* by H. Kelsen; to the Hogarth Press in respect of *Contributions to Psycho-Analysis* and of *Developments in Psycho-Analysis*, both by Melanie Klein; to Tavistock Publications Limited in respect of *Envy and Gratitude* by Melanie Klein and of *New Directions in Psycho-Analysis* edited by Melanie Klein, Paula Heimann, and R. E. Money-Kyrle.

In Chapter 5, there is a brief outline, as stated there, of some of the discoveries of Professor R. B. Onians, drawn from his philological work, *The Origins of European Thought*, published by Cambridge University Press.

First published 1958

1 Introduction

IT MAY BE DESIRABLE to comment very briefly on terminology that I shall use later in this programmatic Introduction.

Applying psycho-analytic concepts to a feature of Greek religion, to art generally, and to the Hellenic origin of science, I shall be concerned in this book with the projection of the integrated ego's structure. I would focus for a moment, therefore, on the Freudian doctrine of projection and introjection as deepened by Melanie Klein.

An 'object' in the Freudian sense is the object of an emotional drive. The first of these is the mother's breast, a 'part-object'. The infant incorporates it as a 'good object' but, in the context of frustration, having projected on to the breast his own rage, he incorporates a 'bad object' also. These are prime instances of projection and introjection or incorporation, mechanisms that persist throughout life. The 'bad' will be re-projected and the 'good' projected for a variety of 'economic' reasons. (As a matter of fact, there will have been projection, also from the start, of what is good if only in the terms of wishful hallucinations.) It is entirely beyond the present scope to give any account of the ceaseless introjection-projection, a process inseparable from the organism's perceptual (or intake) and discharge system, from a basic commerce with the external world. In Kleinian theory, then, the interchange starts not only with the nourishing breast but with the projection of the death instinct in the form of aggressiveness, soon also of envy and greed, introjected thereupon as 'persecutory objects'. A good object – I shall now drop the inverted commas – is conceived to be part of the early nucleus of the ego that exists for a period in a very scattered form. Several quotations will help later to present Melanie Klein's view of the early ego in the subsequent stage when it brings the good and bad internal objects (strictly part-objects) gradually closer together, when it entertains *whole* or self-subsistent objects. A part-object outside will not have been regarded as self-subsistent, as equally distinct from the ego. The transition

to a whole-object world (and to whole-object introjections and projections) accompanies a rarer use of the impoverishing mechanism of projective identification, described by Melanie Klein, a mechanism whereby parts of the ego may be put into exterior objects, or into sections of them, for the purposes of appropriation and control. In this and other ways the infant passes out of the paranoid-schizoid stage into the depressive stage, which will be summarized at the end of the Introduction.

Now Freud spoke of introjection, a concept that he took over from Ferenczi, particularly in regard to the structure of the super-ego, that portion of the psyche which stands over the ego, as it were, as judge. He said that the super-ego, composed from introjections of the father and of the child's own aggression, is the controlling figure, and provides us with conscience. This formation signifies the end or solution of the Oedipus complex. Melanie Klein dates the rudiments of the super-ego from the earliest time, in relation with introjections of the breast, good and bad. Freud too, in one passage at least, allowed to the super-ego a benign aspect.

My own concern with the extreme figures of the super-ego is closely connected with a quality of the early or primitive ego, a quality at which I have hinted, namely the predominance of enveloping states, be they good or bad, with little of no connexion between them: the relevant quality of such states, then, however short their duration, is this homogeneity or undifferentiation by which any distinction of subject from object becomes minimized, blurred, in one way or another. I shall stress the fact that much experience throughout life contains a similar enveloping quality: I shall likewise stress the point that the developed or integrated ego, while it functions as such, accords differentiation and self-sufficiency to objects. Projective identification is, of course, a mechanism that tends to reduce differentiation. Undifferentiation (between subject and object) and differentiation are concepts that will frequently appear in the argument.

These sparse words might be enormously prolonged: I must presume in the reader a knowledge of Freud. It will become increasingly apparent that I lean as well on Melanie Klein's findings with children, and that her theory of the stages of infanthood are at the root of my theme.

Sir Maurice Bowra, among the most eminent of Greek scholars, from whose book *The Greek Experience* (1957) I shall quote several passages in this section, displays not the slightest shame while referring throughout to 'The Greeks', as if they were composed of a few likeminded individuals. He is undoubtedly right to do so because there is no alternative that is not tiresome in such a context. Thus Sir Maurice writes: 'The peculiar nature of man determined the Greek notion of pleasure. They had no ascetic or puritanical hostility

to it; in some respects they regarded it as a supreme good. But at the same time they felt it must be kept in its place and not allowed to upset the harmony of either the individual or the city. They felt too that the strongest pleasures are suitable mainly for the young, and that in due course a man passes beyond them to others which are less exciting. This distinction follows the general distinction which the Greeks made between men and the gods. If the gods enjoy power and freedom, men have responsibility, and through their use of it attain their own dignity, which is different from anything available to the gods. The advantage of this system is that it combines a natural taste for enjoyment with a real respect for proved capacities in action and in thought. Paradoxically, it may mean that in what seems to be his more human side, man is closer to the gods than in what wins honour and respect. But it also means that goodness and happiness are brought together in a balanced harmony: for the Greeks believed that if a man is good he is happy, but also that if he is happy he is good.'

The Good and the Beautiful were brought closer than heretofore. I consider this accommodation, both then and in the early Italian Renaissance, to issue from an adjustment between the good objects of super-ego and of ego. I shall say that the concept of beauty projects, not the ego-ideal, but the ideal ego as an integrated system.

The Olympian gods are finer, yet man may possess his own dignity. The gods represent justice, the super-ego, also the id (see the quotation above). Human dignity is founded partly in the pursuit of an integrative balance or Mean. The alarming envy of man imputed to the gods is a guilty projection of man's envious attitude to their bountiful powers: the pursuit of the Mean will restrict that cycle. It would not be temperate, however, to refuse pleasure, nor to obscure the face of death: the ego disregards them at the peril of some mastery in the psyche.

The Greek concept of temperance, a balance between diverse aims and compulsions, mirrors the ego's integrating character: a degree of excess is often a necessary part of this balance, an excess described as such. As regards mental attitudes, an unqualified vaunting of enveloping states of mind, that is, those that entail a conspicuous blurring of subject with object, are likely to represent an excess, even in the case of the identificatory processes on which a group or culture largely depends. Again, there exists in the super-ego a good object, not to mention a corrective object, with an absolutist bent, agents that may summon excess in the form of the undifferentiated and unconnected absorption with either good or bad, characteristic of the primitive ago. (Throughout this book 'primitive' means not only 'prior' in the course of development, but also 'weak': it is said from the angle of the integrated ego's power to entertain fully differentiated objects.)

Also the ego's good object derives from the enveloping breast, but it becomes

the centre of an interacting system, the healthy body, for instance, to which the Greeks paid unparalleled homage. *Mens sana in corpore sano* epitomized the health of the good object as the nucleus of an integrated unit. Now the Olympians possessed the ideal health: we must see them as the representatives not only of super-ego and of id but of ego. 'In their undecaying strength and beauty,' writes Bowra, 'the gods have something denied to men, which makes them objects of awe and wonder. The Greek sense of the holy was based much less on a feeling of the goodness of the gods than on a devout respect for their incorruptible beauty and unfailing strength . . . The belief in health passes imperceptibly into the belief in beauty, which is especially derived from the notion that through it men and women resemble the gods. Indeed, the Greeks could not think any physical form beautiful unless it was healthy' (Bowra, 1957).

It is not my purpose to argue that the Greek cultural super-ego was attenuated, but I shall submit that a wider reality-sense and the birth of science should be seen in terms of an ego-integrative process unknown before that time as a predominant cultural theme, dependent upon a relationship between ego and super-ego, sometimes accounted to be a result of successful psychoanalytic treatment. I do not think that such a change can be described as a super-ego weakening rather than as a super-ego re-alignment: if it can be, the analogy does not hold, since the Greek cultural super-ego was very strong. The intricacies of guilt and revenge, problems of Justice in the widest sense, were constantly canvassed by the poets. Enormous respect for law on a basis more generous than the one of divine sanction long remained the root of Greek polity. Yet I would affirm that on the whole the distinctive feature of the Hellenic cultural super-ego lay in the development of the guardianship aspect, in its preservation of what we call loosely ego values. That is to say, much of the love in the super-ego was employed to preserve the ego, a solicitude, a protectiveness, which will have been founded in the good breast, then clarified by a later, perhaps post-oedipal, introjection of a good paternal object, it seems to me, with a far less enveloping character. (I am prompted to say so very largely by an evolution in the Olympian religion to which I shall refer.)

We will consider for a moment the four cardinal Greek virtues, translated into English as courage, temperance, justice and wisdom. Justice, of course, is a moral quality, but we should note that the word translated as justice, *dike*, the indicated way, 'Seems to be derived from the boundaries of a man's land and conveys metaphorically the notion that he should keep within his own sphere and respect that of his neighbour' (Bowra, 1957). The philosophers conceived of Justice in the abstract: it appears that such speculations have sublimity only when they are departures from ground previously little touched by transcendentalism. As today, courage was most admired in unvarnished contexts. ' "The

man who can most truly be accounted brave," said Pericles, "is he who best knows the meaning of what is sweet in life and what is terrible, and then goes out undeterred to meet what is to come" ' (ibid.). The wise (in the Greek sense) are courageous just as they are temperate because in this way a man can be himself, keep a unity of function that is impaired by an overriding transcendental attachment with whose help he might be able to solve the moment of crisis through the denial of its manifest nature. Behind the Greek attitude lay the heroic ideal preserved by Homer. 'The great man is he who, being endowed with superior qualities of body and mind, uses them to the utmost and wins applause of his fellows because he spares no effort and shirks no risk in his desire to make the most of his gifts . . . The attention which the Greeks paid to the Mean suggests not so much that they observed it as that, in the fulness of their blood, they felt they needed some curb for their more violent ambitions and more reckless undertakings. . . . Man was indeed worthy of encouragement and . . . society existed to help him reach the limit of his gifts . . .' (ibid.).

> There are many strange wonders, but nothing
> More wonderful than man

wrote Sophocles; and also:

> Speech too, and windswept thought
> He has taught himself,
> And the spirit that governs cities . . .

'(The Greeks) differed fundamentally from their contemporaries in Asia, who thought that the great majority of men were of no importance in comparison with the god-kings for whose service they existed, and from their contemporaries in Egypt, who believed that life in the world was but a trivial preliminary to the peculiar permanence of life in the grave' (ibid.). Of Thucydides, Bowra writes: 'His respect for truth was equalled by his respect for certain moral qualities, especially those which take a civic or social form, and he is a supreme example of the ability of the Greeks to maintain high standards of conduct without demanding any supernatural sanction for them.'

One or two more quotations, still from the same book. 'When the horse of Achilles speaks or the shape of Odysseus is changed, it is Hera or Athene who is responsible. So far as men are concerned (in Homer) they act by purely human means. It is true they do far more than ordinary men ever could, but none the less it is by exerting their own powers to a prodigious degree. This is the more remarkable since in most primitive societies and in much primitive and not too primitive story the chief actor is not the hero, who relies on his human powers of head and arm, but the magician, who works miracles by enchantment . . . The exclusion of magic was no doubt dictated by a feeling that it was beneath

the dignity of heroes, and this in its turn was based on the peculiarly Greek conviction that men are honoured for what they do by purely human means' (ibid.).

And finally: 'The truest wisdom lay in a properly balanced personality, in which neither side triumphed at the expense of the other. What this meant can be seen from the place given to *eros*, which means in the first place passionate love, but extends its meaning far beyond physical desire to many forms of intellectual and spiritual passion. For Parmenides it is the child of necessity and the force which makes men live and thrive; for Democritus it is the desire for beautiful things; for Euripides it is the inspiring spirit of the arts; for Pericles it is what devoted citizens feel for their city; for Socrates it is the pursuit of noble ends in thought and action. These different forms of *eros* agree in making it a power which drives a man to throw his full personality into what he does, which sustains him in powerful exertions and impels him to unusual efforts, which sets his intelligence fully and actively to work and gives him that unity of being, that harmony of his whole nature, which is the spring of creative endeavour. . . . If the complete force of a man's nature works as a single power, he is a full man, and no Greek of the great days would have denied that this was the right and natural way to behave' (ibid.).

The Greek concept lives again in Freud's use of the term Eros for the libidinal and integrating principle that seeks objects. We owe to the Greeks not only the formulation, *phusis*, Nature, but the one of a psyche undivorced from the body. These concepts underlie Hellenic achievement even in other and opposite directions that were to be far more famous for a millenium.

Art shows us that diverse feelings will congregate under an integral form. Much Greek myth retains the character of epitome, a witness of the ego's power to project a good image of its own balance that incorporates under this figure a symposium of meanings, many of which would else have suffered envelopment by one meaning. Again, it is not a question of the weakness of the super-ego but of the consensus between super-ego projection and the integrated ego's more various embodiment. I attribute initially to the super-ego a good object that envelops, enwraps, a good breast of oceanic dimensions that may be found to harmonize not only with the super-ego's comprehensive strictures but with the uniformity of death. He who is deeply under this spell has reduced his need to observe the world in its nature of independent and whole objects. I dare say it would be safer, if less specific, were I referring now to the primitive ego rather than to the super-ego; I shall often do so in the body of this book, since the phrase 'primitive ego' is applicable to wider contexts. I am profiting here, however, from Melanie Klein's metapsychological theory that provides the super-ego with a good object related to the good object in the ego. 'The super-ego,' she writes, 'maintains its connexion with the other parts of the ego

through having internalized different aspects of the same good object . . . In contrast, the extremely bad figures (in the super-ego) are not accepted by the ego in this way and are constantly rejected by it . . . Since clinical developments in recent years have made us more cognizant of the psychopathological processes in schizophrenics, we can see that in them the super-ego becomes almost indistinguishable from their destructive impulses and internal persecutors' (Klein, 1958).

It seems to me that these processes are observable in cultural terms, and that both excessive transcendentalism (an affirmation at any cost of super-ego objects) and a very incomplete power to allow to many objects their own sufficiency (the result of overweening projective identification typical of what we call the schizoid-paranoid position, as well as of primitive cultural notions), are generally best described in terms not only of the weakness of the ego but of a, perhaps consequent, weakness of the super-ego good breast in the face of the negative super-ego components. For, the super-ego, if we follow Mrs Klein, is the locus for the binding of a considerable portion of the death-instinct. Having this view, we shall conclude that in the last analysis the Greek achievement depended, not upon a weak super-ego, but on the strength of a good object in the super-ego that protected the ego; on an access of greater libidinal power in the super-ego altogether, as in the ego.

Those who are inclined to reject out of hand the basis of this approach, may not have considered the problem to which it is here applied, the problem so often posed without result concerning the incidence of Greek art, polity, and the beginnings of science, 'the one miracle in history', it has repeatedly been called. It appears that there is insufficient psycho-analytic comment on the prevalence in cultures of transcendental ideas, with regard to their power to blur subject and object. Freud in one passage spoke of the oceanic feeling (Freud, 1930); he referred to good experiences at the breast, to a feeling of union with the object, but he made no connexion with the surrender in favour of massive identifications of which he had written particularly in *Group Psychology and the Analysis of the Ego*. He there stressed that all groups are based on some exercise of this identificatory process. The enveloping bias of primitive mechanisms, whether passive or active, introjective or projective, is as essential to understanding, to civilization, and to human intercourse as the bias of the integrated ego in favour of self-sufficient objects. But it seems likely that even a passive identificatory mechanism where it is culturally exalted at any expense – we shall see that one side of the aesthetic process strongly partakes of it – will connect with the manic merging of ego with super-ego and with all overriding super-ego attitudes; that, moreover, it is then exercised, save in art as I shall indicate, at some cost to the integrated ego's regard for many differences between objects. But where these have been notably proclaimed, we must, it seems

to me, attribute to the cultural super-ego an unusually strong parental care for the preservation of the ego.

And so I think the best way to summarize Greek achievement is to assert that the Greeks were able to acknowledge as such the most diverse objects and the most diverse psychical phenomena. It is one reason why many of our terms are derived from theirs. Aspects of psychical reality more nearly reach accommodation, as I have said, more nearly congregate, under a notable form of stability, that is, under an image of ego-integration. I shall contend that art in all times has shown this to be so. Psycho-analysis demonstrates that the process is dual: in revealing unconscious phantasy and thereby interpreting psychical reality, the analyst may help to build or restore a greater mastery of the integrated ego.

I have risked these preliminary generalizations with the uncertain belief that they are more helpful to the text than misleading, though I cannot hope that this will apply in every case. But it is imperative not to conclude the section without recalling the outline for what Melanie Klein has called 'the depressive position', in regard to the pursuit of whole, integrated objects accompanying a degree of integration in the ego. I cannot do better than quote a recapitulation in a famous paper by Dr Hanna Segal (1952 and 1956):

'The "depressive position", as described by Melanie Klein, is reached by the infant when he recognizes his mother and other people, and amongst them his father, as real persons.* His object relations then undergo a fundamental change. Where earlier he was aware of "part objects" he now perceives complete persons; instead of "split" objects – ideally good or overwhelmingly persecuting – he sees a whole object both good and bad. The whole object is loved and introjected and forms the core of an integrated ego. But this new constellation ushers in a new anxiety situation: where earlier the infant feared an attack on the ego by persecutory objects, now the predominant fear is that of the loss of the loved object in the external world and in his own inside. The infant at that stage is still under the sway of uncontrollable greedy and sadistic impulses. In phantasy his loved object is continually attacked in greed and hatred, is destroyed, torn into pieces and fragments; and not only is the external object so attacked but also the internal one, and then the whole internal world feels destroyed and shattered as well. Bits of the destroyed object may turn into persecutors, and there is a fear of internal persecution as well as a pining for the lost loved object and guilt for the attack. The memory of the good situation, where the infant's ego contained the whole loved object, and the realization that it has been lost through his own attacks, gives rise to an intense feeling of loss and guilt, and to the wish to restore and recreate the lost loved object out-

* For the description of the preceding phase of development see M. Klein, *Contributions to Psycho-Analysis*, and H. Rosenfeld, 1952 and 1956.

side and within the ego. This wish to restore and re-create is the basis of later sublimation and creativity.

'It is also at this point that a sense of inner reality is developed. If the object is remembered as a whole object, then the ego is faced with the recognition of its own ambivalence towards the object; it holds itself responsible for its impulses and for the damage done to the external and to the internal object. Where, earlier, impulses and parts of the infant's self were projected into the object with the result that a false picture of it was formed, that his own impulses were denied, and that there was often a lack of differentiation between the self and the external object; in the depressive phase, a sense of inner reality is developed and in its wake a sense of outer reality as well.

'Depressive phantasies give rise to the wish to repair and restore, and become a stimulus to further development, only in so far as the depressive anxiety can be tolerated by the ego and the sense of psychic reality retained. If there is little belief in the capacity to restore, the good object outside and inside is felt to be irretrievably lost and destroyed, the destroyed fragments turn into persecutors, and the internal situation is felt to be hopeless. The infant's ego is at the mercy of intolerable feelings of guilt, loss, and internal persecution. To protect itself from total despair the ego must have recourse to violent defence mechanisms. Those defence mechanisms which protect it from the feelings arising out of the loss of the good object form a system of manic defences. The essential features of manic defences are denial of psychic reality, omnipotent control, and a partial regression to the paranoid position and its defences: splitting, idealization, denial, projective identification, etc. This regression strengthens the fear of persecution and that in turn leads to the strengthening of omnipotent control.

'But in successful development the experience of love from the environment slowly reassures the infant about his objects. His growing love, strength, and skill give him increasing confidence in his own capacities to restore. And as his confidence increases he can gradually relinquish the manic defences and experience more and more fully the underlying feelings of loss, guilt, and love, and he can make renewed and increasingly successful attempts at reparation.

'By repeated experiences of loss and restoration of the internal objects they become more firmly established and more fully assimilated in the ego.

'A successful working through of the depressive anxieties has far-reaching consequences; the ego becomes integrated and enriched through the assimilation of loved objects; the dependence on the external objects is lessened and deprivation can be better dealt with. Aggression and love can be tolerated and guilt gives rise to the need to restore and re-create.

'Feelings of guilt probably play a role before the depressive position is fully established; they already exist in relation to the part-object, and they contribute

87

to later sublimation; but they are then simpler impulses acting in a predominantly paranoid setting, isolated and unintegrated. With the establishment of the depressive position the object becomes more personal and unique and the ego more integrated, and an awareness of an integrated, internal world is gradually achieved. Only when this happens does the attack on the object lead to real despair at the destruction of an existing complex and organized internal world, and with it, to the wish to recover such a complete world again.'

2 The Ego-Figure

I TAKE IT THAT SUBLIMATION, unlike substitute satisfaction, is a process through which the tie to part-objects may become an attachment to objects valued for their connectedness: it is itself a mark of some integration or wholeness in the ego. Sublimatory power implies an outcome from the depressive position whereby the realization of a whole-object loss entails the longing to repair that loss not only internally but externally in a growing appreciation of outside and independent structures. As we have seen, Melaine Klein attributes to the infant an earlier depressive anxiety in connexion with the loss of part-objects, but she has been careful in so doing to emphasize that the depressive position succeeding the paranoid-schizoid phase is central and crucial for further development, i.e. for integration in the ego (Klein 1948 and 1952). Of the nature of ego-integration generally she has written: 'We may assume that when persecutory anxiety is less strong, splitting is less far-reaching and the ego is therefore able to integrate itself and to synthesize in some measure the feelings towards the object. It might well be that any such step in integration can only come about if, at that moment, love towards the object predominates over the destructive impulses (ultimately the life instinct over the death instinct). The ego's tendency to integrate itself can, therefore, I think, be considered as an expression of the life-instinct' (Klein, 1952).

Again: 'Out of the alternating processes of disintegration and integration develops gradually a more integrated ego, with an increased capacity to deal with persecutory anxiety. The infant's relation to parts of his mother's body, focusing on her breast, gradually changes into a relation to her as a person' (ibid.).

And again: 'I have made it clear that the processes of integration, which express themselves in the infant's synthesizing his contrasting emotions towards the mother – and consequently the bringing together of the good and bad aspects of the object – underlie depressive anxiety and the depressive position' (ibid.).

She had previously written: 'Returning to the course of early development, we may say that every step in emotional, intellectual, and physical growth is used by the ego as a means of overcoming the depressive position. The child's growing skills, gifts, and arts increase his belief in the psychic reality of his constructive tendencies, in his capacity to master and control his hostile impulses as well as his "bad" internal objects. Thus anxieties from various sources are relieved, and this results in a diminution of aggression and, in turn, of his suspicions of "bad" external and internal objects. The strengthened ego, with its greater trust in people, can then make still further steps towards unification of its imagos – external, internal, loved, and hated – and towards further mitigation of hatred by means of love, and thus to a general process of integration' (Klein, 1939 and 1948).

I cannot claim that passages such as these lend credence to the unsupported statements on which I shall soon embark. I quote them first of all because they indicate the integration I shall have constantly in mind when I use this word, as I must repeatedly, and second because they might suggest to some that in favourable circumstances the external world of things as well as people, even apart from its role as a locus for displacement, bolsters up ego-integration. Indeed, Melanie Klein herself has summarized in a footnote one of Ferenczi's (1955) *Notes and Fragments* as follows: 'Ferenczi suggests that most likely every living organism reacts to unpleasant stimuli by fragmentation, which might be an expression of the death instinct. Possibly, complicated mechanisms (living organisms) are only kept as an entity through the impact of external conditions. When these conditions become unfavourable the organism falls to pieces' (Klein, 1946 and 1952). This is suggestive for my purpose if I am right in thinking one meaning is that physical permanence and possibly organization (projected on to the external world to be there perceived) may afford example and encouragement to the ego. No one would quarrel with that: but I must go further because I judge the evidence of all art demands it. I am going to say that an imago of ego-integration is projected and perceived as an object, i.e. this imago comes to us from the external world in the terms of a whole and independent and corporeal-seeming structure.

But before I embark on even vaguer themes, I want to mention this point: I shall be saying that works of art neither taste nor smell, an elementary fact that may have been overlooked. The discrimination, the recognition-power, of week-old infants appears to be of taste and smell in regard to part-objects. Now, there will be many reasons, other than impermanence, why taste and smell lack *direct* satisfaction in art. The one of possible interest here may lie with the aesthetic stress on whole objects, with the repudiation of those sense organs originally tied to part-object discrimination in a manner never sufficiently to be overthrown for aesthetic purposes. I think the degree of envelopment by the

object in terms of taste and smell at the earliest time is relevant. I shall suggest that in art the mother must be re-created through the forms of the integrated ego-figure to which she already belongs as introjected objects. In the relationship to this aesthetic figure and similarly in the earliest signs of more mature relations to the mother, tactile and kinaesthetic perceptions are, in my opinion, uppermost. Unlike taste and smell they afford sensations which can be enjoyed through vision, at a distance, as are the so-called tactile values in a painting. My reasons for saying this are drawn entirely from the nature of the form in art as I shall present it. But I will quote from Margaret Ribble the same passage as does Melanie Klein in another context (Klein, 1952): 'Much of the quality and the cohesiveness of a child's personality depends upon an emotional attachment to the mother. This attachment or, to use the psycho-analytic term, cathexis, for the mother grows gradually out of the satisfaction it derives from her. We have studied the nature of this developing attachment, which is so elusive yet so essential, in considerable detail. Three types of sensory experience, namely, tactile, kinaesthetic,* or the sense of bodily position, and sound, contribute primarily to its formation. The development of these sensory capacities has been mentioned by nearly all observers of infantile behaviour but their particular importance for the personal relation between mother and child has not been emphasized' (Ribble, 1944).

I would remind you once more of the ego's hard battle to preserve integration. Here is a broad cause for identification between many persons, for their mutual respect and bond, if one supposes, as seems necessary to me, that integration is best enjoyed by perceiving it in others or in things, and that a corporeal imago of ego-integration, formalized by art and cult, is perpetually re-introjected. Such a conception provides an additional background for group loyalties wherein the ego ideal has been exchanged for the body of a leader or for other objectives held in common.

We say awareness of the self comes to us from somatic sensations; but more truly, I think, we refer here to an awareness of this or that process in this or that part of the organism whose sense of wholeness, structure, physiological and psychological, may be partly sacrificed to the over-cathexes of particular functions. In order to view ourselves not merely as continuous but as integrated we need, I submit, probably as one among several parallel ego symposia, a constant intimation of wholeness, a figure that condenses not only sensations and perceptions but principal 'good' introjections and object-relationships, a body-ego projection of its own wholeness, an awareness founded on synthesis of previous body-egos belonging to other periods of psychical growth, an empathic awareness of a corporeal figure with a generalized reference that is likely to make

* J. O. Wisdom has attributed awareness of the body-ego primarily to tactile and kinaesthetic sensations (Wisdom, 1953).

itself felt, according to the perceptual context, by such qualities, contributing to wholeness, as balance, rhythm, movement, texture; a figure, then, that comes best before us in the act of receiving objects, regarded as independent, which by their structure and concreteness and exact limit bring with them the sense of our composite selves. Whenever there is empathy of this kind, a version of the ego-figure – it includes the body-image – will be re-created.

It appears already how snugly the conception would apply to formal properties of works of art which they have by definition. Indeed, in view of my own prepossessions it may be thought that I am about to extend a compulsively aesthetic viewpoint. The judgment may prove justified: if so, something will possibly be revealed concerning aesthetic compulsion.

Meanwhile all will agree that cults or cultures have required the attentions of art and ritual to crystallize their entities. Where do these outer shows which, as in the individual, express cohesive being – where do they stop? It would be difficult to say: there is surely an aspect of custom, of communal obsessive acts that contributes to a shared representation of simple structure whatever the main origin of the compulsive element.

On the other hand, it cannot be thought that many cultures, when viewed from the side of ideals rather than of practical affairs, contrive specific homage for the ego's powers of integration, if we take this integration to mean a nice balance of the various parts and demands and stages of the psyche in the face of external reality. Regressive compulsions have gained outlet through other identificatory mechanisms invaluable for binding society together. Some very civilized cults foster with greater intensity more primitive identifications, an increase particularly of projective identification, a return to, the control of, the breast surrogate or even that of a pre-natal condition. We may wonder whether the need to regress is entirely the work of guilt, anxiety, and ego defence, or whether there is more direct aid – comfort, one might say – from the death-instinct.

However it may be, culture, many roots of which are pre-oedipal, compounds with such 'monolithic' aims, especially by means of a religion that is 'advanced'. One cannot think that oedipal super-ego demands encompass the character of religion. The more mature vintages possess pre-oedipal bouquet. I refer especially to the ambitions, the world over, of the mystic. He sometimes eschews even a manic solution, forced back to a more primitive state both of the ego and of the super-ego, rejecting variety in object-relationship, and finally object-relationship itself, in favour of an envelopment by the Divine Ground, it is sometimes called. Mystics, in the Yoga discipline for instance, may undoubtedly achieve a stupor by which they are insensible for long periods even to their own bodies. (We should remember Freud's dictum (Freud, S., 1927) that the ego is primarily a body-ego.) I do not know, of course, whether such

states are predominantly blissful, sublime. It is natural to suspect that on the pattern of schizophrenia, bliss will alternate, if only rarely, with appalling feelings of disintegration and persecution.

There are many less arduous mystical experiences gratifying to the senses; and they are common: indeed, any study would have difficulty in dividing those experiences from 'monolithic' moments, physiological especially and contemplative, that we all undergo.

Culture mirrors contrasting ego-states. Where one is stressed it is likely to be at some sacrifice of others, if only because of influence upon the character of the ego-ideal. But even in the instance of a palpably regressive ideal, we must suppose that the integrated ego organizes the symbols and rituals of that ideal. I shall be considering very briefly a culture that represents the other extreme in a few remarkable ways, the culture of the multiple Hellenic communities from which a possibility of science and democracy derives, as well as, for many centuries, much art. Of what I have to say a part will be common, if in a minor degree, probably to all cultures. I must remind you at once of the subjection of women in classical times, the often brutal attitude to slaves and to infants, the ruthlessness to enemies, and the almost uninterrupted state of war that issued from the economic necessities of a threadbare land over which so lucent a light shines. I must remind you also of the survival of tyrannical superstitions even in a most primitive form. On the morning of Salamis Themistocles sacrificed to Dionysus Persian youths.

Whereas most religions seek to raise or limit the barrier of death, an acceptance greater than is usual of death and decay was regarded by the classical Greeks of the Homeric or Olympian tradition to be a virtue, since it favoured godlike values of youth and activity. Guilt, depression, and paranoid anxiety belong, of course, to the picture. The gods who in Homer behave like a much interfering and incalculable and disunited upper class, must be ceaselessly propitiated or invoked with succulent sacrifice. The gods at home are the butt of Homer's humour as an aristocracy is likely to be of those who depend, even utterly, on their foibles. The gods will wrestle or plot among themselves – the world and its men are their common ground, the centre of existence – in the manner of an interplay of internal objects; but Fate, or Zeus as Fate, vastly stronger, is immovable. A Homeric deity might exceptionally be wounded. In the Fifth Book of the Iliad, Diomedes wounded both Aphrodite and Ares. This was not overt hubris, the great sin of pride, which comes about by believing oneself to be the god, by scorning the laws of gods and men. The universal conception, hubris, will have sprung from the wish, and then the fear, of usurping the father's place, a conflict that in the highest Hellenic culture seems to have left a horror of defences *predominantly* manic, in view both of denial and the reminder of omnipotent thinking. (I stress the word 'predominantly' because I

attribute a lesser manic component to the creation of art.) The god too sheds some of his omnipotence: as well as the super-ego he may mirror the ego. Odysseus discourses wrily with Athene, one part of the self with another, or as one plotter with another (Odyssey, Book Thirteen). Similarly, not only in Homer but in the Athenian plays, all men, whatever the respective rank, speak to one another with an equality bred of discourse itself.

The decisive moment of the Olympian religion as presented here, occurred in the sixth century according to J. W. Mackail and Gilbert Murray (1935) when 'Homer came to Hellas', to Athens from Ionia; that is to say, the Homeric poems. They may be seen to enlarge upon an alternative to the *mana* conception of power. The *mana* of animal or god or old man is not at all the object's ego but an abstraction, a part-object. You imbibe the godly power, get the inside of the god into your inside, achieve a state of undifferentiation through a part-object, whereas a whole object, in this case the Olympian, whether or not he becomes an important part of the devotee's inner world, preserves the character of an entity in touch with a manifold world. For, there cannot be the sense of the wholeness of an object, or of its variety, without some sense of contour and limit.

A strengthening of the beneficent paternal side of the super-ego may have favoured the placid lure of whole objects. It will be appropriate further on to cite Aeschylus' *Oresteia*: in *Eumenides*, not only a primitive, tearing, maternal, pre-oedipal super-ego component is forbidden the manners of her original out-let, but both Olympians involved in the situation with the Furies, Apollo and Athene, pronounce in favour of a more balanced authority. Aeschylus' Prometheus plays – the second has been lost – were probably put on in Sicily towards the end of his life. This time the conflict grows between the ego in the person of Prometheus and a ruthless, patriarchal, and irresponsible super-ego, Zeus: the protagonists eventually compromise, to the advantage of order and justice on earth (in the psyche).

I mention so soon these small points because they indicate vividly, in the terms of the greatest art, the theme of integration for the super-ego and for the relation with the ego.

The first strength of fifth-century official religion belonged to corporate observances, to identifications with the body of the city-state, in turn identified with the very statue, the *seen* body of the god or goddess. There was air, measure, in the manic mechanisms employed, particularly for art: plentiful reminders of the structured ego were gained from representations of the super-ego. It seems likely that the exacting purifications required by Apollo in cases of a civil homicide, however accidental, were used partly as defences against the manic feeling of triumph. Some Hellenes cultivated distaste for strongly manic displays, or regarded them as barbarous imports. It is significant that the Greek

word for madness has become our word for mania; the Greek word was also used for states of exaltation. The power to accept loss, even in the guise of jealous Nemesis, without manic denial or fatalistic identification, was part of the wider Hellenic ideal. Loss, fully admitted, stimulates reparation, resourcefulness. (Cf. the character of Homer's hero, Odysseus.) Of such kind was the very rare leaven – I claim no more – that tempered far-different and extreme attitudes. Hence Apollo's 'Nothing too much' in a land of tremendous light, and 'Know thyself'. An ability to accept loss is a first condition for some appreciation of psychical reality (Segal, 1952 and 1956). The profound need for mourning, as well as its ritual, characterizes Iliad and Odyssey. When Odysseus meets his mother in Hades – he had not known she was dead – he tries to embrace her wraith and cries: 'Mother, can you not abide the loving arms of one who yearns so sorely after you, that here, even here in Hades, we may tearfully sate ourselves with icy shuddering grief' (Lawrence, 1935).

Even so few words about Hellenic culture will suggest, I hope, a temper propitious for art. Aesthetic creativeness requires both the acceptance of loss (Segal, 1952 and 1956) leading to a reconstitution of a self-subsistent object, and some idealism or even a fusion with good objects of a kind that suggests not only a manic process (Stokes, 1956) but a partial revival of the primitive ego. I shall defer explanation of this statement. For purposes of art, the degree to which self-subsistent object-nature, innocent of transcendental overtones, can be admitted, may not always be very great (Stokes, 1955). Yet upon the pursuit, often the manifest pursuit, of part-objects and upon the oceanic states to which they lend themselves, there supervenes in art, it appears to me, an impress of equilibrium deriving from the composition of whole objects.

I now suggest a third constant process projected into the work of art, interfused with the two above, the projection of the integrated ego as a corporeal form, the main subject of this book. I think in this matter Hellenic art has been the model and indeed the despair of many civilizations.

A word on terms. I do not try, of course, to demarcate the unconscious ego from the id, nor would it be to my purpose. The ego in this book is regarded as that limb of the psyche that struggles, consciously, and far more unconsciously, between the outside world, the super-ego and instinctual urge; as the seat of defence, the source of organization including the splitting of an object and self-splitting, the receptacle for introjections (which have always an ego as well as super-ego aspect), the initiator of projections, of hallucinations, and of phantasies as well as of sublimation, reason, and reality appreciation; as the entity, in fact, whose greater cohesiveness epitomizes the aim of psycho-analysis. It will be thought that this should go without saying; and indeed it does. I want to suggest how uninspiring such a description appears, contrasting with the anxious necessity likely to be felt concerning a measure of integration; how

negative in relation also with the lively demand that aspects of the exterior world should be found to echo or, rather, to reinforce, stability, the more appropriately so since the first function of the ego is perception. It appears that in perception, which has been shown by Gestalt psychology to be an act of co-ordination, we perceive with the object a reminder of the perceiving agency, the ego; implied in the act of perception is awareness of the perceiving agent, very likely in regard to a past state or experience. If this be a variant of *cogito ergo sum*, it is not intended philosophically at this late date. I affirm merely that awareness of psychical co-ordination may be received together with perception of objects and is known best to us in this way accompanying an image of concreteness, as part of the perception of an object; vividly, of course, in untroubled perceptions of harmonious structures, ideally in terms of harmonious bodies or of what may be imagined to stand for them – that is a very wide range – since the ego is felt, at any rate in the context of perception, to be inseparable from the body, and is itself largely composed of introjected bodies or parts of bodies, all of which have to be co-ordinated, if possible, as one body. I am speaking now entirely of an integrated ego that not only sees itself (perhaps literally) in untroubled moments as stable, but sees other objects as whole and separate. Thus, there is obviously a delight in social intercourse additional to practical pressures or to aims more directly libidinal. The outlets, and particularly the reassurances that are sought, will be of many kinds: one constant factor, I think, has reference to what might be called a show of integration assumed to be present. I have thought of calling the species of projection I have in mind which, I submit, plays a very large role in art, the body-image; but that term has physiological associations more with the parts than with the whole. I should not quarrel with anyone who would say that the work of art reconstructs the body. On the contrary, I should agree. But I should want, as now, to comprise in that integration of the body the integration of the psyche. Also I am not sure that the word 'image' is happy for the context. Certainly the projection is an image in the sense of a reflection; but whereas what I have in mind serves as a picture of the integrated ego, as a structural and often idealized picture, this representation is the sole means that enables the ego entity to *perceive* that integration from outside. In other words, since the ego is the organ of perception, a self-perception *in regard to structure* is best organized when it is an outer perception of the senses, possessing thus a degree of impersonality, since the reference is not primarily to the personality but to the skeleton, as it were, to a stable framework. Hence there comes about on the aesthetic side, I shall suggest, an abstracted interest in structure; hence detachment from the emotional stimulus of the artist's subject-matter, no less than deep involvement, characteristic of aesthetic contemplation and therefore of aesthetic creation.

It will now be obvious that I am not referring to what is called the personality,

nor does the word 'self' assist my sense. What I have in mind starts with, and is ceaselessly supported by, kinaesthetic sensations. A sum of these sensations that serve as hidden spokesmen for the movement, the interplay, of internal objects and of other layers of the psyche, are embodied outwardly, come back syn-thetized, structuralized, even conventionalized, in the terms, that is, of a tactile object, furnishing us with an easily shared skeleton upon which may be moulded the individual self-esteem. I shall use for this ego-object the term 'ego-figure'. I see it as an epitome of balanced or stable corporeality, more concrete, more object-seeming than any image of what is called the personality. I hope to show that the nature of art in particular requires the hypothesis. I must stress again that this interlocking entity is always viewed here as a corporeal construction whose analysis reveals somatic sensations, consorting introjects and cathected outside objects, a meaning obtained from the contemplation of others as well as of ourselves.

A need to project corporeal structures may provide, it appears to me, a further encouragement for the over-reaching mechanism of projective identi-fication. As for art, I think I am already discussing the aesthetic means of en-dowing symbolic material with a potent form; and may it not be that for much rational elaboration this concrete prototype has been indispensable?

Conforming to the stability of the ego, the ego-figure offers the model for repairing and esteeming others, in terms of a body structure to be mended or treasured, in terms of a whole object that emerged originally in the wake of the depressive position when the mother could be seen restored and self-subsistent, and was thereupon introjected. Following decreased reliance upon both self- and object-splitting, integration grew in the ego, provided a basis for the projection of an ego-figure dependent, therefore, upon the framework of the introjected whole mother and, from an earlier stage, upon the introjected 'good' breast described by Melanie Klein (1956) as 'a focal point in the ego'. She writes in the same paper: 'One of the main factors underlying the need for integration is the individual's feeling that integration implies being alive, loving, and being loved by the internal and external good object; that is to say, there exists a close link between integration and object relations. Conversely, the feeling of chaos, of disintegration, of lacking emotions as the result of splitting, I take to be closely related to the fear of death.' An aesthetic object is integrated. In the light of the above quotation it is surely interesting that many aestheticians have followed Berenson in calling aesthetic formal (integrative) values, and thence the work of art, 'life-enhancing'.

There is the phrase 'respect of the person', the fruit of an attitude, often only occasional, without which culture would have been unthinkable. I suggest that projection of the ego-figure reinforces the contours of most object-relationships. 'Respect of the person' underlines libidinal value in the possession of an erotic

97

object, and similarly heightens the import of aggression. It tends to balance disgust, reaction-formation, in regard to bodies and their products. The artist, possibly even more than the physician, needs to be a great respecter of the person in this sense, a sense that colours the admission or the defiance that is implied by a Bohemian disregard of cleanliness.

Works of art have no taste or smell; that is, their taste or smell, should they have them, are entirely excluded from the aesthetic aim and the aesthetic result. A statue soused in perfume would be aesthetically most offensive, except that our imaginative faculties would not even then treat statue and perfume together, save in regard to wetness which would be of significance as a texture. Should we conclude that some neglect of taste and smell accompanies a marked insistence on the wholeness and independence of an object?

A degree of distance helps to enforce the independence and integrity of the object. Art presupposes visual (i.e. from a distance) apprehension of the object; yet while observing this otherness, art, I must add, strives also to bring the object nearer to us so as even to envelop us, principally in terms of tactile and kinaesthetic sensations. This antinomy explains, I think, the *tour de force*, the common enough element of trickery and virtuosity; hence the virtue even of the mere fact of painting in the depicting of three-dimensional form on a two-dimensional surface. The nature of the canvas is in fact very 'other' than the represented shapes, and indeed we tend today to deprecate a paramount use of such manipulations.

Nevertheless preoccupation with envelopment and with oral need restores art, in a revised sense, within the area of taste and perhaps of smell. We speak of a taste or distaste for a phenomenon or an activity, particularly in connexion with art. 'It is not to my taste', one says, meaning it may be good but it is not a form I have cultivated: it does not enfold nor do I go out to meet it.

The work of art has no taste; a satisfaction, however, provided by this thing at a distance, has often an obvious oral component; we are then both feeding from the mother and re-introjecting the image of ourselves viewed as independent structures as she is viewed. I think that particularly in the case of architecture there is a pre-eminent oralcum-tactile appreciation: yet such a mechanism is subsidiary to enhanced recognition of another object and of ourselves. All in all, art shows us that the picture of psychical co-ordination cannot be separated from a picture of physical coherence. In concerted sound, from accompaniment, we entertain a vivid sense of co-ordination *in process*, of sounds within sounds, harmony within melody and warring voices, of bits and polarities as they become a whole that is self-sufficient. It is often much the same when we look at a view. Bits of objects controlled by projected bits of the ego, as well as internal objects, are given the air, are found reconstructed within their proper spheres throughout a panorama. What consumes, what attacks, what

rejects, what envelops or is enveloped, stand together as parts of a perceptual construction, space. The reassurance, it seems to me, gained from such contemplative experience mirrors our anxiety concerning ego-integration whose importance is doubtless connected with the fear of psychosis and, maybe, of the minute splitting that Bion (1957) has described, a splitting not only of sense impressions but of thought processes. Some Greek philosophers were bold enough in intellect to attribute to common conceptions many inconsistent parts, though not rejecting them altogether as illusory; they visualized in several forms the problem of the One and the Many, a problem for which I shall give a more general interpretation. I mention it now in the context of bits, bits of objects encapsulated with bits of the projected ego, a confusion out of which ego-integration and the world of self-sufficient objects have been gradually amassed together, a process in some part to be constantly renewed and, if possible, reinforced. The work of art, often called dynamic, vital, organic, provides a figure not only of the aim but of the process.

3 An aspect of Greek culture

EACH STATEMENT, WHERE IT IS my own, has been put forward without proof, without support of a close argument. I can offer little detail. Should I have retained a listener, he may find something that enlivens the theme in short references to Hellenic culture and to art.

The tolerant Olympian cult tended to uphold central positions of the ego. The Greeks could bestow greater definition than had been allowed by other cultures on attitudes which are, as it were, more to one side. I have said that *mania* was the Greek word for psychosis as well as for exaltation. In Euripides' play *Bacchae*, we read of the Maenads wandering the mountains in a state of *enthusiasmos*, that is to say, with the god in them, the god Dionysus. The culmination of orgy will be *sparagmos*, a tearing to pieces of a living creature. Apollodorus wrote of the Dionysus legend: 'Having shown the Thebans that he was a god, Dionysus came to Argos, and there again, because they didn't know him, he drove the women mad and they on the mountains devoured the flesh of the infants whom they carried at the breast' (Guthrie, 1950). Not for the first time the poetry of a Greek myth is sufficiently concise to furnish with little change a scientific concept. 'The apparent hypergenitality of the typical maniac', we read in Fenichel (1946), 'has an oral character and aims at the incorporation of everybody.' We have inherited the terms before the concept, in this case 'mania' and 'enthusiasm'. Greek power of definition will have depended upon a profound acceptance of variety in experience at the sacrifice, maybe, of a 'monolithic' reduction: it will have issued from the kind of contemplation of experience, rich in detachment as in sympathy, under the aegis of the ego-figure, that I have called aesthetic; and, indeed, it may be the definition and poise of this shape attributed to, or enjoined upon, different phenomena, that provide an essence not only for the aesthetic or poetic, but also for any gift of precise formulation. I claim it to be apparent in matters of art, visual art especially. Greek visual art, with a style founded upon the human body yet associated

with the Delphic maxim, 'Nothing too much', appears to us more Hellenic, more vividly of the classical mould than even the Homeric epics, than Greek literature and philosophy as a whole.

Pater, in *The Renaissance*, described the classical mould of art as that 'in which the thought does not outstrip or lie beyond its sensible embodiment'. The blemish has sometimes been that the 'thought' drains out, leaving a numb perfected form. The inventors of this style were not in such danger. Not only had alternative key phantasies been attached to the life history of each deity but, contemporaneous with the Olympian religion, there existed in hermony with it many Greek non-Olympian cults. To the urges and ego defences that these cults served, the generalized Olympian attitude lent a containing style of a kind that expressed more than is usual the command of the integrated ego. Thus, as a consequence of Olympian influence upon an ancient cult found in many parts of the world, dionysiac and dithyrambic orgies, the manic furniture of shared exaltation and licence, achieve a showing in sculpture, for instance, through a wrapt spirit of harmony or balance without falsifying the ecstatic content; the Maenad is still 'possessed', figuring in a calm though not abstracted art. To the manic state is lent a perfection which is not manic: we are aware that it is a state among others, a bent or propensity of the psyche, reproduced with more sympathy than will be permitted to the recorder of a case-history. The abnormal state is projected as abnormal but clothed with the ego's beauty. It is poetic. Nevertheless in this way Greek culture of the best period showed itself anti-manic, anti-monolithic; at least, there is an anti-manic veneer, even upon a system such as Plato's, an anti-manic style (if not a content) that civilizations deriving in part from the Greek – and they are numerous – cannot afford to lose altogether. The case is largely similar to the super-ego's simpler formations that inspired the poetic tragedies. *Oedipus Rex*, of course, has provided a model to psycho-analysis of its most precise equation.

Before discussing, then, the overwhelming health of the Olympian deities, who contrast with the Chthonic gods (or with their own origins) many of whom must earlier have died in company with the passing year and grown up with the new, I emphasize the consonance between what appear, as we dissect them, to be opposite cults. Like parts of the psyche they existed even harmoniously together, partaking in some instances of one another. We regard Apollo as the typical Olympian; yet there was a mystical and ecstatic side to his cult which provided also a focus for reaction-formation. Moreover, his shrine at Delphi was associated with the resurrected Dionysus whose tomb stood in Apollo's sanctuary; indeed, Apollo was thought to vacate his seat in favour of Bacchus during the winter months at a time when devotees sought Bacchic frenzy on the side of Parnassus. 'To us the difference between the worship of Olympian Zeus and the mysteries of Demeter may seem as great as those between any two

religions of more modern times. Yet not only did they never lead to wars or persecutions, but it was perfectly possible for the same man to be a devout participant in both. More than this, Kore (Persephone), daughter of Demeter, in whose honour as well as her mother's the mysteries were held, had Zeus himself for father, and Zeus could be addressed as Chthonios as well as Olympios' (Guthrie, 1952).

It has been suggested (Dodds, 1951) that the transition from the Homeric to the Archaic period represents the growth from a 'Shame' to a 'Guilt' culture. Some liberation of the individual occurred from the bonds of the clan: the revolt fortified the sense of individual responsibility while furthering such obsessive beliefs as, for instance, in the *infectious* character of *miasma*, pollution. Even far later, Plato in the *Laws* would retain the Athenian death penalty for the crime of sacrificing to a god in a state of impurity. 'In becoming the embodiment of divine justice,' writes Professor Dodds, 'Zeus lost his humanity' (ibid.). But both he and man added to the niceness of their responsibilities as individuals. The concept of Justice grew, yet, for the most part, the 'humanity' remained. This clarification of individual responsibility and of the paternal aspect of the super-ego appears to have been an essential part of a situation wherein the super-ego proceeded to strengthen a paternal protection for the ego itself.

The Oresteian trilogy pictures for us, in terms of the perennial Greek theme of blood-guiltiness, such tensions as existed between the older and Olympian gods. In *Eumenides* the Furies denounce both Apollo and Athene as new-fangled. Athene's solution is perfectly Hellenic. So that they shall accept her verdict for Orestes of freedom from their attentions, and in closing the cycle of vendetta, the Furies are given a home at Athens to be avenging upholders of the State whose sanction must depend in part on fear. Thus the Furies are flattered to evolve into the so-called Eumenides, that is, the well-disposed, to merge into a more developed super-ego, though they themselves derive from the infant's phantasies of biting and tearing the mother in utter destructiveness. The reasonableness of the attention given to what are regarded by Olympians, as by men, as utterly repulsive creatures – a reasonableness that cannot wholly acquit Apollo and his oracle and his system of retaliation combined with purification – is the finest example of the Greek (occasional) ability to give a form to each manifestation of the psyche, however primitive, to contemplate it from a certain distance without the super-abundant aid of mystical identification, and to discover for it an integrative role. I doubt whether this degree of science at any rate can be isolated from the aesthetic apprehensions and aesthetic constructions that shape it.

Everyone knows that drama evolved as a part of the rite in an Athenian Dionysian festival that had been purged of Bacchic excess. (Attributing, as I do, a manic component to all art, I think of this context for the origin of tragedy,

this canalization of the hypermanic, as appropriate.) Dionysus, finally adopted as one of the twelve Olympians at the expense of Hestia, conquered Hellas, but in so doing he had often to endure modification. Euripides makes Pentheus say in the *Bacchae* that the acceptance of Dionysus was 'a great reproach to the Hellenes'. Conversely, Apollo, lawgiver on the subject of ritual and of purification *(catharsis)*, spoke for all Hellas through the mantic Pythia at Delphi: he upheld the regional deities and instructed colonists on the propitiation even of foreign gods. The Pythia, who, seated in a bowl supported by a tripod, uttered in trance, seems to us a strange mouthpiece for this god who asked moderation in all things. It is, I repeat, as if the hierarchy of cults, particularly in regard to their overlapping, represented the unit of the psyche built on different levels. Something of this character pertains to all the catholic religions, to Hinduism for instance. The extraordinary quality in Greece was of the pervading Hellenism, that is, the quality of 'the intelligible, determinate, mensurate, as opposed to the fantastic, vague and shapeless', to quote E. Fraenkel (1935), who, like all commentators, writes in this manner in spite of the condensation and confusion and riot of primitive fantasy in Hellenic religion of which we have offered the briefest note. Today, in the terms of psycho-analysis, we can diagnose the distinguishing mark; we can say that in no other catholic articulation of compulsiveness and aspiration do we discern at the head so firm an ego-figure. From Greek myths, as from other myths and rituals, we hear echoes of many ego-states including some pertaining to the primitive ego, its objects and defences; echoes, consequently, of earlier cults and, of course, constantly, of super-ego demands. What stands out as Greek is the reflection, from a modification of the content that conforms with a pellucid daylight, of an integrated ego. For once it is not the super-ego, not the super-ego supremely, that vaunts power though confronted with the huge range of libido. So we think if we compare typical Indian temple sculpture that shows the deity among men in an art no less representational than the Greek, with any similar scene depicted from Homer. We notice the disproportionate size (far greater than on Hephaestus' shield in Book Eighteen of the Iliad) allotted to the Indian god for an incident demanding homage from mortals, together with an emphasis upon libidinal disorder, conveyed especially by the temple architecture; whereas in the uncrowded Hellenic representation we distinguish god from man by iconographic detail alone, should there be any.

The Olympian's strongest mark lay unseen in immortality: despite magic means of transport, of control of the elements and metamorphosis, most experiences other than death might befall the Homeric god. Perhaps, even, it is not accurate to say the god was immortal: without magic food and drink, ambrosia and nectar, he would not be so (Rose, 1953); not without constant introjection of an inexhaustible breast. But the central Olympian situation

repels the one of the Bacchic worshipper who imbibes the god, becomes the god in the manner of all extreme religious devotees. The inexhaustible breast is part of the nucleus of the ego: the god who fed on it was capable, I have said, of most kinds of experience: he trusted always his own health, his own divinity at the core. The worshipper was not immortal, he could not *be* the god whose chameleon power was introjected into the super-ego. The ego, however, was served by such a god, not only in terms of the ego cultural ideal but as reinforcement of the individual ego's integration, through the presence of the ego-figure, as is seen in the easy balance of the god's statue. Classical sculpture provides the psyche, first of all, with amulets and monuments of the integrated ego. All art brings this gift, usually with less confidence.

The Christian slave was easily endowed with the promise of immortality, but not an Athenian citizen who ignored the Eleusinian or other mysteries. *Thneta fronein*, mortal thoughts for mortals, was a motto that ran counter to the identification of ego with super-ego, as well as signifying some acceptance of death as such. Very few stories in Greek mythology tell of translation from human to divine status. If they are not, patently still, fertility spirits, the Heroes, except for Hercules, will survive only as Chthonic ghosts, with some power near their graves, a little more power than the Homeric wraiths, the 'strengthless dead' who must be fed on blood before they can utter. Conceptions deriving with some simplicity from a more primitive ego lingered, of course; more than lingered: they helped, as so often, to inspire philosophers especially; Pythagorean and Orphic mysticism also, not to mention the Socratic immortality. But it took a deal of time to oust the Olympian cult, even though identified with the corporation of the mortal city-state whose Olympian functions were enacted in the light of day amid a radiant architecture mindful in every detail of the bodily ego-figure.

Homer is the Pope of the Olympian cult. Homer does not offer to man kinship with all creation; enough kinship for poetry, a very temporary possession as a rule, or disruption by the god, not enough for constant mystic immolation. I take it that some inhibiting of the projective-identificatory process was at work, a rather less tentative absorption of primitive ego mechanisms than most cultures display, an absorption into the depressive position that allows more willingly to objects their otherness and to the ego a greater independence.

An acceptance of the fact of death as the end of valid living provides a parallel to the acceptance of loss in the depressive position which must precede a compulsion to restore. 'Greek epitaphs (in the later classical period) are well known to reflect an almost universal pessimism with regard to any life beyond the grave' (Guthrie, 1950). In Homer Menelaus is promised translation, *but without the death of his body*. The body safeguards, to put it mildly, the individual: the ego concept, similarly, is inseparable from that of the body.

The Greeks, in common with others, regarded death as a pollution: both in Homeric times and later, considerable stress was put on burial or on the burial of ashes, for the sake both of the dead and of the survivors. The Olympian cult did not counter this belief in vengeful spirits. Those gods are young: even old age is near to a pollution. Homeric man is usually bereft of precise manic solutions; the enveloping Great Mother, Athene, Artemis, became the Sister. Zeus, and perhaps Poseidon, are father-figures; but Zeus is first father of the gods. The gods, in some ways easy-going (Homer), certainly happy (Homer) – especially the gods, with *ichor* in the place of blood – display bodies not only undiminished, as in other religions, by spiritual excess but innocent of spiritual excess, of any transcendentalism dear to a regressive temper.

Sublimation is an activity of the integrating ego. Psycho-analysts have often recognized in some versions of Greek myths rounded sublimations, perfected in every detail. I have particularly in mind Dr Heimann's (1952) note to the myth of Narcissus. The ego that can undergo considerable frustration and grief, without undue defensive denial in deeper layers, is ready to sublimate with wider embrace. I hold that the form will bear some relation to that of the ego-figure. The fact that Greek poetry and myth often *epitomize* the sublimation of unconscious phantasy is, in my view, a tribute to the strength of the ego-figure overlaying the manifold ruthlessness of Hellenic civilization. An even pressure from that involucrum is perhaps most remarkable when it encloses blurring states of rapture as in Bacchic or Eleusinian rite, or in the nobler mysteries that inspired the penetration of the great philosophers. Such matters may be treated by art in a thousand ways. The Greek approach is perhaps the clearest: the ego-figure in Greek art is especially consistent. Among forms characteristically Hellenic are the fluted Doric column and the idealized marble or bronze youth, the god in his hundreds, fetishes, part-objects, made into whole objects. I doubt whether our own civilization more than two thousand years after, can altogether dispense with these images. 'The dwelling place of the heavenly gods is not above the clear blue sky, it *is* the clear blue sky' (Guthrie, 1950), that is to say, the dry *aither*. These gods are not distant peaks, nor stars, deities the worship of which was sometimes regarded by the classical Greeks as barbarian. 'From old times the Hellenic has ever been distinguished from the foreign stock by its greater cleverness and its freedom from silly foolishness', wrote Herodotus. I regret that I must talk instead of sublimatory power and the aegis of the integrated ego even in the face of appalling super-ego demands. Aegis (*Aigis*) was the Greek word used for the shining shield, or blinding hide coat, especially of Zeus and Athene. The root of the word *Zeus* means shine. Zeus has no truck, except as Chthonios, with D. H. Lawrence's 'dark gods' who seem today so much more dynamic. I have said that classicism, in similar case with any developed form, is at once desiccated should this shining aegis resemble a husk

emptied of the seed of proliferating unconscious phantasy; divorced from the rest of the psyche. But the classical Greeks were no less tied than are Mexican peasants to the fertility of the soil, to the fertility rite (Harrison, 1912).

Various Greek religions developed so widely in terms of sublimatory ramification that the origins of those cults remain a matter, even more than usual, of differences among scholars, classical and anthropological. Does any Hellenic myth or saga epitomize, neater than the next, what I have called the ego stamp? I am inclined to point to the story that explains the establishment at Delphi of Apollo who has come to Greece from a far northern or eastern home. The story condenses the substitution at this ancient shrine – archaeology has revealed its age – of an oracular Earth goddess by the Olympian embodiment. There are several traditions. Aeschylus in *Eumenides* tells us little, but Homeric Hymn III, a fragment of Pindar and some lines from Euripides' *Iphigenia Taurica* relate that Ge or Earth, or her daughter Themis, were dispossessed by Apollo who slew the guardian serpent Pytho (Parke, 1939). According to some accounts Apollo had to perform atonement for the murder. Presumably the serpent, like the conical stone Omphalos that marked the earth's centre at Delphi, represents the Kouros, the Earth goddess' young lover: he in turn represents also her phallic aspect. The phallic mother gives way to the androgynous Apollo, to a more developed form of bisexuality. Whereas the goddess embodies an infantile conception, Apollo, inspirer of the arts, is he who in maturity can manfully employ a sublimated feminine component of the ego at whose centre there live the introjected good breast and the introjected whole mother. In some accounts Apollo was only an infant when he slew Pytho. We know that the mother is often slain by the infant's omnipotent thought. Apollo too mourns: and he institutes the Pythia, the prophetess, as his mouthpiece. (It was far more usual for gods to be served by priests, goddesses by priestesses.) Except for Bacchus, the gods are not effeminate, but most possess an androgynous cast, the goddesses as well, a model of integration that has proved of lasting value as an ego-figure symbol. Michelangelo's Sistine ceiling is another and more passionate witness: we are confronted with balance and an extreme corporeality; no aspect of the body obtrudes, no *part-object*. Here ego is body entire: that, I suspect, is the first meaning of beauty. It may be remembered that Freud (1930) said: 'It is remarkable that the genitals, the sight of which is always exciting, are hardly ever regarded as beautiful.' The relationship to part-objects is carried on, especially in art, as truly a relationship to whole objects. In Homer we have unceasingly swords and spears, cauldrons and tripods.

One classical statue breeds a thousand good or bad, more likely bad. Cassiodorus relates that following the fifth-century sack of Rome, there were left as guardians of the city many more statues than inhabitants. The statues will have been for the most part nude figures neither spiritual nor sensuous, involucra of

the psyche that had largely drained away. Yet repeatedly, in spite of the arid example, a classical involucrum has inspired great art, has become a form re-infused, so memorable was a pristine perfection, the balance between content and form, between symbols for the pressure of unconscious phantasy and the figure of an integrated ego.

4 Art

IN *The Future of an Illusion* FREUD WROTE: 'As we have long known, art offers substitute gratifications for the oldest cultural renunciations, still the most deeply felt, and for that reason serves as nothing else to reconcile men to the sacrifices made on behalf of culture.' This is doubtless true but very misleading unless it is fully realized that art ever remains the slave and reflector, the principal re-flector, of culture. The nature and magnitude of art and artists in any period is greatly conditioned by the character of the culture and by the stage in aesthetic development; so far from art enjoying superb triumph in periods wherein such compensation would appear most needed, the contrary tends to have more truth. Art compensates, by and large, as an activity that contrives for a culture, and for the participants in art, more definition and more self-sufficiency: at the same time, environment, a society, the quality of a culture or of the revolt against it, assume in art a substance of which we partake: it is often as if culture were an oral object to be incorporated. A specific work of art, even with an immediate content that is anti-cultural, should not be discussed irrespective of this mechanism – it pertains to many cultural activities – nor should the artist's personal aim be dissected without more reference than was allowed in the con-text by Freud, to the super-ego and to the construction of the ego whose balance and integration, I believe, are mirrored by the so–called aesthetic formal values that have proved such a stumbling-block for psycho-analytic aesthetic theory confined, as it once was, to the examination of repressed id contents permitted, through the subject-matter of art, a perennial air.

However vulgar or paranoid a feeling, we are inclined to use the word 'art' to describe the fact of its embodiment in terms stimulating to the senses. I regard the word 'embodiment' here as felicitous beyond the ordinary usages of meta-phor.

Now, the expression 'formal values' seems vague, perhaps formidable, or at least cold when we remember the satisfying concentration of experience and of

wish-fulfilment in the work of art. I would indicate by the term an intense physical appeal, especially to our hands and to kinaesthetic feeling; I refer to balance, pattern, movement, rhythm, surface quality (i.e. texture), volume, proportion of parts to the whole. Subject-matter comes to us in these terms which themselves make a wholeness, so that a configuration of the subject-matter that stimulates tactile sense is said truly to be within our grasp. The means are as various as the arts. Thus, to speak of the texture of sound in one or more rhythmic processes, or of intervals, is to mention an important way in which they are felt. In the present-day analysis both of poetry and prose, the word 'texture' has been used to point out an interaction of sense, sound, and rhythm which is not reducible further.

I want to go on a bit more about texture and its relation to the ego-figure, but without referring to manifest portrayals of the body in visual art; they are no more representative than many other themes and I do not base my argument on the mere fact of figuration. Indeed, what impresses me more is the prevalence, the dominance, of the theme of texture in *all* the arts, of bone and flesh, as it were, of rough and smooth, a wider consideration than the expression of any mood or subject. No one will deny many references to the body in architectural art. Proportion, symmetry, derive from ourselves; the alternations of architectural features suggest to many the rhythm of breathing. Buildings are giants of ourselves as well as symbols of the mother and of the womb. I have made elsewhere (Stokes, 1951) a generalization concerning the alternations of wall with aperture, the recession and protuberance of architectural members, and the constant interchange of surfaces which are smooth or suggest smoothness with those which are rough or suggest roughness; an antithesis that in my opinion colours all other proportions, including those of dark and light and even of void and the surfaces that surround it. I have tried to show that this identity in difference, evocative of kinaesthetic feeling and of touch, underlies the process of the graphic arts which have in some sense been largely tied to building, until the present time when the graphic arts have at last won an independence, though it entails a larger and compensatory use of manifest texture by means of brush-stroke – Chinese painting grew largely independent of architecture – or by the contrast of broken with homogeneous surfaces and, as in the case of Cubist painting, by the breaking up and reconstitution of planes.

To consider just one detail, the picturesque, i.e. the picture-like; namely ruins or other architectural bric-à-brac, moulded, decayed, but the more durable and obstinate since their brick and stone emit a structure pulsating still with a projected life that intensifies our own. There have been great styles of graphic art wherein the representing of dramatic events relied necessarily on an architectural *mise-en-scène*: or when the theatrical décor possessed no other theme by which to measure each qualification arising from human action on the stage. It

is, I submit, decorative, even more directly than figurative, art that requires the supposition of the ego-figure. The pulse or rhythm, too, another life-giving theme of the arts, cannot be isolated from structure; that is to say, rhythm is movement, of, or in, something, of, or in, mass. Thus, not only Greek music but the various metrical units, the 'feet' of Greek lyric poetry, were founded in the dance, that is, in rhythmical bodily movement (Bowra, 1957).

Since I make the point that with whatever sense we perceive, the work of art provides a stimulus of tactile and kinaesthetic evaluation, it will be worth re-marking that in *The Ego and the Id* Freud (1927) wrote: 'The body itself, and above all its surfaces, is a place from which both external and internal percep-tions may spring. It is seen in the same way as any other object, but to the touch it yields two kinds of sensations, one of which is equivalent to an internal per-ception.' Freud is referring to the fact that when we touch our own body – it seems to me the remark is applicable to the touching of *any* object – we are aware not only of the object, we experience also an inner sensation in the touching. The other senses do not furnish a dual effect. In eating we touch with our mouths and tongues: the experience of tasting, could it be isolated from the touching, is an external perception only, as in seeing and hearing and smelling. Aesthetic appreciation appears to be an exercise in the perception of an outside structure that elicits strongly and pleasurably a perception of an inner structure.

I have interpolated this very brief outline of an extension of the meaning of texture – it includes colour – since it has a bearing on the structured, corporeal qualities, the liveliness that must be very *palpable* in a work of art however drawn out in time, as by music. Content, subject-matter, even when they are very closely defined by society (as is form also), may seem almost alone to carry the artist's viewpoint and imagination; yet it is obviously not so. Form, the projection of the ego-figure, attracts, it seems, and condenses symbolic expres-siveness even of the most horrible kind. For, as soon as any experience is trans-lated into art, it becomes bearable. I shall say no more about subject-matter which in pathetic isolation has so often served the purposes of psycho-analytic investigators; naturally the material has been for the most part literary, provid-ing studies in symbolization rather than primarily studies in aesthetic sym-bolization. From the aesthetic contemplative point of view any record of feeling, any emotional gesture *in itself*, is something of which one tires sooner or later; that is the experience of those who spend their life in art; whereas the excitation from formal values is regarded always as inexhaustible, as 'life-enhancing', and only then, *through their complicity*, any particular content may be so viewed. In this way, and in this way alone, one may never tire of a painting's subject or of a symphonic poem. The Greeks made a similar division. 'Homer,' it has been remarked (Dodds, 1951), 'always asks the Muses what he is to say,

never how he is to say it.' The Muse, not the poet, plays the part of the Pythia: the poet interprets the entranced Muse who symbolizes, in contrast with the ego-figure, his other immediate compulsions.

This division between form and content is, of course, ultimately artificial: but it does nothing but good to make it. However, the distinction, I repeat, is ultimately artificial as every argument in this book so far has gone to show, since I have been at pains to suggest a subject-matter for the formal qualities, the one of reconciliation between polarities that immediately lends itself as clothing to individual themes of conflict, and elicits from the artist a condensation of his 'thought'. What fascinates the artist in his subject is the body of impressions or feeling for which it is the symbolic focus. He must now recreate for this focus a new body: body means organism, integration, a *self*-contained entity as we say, an ego-figure. Moreover, the artist is likely to incorporate in his work reflections of physiological ecstasy associated with good objects, oral, anal, genital, since it will have belonged to his attitude, his attraction, to the medium.

Thus there are many connexions for an intimation of corporeality in the work of art. I tried to show in a recent paper (Stokes, 1957) how words and clichés harbour subsidiary corporeal meaning that the ages do not stamp out. The effect of even so cursory an examination of popular expressions was, and always will be, whatever the extent of research, the unavoidable corporeal reference. Words are symbols, all our mental constructions are symbols based in the last analysis upon the body or upon parts of the body. Now, in the previous study of words my chief point was concerned with clichés and slang phrases which described the situation of the ego by reference to balance, position, substance, tension, shape, in sum, by using the language of the formal elements considered aesthetically to be 'life-enhancing'.

This leads me to a new consideration. The artist sometimes claims his work to be 'more real' than Nature in virtue of having distilled the essence of Nature. That Platonic claim will remind us of an attitude in some primitive societies – we preserve other echoes of it – whereby the sign may occasionally be as significant as the entity for which the sign stands and his name may be *more* than the man: it is his essence. Such a line of thought is not entirely removed from what is called concrete thinking: and, indeed, I at any rate have found in reading case-histories that schizophrenic utterances can be extremely poetic, in virtue of a parallel to the equations and condensations by which the poet extends imagery. A less exalted use of words throws light here, namely obscene terms which, particularly in a few perversions, may be uttered as the near-equivalent of a sexual act (Jones, 1920 and 1951). The poetry of words is sometimes enhanced, sometimes denied, by such a magical and concrete function of language, observable not only from obscenities but also to some extent

from slang: for a split second the word possesses more than the mere aura of the thing: hence the juiciness of words, and indeed very often of things, in virtue of a word that 'equals up' to them. Plainly the artist in words must obtain for his effect something of this juiciness: he does so, I think, more often through the manipulation of sound and rhythm than by the blatant invoking of symbolic equivalence – I use Dr Segal's (1957) term – at the expense of metaphor. Yet, though art be the exemplar of symbolization, a degree of concrete thinking is unlikely to be altogether absent. In the first place, the work of art, the symbol, may be put on an equality, in regard to essence, with the phenomena thereby symbolized.

Moreover this 'reality' is thought of as super-real in virtue of the first aim in art, to represent concretely, by objects of the senses, mental structures as well as physical structures.

The element of equivalence, as opposed to true symbolism, may be in tune with a projection of the ego-figure that provides an entire feeling of ego-integration, rather than a symbol for it. The influence may spread to the condensations that symbolize the hidden subject-matter.

Now it seems to me that modern art, the art typical of our day, is the slang, so to speak, of art as a whole, standing in relation to the Old Masters as does slang to ordinary language. There are many beside myself who consider the work of the painter Braque to be the most perfected of our time. Let us see what he has to say about his own art and about art in general. He has written: 'I am no longer concerned with metaphors but with metamorphoses. . . . To define a thing is to substitute the definition for the thing itself.' I will interrupt to mention that that is considered by Braque to be unaesthetic: painting should not provide a substitute for the object: better to appear as a metamorphosis of the object than as a metaphor for the object. 'It is wrong to imitate what one wants to create,' writes Braque. 'One does not imitate appearances; appearances are results. In order to achieve pure imitation, painting must disregard appearances . . . It is not sufficient to make people see what one has painted, one must also make them touch it.' In viewing, it should be as if one were touching the painting. 'I care much more for being in unison with nature than for copying it' (Braque, 1952 and 1954).

Some of these remarks will suggest a very primitive state of mind: indeed, one function of art may be to rebuild the world with adult strength around the primitive core of the ego, the primitive vision, not entirely lost, whereby objects are extensions of one's flesh, one's own organs, objects whose absence will be overcome by hallucinating them. Braque has written: 'I am extremely sensitive to the atmosphere around me, and if I had to try and describe how my pictures happen, I would say that first there is an impregnation, then hallucination – a word I do not like, though it is not far from the truth – which turns into an

obsession: and in order to free myself from this obsession I have to paint the picture as a matter of life and death' (ibid.).

The phantasy of metamorphosis, particularly in connexion with the art of painting, must derive in part from the translation of food into faecal matter. Cubism required fragmentation of the object and a rebuilding through a combination of facets so that there is evolved from the subject-matter a so-called metamorphosis extremely evocative for the tactile sense in virtue of the multiplicity of planes. Texture – and texture will be represented by many means other than the actual texture of the pigment – plays an enormous part in the effect. The paintings are indeed constructions or reconstructions of the most palpable kind.

We will view these works largely, though not entirely, for their abstract or generalized content. But we know, and we may finally feel, that their immediate subject-matter, a portrait, a still-life, was of moment to the Cubist painter: he expostulates that he does not abandon his subject: he dissolves it in order to appropriate it, and we are able to follow him in this to varying extent. Yet the object is re-created as well as joined to the ego in an oceanic union. The framework, the indispensable carrier of this passionate process (and of a degree in symbolic equivalence) is the idea of construction itself, seen as identical with the ego-figure: hence our feeling of well-being, of health, before the successful painting in spite of the often considerable aggression that has gone to make it.

To restore the ego is simultaneously to restore the object, and vice versa. I have contended that part-objects will be drawn into whole objects if they shall contribute to the structures that reflect ego-integration. The work of art is esteemed for its otherness, as a self-sufficient object, no less than as an ego-figure.

I have said that modern painting is the slang of the Old Masters. Let me remind you what slang implies. Many slang words seem to partake somewhat of the action they designate though in a less powerful way than obscene words. I have already indicated that I think that this quality is retained in the vivid, that is, poetic, use of words, and in art as a whole. By calling modern art the slang of the Old Masters, I wish to point to a near-concrete type of thought now overtly displayed. We have as well in much modern art a process of fragmentation, also usually identified with schizoid states. I do not think that those who accept Melanie Klein's infantile paranoid-schizoid position preceding the depressive, would have difficulty in supposing that schizoid nuclei remain intact or easily resuscitated, and that they may be put to work especially in the more narrowly compulsive ranges of ego activity (art) dominated by the depressive position. On the other hand, whereas the schizophrenic allows no separate existence to the objects in the outside world upon which the image of his psyche has been cast, an emphasis on separate existence provides the means by which projected emotions are transfigured in art. The modern painter, as we have seen

through the words of Braque who speaks in this respect for many others, insists on the separateness particularly of the object he himself creates, as well as on oceanic feeling; indeed, according to this theory, the otherness of the outside world can only be represented by the separateness and wholeness of the work of art. Yet it is a means also for realizing the structure, the stability, of the ego-figure in the very terms of object-otherness.

To sum up. The work of art is a self-contained object that crystallizes experience symbolically. It is esteemed for its otherness, and simultaneously as an ego-figure. Also, we are drawn into the sphere of its meaning without prejudice to the separated object-nature; there is some fusion with the object on the model of the good breast, and there may be experienced a limited equation of symbol with thing symbolized. However, even though aesthetic and mystical experience will sometimes merge, there remains a fundamental distinction between them in regard to the integrity of the object.

One word about aesthetic detachment. Aestheticians, particularly since Schopenhauer, have underlined the contemplative nature of aesthetic enjoyment, that is, an enjoyment unconnected with an immediate call to action, erotic or otherwise, a contemplation that in virtue of the formal pattern offered may subsume very large areas of experience. Even at the life-class the model must be viewed some of the time as a formal pattern.

I take this 'detachment' whether seen from the side of creator or of aesthete, to provide the same witness as formal values to the projection of the structured ego-figure. Vernon Lee (1913) wrote: 'Perhaps the restorative, the healing quality of aesthetic contemplation is due, in large part, to the fact that, in the perpetual flux of action and thought, it represents reiteration and therefore stability.'

A story of Phryne, the beautiful Greek girl who was once accused of profaning the Eleusinian mysteries, tells that she was allowed by the authorities to go naked to bathe. Evidently it was thought that to her perfect shape would be attributed the formal relationships of a statue; that a scheme, a system of stresses and proportion, would partly usurp the place of female vulnerability, since, as far as the sculptor is concerned, density, mass, the air displaced, the nude, tend to supplement, though not of course to supplant, the heaviest robes of mere allure. Indeed, there is a further report that Phryne was model to Praxiteles. It is hardly necessary to add that Praxiteles became Phryne's lover.

Of its own nature aesthetic detachment will not be consistent. Nevertheless the unity of experience, I would say, can be contemplated only under the sign of the ego-figure: there is that truth in the beautiful. It follows that we tend to react with a more pointed depression to emptiness made by man than to even the most desolate natural scene. From the point of view of a strong aesthetic sense in regard to human constructions, ugliness, 'badness' as such, is not most

feared, but emptiness; that is to say, lack of identity, lack of focus, promoting a feeling of unreality as may be transmitted, for instance, by an ill-proportioned flashy apartment yet designed, it seems, to banish space and time and so the sense of any function to be performed there. A crack in the plaster would be a relief. The squalid, the ugly, do not necessarily lend themselves to this numbing sense of unreality, deeply feared as proclaiming lack of relation, disintegration, the undoing of the ego-figure.

Shape, pattern, growth, rhythm, interlocking parts of whatever kind, restore ourselves to ourselves.

5 (a) A note on Homeric *virtù*

WE ARE TOLD IN THE ILIAD that Andromache, lacking Hector's body, intends to burn his fine clothes. Achilles is set on the corpse's utmost desecration, just as he has cruelly treated Hector at the point of death: yet in speaking to his followers who are plunging spears into the dead body, Achilles even now refers to him without irony as the noble Hector. That is consistent with the Homeric hero-philosophy: the positive 'quality' of a man is regarded as unchangeable, even by those who hate him altogether. Every hero has his appropriate epithet even in inappropriate circumstances (which are thus dramatized), as when Achilles, showing himself so bitter, so hysterical and cruel, is called the 'excellent' though he be butchering unarmed Trojan youth.

The constant epithet, a cluster of alternatives, is an instrument of epic poetry, poignant to us in Homer. The convention fits tragedy and the acceptance of Fate as a stock character who, though fully known and acknowledged, cannot discourage the Hellene, endowed with wit as with wits, from acting as may be best for the immediate situation. The conventional epithet is on a par also with the continuous re-discovery of the heroes to one another, with the ruthless retailing of genealogies, with the necessity to know friend and enemy alike by *name* in all his circumstances and ancestry, with the repeating of such well-known facts *ad nauseam* yet with a fund of variations and additions that suggest the surprising fertility of great music. The character of a god, of course, is similar and, as in every religion, of the iconographic trappings. Art, especially classical art, largely employs stock characters.

Homer's harping upon identity (rather than upon a part-object or *mana*), in terms of total physical radiance and strength, seems characteristically Greek to us, the more so since Ilium's plain is statueless, and the Argives must live in huts. But we are given detail of workmanship, of armour and weapons: these also, and most other things, natural things, have unchanging basic properties or *virtù*, to use the word common at the time of the Italian Renaissance for heroic

quiddity. *Virtù* was seen to reconstitute the essence of the Antique spirit, and thereupon inspired the so-called cult of the individual.

It is an aristocratic conception of persons and things, often a noble ego-ideal introjected along with the ancestors. The basic pattern, I suggest, is once more the corporeal ego-figure. The essence of *virtù* resides in configurations that illustrate a total spirit. There is, then, kinship with preconceptions inherent in the aesthetic process. As well as greatness, the felicity of art during what might be called *virtù* periods confirms it.

Physical quiddity of things and people, *virtù*, Plato's 'ideas' disembodied though they are . . . There is connexion here in common, first with *mana* then with the ego-figure; and yet Plato's philosophy conveys also a leaning to Pythagorean mysticism, a silhouetted convergence of trends some of which will have derived from phantasies that possess the primitive ego.

It seems to me that such 'confusions' of fundamentally differing object-relationships, often propitious for art however uncomfortable for exegesis, have dominated intellectual 'positions'. They are in fact a clumsy form of art inasmuch as they symbolize the variety of ego attitudes *vis-à-vis* objects that each normal person experiences and must seek to harmonize under the predominant influence, it is to be hoped, of the ego-figure.

5 (b) Homeric physiology

WE READ IN PLATO'S *Timaeus* that the sense of touch is diffused over the body which discriminates between hot and cold, hard and soft, heavy and light, rough and smooth. From J. I. Beare's (1906) *Greek Theories of Elementary Cognition* I string together the following information: Aristotle speaks of the smooth as the cause not only of reflection but of whiteness: moreover the bronze sounds because it is smooth. Aristotle remarks an analogy between that which to the touch is sharp or blunt and what to hearing is sharp or grave: the sharp, as it were, pierces while the flat pushes. Empedocles, according to Theophrastus, relates odours to the texture and weight of bodies. In the *Timaeus* again we read that the sensation of taste is bound up with the quality of roughness or smoothness. Plato contrasts an astringent taste with what is smooth. Aristotle says that what is gustible is the effect produced in the moist by the dry. Taste is a sort of touch if only because it has to do with nutrition. Nutriment must be something tangible. The sense of touch can exist without the other senses, but not they without it. By their possession of tactile sense, animals first arise above, and are distinguished from, vegetables. Aristotle all but identifies touch with the central, synthetizing *sensus communis* of consciousness. Democritus had further simplified all *aisthesis* into modes of touching. (I would revive this idea in reference to our modern connotation of *aisthesis* or the aesthetic.) Aristotle thought that man's sense of touch excelled in fineness that of all animals. He considered the sense of smell to occupy a place midway between the two senses that employ touch and the remaining two, sight and hearing, which act through a medium in virtue of the organ's possession of elements (air, water, fire) in common with the medium and with the objects perceived. Odour, physically considered, comes from the dry just as taste comes from the moist.

I offer this minute glimpse of some Greek theories of perception for which the tactile sense is the touchstone, with reference to the foregoing hypothesis of

the ego-figure, a projection predominantly, as I think, of tactile and kinaesthetic sensations, an image of the integrated ego. It provides the basis for the formal qualities such as rhythm, texture, balance, with which the content of a work of art is clothed. I want now to mention a physiological-cum-psychological unity, preceding the mind-body dualism, that may be considered to have bearing on a growing synthesis or integration within the ego-figure.

I shall therefore bring to your notice a more primitive Greek physiology, the Homeric framework of all classical culture; in brief, as you will see, the genitalization of the body combined with an ordering of internalized part-objects but in such a way as to emphasize a working system, an amalgam, a tactile whole object of peculiar dignity.

The centres of the Homeric body are the lungs with the heart on the one hand and the head on the other. Experience is breathed in, emotion, often implanted by a god, is on occasion breathed out, Air surrounds and feeds from every side. The lungs receive not only air but also liquid drunk; as well as taking in, there is a breathing out. The lungs, with the heart, are the seat of consciousness. The head, the moist brain, on the other hand, together with the spinal fluid, are viewed as the fount of a seminal system, of virility, the life-force that in some contexts suggest to us not only libido but the unconscious. The head is also identified with the spirit still corporeal, the *psuche* that floats clear when lungs and heart cease action. Homer speaks of the 'strengthless heads of the dead'. Like the absolutes of the Ionian philosophers, Thales and Anaximenes, moisture and air are elements strongly represented in the popular physiology. Visualize for a moment the statuesque Julius Caesar, many centuries later on the approaches of the Capitol, toga, column, steps, the enfurled head which, we shall see, he will have regarded as sacred. These forms and textures are all of one body to which the mind is unobtrusively central.

It seems extraordinary to us that the brain was not recognized to be the thinking apparatus, if only in view of a sensation of slight pressure within the head when the brain is overtaxed. But the clear-headed classical image dies very hard. One notes that in diagrams of the cranium for physiological books and surgical charts, the head and features are of a particularly classical mould; an illustration such as this of these powerful organs unwittingly suggests that a seat for the processes of thought must be looked for elsewhere.

I have called the head initiator of the seminal system: almost the whole length of the bodily form was genitalized. Thus knees were clasped in supplication since they too were cavities lined with a precious oil or fluid. Even for late classical times we should remember the Homeric parts of the body organized in a predominantly oral-genital system, a corporeal integration that suppresses the manifest interacting of good and bad inner objects: indeed, in a moderate sense the conception is ideal, though we encounter, in Homer too, an organ

badness, for instance the breathing out of fury, like the bad humours of the body that belong to a later physiology deriving from the Greek. The poetry of the conception and the science also that may issue from it, lie in the bringing together of part-objects. We can become dramatically aware of the process if we contrast a marble fifth-century athlete with the herms that were often fixed superstitiously outside houses, a stone terminal possessing articulation only of a head and a phallus, or with the roughly-hewn log that even in late classical times served as the image of Hera at Samos. It seems to us that the Greek athletic cult was made poignant, similarly the naturalism of painting and sculpture, by a compulsion to represent a controlled yet vivid action as a movement belonging to a complex of the *whole* body.

My details of the breath-blood and the head-*psuche* systems are the discoveries of Professor R. B. Onians, set forth in his extremely important philological work, *The Origins of European Thought* (Onians, 1954). I believe it remains unchallenged so far *in toto*.

Onians has established firmly that *phrenes* in Homer means lungs, though often translated 'diaphragm' which is the meaning that it has later in Plato and in the Hippocratic writings: *phrenes* were lungs still for Aeschylus. Similarly with *thumos*; in Homer it was what may be called the 'breath-soul', not a function but a thing active in the blood and lungs: air as well as blood was attributed to the arteries; breath within was a vapour related to blood. Thought and feeling were hardly separable: emotion was part of the breathing system. Even today a man may strike his chest in referring dramatically to his conscious intention. Inspiration was a *menos*, a god-sent access of energy breathed into a hero. One sought prophetic inspiration by inhaling vapour as at Delphi, it was anciently supposed, or by drinking blood. Thoughts were words and words were breath: winged words and all sounds flew down the trachea of the hearer. Plato, in the *Timaeus* subscribes very largely to this physiology; even in the late dialogue, *Theaetetus*, there is the image of the mind as a cage full of birds. Emotional thought, anxiety, were breaths for Homer, troubling the organs of the chest. In early Upanishads also, speech, sight, hearing, mind, are forms of breath. In Anglo-Saxon a man's lungs may be said to amount to his mind, and possibly his soul too. We still talk of getting some emotion or decision off our chests. Homer speaks of 'The bushy heart of Patroclus' and Empedocles of the heart as 'dwelling in the sea of blood that leaps against it where is especially what men call thoughts'. Understanding is the work of pure and dry air: though the theory be transformed, clear air of Athens was contrasted in the late fifth century with the stupid-making Boeotian fog. I interject that in the comedy *The Clouds* by Aristophanes, Socrates is said to be suspended in a mid-air that will be the more dry and therefore conducive to better thinking. We still associate clear air with keen thoughts, a largeness of space with an unsuffocating configuration of the

internal objects. Wine goes to Homer's *phrenes*, the lungs, as if the various world of adult consciousness could still be lulled away by re-incorporation of the homogeneous good breast. It is a surprise to come upon the same statement about wine and lungs in Plato's *Timaeus*, not to mention Horace and Cicero. Sleep and drunkenness are alike moisture for the mind. 'It is a pleasure to souls to become moist', wrote Heraclitus when announcing the supremacy of dry and more various thought. I note that there is today a slang use of 'wet' indicating that such regression makes for stupidity. Lethe, forgetfulness, was, of course, a river drunk. The liver, an organ with plentiful blood, also received sense-impressions and emotions, particularly impressions, it seems, of sound. All blood-vessels were apparently receptors of tactile sensations: some *thumos* inhabited the limbs.

This system had many variations and alternatives: gradually key-words changed sense, perhaps entirely. Later on it is correct to translate *thumos* as courage or anger: the term has come to rest in the name of the thymus gland.

Turning to Latin, we find the same values of wet and dry expressed with different emphasis. *Sapere*, to know, is to have sap, to have the native juice, that is, the blood, active in the chest. *Animus* was originally the breath of consciousness, issuing as words from the lungs and the heart (*praecordia* and *cor*). Also *spiritus* connoted breath: the later meaning of *spiritus* illustrates the tendency of which in Homer there is no trace, to identify the surviving soul with an aspect of consciousness or intelligence. As I have said, the Homeric *thumos* is utterly destroyed at death; in spite of the introjects, consciousness or connectedness was of the body alone. Sleep in Homer entails a covering, like darkness which was not conceived to be absence of light but to be substantial mist. Later thought, although a product of such feeling, tended to diffuse the body-image focus, for which homogeneous states of mind appeared as vaporous clothing upon consciousness, substantial, of notable texture. Death brings to view another texture. The *telos* of death, a band or wrapping, covers nostrils and eyes. The Latin word, *religio*, meant first a binding. We speak still of debts as bonds and of the bonds of death: we also say: 'He is bound to lose.' Both Greek *ananke* and Latin *necessitas* connect with the meaning of bonds. The Fates, of course, spun cords to which men were attached: what 'lay on the knees of the gods' had been spun. Zeus could unbind but he must not 'play fast and loose' with Fate. A crown or garland was the concomitant of priestly work, serving as does the mayor's chain of office. 'In such a world,' writes Onians, 'binding was almost coextensive with fixation or fastening.' He is not of course using the word 'fixation' in the psycho-analytic sense of which we can reaffirm the body that the term contains in metaphor, the image of a substance relevant also for binding together in the case of the integrated ego.

Turn now with Onians to the Homeric *psuche*, the system of the head, bones,

and seminal fluid. Observe first the sanctity of the nod and the superstition still commonly associated with sneezing, an involuntary, explosive comment from inside the head: the *psuche* speaks, the spirit, perhaps on occasion the unconscious. Hair was the first offering of sacrifice, from the top of the head. It may have been sometimes thought that castration preserved and strengthened the seminal fluid in the head and spine. Athene was born from the head of Zeus. Men are like ripe cornstalks in Demeter's fields. Although, later, having absorbed much of the role of *thumos*, the *psuche* may be associated with the chest also, it can still be identified with seed (*sperma*) as in the *Timaeus*. But *psuche* was from the first bound up with blowing. Seed itself was breath for Aristotle and for the Stoics. The verb *psuchein* meant 'to blow'.

We may still speak of the source of a stream as its head. According to Onians, an early term in Latin for sexual intercourse is *caput limare*, 'to diminish the head', literally 'to file the head away'. *Cerebrum* derives from *creo*, I beget. Representations of horses' heads, also masks, were symbols of fertility. *Genius* is Latin equivalent of *psuche* and also of *daimon*; it is the part of a man (obviously embracing the good object), which during his life was honoured as a god. The *genius* is less obviously procreative after death and is then commonly called *umbra*, shadow, and *anima*, which denotes also breath or wind. *Numen* is something that nods or is nodded. The continuing iconography can be traced in medieval art and in the winged heads of the Renaissance. Ancient German belief about head and chest was not dissimilar. The *genius* could also be unpropopitious. There was, we have seen, close association of the head, particularly of the brain, with the spinal fluid and with the marrow in the bones. Knee, *genu*, is cognate with generative. The knee was associated with the thigh, the largest bone. Dionysus was born out of Zeus's thigh. We speak today of 'the sinews of war' and employ the skull and crossbones to express the drained marrow of the departed soul. Seed, *sperma*, was of course equated with oil and grease: we talk of 'elbow-grease' and 'more power to your elbow'. The Hebrews, especially, made much of anointing their kings. Sweat was another precious fluid: the Latin *sucus* means sap. Oiling the body was a restoration of phials lost in sweat. Democritus advised the moistening of the inside with honey and the body's surface with oil. Youth abounds in life-giving moisture. Ageing was seen as drying up. *Aion*, life-liquid issuing from the eyes in tears, also including the spinal marrow, assumed the meaning of 'a life-time' and finally of eternity. In classical literature there are phrases such as 'during my water' meaning 'during my time'. Antiphanes wrote: 'The life in us approximates to wine; when but little remains it becomes vinegar.' And Petronius: '*Vita vinum est.*' Rivers were seen as youth-rearers, bestowers of seed, and since the growth of hair was associated with sexual vigour, we arrive at deeply bearded river-gods. Like the knees, the chin was generative. The Latin words

for brain and for horn are akin. In Homer the river encircling the world, *Okeanos*, generated all. *Okeanos* was conceived in serpent form, so too the *psuche*. Also the Sumerian serpent engirdled the earth. The small fry of early Christian iconography were by no means other. *Skeletos*, on the other hand, means dried up. Onians supposes that the complete burning, and the earlier custom of scorching, the dead helped the *psuche* to escape by separating the moist from the dry. But libations may be poured to provide the bones with a new moisture and they might after the pyre be wrapped in fat just as bones were wrapped in fat for Homeric sacrifices. Incense too is undoubtedly employed to bestow on the god more sap: both Bible and Koran support the libation of liquid or sap to the god who imparts a similar power in the ceremony of baptism. Ambrosia was the divine counterpart of animal fat and of oil, while nectar was equivalent to wine.

Vir himself, man, maleness, seems likely to come from a root for liquid or sap. *Libare*, to pour, is likely to be the same as to love, the same as *lieben*, *libido*. *Liber*, *libertas*, is what the slave has lost in having his procreative head held captive. Anglo-Saxon *freo* is not only 'free' but 'having desire, joy'. Finally, it may be remarked that knees and thighs especially have similar connotations in Hebrew folklore. We find there a conception of wind or blast, perhaps flatus, hinged on to a conception of generating sap.

This short account (from p. 119 above) of words and concepts widely diffused in ancient cultures and not unknown today, in Hindu village society, for instance (Carstairs, 1957), is entirely derived from Onians whose many-sided volume should of course be consulted. It illustrates an erotization of parts and processes of mind and body, particularly their quality as reported by touch and kinaesthetic feeling, their tightness, looseness, wetness, dryness, thickness, thinness. Nor did the Greeks stop short: all air, water, have this beauty bestowed upon a functioning that can be seen as native to a marmoreal whole: the good oral object is near to hand and mouth: like the integrated ego it shapes or is shaped. Some of the conceptions belong to the terms of many languages. I hope I do not speak only for myself in discovering that this kind of information suggests more vividly what is Hellenic than do many plays and all the dialogues of Plato. I have in mind the image of a thinking torso and a wealth of contrasting textures that embrace the body, the ego, the mind, without transcendental reference. But it is obvious that this would not be so except in the light of Hellenic and classical achievements and of Western civilization altogether. Otherwise we would hardly know that such a system of corporeal projection differed widely from its source in those part-object effluences that characterize the thought and emotion of savage societies. There obtrudes, however, a notable character in regard to the absence of a transcendental reference, the very point that is characteristic of the early Ionian thinkers who

are generally considered to be the fathers of science. They made great play with the wet and the dry, being heirs not only of the conceptions noted above or of Greek mythological thought concerning the marriage of the sky with earth by means of the fructifying rain, but doubtless of similar myths from Egyptian and Babylonian sources. Thus, a belief such as the one that life arose spontaneously from the mud of the Nile under the sun's action persisted for many centuries. (Especially the Athenians sometimes claimed to be *autochthenes*, sprung originally from Attic soil like Cadmus's sown teeth in the Theban.) Such a theory, in the instances of several forms of life, particularly maggots, appeared reasonable until a short time ago. In a word, mythical thinking – it must always be the case – influenced the direction at least of systematic thought and research (Guthrie, 1957). The present point, the point of first importance for the development of science, is that the early Greek cosmologists projected on to the outside world corporeal images of the balance that issues from the firmer integration of psychical processes: they therefore searched the physical world for principles of interaction, of change, with such singlemindedness that by few of the early thinkers was a prime mover of the universe personified, in the manner of Hesiod's or Pherecydes' mythological cosmogonies, except as a corporeal 'life-force', an immanent *logos* dissociated from cult or worship: there existed as the terms of discussion, so to speak on equal terms, the undifferentiated and the differentiated, the One and the Many; their relationship was to be systematized, just as the undifferentiated character of experiences inspired by mechanisms of the primitive ego, should be integrated by the developed ego among experiences that are composite.

As I find that the information I have given of a corporeal mind-body system helps me to envisage the ego-figure concept, so, perhaps, more such details, could they be substantiated beyond question, will be of use to those who are trying to construct the figure still so brief yet so magnetic, the body-ego itself.

I hope I have yielded some image of olive, vine, marble, within the sparse and clear Hellenic land.

6 Early Greek science

ACCORDING TO FREUD THERE IS at the beginning of life no awareness of objects as distinct from one's own body. The statement presumes self as object. Object-relationship, Melanie Klein has said, exists from the beginning: so much depends on the breast as an object, now gratifying or frustrating, introjected in both aspects, the target also for projected destructiveness often under the influence of envy; the focus for many different states, each discontinuous with those of different quality. But if we are ready to allow that Thanatos, or a correlate, as well as Eros operates from the inception of life, we can see that the one biological urge obtains a definition from a state characteristic of the other, provides, in fact, a bridge of anxiety, an elementary connectedness for consciousness and for the ego. On the other hand, the great psychological intensity due to opposite drives and to their confusion, tends to reinforce a discontinuity of experience, since discontinuity has value as a defence. Parts of the ego and parts of the object are split off: the primitive ego especially strives to keep what is good at the furthest distance from what is bad. Therefore Melanie Klein (1935) emphasizes the centrality of what she calls the depressive position, the stage wherein feelings of loss and of guilt can be more safely undergone, when depressive anxiety exceeds the paranoid, when the mother, good and bad, is to some degree visualized as a whole, independent object. Similarly in the ego there proceeds integration, the bringing together of opposite states compulsively kept apart. Ego synthesis belongs to the apprehension of objects that occupy their own orbit. Perhaps we should discern here the deeper meaning of Parmenides's dictum embodying a concept that ceaselessly reappeared in Western philosophy: 'It is the same thing that can be thought and that can be.'

When we say that someone needs a holiday, a change, I think often we have in mind a pleasurable regression in the form of a quietness, a communion with Nature as it may pompously and misleadingly be called, experience by the ocean, for instance, clear water flooding rocks slowly at the turn of the tide,

floating off sea-weed stems gradually. The essence of the experience is the soft flooding and encompassing, the smoothing of each projection and recess. How much this passive experience derives directly from infantile gratification will vary. One cannot but be aware that it contains a strong identificatory element suffusing, mitigating, the sense of otherness, the stand over against objects. I must stress that the good enveloping inner object is the crux of the well-integrated ego also. Are we to say that this feeling of oneness derives more from the super-ego than from the ego? 'It may well be,' writes Melanie Klein (1957), 'that his having formed part of the mother in the pre-natal state contributes to the infant's innate feeling that there exists outside him something that will give him all he needs and desires. The good breast is taken in and becomes part of the ego, and the infant who was first inside the mother now has the mother inside himself . . .'

'Integration stems from the life instinct and expresses itself in the capacity to love' (ibid.). When perfected it depends upon a firm belief in a good object that has not been unduly idealized as a defence against destructive impulses which often may otherwise be said to predominate in the true picture. Even so, in very early times, I repeat, the ego as well as its object will have been fragmented in order to achieve a dispersal of destructive impulses such as greed and envy. A capacity to love that is partly innocent, so to speak, of the negative prompting, will allow an eventual high degree of integration preceded by the successful primal splitting between the loved and hated object. 'If the good object is deeply rooted,' writes Melanie Klein, 'the split . . . allows the all-important processes of ego integration and object synthesis to operate. Thus a mitigation of hatred by love can come about in some measure and the depressive position can be worked through. As a result, the identification with a good and whole object is the more securely established; and this also lends strength to the ego and enables it to preserve its identity as well as a feeling of possessing goodness of its own. It becomes less liable to identify indiscriminately with a variety of objects, a process that is characteristic of a weak ego. . . . When things go wrong, excessive projective identification, by which split-off parts of the self are projected into the object, leads to a strong confusion between the self and the object, which also comes to stand for the self. Bound up with this is a weakening of the ego and a grave disturbance in object relations.

'Infants whose capacity for love is strong feel less need for idealization than those in whom destructive impulses and persecutory anxiety are paramount. Excessive idealization denotes that persecution is the main driving force. As I discovered many years ago in my work with young children, idealization is a corollary of persecutory anxiety – a defence against it – and the ideal breast is the counterpart of the devouring breast.

'The idealized object is much less integrated in the ego than the good object,

since it stems predominantly from persecutory anxiety and much less from the capacity for love. I also found that idealization derives from the innate feeling that an extremely good breast exists, a feeling which leads to the longing for a good object and for the capacity to love it. This appears to be a condition for life itself, that is to say, an expression of the life-instinct. Since the need for a good object is universal, the distinction between an idealized and a good object cannot be considered absolute' (ibid.).

Devotion to the good object is part of psychical reality. Much depends on the kind of devotion, on the amount of denial involved. We will agree that devotion supplemented and dominated by super-ego and ego-ideal demands, has been reflected by a variety of cultural projections often to the detriment of the grasping of reality, both psychical and physical; but the integrated ego will be a form embracing opposites under the aegis of a firmer good object, a blending strong enough to discard as a major propensity a manic defence, the last method evolved to achieve split-off, absolutist solutions. To find in the world accommodation of the good with the bad without a denial or an exaggeration, is to have projected those processes in the ego. On the other hand, whether egos be more, or whether less, integrated, we all find that in reality death, disease, ill-chance and old age, like our destructive and disintegrative impulses, lie in wait. Shall we personalize misfortune, shall we make it the instrument of retribution, shall we send the good object far away in an attempt to contemplate the enduring and eternal, shall we welcome even a symbolic disintegration of the ego, a mystic union with a distant, featureless good, a denial of chance as of alternation, while pursuing in everyday life a more limited and normal good? These are methods reminiscent of the infant: even for favoured temperaments there is much in reality, in adult circumstance, to reinforce primitive ego methods for the safe disposal of its good object, to encourage splitting, denial, omnipotent insistence upon the uniform, upon the unvaried, the invariable, the absolute. Such methods influence, and are influenced by, an anxious conception of the good object to whose beneficence will be joined persecutory and forbidding super-ego features, any features indeed that are in their character overriding and enveloping: if we consider also that sleep, drunkenness, all-absorbing physical conditions, including orgasm, as well as contemplative states, tend to merge ego with object, we are bound to be aware that there is always a great deal in normal life and in normal as well as in abnormal capacities for which the fully developed ego that surveys a multitude of differing objects, must be at a strong discount: and, though pressure of reality is matched best by an adult grip upon a finite and steady object, the wonder remains that the limited satisfactions of those professedly impartial attitudes we call scientific, could in the first place be identified with a good object, or with super-ego commands in general. The sentence La Rochefoucauld wrote about youth can

be referred to many states of mind: *La jeunesse est une ivresse continuelle: c'est la fièvre de la raison.* The primitive ego remains strong throughout life: the integrated ego needs renewal daily, more especially since the primitive ego is of prime importance in regard to corporate identification upon which all forms of culture depend. In the train of primitive ego projection there has followed what might be called anti-science compulsion, a compulsion so strong that it is a problem to see how the possibility of science could have arisen.

I fear I shall have to refer to a more complicated aspect of the mechanisms in which an overriding good object is often engaged. I have hinted already that the super-ego takes a large part – indeed it is the leader – in any compulsive cultural insistence upon the uniform at the expense of variety of objects. Now, without acknowledged help from psycho-analytic concepts Hans Kelsen, author of the important sociological study *Society and Nature*, Kegan, Paul, London, 1946, has suggested very firmly that primitive man suffers from a weak development of the ego: he allows, says Kelsen with a wealth of illustrative material, comparatively few differences between objects, due to the ease of his identifications. (We would add of projective identification also.) As a consequence there is a 'homogeneity of men and animals, plants and other natural objects'. These are not identified with a contained self so much as with that first extension of a man's self, his kinsmen and his society whose beliefs are prompted first of all by the fear of retribution through the agency in particular of ancestral or other souls. Kelsen quotes from Gennep a charming, well-known example of the failure to admit new objects. 'Since primitive man,' he writes, 'does not discern an essential difference between man and animal, it is not as surprising as it might appear that Australian natives, when they first saw white men riding horseback, believed that the horses were the mothers of the men, inasmuch as among them children are carried on their mothers' backs; nor is it astonishing that they considered the track buffaloes as white men's wives, because with them luggage is carried by their wives.'

We have realized of late that savages often show a good adjustment to the functions of everyday life, and that some so-called primitive societies are more remarkable for the moderation than for the excess of projections of social values on to Nature. None the less the idea of the weakness of the ego, it is likely, can contribute to a part of the truth in regard to the nature of primitive society.

One may guess that Kelsen rejected precise help from psycho-analysis because his researches, it appears, carried him only as far as Kaplan's book of 1927, *Das Problem der Magie und die Psychoanalyse*, where he found much use of the term narcissism and of narcissistic projection, unpromising as he thought in connexion with the weakness of primitive man's ego. It is a pity he has not encountered Melanie Klein's conception of the early ego, the splitting, the projective

identification, to be contrasted with the integrated ego which is able to allow more independence and more variety to objects. I think it might be agreed that the tyranny of the super-ego in many primitive societies, notably the strong feelings of guilt belonging to what is called a 'shame culture', appear to stimulate a persecutory rather than a depressive form of anxiety. The norm is not the one of the integrated ego – it rarely is, for any culture – and of the depressive position: the norm, on the contrary, exists in a degree of regression to a position predominantly paranoid-schizoid. Spirits, part-objects, are strong everywhere, and their retribution. I think Kelsen is right to say that the term animism presupposes a keener recognition of an object *per se* and is therefore inapplicable in such cases; and that where primitive man does not know Nature in other form than as an extension of society, he does not conceive the supernatural either. 'Promitive language is often characterized by the fact that the possibilities of expression in the first person are comparatively undeveloped.' It may be that in the case of illness all members of the family must undergo treatment and, in the case of a delict, retribution be envisaged for the whole group. Sometimes even kinship is not founded directly on physical facts – paternity, maternity, blood relationship – but on a social tie.

In historical times, the soul became the target of retribution rather than its means. There grew in Greece especially an abstract concept of Justice: the innocent may suffer here because of past misdeeds, and the guilty, if scatheless, will suffer later on. This immortality, the centre of the Pythagorean and Orphic religions, was approved by Empedocles as well as by Plato. Justice may then be dissociated from society and the state. Nevertheless Kelsen thinks that, in early Greek philosophy, even Nature was still explained by close analogy with society, and that the underlying theme is still the one of retribution. I am sure he is right. 'The cause,' as he says, 'attracts the effect just as the wrong . . . attracts punishment': the cause must therefore be equal to the effect. Heraclitus wrote: 'The sun will not overstep his measures; if he does, the Erinyes, the handmaids of Justice, will find him out.' Parmenides' philosophy is outlined in the proem to a bad poem in which he imagines his journey to the temple of the goddess of 'Avenging Justice' (Burnet, 1952). Truth is identified with Justice. In the case of the balance of elements, Anaximander spoke of the one making reparation to the other. The most telling of Kelsen's points is concerned with the word *aitia*, 'cause', which in Pindar, Aeschylus, and in Homer as an adjectival form, had meant 'guilt'.

I have attempted very briefly to summarize Kelsen's theme because of the relevance, as I see it, to Melanie Klein's view of the early ego, but more immediately because he gives, in terms of the super-ego, a convincing outline of the initial development of science, except that he offers no explanation how this development could have arisen. We can interpret felicitous changes of super-ego

projection only in the light of the demands made by a more integrated ego. I, therefore, will be speaking of the earliest science in the language of the ego alone: I shall refer in this way even to Plato's system whose centre was not Nature but, once more, society and its sanctions, human and super-human. (The aim of the State, according to both Plato and Aristotle, is self-sufficiency, *autarkeia*.) I think that primitive Greek attitudes to a whole body, abundant in associations of texture as I emphasized in the last section, are similarly to be distinguished from those endless part-object contagions and emanations with which primitive man is concerned. As of the whole ego, conceived not as mind but as integrated physique first of all, the great Greek discovery was of *phusis*, the body of Nature, necessity outside, the non-ego.

I shall speak, then, in terms of an ego-integration conceived as an ideal – an integration around the good object – and thence of objects conceived as independently organized, a projection parallel to the one of the ego-figure subsuming the good object, which I have taken above to be the basis of form in art. I then attempted to show that works of art are devised on the formal side in the image of an integrated ego that embraces some inclinations of the primitive ego. Theories of the earliest Greek thinkers of whom we know seem to me a parallel subject. While the One became an aim of *rational* search, they sought also for physical balance between opposing and equal forces.

Dr Hutten in his paper *The Origins of Science* has said that 'reality is first and foremost another human being'. He was referring to the mother as an independent person. My aim is to add an appendix to that excellent paper, to suggest that this reality allows the kindred image of self-integration. He pointed out that astronomical studies differ from astrological in their degree of abstraction, in their distance from the body-language, as he puts it, of the infant and the dreamer. I suggest the further body-language of the integrated ego; the prime abstraction from this source is the impersonal image of the ego as a working whole, what I call the ego-figure, a model for all self-subsistent compounds. Unconscious phantasies that have been transmuted by this stamp will need for their frame observed experience, the composition of details, rather than the transcendental flights based far more widely on splitting or on denial.

All the same, magical practice too is served by observation. The Babylonian cultures for many centuries amassed data for astrological purposes, especially in regard to eclipses. These data, and practical Egyptian mathematics, were starting points for the Greek cosmologists. The true nature of eclipses was averred – or so it appears from a fragment of Empedocles – presumably by means of a mode of reasoning called 'objective': yet it must be emphasized that the thought of Empedocles as of Pythagoras displayed a mystical or religious propensity. Originally Pythagoreanism was a very strict and esoteric dogma. Some later

Pythagorean schools preserved or resuscitated the earlier rituals and superstitions, the taboo on beans for instance. However, I think we may regard it as something new in the history of thought that many second generation Pythagorean thinkers discarded the more blatantly religious element in favour of a purer and more mathematical thought.

We still speak of pure thought and pure scholarship and pure science. What do we mean? Socrates, we all know, attributed to reasoning, to understanding, an irresistible power *vis-à-vis* the emotions. We can acknowledge at once that an aspect of the search for truth is connected with a desire for fixed points, for certainty, for control as well as for justice; in terms of rationality, for what is intelligible or systematic. We encounter once more the need to preserve intact a good object without blemish as well as one which is authoritative whose authority we can borrow. But, obviously, we are no nearer yet to understanding why pure reason should be chosen for such an object. Man – I am not now speaking of really primitive man alone – had lived in culture for a long time with rudimentary technology and with a wealth of magical certainty. There are easier, more rapid methods than the exercise of pure reason for projecting the need of certainty and omnipotence. I do not think that anyone trained psychologically will believe that reality sense, considered apart from emotional fulfilment, can be invoked to explain the birth of science. We will believe that an adoption of scientific method will have corresponded to the enlargement of certain emotional combinations at the expense of others. We will also agree that modified forms in the projection of the super-ego are not to be explained in the terms of its economy alone.

How, then, shall we approach the inception of scientific thinking? There seem to me only two psycho-analytic concepts that fill the bill. They are both Kleinian: first the concept of the integrated ego of which I have already spoken, the bringing together of the good and the bad, the fitting together of various strains in the psyche that are neither split-off continuously nor denied; and second, the Kleinian conception of creativeness or recreativeness of a whole object following upon the sense of loss. The two concepts are close to each other since the recognition of an independent whole object accompanies a similar synthesis in the ego itself. Good and bad are no longer unrelated; depressive anxiety takes precedence of paranoid anxiety; there is far more responsibility for the attacks upon what is good and a corresponding growth in the sense of loss. Applied to what a society considers to be the norm, this means smaller emphasis upon the transcendental values of regression, a greater value attached to the individual, at the expense of social rigidity to some degree, inasmuch as society, and Nature if it be assimilated with society, are the largest targets for projective identification. And again, it means a far stronger relish for seizing the precise nature of objects in themselves, a relish that at times adds

force to the spur of the reality principle. The search for truth presupposes that truth, like the whole object apt to be lost, is precarious, and that the search will not be based upon the denial of long periods of uncertainty. Creativeness is similarly precarious: were it otherwise we would not understand fully why so enormous and so reverent a curiosity on the part of the public attends the creative processes of the artist or inventor. Indeed, in modern times, the process excites far more respect and understanding than does the product, which often seems to have no further appeal whatsoever. The true creator, an expert in suffering emotional pains, re-fills a void, a lack, a loss, without recourse to manic denial of confusion (Segal, 1952 and 1956). The act of creation restores to us the courage to contrive stability from what is admittedly diverse.

I do not mean to infer that there is a clear-cut division between cultures that are characterized by a flight to an all-absorbing super-ego or to the distant good object put in safety beyond the senses, and a view of the world better constructed in accordance with ego-figure projection. The former projections too may well be founded upon observation, upon reasoning: they will be systematized, that is, in my language, they will be endowed with a tenuous and perhaps subtle body that reflects mature ego activity. But these are means of an overriding aim to insist upon the One, upon the absolute, upon denial of all eventual difference, while in current life both Church and State will claim kinship with what is eternal. (I would remind you that though there were a few whole-time priests employed by the Olympian religion as by the Mysteries, there existed no Hellenic priestly caste, nor any enduring political ideal.)

I must repeat that in the construction of the ego-figure, reliance is not lessened on the earlier good object, the good breast within that both nourishes and is nourished by each of us, the source for stability. I suggest that this goodness is projected by the ego-figure accompanied by less manic denial of what is opposed, entering more varied relationships. Thus, it is apparent that so characteristic an ego activity as art, remains, nevertheless, a child of its culture, an enveloping object in which we all partake, though, now that we have disentangled Nature, in a manner less precise than does the savage. Such are the terms, I think, in which the concept humanism should be defined, a devotion to whole objects in whose name the good breast may be freed from overriding super-ego systems, or perhaps suffer return from a stupefying yet intermittent infinitude since the attempted resuscitation of a primitive state can have involved regression to a paranoid-schizoid phase. Indeed, I think that the dominant factors of Greek culture reflect the dislike, the fear, of schizophrenic attitudes to which, with the admission of machines, we have again become more accustomed (Sachs, 1942, and Stokes, 1951).

Now, the articulation and richness of Hellenic language was the prime connective basis for all Greek achievement. We can safely say there is no

articulation, no form, without the impress of the fully-fledged ego, In spite of their insistent idealism, it remains partly true that in much Greek thought as in their art, the aim was to discover a mean. The following are the words of Heraclitus according to Robin's (1928) translation put into English: 'Things which are cut in opposite directions fit together. The fairest harmony is born of things different, and discord is what produces all things. . . . Let us unite wholes and not-wholes, convergence and divergence, harmony and discord of voices.' There is a sense also, perhaps more prominent even in early times, even for Heraclitus, in which the forms are pure, and matter, the sensuous world, is mixed. Such is the problem of the One and the Many: those instances where the Many has not been ruthlessly sacrificed to the One I would identify with the need to accommodate on an ideal plane the all-embracing pure good spirit with the varied whole objects known to the mature ego, the mean, the measurer, of diversity. The fact that for a long time everything was considered as corporeal by Greek thinkers – it seems that Melissus was an exception (Kirk and Raven, 1957) – may be viewed either as an inheritance of part-object projection or as a witness to the characteristic stamp of the ego-figure. I am concerned with the second phenomenon to which I impute the character of a mean, since I can imagine that a very high degree of abstraction could restore the enveloping climate of part-objects. (The further isolation and manipulation of parts required in the conceiving of a laboratory experiment, appears to have been almost entirely alien to the Greek spirit. Hence the severe limits of Greek science and the absence of a developing technology.) Parmenides' system, whose influence was revolutionary, is based upon the conception that nothingness cannot be conceived and that therefore it cannot exist. The famous paradoxes of his follower, Zeno, depend upon the contradiction of a space conceived as a series of points with magnitude. Even the *nous* of Anaxagoras, the first introduction of mind-in-general, has physical property: he described it as the thinnest of things. An equivalent cannot always be found in Greek thought for our use of the words 'mind' and 'mental'. Neither *nous* nor *psuche* nor, I suggest, both together, fill the role. Initially, this is because of the Greek theories of perception: the early philosophers distinguished little between sense-perception and physical interaction. Yet it would be absurd to call their attitude materialistic. It would be more relevant to say that these theories of perception were influenced by an entity altogether mental, the corporeal ego-figure. The organs of perception are described sometimes as a mean, an instrument, that is, for measuring differences in other objects. Because, says Aristotle, a sensory organ has the constitution of a mean, it is able to discriminate the qualities (i.e. the form) of objects apart from their matter. What is of the same temperature as the body is neither hot nor cold: the body is the mean for determining temperature (Beare, 1906).

As I have said, we do not always find in the early philosophies the Limited sacrificed to the Unlimited, to use the remarkable Pythagorean terms, remarkable because the Limited is regarded as the good (and is, indeed, in another sense, unlimited). In this way the mood of all Greek philosophy, even when most idealistic, is far more moderate than most speculative thought. Certainly the Unlimited, itself conceived as spatially extended – so is darkness in Pythagorean theory – serves as the cause of the Limited; yet at first we are made to feel that the Unlimited is unformed, shapeless, that shapelessness is the property of undifferentiation. The real may be rescued from shapelessness by being thought finite as in Parmenides' spherical universe. I believe the later Pythagoreans found difficulty in reconciling the fine 'figures' (*eide*) of mathematical construction with the original character of the continuous Unlimited, to the mystique of which, unlike the oracular Heraclitus, they were not inclined. The Unlimited is here the bad; as I have said, the Limited, the forms, are the good; limited, that is, in virtue of their purity and perfection like the Socratic ideas in the *Phaedo* and *Republic*, removed in their essence from Heraclitean flux or becoming, though they permeate it. It is inevitable that the search for the ordered and systematic, though visualized as a kind of corporeal perfection on the lines, as I think, of ego-integration, should often lead to the conception of all-embracing forms that in one strong aspect, therefore, themselves recall the undifferentiated object of the primitive ego. Yet, even so, even upon the permanent arrival of the soul or, rather, souls, and of thorough-going *a priori* submissions, central conceptions are still concerned with a blend, with the processes of life and of physics as a blending. It seems that Plato's own conclusion, after having canvassed in many dialogues every view of the time except the Atomist (unless it be in his theory of colour), was hinted at in a sentence of the *Timaeus*: Being is a blend of what is the same and of what is other (Burnet, 1952). Reality, we learn in the *Philebus*, lies with the combination of matter and form. To which should be added a conclusion of the *Timaeus*, namely that knowledge is higher than belief, science than myth, though, in fact, only by absorption in the dream-like terms of myth do we approach cognizance of the ultimate.

Plato's account in the *Timaeus* of what he calls the appetitive soul will instruct. The thoughts of the rational soul are reflected on the smooth surface of the liver which belongs to the department of the appetitive soul. This organ, the liver, is the seat of the prophetic agency and of the irrational nature of man to which Plato thus accords recognition for the times particularly when the rational soul is suspended, during sleep, in diseases or in fits of temporary ecstasy: no man in his senses comes under the influence of a genuine prophetic inspiration.

This is a very Greek observation on the part of Plato the idealist, whether

or not it reflects his own view. While doing justice to the manic state he neither exalts nor denies it. In spite of the mathematical mysteries in which he is himself deeply involved, in spite of the range allowed to inspiration, to myth-projection, he prefers, we feel, to link the first of these activities with an understanding that is more conscious if more limited. It led him at times to denounce art. Since he was himself so great and successful an artist, there is nobility in the temperance of his views concerning the roots at any rate of art, that is to say of art as we conceive it now. Faculties other than the appetitive, he says truly, are needed for the interpretation of prophecy and myth.

Though the body be seen as the prison of the soul, the prime aim, it seems to me, of Socrates, as revealed by Plato, was to transfer to the eternal verities a near-corporeal shapeliness. For the first time in Greek philosophy, if we except the religious side of Pythagoreanism, the soul was thought to be in no way dependent for full power upon the body. Yet while the soul remained entirely in Greek hands, it was unusual for spirituality to be gross before the late Hellenistic age. Our feeling is strong that the Socratic fabric of argument coupled with his activities as an Athenian citizen, coupled with the Socratic irony and with his open admiration of beauty in the flesh and his constant awareness of new problems, our feeling is strong of an *ensemble* that is among the nobler Greek monuments. Socrates's world of appearances partakes of the eternal forms: we are told in the dialogue *Parmenides* that he abandoned the idea of discovering set forms for every kind of phenomena for fear of utter contradiction and nonsense; and if real goodness and beauty are far from the body, Socrates identified goodness with knowledge. Though, like any Joan of Arc, he attended to his 'voices', to his undoubted states of trance, yet he never entertained the suggestion of a different way of knowing to which we should direct ourselves, when reason and intelligence appear to fail (Burnet, 1952). This is surely very remarkable in view of his own ecstatic experiences. How gifted for art were the great Greeks, how cool in the face of the mysticism to which especially in mathematical and similarly disguised contexts they were the prey! Socrates believed that all men would be good did they reason things out to the end, that is, did they come to understand the different parts of the soul and of its harmony through the logical analysis of behaviour and of concepts. The conclusion seems trite, but the soberness, the variation in many arguments, the aesthetic skill of Plato's presentation constructed from disputants' differing responses, speak to us of daylight, differentiated things, and of an embracing condition of Being that seeps through, such as will have reached us in the proper contemplation of a work of art.

In Plato's later dialogues wherein his own later views, it is often said, are likely to be, he speaks in Pythagorean parlance of the forms or ideas as limited; the intelligible partakes of the limited, that is, of the systematic, whereas the

infinitely divisible sensible world partakes of the undefined. But the boundary between intelligible and sensible is not fixed: the sensible may become progressively intelligible. Similarly, in the dialogue *The Sophist*, the necessity is established for the conception of an infinite not-being alongside that of being, though not in the sense of an opposite (ibid.).

I abstract such details from a vast and complicated system rich in alternatives and contradictions because I believe they mirror an underlying moderation within the idealism. It is not because we may use the word 'form' to translate the Greek *eide* or *idea* that I find a reference in *eide* to the ego-figure magnified by the formal values of art. *Eide* means a figure in the sense of an entity, independent of process. It connects with the hypothesis of an ego-figure that does not represent bodily processes, neither those unceasing throughout life nor those characteristic of physiological stages or conditions except so far as, conjointly with psychical processes, they can be re-interpreted as rhythm, rhythmic motion. Now Plato's philosophy of movement was part of his philosophy of the soul. He was obsessed with the concept of mathematically regular motion: he very largely identified musical and mathematical studies. That again is Greek through and through: rhythm and regularity was an ideal synthesis taken from the body, infused with number and projected on to Nature. Hence we read in Plato's *Laws* that the abiding spirit of the larger body, the state or polity, depends in no small part upon the very sameness of the rhythmic songs that each generation of children should learn.

Plato and Socrates were firmly based on their predecessors of whom we would otherwise know very much less. They help us to discern the spirit of the earlier cosmologists and to fathom the contradictions that else might spring too forcibly upon us. Remembering the pull of the Greek intellect predisposed towards the physical, the physiological, the mathematical, even in the areas of the soul, it is easier to understand that Empedocles in the fifth century, charlatan and shaman, according to legend, who claimed to be a god, knew nevertheless that night is the conical shadow of the earth rather than a kind of exhalation, as darkness was often conceived to be. He was far more interested in physics than was the Socrates of the *Phaedo* or the Plato of the *Timaeus*, a dialogue for the most part of reckless Pythagorean myth, the foundation of neo-Platonism. Empedocles found by experiment that air is a physical entity other than rarefied mist, that water is not liquid air. He was the first, it seems, to formulate a theory of the flux and reflux of the blood from and to the heart. He wrote: 'The contest of Love and Strife is manifest in the mass of mortal limbs. At one time all the limbs that are the body's portion are brought together by Love in life's high season; at another, severed by cruel strife, they wander each alone by the breakers of life's sea' (Burnet, 1952). Love and Strife are principles of co-ordination and of division. In a fantastic account of evolution Empedocles put out the

idea of the survival of the fittest. 'Eyes strayed alone in need of foreheads'; not only part-objects but monsters, deformities, occur in this evolution (subject to the compulsions of Love and Strife) that suggests at times a parallel for the development of the integrated ego. 'Whenever, then, everything turned out as it would have if it were happening for a purpose,' wrote Aristotle in his account of this theory, 'there the creatures survived, being accidentally compounded in a suitable way; but where this did not happen, the creature perished and are perishing still, as Empedocles says of his "Man-faced ox-progeny" ' (Kirk and Raven, 1957). We might today call him, and Pythagoras who was the founder not only of a religion but of a church, visionaries and seers akin to Blake. But Pythagoreanism was certainly a bulwark against the unintellectual Orphic mysticism from which it largely derived, and in speaking so we forget empirical discovery, an engrossment in the sensuous from the careful contemplation of which there was constructed a balanced body of thought. Meteorological and medical observations are very important in these philosophies. The microcosm is the human body, the integrated ego, and the corporeal ego-figure. According to Anaxagoras everything, except in the case of *nous*, has a portion in everything else: even snow has a black portion.

Alcmaeon of Croton, probably a young man in the old age of Pythagoras (ibid.) was the first to claim the brain to be the common sensorium, a discovery adopted by Hippocrates and by Plato, rejected by Empedocles, Aristotle, and the Stoics, who reverted to the heart as the centre of consciousness. Alcmaeon trusted the usual duality of matter, the hot and the cold, the moist and the dry: disease, he said, was the 'monarchy' of any one of them: health lay in balance: we would add mental health, the strength of the ego.

The early Greek cosmologists flourished in the hundred years from the middle of the sixth century BC; Thales a little earlier. *Kosmos* first meant the marshalling of an army, then the ordering of a state and then the regularity of things in a Pythagorean sense. Every hypothesis must 'save the appearances' (*sozein ta phainomena*), a classical Greek cliché meaning that the hypothesis must do justice to all the observed facts, particularly, as it turned out, to those of astronomy, medicine, meteorology, and mathematics.

Thales asked what the world is made of or, at any rate, what was its original substance (ibid.): his answer, water, is reasonable as well as traditional since water is the one phenomenon known to ordinary perception in liquid, vaporous, and solid forms. Ionian cosmology initially paid first attention to the three states of aggregation, solid, liquid, gaseous, surprisingly ignored mother earth as a basic element (introduced partially by Heraclitus and firmly by Empedocles: via Plato and more especially Aristotle, it continued to function with the other three elements until near modern times). Anaximenes held that earth and stones were water frozen harder than ice. His was a system of rarefaction and con-

densation. In more than one early cosmology air is regarded as a moist, fire as a dry, exhalation from water, a theory derived from evaporation.

Anaximander preceded Anaximenes. He is said to have constructed models whereby to illustrate the relative sizes and movements of the heavenly bodies (Sambursky, 1956). I quote a passage from *Greek Philosophy: Thales to Plato* by John Burnet, 1914. 'Anaximander seems to have thought it unnecessary to fix upon "air" or fire as the original or primary form of body. He preferred to represent that simply as a boundless something (*apeiron*) from which all things arise and to which they all return again. His reason for looking at it in this way is still ascertainable. It is certain that he had been struck by a fact which dominated all subsequent physical theory among the Greeks, namely, that the world presents us with a series of opposites, of which the most primary are hot and cold, wet and dry. If we look at things from this point of view, it is more natural to speak of the opposites as being "separated out" from a mass which is still undifferentiated than to make any one of the opposites the primary substance. Thales, Anaximander seems to have argued, made the wet too important at the expense of the dry. Some such thought, at any rate, appears to underlie the few words of the solitary fragment of his writing that has been preserved. He said that things "give satisfaction and reparation to one another for their injustice, as is appointed according to the ordering of time". This conception of justice and injustice recurs more than once in Ionic natural philosophy, and always in the same connection. It refers to the encroachment of one opposite or "element" upon another. It is in consequence of this that they are both absorbed once more in their common ground.'

These last sentences, including the only surviving words of Anaximander, to which I have already referred in the matter of the super-ego, convey a sense of the ego's growth in the depressive position, the taking account of the object's opposing qualities, a process often interrupted by the manic defence or by reversion to a split-off, undifferentiated state, a reversion to Anaximander's 'boundless something'. 'When the One is divided, the opposites are disclosed', said Philo in a comment upon Heraclitus' system (ibid.). In the sphere of the ego, when the opposites are brought together we perceive a more limited One, with reversions to the boundless One.

'Anaximander pictures the earliest forms of life as crawling painfully, shell-encrusted, out of the sea. Empedocles imagines creatures of no contemporary species fighting for their lives against adverse conditions and disappearing in the struggle. It was, one must admit, Aristotle who burdened science for centuries with the dogma of the fixity of the species' (Guthrie, 1957).

Heraclitus, on the other hand, was no scientist but a philosopher of a Hegelian cast: he found reality in ceaseless becoming between opposites, between what later were called elements. He probably considered opposite concepts also to

be interdependent and indeed, to indicate parts of the same thing (Kirk and Raven, 1957). As well as change, no less than his opponents, the Pythagoreans, he emphasized an attunement, an *harmonia*. The wet and the dry are of first importance. Sleep and death are due to an increase of moisture as is shown by the advance of drunkenness. Milk from the breast, communion with the original object, is to be associated, we would say in our language, with an increase of undifferentiation. When we are awake, said Heraclitus, the rational (i.e. the differentiated world) surrounds us and we breathe it in. 'The dry soul is wisest and best.' That is because dryness, fire, *aither*, is the controlling element near to the *logos*, though not all the fire will be burning at the same time (ibid.). In spite of such omnipotence, I think we should also equate the dry soul with the typical functioning of the integrated ego, interrupted by states wherein the difference between objects and between subject and object may become fluid. I like particularly Heraclitus' remark: 'Corpses are more fit to be cast out than dung', a pithy attack upon superstition.

The pursuit of plurality, of balance, was bound to call forth a champion of the single, undifferentiated object. Greek thought would not have been so great without such a champion: it is difficult to conceive of an Empedocles, an Anaxagoras, of Socrates, Plato, Aristotle, had there been no Eleatic riddles, no Parmenides. He construed the absolute, in Burnet's phrase, as an ever-present corporeal plenum innocent of movement and change. A void is unthinkable and therefore does not exist. It follows that whatever does exist has neither a beginning nor an end: *ex nihilo nihil fit*. Since matter is infinitely divisible there can be no room for it to move nor can there be more of it in one place than in another. Reality, therefore, is one; there is no room for the many. It seems that from an ego standpoint we are back in the womb without the means of being born. Whereas this doctrine has been regarded sometimes as the summit of idealism it has also, in view of the corporeal plenum, been regarded as the summit of materialism; a situation that reflects its pecularly Greek character.

I must mention one fruitful outcome of the monist-pluralist debate, a solution of genius, a new mode under pressure, as we see it, of integrating the One, the good object, in a various world and within a various ego. Empedocles was not sufficiently precise to counter Parmenides successfully. Melissus remarked that if things are many, then each will need to have the nature of Parmenides' One. He intended this as a *reductio ad absurdum* of pluralism, Burnet says, but Leucippus made it the foundation of his atomic system. 'Aristotle, who in default of Plato is our chief authority on the subject of atomism, gives a perfectly clear and intelligible account of the way it arose. It almost appears as if he were anxious to give a more strictly historical statement than usual because so little was known about atomism in the Academy. According to him, it originated in the Eleatic denial of the void, from which the impossibility of multiplicity and

motion had been deduced. Leucippus supposed himself to have discovered a theory which would avoid this consequence. He admitted that there could be no motion if there were no void, and he inferred that it was wrong to identify the void with the non-existent. . . . The assumption of empty space, however, made it possible to affirm that there was an infinite number of such reals, invisible because of their smallness, but each possessing all the marks of the one Eleatic real, and in particular each indivisible (*atomon*) like it. . . . The differences between groups of atoms are due to (1) arrangement and (2) position' (Burnet, 1914).

A resemblance between scientific Pythagoreanism and Atomism was noted already by Aristotle. 'Leucippus and Democritus,' he says, 'virtually make all things numbers too and produce them from numbers' (ibid.). Numbers are integers, that is to say, untouched, whole: they are also units predisposed to many relationships; in series they initiate patterns and the patterns suggest constructions. We encounter for the first time in Pythagoreanism the Greek arithmetical mean connected with Pythagoras' discovery of a numerical series that covers certain harmonic intervals. 'In a well-known passage of Plato's *Phaedo*', writes Burnet (ibid.), 'we are told by Simmias that the Pythagoreans held the body to be strung like an instrument to a certain pitch, hot and cold, wet and dry, taking the place of high and low in music. According to this view, health is just being in tune, and disease arises from undue tension or relaxation of the strings. We still speak of "tonics" in medicine as well as in music' (and of the tone of the bodily system). . . . 'The blend (*krasis*) itself was used both of bodily *temperament*, as we still call it, and of the temperature which distinguished one climate from another.' The Pythagorean arithmetical mean entailed a conception of figure or form. We still speak of numbers as figures in spite of the 'Arabic' notation that has intervened. Geometry grew from an arrangement of numbers like the dots for units upon a dice. Pythagoras' *tetraktus* of the decad was a triangular arrangement of the numerals up to ten. It showed at a glance that ten is the sum of the first four natural integers. He proposed square and oblong figures: we speak still of the first. He probably discovered the golden section, a mysterious – except numerically – rule of proportion, from constructing the dodecahedron. 'Eurytos,' writes Burnet, 'a disciple of Philolaos, one of the last pure Pythagoreans, went on to express the nature of horse, man and plant by means of an arrangement of pebbles and counters, we are told' (ibid.).

I hope I have said enough to indicate the connexion felt between numbers and corporeal forms, a point of importance in a discussion on the origin, or even perhaps on the nature, of mathematical pursuits. We are ignorant of the theory yet we glimpse the origin of the proportion, the measure, embraced by the builders of the Parthenon as by the Greek sculptors. Both a degree of detachment

(cf. p. 114) in the observation of the physical world on the part of the early cosmologists, and their mathematical prepossessions with varied relationship in an ideal form, will have contributed to the *milieu* from which the unparalleled flowering of art in the fifth century arose. This tone of thought was itself strongly aesthetic if by that I may be allowed to mean an undiffused projection of what I have called the integrated ego-figure.

There is no parallel in art today. If we would search our time for the Greek spirit, we had better pass over Alma Tadema and the Madeleine in Paris, then remark the invention of the lawn tennis court and net, a precise geometrical form that together with the instruments of racquet and ball appropriately weighted, allows to the human body a full exercise of skill, strength and sometimes grace.

Three Essays on

The Painting
of our Time

ACKNOWLEDGMENTS

Thanks are due to Chatto and Windus for permission to quote from *The Doors of Perception* and *Heaven and Hell*, both by Aldous Huxley; to Thames and Hudson in respect of *The Concise History of Modern Painting*, by Herbert Read; and to the Editor of the *International Journal of Psycho-Analysis* in respect of papers by Hanna Segal and Elliott Jaques.

First published 1961

PART I
The Luxury and Necessity
of Painting

NOT EVEN THOSE WHO DETEST art will be averse to the presence of picture galleries near luxurious shops. For a moment luxury may satisfy greed and provide the riches that separate us from loneliness. We sniff a bountiful air at shop windows, contemplating possessions not yet allotted, and sometimes unenviously any magnificence, the width of a street or the span of a doorway. Entertainment seeks to bring in train such bounty, experiences that are of the nature of meals; though they but symbolize suppers, surfeit supervenes. It comes about, then, that when we are at table we may hope to incorporate far more than our food; as we watch others they appear to reabsorb what we imagine to be predominant experiences. I have had this fantasy when watching directors of galleries that exhibit paintings, at a restaurant. It seemed that theirs was very fine nourishment, with associations that differed greatly from a stuffing or emparcelling: indeed, so enduring and so various is the luxurious stain upon directors of good paintings that their actual nourishment appears to lend them the overtones of lasting reassurance that may visit others only occasionally, should the satisfaction of various appetites coalesce in the pleasure of the table.

Of course good paintings are extremely valuable, a richness that lends itself to these imaginative richnesses. The gallery director has them on his walls. He may suffer from various difficulties in connexion with food; nevertheless, a modicum of the fantasy of the luxuriousness of his eating will, I am sure, occasionally at least, be his as well.

To his sanctum I attribute some Italian Baroque paintings, small, boldly painted with the raw touches that will eventually prove to have heralded the modern pictorial era. The canvases were studies and sketches for large paintings, or for their details. In one a mushroom cloud of angels grows, as it were from the compost of an ecstatic saint who grovels upward from below: the picture

vibrates with rays of a sudden flowering, but lines in one corner indicate a hard architecture, the pillars and the underside of a cornice whose grooved, stepped mass embraces the shrinking or resurgence of figures as does a basin that both holds and spills the fountain's play. The union is ennobling, an interchange or commerce we would have in ourselves between passions and the stone, since the architecture symbolizes our rational disposition unberated by death and decay, embodies a Parnassus-like bent whereby proportion and space envelop our emotions, dispersing litter on a desk and the rhythmless rush of noises from the street that link us to a chaos, otherwise inescapable, throughout the length and breadth of London ever ignoble where this painting is noble. How few are the colonnades, those tunnels with pierced sides, how small the perpetuity of silent flank and orifice, how little by which to recognize our own ideal states. . . . As well as of the rational disposition, a good building is the monument to physique.

But it is unlikely that this director has much interest in architecture: it is not necessary today for devotees of painting: they do not acknowledge building to be the root of any grandeur and the presiding genius of graphic art. The lapse is due to failure, and to a resurgence that is taut, of architecture in our time; even more because, in view of this failure from the middle of the last century, painting, while avoiding as a rule an obvious architectural balance, has itself been inspired to fill the void, to provide the more intimate architectural pleasures, striving to envelop and to feed us without ceremony by means of clamant textures, to enwrap us with a surface, to drive us by shock into a place of safety, to declaim from a wall the need for tactile passages and transitions that were once available in lovely streets. The primacy of architecture, mother of the arts, is not first as the school of proportion and design but as the universal witness to the luxuries of art, to the aesthetic translation of mental process, as well as the scenes of living, into the terms of an absorbable substance, or of our envelopment by an object. But simultaneously there exists an emphasis upon the separateness of the artifact, upon the cake that survives our eating of it. Thus, in the name of object self-sufficiency and corporeal wholeness, art may bestow another luxury in the enshrinement of even the greatest misery, a luxury gained from the putting together of fragments of experience that have been dispersed, so that even pain coheres, owns features: a service is done thereby, a good restored. Graphic boldness and idiosyncrasy satisfy more people today than fine building surrounded by ill-advised curves and strong material and dreary roofs and the blatant, negative pretension of all urban scenes. Surely there has never before been so sterling and durable a debasement, multiplied in instances by the million, of members and materials that were once well used. It will be some time before late Victorian and Edwardian miasmas will have yielded their present air of universality.

Envelopment by building, by street, is almost unknown to Englishmen as a reassurance, but is universal in experiences of confusion or of the drugs that alleviate, such as the droplet comfort in a cottage roof, in a quaint lamp-post or a causeway too windswept for advertisements. Even so, our director has enjoyed visits to Rome; his pleasure in his Baroque paintings reminds him of cobbled roads and their smooth houses with apertures that are tall: and he has read in Wittkower of a conscious Baroque aim to envelop the spectator. 'With Caravaggio the great gesture had another distinct meaning; it was a psychological device, not unknown in the history of art, to draw the beholder into the orbit of the picture . . . Bernini's St Theresa, shown in rapture, seems to be suspended in mid-air, and this can only appear as reality by virtue of the implied visionary state of mind of the beholder . . . Miracles, wondrous events, supranatural phenomena are given an air of verisimilitude' (Wittkower, 1958). The power of this art to envelop us suggests confidence in the phantasy that an interchange infuses the complexity of relationship between substances themselves, between objects, between different arts though employed to represent a single vivid happening. Architecture, sculpture, painting merge in the representation of St Theresa's ecstasy, just as river-god, shell, dolphin are as one with the water of the Barberini fountain.

Architecture is limited to forms without events; in many styles or periods an architectural exemplar has provided the model for translating graphic subjects into the terms of a concatenation built upon a ground bass. There are Italian masterpieces, for instance the operas of Vincenzo Bellini, whose continuous simplicity remains poignant, whose lyricism remains unmatched in a firmness far from romantic, suggesting sunlit or shaded loggias and above them, upon the wall, smooth apertures that give light, and above again the jutting features of a cornice-head.

The churches of Rome reign easily over the noisiest traffic in the world; even in this wretched sanctum in the West End of London, the Baroque paintings lend a Theatine quiet unseparated from the life of the town, as if a burst pipe that floods a building's face in patches might yet convey the image of a spring. We hang our paintings to convert not only our houses but our neighbourhoods and our neighbours.

Little understood by our director, the Baroque paintings are a side-line relegated to this narrow room. Modern paintings are his livelihood and his life. Let us go into the galleries. There he is, in the hour before the midday meal, doubtless still stimulated by pictures whose appeal fails only at the tap of another example. They titillate the appetite to absorb all things: who can say where limitation lies since these artists' aims have been to show the unknown as uniform in strong impact with the known? We have here the manner of endless bodily function as well as of hardly touched states of mind, more muscular,

more independent than the resonance of images in a dream yet, when viewed in terms of the intellect's categories, vague and boundless as are the spongy images of sleep so often tied to an inconsequent context, equalled occasionally by the name the modern artist puts upon his painting in the catalogue.

'I no longer invite the spectator to walk into my canvases,' writes the American Action painter, Grace Hartigan (1959), 'I want a surface that resists, like a wall, not opens like a gate.' The wall, Leonardo's homogeneous wall with adventitious marks which, he said, encourage fantasy to reinforce their suggestion, has been an especial spur from the time of the Impressionists, from the time of the new negative significance of buildings in our epoch for which the picture plane, the picture surface, has become an affirmative substitute; so much is this so that much modern painting ceases to have parts or pieces, in the sense of parts that when abstracted from the whole would remain objects of beauty as of value. What price a section of an Action painting (of one section rather than another), or even of a Cubist painting or a Mondrian? The modern stress upon unity and purity, upon strict aesthetic relevance, connotes a stress upon homogeneity: in some styles the picture plane in fact resembles a blank wall to which is entrusted the coalescence of dissonances or blows directed at the spectator. Even when this is not so, we are likely to discover the kindred notion of something unlimited. Unspoken experiences, bodily and mental, have always been incorporated into art through the appeal of formal relationships: but when, as now, they are offered without the accompaniment of any other symbolic content – or if there is another programme, when it is distorted or simplified even to a greater extent than in a style that has been strictly conventionalized – they readily suggest the unlimited, a concept always present to the mind in terms of a boundless, traumatic bad or a boundless, bountiful good, by which we suffer envelopment or from which we would perpetually feed.

Now, the simplest relationships, the most sporadic marks, have deep meaning: we have been shown it beyond all question. We have today an art without manners, without veneer, arresting, knock-you-down yet unbraced and unlimited, it appears, in scope: that is one reason why it must continually change so much: what is novel affords a sense of boundless possibility with which we may exchange ourselves in lieu of achievement. Modern art tends thus to be romantic, somewhat at the expense of the other fundamental draw of the work of art, as a self-sufficient entity, though this character too has been isolated and worked upon. The palpable textures of modern painting express the division and disintegration of culture as well as the ambivalent artist's restitution, often carried no further than an assembly of scaffolding. We are then left with an unceremonious image that seems to symbolize the process of art itself, of the hidden content, always immanent, whereby mere space and shape touch in us sensations of pain, struggle, anxiety, or joy that we have already begun to

translate into tactile and even visual sensations, since a parallel amalgam is ceaselessly registered in some part of the mind. Appreciation is a mode of recognition: we recognize but we cannot name, we cannot recall by an effort of will: the contents that reach us in the terms of aesthetic form have the 'feel' of a dream that is otherwise forgotten. This 'feel' too may be lost until it is recalled by an action in the street, by some concatenation of movement or of substances: in just this way much modern art offers us the 'feel' of our own structure, sometimes overriding the communication of particular feelings. Painting usually presents as well a specific subject-matter equivalent to the manifest content of a dream, in terms of an image of the waking world. The painter has been happiest when surrounded by an actual architecture which provided an assumption (a living style) that made it unnecessary to reconstruct *ab initio* for every work the rudiments of the body and of the psyche. Titian was adorning, not creating, the stone Venice, and Rembrandt the new Amsterdam. Architecture in the West has been the prime embodiment not only of art but of culture. There are left, of course, many beautiful places, many ordinary houses that are satisfying, particularly in the South; but it is not our ruling culture that creates them. Marinetti considered all the beauty of Italy an obstacle to his harsh idealization of the machine by which alone he felt enveloped in the unlimited way he demanded.

We will agree that the work of art is a construction. Inasmuch as man both physically and psychologically is a structure carefully amassed, a coalescence and a pattern, a balance imposed upon opposite drives, building is likely to be not only the most common but the most general symbol of our living and breathing: the house, besides, is the home and the symbol of the Mother: it is our upright bodies built cell by cell: a ledge is the foot, the knee and the brow. While we project our own being on to all things, the works of man, particularly houses or any of the shelters he inhabits, reflect ourselves more directly than will inorganic material that has not been cultivated thus. Of course buildings and the engineering involved, roads, bridges, and the rest, are so common as to be a part of a ceaseless environment. The ordered stone or brick encloses and defines: whether we will it or not, the eye explores these surfaces as if compelled to consult an oracle, the oracle of spatial relationships and of the texture that they serve. Hurt, hindered, and inspired by wall and ledge, the graphic artist has bestowed upon flat surfaces an expressiveness of space, volume, and texture equivalent to the impact, at the very least, of phantasies, events, moods. Architecture has provided the original terms of this 'language' that can rarely be put into words, though words may sometimes be found for the simple employment of the 'language' by building when taken in conjunction with the natural scene. For instance, in the fascination of gazing along a dark passage into the outside light that invades an entrance, in a subject not uncommon for

seventeenth-century Dutch painters, we may become aware that we contemplate under an image of dark, calm enclosure and of seeping light, the traumatic struggles that accompany our entry and our exit, in birth and death. To look along the walls of a cave into the blinding entry would be to experience a more dramatic symbol except for the consideration that a thousand threads of conscious life bring now to the passage and to the house, to the constricted brick or stone, an appropriate association. Seeing that the projection of phantasy on to all the phenomena of Nature is ceaseless, I would not deny that the 'language' of form must have a far wider origin; but I would claim that the example of building, not least in view of a context in the natural scene, has greatly served the precision of that 'language'; nor is it irrelevant that the graphic arts have been expended in many cultures on the adornment of building; nor that in pictorial art there has often figured the architectural organization. In almost all periods and styles buildings have been represented in painting: this is due not only to their commonness or to relevance for many scenes: a study of the employment of the architectural background in Renaissance art and in the theatre, shows without question that they are treated as the emblems both of ordered beauty and of a psychological tenor, in general as the presiding example of the conversion of phantasy into substance and for bestowing upon phantasy an autonomous and enduring body.

I shall now leave the terms of architecture and of luxury and our gallery director who loves luxury, achieves it from painting while more or less blind to building. I take leave of him because of the great distance between gallery and studio, between art as luxury and art as necessity, though the former meaning is dependent upon, and founded upon, the latter.

The calm, the architecture, the luxury of pictures, what are they to the artist? Everything, I dare to say, though the making of art is a compulsive fruit of conflict, grief, and loss, of a sadness or a lack too old and bitter, too keen though hidden, to carry for long any romantic overtone. These feelings, the spring of art whatever an artist's overt temperament may be, correspond with our own feelings of loss and confusion: none of us has escaped them; hence the reassurance and luxury, since a synthesis and restitution will have been forged in the studio.

I do not want to hint that the artist should paint with tears rolling down cheeks, misting vision, but that he projects with astuteness upon the canvas an inner need in terms of the outside objects he has chosen, so that both he and they renew life; that is, so as to figure forth a pattern wherein confusion, though it be rehearsed there, may not rule; and greed and sadistic control of the object, though they too may figure, are not unchallenged.

We have no difficulty in speaking of the painter as the artist *par excellence*, of painting as the representative of art in general. I think that this is because of the

instrument, the brush, tipped with the creative material, and because the canvas is worked at arm's length, with the result that the very act of painting as well as the pre-occupation with the representation of space, symbolize not only the restitutive process but a settled distance of the ego from its objects. The distance from us of our world varies continuously: the artist brings all into view, into focus, at arm's length as it were. Throughout consciousness one thing stands for another: we traffic all the time with symbols, in thought as well as in emotion; for, behind any feeling, behind the 'feel' of any argument even, there lurks another that is older and, as we proceed back, that is nearer to the source of its power over us. More than the rest of us, the artist is aware that what we see symbolizes the history as well as the aspiration of the mind: his task is to discover for them a felicitous embodiment in the outside world so that they be recognized as any object of perception is known, and better known the better the character of the object or scene represented has been seized in paint.

I am not necessarily referring to an artist's manifest aim but to the springs of his compulsion; nor do I refer in this context to anything that throws light on the immense variety of art, on the need for change. One of our most comprehensive symbolic objects – the artist is very aware of it – is the culture in which we live. In one aspect, culture and society are foods just as art itself is a food, an absorbable structure that nourishes our own. The artist absorbs his 'times', 'what is in the air'. On the other hand culture is recognized as an entity in the terms of the art it inspires; differences of culture are often measured succinctly in terms of art: and art itself, as a history of development and as a model of achievement, is another comprehensive object that the artist will tend to incorporate. Symbolic activities, art in chief, have their richest material in what is already richly and widely symbolic: the outermost ripple on the pond after the stone was cast is the one that most vividly reveals the power of the throwing and of the thing thrown. It seems that contemporary attitudes and achievements, whether or not we are sympathetic to them, provide indispensable terms for creativeness. It is well known that old works of art vary to some extent in their power of evocation, in accordance with their apparent comment upon a present cultural endeavour: and that the 'climate' of feeling is an inescapable framework for aesthetic emotion.

Our relationships to all objects seem to me to be describable in the terms of two extreme forms, the one a very strong identification with the object, whether projective or introjective, whereby a barrier between self and not-self is undone, the other a commerce with a self-sufficient and independent object at arm's length. In all times except the earliest weeks of life, both of these relationships, in vastly differing amalgams, are in play together, as is shown not only by psycho-analysis but by art, since the work of art is *par excellence* a self-sufficient object as well as a configuration that we absorb or to which we lend

ourselves as manipulators. (The first generic difference between styles lies in the varying combinations by which these two extremes are conveyed to us.) Here is to be observed a fundamental connexion of art with the culture from which it arises; for, art helps us both to identify ourselves with some aspect of our culture, to incorporate cultural activities or to reject them, and at the same time to contemplate them as if they were fixed and hardy objects. From the angle of contemplation culture *is* art – hence, once more, the necessity of having art – since culture is most easily seen as an object for contemplation in aesthetic terms. Moreover, a cultural reconciliation of what is various, and even opposite, is perceived, when reflected in art, as a symbol for the integration that we have carried out upon contrary urges, opposite feelings, once widely separated, about one and the same person. In painting his picture the artist performs an act of integration upon the outside world that has reference, then, as well as to the independence of objects, first to the re-creation and to some resolution of his own inner processes, next in regard to the organization of the ego in a generalized sense, and finally in regard to a cultural significance. The result is an interplay between these modes of organization to the end of making one of them more poignant since it possesses the services of the others. Romantic art underlines an aspect of the artist's personality, Hellenic art the generous ideal of ego-integration, a severely conventionalized art, such as the Byzantine in a characteristic phase, the cultural hierarchy. Throughout the history of art, emphasis has more commonly lain here: art has been employed to mark ritual and religion, cultural pride, social distinction and consequence. Moreover in ceramics, in all of what are called the applied arts, only a cultural identity, by and large, is likely to survive: indeed, the potter's compulsions, as reflected by his work, will rarely have been apparent beyond his immediate companions, beyond the workshop: we remain very much aware, however, that the Korean dish or Sung bowl was an outcome not only of a tradition to which numerous artists had contributed but of an individual who must have again, in his turn, been subject to the aesthetic compulsion to reflect an ideal of ego structure. The same is often true in the sphere of building. We have arrived at a further reason why the painter may represent all artists: his work usually allows us to discern other syntheses (beyond those of a style and of a culture) that underlie the practice of every kind of art. But whereas architecture does not possess the many facets of painting, it shows us the surfaces that matter most, the 'language': it surrounds us so widely that the art of painting cannot be viewed apart from architectural alternatives, volume and void, light and dark, recession and protrusion, the rough and the smooth. That is not at all to say we would have no sculpture or painting without an example of building, but only that in such case, painting and sculpture would themselves have to find a partial substitute for this absence, just as they tend to do now.

To speak of art is sometimes to estrange ourselves from the artist. He seems today often to be concerned merely with the expression of sensations, maybe sensations to touch and tear and mould material. Nevertheless, whatever he may profess, no artist, old nor modern, with the possible exception of a few child-like or naif painters, achieved his aim without having been fired by already existing works of art, especially by the work of contemporaries. The itch to create in the aesthetic sense is perhaps a thing apart; but it follows that the artist is himself no mean connoisseur of creativeness: he understands art; he could not be much of an artist if he did not, since he is extremely sensitive to what lies together, especially to what is intentionally symbolic. There is no hard-and-fast division between the appreciator and the creator of art. Indeed, whatever his conscious interest or knowledge, I have no doubt that the artist is potentially the most highly-trained appreciator, often confined in range of interest by the preoccupation of his own creative field. This is but to emphasize again in a different manner that art is a cultural activity though the fount be hidden and untutored. Were it otherwise, art would not mirror the whole man, the whole of his capacity. The fire of Van Gogh would have been of small consequence had it not consumed Vincent, the copier of drawings in the *Illustrated London News*, the admirer of Millet, and the near-contemporary of the Impressionists. Some artists today ape an effect that is untutored, but insofar as their work is notable, it will be obvious that they are, as artists, the product of modern museums. Nor do they work now in more isolation than heretofore. On the contrary, the movement, the fraternity, seems more essential: few modern paintings make their utmost point without reinforcement from others.

I sent our gallery director packing, yet he now reappears in the train of artists: we are not interested in his business acumen but in his nose. He and his smart gallery are symbols of the cultural relevance of hard agonies in the studio. Picasso is reported to have said that as a child he could draw like Raphael but that later, as an adult, it had taken him a long time to learn to draw like a child. It seems that the character of our culture has inspired an element of regression: it inspired Picasso's early appreciation of the values of Negro sculpture, a very important part of his creativeness. We taste a new humility and a new arrogance, a sophistication and a barbarity in all the people and all the things surrounding us: and I do not use the word 'taste' altogether meta-phorically since I would stress the oral component in our attitudes to parts of our environment: as presented by art, I have said, it does not overwhelm us since, as well as in the terms of envelopment and incorporation, we are shown an aspect of our environment and 'mental climate' by the painter as an enclosed object, at arm's length, reflecting what I have called two basic relationships to objects. They are usually experienced together; in art alone their collusion

seems perfected to the extent that we appear to have the cake and to eat it without a greedy tearing, the object to incorporate and the object set out and self-contained. Surely the status of this cake is the one of the 'good' *internal* object, the 'good' breast which, as Melanie Klein (1957) has repeatedly said, formed and forms the ego's nucleus, the prototype not only for all our 'good' objects but, in the unenvious, unspoiling relationship with it, for happiness.

But it is always a prime error to search only for derivations that are positive, affirmative. I have not pointed to the fact that part of the aesthetic compulsion will have a negative basis in the component of aggression and, perhaps, of organ deficiency as well as in the threat, perhaps always present, of incipient confusion. We know of several great painters who have had ceaseless trouble with their eyes, imaginary or real. When the trouble has been imaginary we must impute to them an unconscious sense of guilt, unusually strong, in connexion with the greedy, prehensile, and controlling act of vision as it has appeared to the phantasy in early years. To observe is partly to control, to be omnipotent: whereas the exercise of the cruel power continues in the making of art, it is used also to reconstruct what thereby is dismembered: in reflecting such combined yet antithetical drives, a work of art symbolizes the broader integrating processes. The aesthetic account of integration is an end-in-itself, unlike the stock syntheses that construct a character type, professional, class, or national, often valued beyond all other ego projections by unaesthetic persons. Genius displays a new mending of impulse, of feeling, with such conviction that there issues from it a novel treatment of subject-matter as of form. Cézanne applied a steel-bright-knife to pattern and to distance: he introduced love and respect into an extraordinary attack upon his apples and upon the landscapes of his home. His paintings are unified by a play of glinting cuts that both bisect and glorify the contour. It is above all composers who demonstrate easily the varieties, and even the contrariety, implicit in a theme. What twists of combined feelings Mozart contrived within the clear cascade of a chamber work.

Many artists of an opposite temperament to Cézanne's will have availed themselves of his discoveries. Considered psychologically the development of art is no less complicated than the view from any other approach. But I want to stress a factor that has usually been simple, the compulsion to 'get things right' issuing in part from the fear of deformity and of aggressiveness. In the case of naturalistic painting the first test of what 'looks wrong' has been very simple. In drawing a jug how shameful it is that a side should become swollen or should be impoverished, how poignant and sacrilegious the lop-sidedness. Many present-day artists defy this fear and scan the lop-sidedness of our environment: modern art tends to conventionalize ugliness and distortion in the search for comprehensive balances: the vibrant power wanes to correct each enormity without devitalization, since art must reflect as well as affirm: idealism

in art has been the face put upon some degree of truth, upon some need of balance amid discord: also the unabashed shape of the deformed jug may have this timeless quality. In the past undeformed shapes have sometimes been balanced in a picture asymmetrically: today we often see deformed shapes balanced squarely.

I have already introduced a negative approach in attributing the development of modern painting partly to the nineteenth-century vulgarization of architecture. Ugliness has strengthened not only confusion but a desire for collapse: in art we will here discern an amalgamation of negative and positive components. A collapsed room displays many more facets than a room intact: after a bombing in the last war, we were able to look at elongated, piled-up displays of what had been exterior, mingled with what had been interior, materializations of the serene Analytic Cubism that Picasso and Braque invented before the first war; and usually, as in some of these paintings, we saw the poignant key provided by some untouched, undamaged object that had miraculously escaped. The thread of life persists, in the case of early Cubist paintings a glass, a pipe, a newspaper, a guitar whose humming now spreads beyond once-sounding walls that have become clean and tactile remains. In such strange surroundings, not altogether unlike the intact yet empty buildings invented by Chirico, the brusque accoutrements of comfort for pavement life, the one of the café, extend a great sense of calm: a simple shape and a simple need emerge from the shattering noise and changing facets of the street. Later work by Picasso is more disturbing, since he has broken off and re-combined parts of the body, often adding more than one view of these part-objects. Disruption of flesh and bone extends to the vitals, but the furor of his genius is such that the sum of misplaced sections does not suggest the parts of a machine: on the contrary, in the translated bodies, as in the rent room, of Guernica, there exist both horror and pathos as well as aesthetic calm: the interior of the body is not represented as a ruined closet but as part of an exterior décor. Similarly, the New York Manager of Picasso's ballet, *Parade*, wore his ribs outside his costume and outside the child's skyscraper attached to his head. In the period known as Synthetic Cubism, Picasso and Braque had joined into whole objects upon tilted table-tops the piled-up abstract bric-à-brac accumulated in Analytic Cubism, to an enfolded effect as fresh as fruit. Strong, jagged pattern, a wrought-iron jointure, the curve of a rib blunt or acute, typify enduring characteristics in the manifold variations of Picasso's art, a giant in our times.

The distinctiveness of what we call modern art does not lie in the degree of conventionalization or of distortion or in a total neglect of appearances but in the treating by means of such methods of all experiences as if they were rudimentary; impact takes precedence of the values revealed by the last ripple on the pond. Things are already in bits and must themselves be broken up into

absorbable parts. The emphasis upon strong impact is an emphasis not only upon the projection of proprioceptive or interoceptive sensations and images associated with a mere part of the body, but consequently upon the merging or incorporating function that belongs pre-eminently to our relationship with any part-object, in the first place the breast of infanthood: we cannot attribute originally to the infant an awareness of whole or separate objects either visually or imaginatively, only of highly coloured attributes or parts that in their supreme goodness or badness are assimilated with himself. In modern art, then, the wealth of adult experiences is often endowed with this primitive cast that is normally retained at such strength in adult life for some states only, such as sleep. I am here referring to a treatment in the work of art, not entirely to the effect of the work itself, which by definition brings to us also the sense of a whole and self-sufficient object. On the other hand, a unifying simplification of shape (and often a shape's mere exaggeration) to some degree figures in *all* plastic art: it facilitates the clutching impact, the easy identification, characteristic of relationship with a part-object, whereby the world is homogeneous. As well as to observe, Form induces us to partake.

We are not likely to use the word 'imaginative' in connexion with modern art. This seems strange if we recall the extraordinary inventions of Picasso, for instance, syntheses of many experiences, many feelings; reflections, very often as well, of numerous cultural *nuances* past and present. Are not his phantasmagorias imaginative by definition? Yet I think that even here we are loath to use the word, though we do so at once in regard to works of the early periods and to his classical reminiscences particularly in the early 1920s, to the horses and giant women by the sea and to echoes of pagan myth in representational drawings, to such a series as the one of the artist with the model. Why do we call these works imaginative whereas we make no immediate call for this word in contemplating the far greater fertility of his more recondite works? I believe the answer to be that they are more recondite in a limited sense only, since they are by no means of a hidden or etiolated manner. While it remains difficult to define the imaginative content, we are strongly aware of a constraint upon us to regard their richness as a stripping, a baring, as a defiance even of the symbolization or image-building attributed to the processes of imagination. Indeed, the word 'imaginative' is no longer in constant employment even beyond the range of professional art. Do we any more say that children are imaginative; or children's drawings? We have come to realize that *all* expressions are symbols of a further meaning. I have asked the question whether a typical child's drawing should be considered imaginative. The answer surely is No: a child's drawing finds the equivalent, without much ado, to a hidden tension in himself: hence the lesson learnt by modern art from child's art. The attempt in modern art to break down the accepted image in favour of primitive entities that it symbolizes,

results in the formation of images without resonance from which we withhold the adjective 'imaginative'. In pursuing his spadework on what seems virgin ground, the artist of today sometimes manipulates appearances out of all recognition or refuses altogether to have truck with appearances other than the one of his own painting to which, as by Mondrian, the laws of the cosmos are instantly related: the world comes back with a rush in catalogue explanations, whereas what we value in Mondrian are the sensations of architecture of which we are always in need.

Though the greater part of the art of the world demonstrates varying compromises between two treatments of symbols – we can call them here the classical and modern – I do not think that the rawness of impact rescued by recent generations from primitive art and so prized in our own art today – remember, it means a raw impact of formal relationships no less than of other symbols – is likely to cease in attraction, especially since the art of the world has been assembled in photograph and in museum. But there is this point: the slower art, slower, though as strong, in formal impact, is obsessed with the variety and smooth interpenetration of things that in their sum symbolize an integration and independence of the self and of our objects, maybe at some expense of a blatant (though not an eventual) enveloping power to which I have referred. I submit, therefore, there has not been in the West an art reflective of the entire man as successful as the classical Greek and the Renaissance art at its greatest, which strove to endow symbolic objects with the full value of their own appearances.

All great art commands a strong impact, and all great art records as well the last ripple on the pond. Which aspect will be more needed in the future; will the modern concentration upon impact diminish? I have attempted to isolate the deeper necessity of these emphases: there is obviously unforgettable virtue in both.

Epilogue

My hope is that far from needing a more abstract treatment, what I have written above will have stimulated a modicum of consent to the following very brief summary: it embraces similar propositions I have previously put forward (1955, 1955a, 1958).

There is a sense in which we absorb the object of our attention: we speak of absorbing or imbibing knowledge while, for the moment, the rest of the world is excluded. Except for contemplative acts we do not mentally imbibe a thing as an end in itself but as part of a wider activity. Though things and their systems remain outside us, we seem to get to know them by taking them in; for

the most part, however, we do not will them to flood through every atom of our being in entering the store of what we call the mind. The work of art, on the other hand, though by definition a complete and enclosed system, strongly suggests to us physical and mental states of envelopment and of being enveloped. These identifications vary from strong manipulation of the object to an absorption of it and a sinking into it; I have used the word 'envelopment' as shorthand. Since art is useless, it exists solely for the contemplative act in which the senses are not the mere vehicles; the appeal is first to them. Two important results follow: as the senses are the feelers by which we apprehend the otherness of outside things, the otherness or object-nature of the work of art is stressed in this act of its contemplation; yet, as I have said, the ruling attention is also engaged by the process of its absorption no less than by the more obvious projecting therein of our feelings. The great work of art is surrounded by silence. It remains palpably 'out there', yet none the less enwraps us; we do not so much absorb as become ourselves absorbed. This is the aspect of the relationship, held in common with mystical experience, that I want to stress, because the no less important and non-mystical attitude to object-otherness in aesthetic appreciation has been better admitted. Aesthetic form immediately communicates, as well as a symbolic image of an integrated ego (Stokes, 1958), the answering image of a reconstituted and independent 'good' object. This object thereupon becomes incorporated with a satisfaction that evokes in turn a more permeating ground for what is felt to be good, and so a symbol for the 'good' breast. The process entails the feeling of 'a pulse in common', of a heightened identification between the appraiser and his object: it is a process that has been accentuated in the so-called conventionalized or conceptual styles of the graphic arts; without ado they impart a generalized image imposed upon what is particular, upon what is mere appearance, transcendent equally of self and of object-nature. Evoking, through the creation of symbolic inducements, the manner of primitive attachment to a part-object (e.g. the breast), art has served ritual, religion, and every cultural aim. In this context, but more particularly outside it, that is to say, in examples which lack the focus of a narrow cultural ideal, we find an employment, as I shall show in the following two essays, for a type of experience that may be called visionary, though coupled (as assuredly it must be in the creation of art) with an insistence upon the independence of a limited, self-sufficient object.

What common analogy can we find for so strong an absorption of ourselves into other things? As a matter of fact such identification is extremely common: an element of it enters into all group attitudes, all states of contemplation and physical engrossment. The most common is surely the state of sleep wherein we discern best the 'oceanic feeling' as Freud called it, a loss of identity that he referred to the infant's satisfaction at the breast with which he is one, a part-

object that does not suggest the distinctiveness from its perceiver of a whole object. (There are many methods of confusion with the object, under the stress of predominantly negative feelings, that result in serious loss of ego power. The affirmative quality of aesthetic value I have in mind is bound to be related, largely in a compensatory manner, with these mechanisms of attack and of defence.)

Dr Lewin's so-called 'dream screen' is 'distinguished from the rest of the dream and defined as the blank background upon which the dream picture appears to be projected.... It has a definite meaning in itself'... and 'represents the idea of "sleep"; it is the element of the dream that betokens the fulfilment of the cardinal wish to sleep, which Freud considered responsible for all dreaming. Also, it represents the maternal breast, usually flattened out, as the infant might perceive it while falling asleep. It appears to be the equivalent or the continuation, in sleep, of the breast hallucinated in certain pre-dormescent states, occasionally observed in adults' (Lewin, 1948). Whether or not the dream screen is well authenticated, it serves to illustrate the formal value to which I would point in aesthetic experience, usually associated with a subject-matter (the dream itself). In such projections the good breast is of an illimitable character: art is here joined by religious and philosophical yearning for the absolute, so primitive and, some will think, so destructive of good sense in a pretended context of universal truth. The superb place for it is in useless art, harnessed to an equal emphasis upon object-otherness. We must realize at the same time that more generally an oral character in experience is very common; the modes of identification necessary to culture and to cultural behaviour, in part depend upon it.

Thus, in virtue of its form at least, art rehearses favourable relationships free of excessive persecution, greed, and envy. Convention, stylization, the power to generalize, are among the means of furthering the enwrapping component in aesthetic form: where one line does the job of two, in any simplification, we experience the emphasis upon singleness. But at the same time the identical formal qualities, such as pattern, that lend themselves to an envelopment theme, are the means also for creating the object-otherness, independence, and self-containment of the work of art: it 'works' on its own, 'functions' in the way of an organism: this phantasy accompanies the one of our being enveloped, but is connected with another that projects the ego in terms of an integrated figure in which opposite characteristics coalesce. The idea of beauty, I have said elsewhere (Stokes, 1958), projects the integrated ego in the terms of a corporeal figure.

I add this note in regard to Dr Lewin's description of his dream screen as a flattened breast. One thinks at once of the flattened shapes especially of low relief in much art of the world, particularly Quattrocento low reliefs, often of

the Mother and child; and more generally, one thinks of the picture plane in painting that is preserved at all costs by modern art: more generally still, one thinks of the little recessions, lines, and protuberances of pilasters, for instance, of the markings on freize or cornice, by which architecture reconstitutes the body. I wrote many years ago: 'Architecture is a solid dream for those who love it. One often wakes from sleeping without any recollection of a dream but conscious of having experienced directions and alternatives and the vague character of a weighty impress in harmony with the non-figurative assertiveness of building. In architectural experience, however, changing surfaces, in-out, smooth-rough, light-dark, up-down, all manner of trustful absorption by space, are activated further than in a dream; full cognizance of space is sign enough of being wide awake. The state of sleep has thus been won for actuality.'

And so, too, I make bold to say, in art altogether.

PART II
Some Connexions and
Differences between Visionary
and Aesthetic Experience

I AM NOT WRITING ON THE SUBJECT of hallucination as a whole in connexion with art. The aspect of adult hallucination with which I am concerned is usually spoken of as mystical or visionary experience.

In a book on colour nearly twenty-five years ago (1937) I tried to divide sharply a characteristic visionary experience of colour from an aesthetic. 'When we shut our eyes', I wrote, 'we see a film of colour that scientists call the visual grey.' They distinguish so-called film colour from what they call surface colour on which there is always a perceptible texture or microstructure. . . . 'The visual world' – I should have said the adult visual world – 'exists between the film colours of our closed eyes and those of an unclouded sky: as harmonious surfaces in this outer world the artist externalizes and orders the divisions of the ego.' It appears certain, I realize now, that the infant at first sees film colour only. I regarded the experiences of colour that are inseparable from textures to be potentially aesthetic, allowing in the aesthetic effect only a small admixture of the always spongy chromaticism, ill-defined in space, of film colour. I was referring to visionary experience when I wrote: 'The tenuous and rakish mythology of film colour has little or no connection with the general appearance of colour as the attribute of surfaces.'

I think that this judgment was extreme, not only in regard to colour, but in the more general sense of an almost complete separation between visionary and aesthetic experience. Attempting to re-define an aspect of their relation, I hope that I may be discussing to some purpose a quality of their characters. In basing so much on a distinction between film and surface colour, I attempted to indicate the gamut of object-relationship, that is, the distance between the relationship that entails an envelopment with the object and the relationship that preserves intact an independent and separated object. But for many years now I have no longer regarded an enveloping relationship to be foreign to the intention of art: on the contrary. I have thought of it as a fundamental attribute when associated with the opposite relationship to an independent object.

Throughout the book on colour I was very severe, then, on film colour and on any effect allied to it, for instance, in the case of what is burnished or lustrous or sparkling, indeed on all effects most dear to infants and children: severe from the point of view of art, that is. Yet after reading Aldous Huxley's two short books, *The Doors of Perception* (1954) and *Heaven and Hell* (1956), I cannot think that the prejudice was entirely ill-founded. I do not hesitate to draw on these books alone for the few generalizations I want to make about visionary experience, since they are wide-ranging as well as poetic: and Huxley is always excellent about art: moreover there is the advantage that he has not hesitated to relate schizophrenic states with the visionary: the connexion exists from the first pages of the first book when he discusses adrenochrome and mescalin, the drug that he took in order to enter what he calls 'Mind-at-large' or, in the second book, 'the mind's antipodes'. He attributes to these experiences (which were not in his case inner visions but glosses upon exterior perception) some awareness of cosmic reality – I think to those that are negative also, undergone particularly in schizophrenia – believing that the superior visionary grasp of essence obtains the attention of consciousness as a result of minimizing what he calls the reducing-valve of the mind, by means of drugs, starvation, flagellation, and other methods whereby the somatic chemistry is altered for the worse from the point of view of coping with ordinary external reality. Mystical illuminations do not tally with what are commonly regarded as normal faculties of mind and body. I believe it is sometimes supposed that extra-sensory perception will be favoured by a similar limitation. Telepathic hallucinations, do they exist, reveal cognizance of actual occurrence beyond ordinary ken in the realm of ordinary fact. On the other hand, the very radiance that bathes the objects of environment in an 'outer' visionary experience is claimed by Huxley and other mystics to partake of an underlying status throughout the cosmos. These experiences at best are thought to oppose the temporality of ordinary existence, point to a final aim, to the reconciliation of opposites, to a merging or loss of self in the impersonal Divine Ground. It is obvious to anyone trained in psycho-analysis that such experiences, no less than the schizophrenic, entail the regression not only to the perceptions, but to concepts, characteristic, in one part, of the primitive ego. I shall have two points in mind when quoting Huxley, the merging with the good breast and a rejection of symbolic meaning. I shall ignore an equally significant aspect, the swift change of the good object into Hell, into the bad.

We encounter, then, a very youthful light; the treasures are mostly of the breast as we are transported into a world blazing with colour. The incidence of visionary experience is usually described as a state of being transported. It has suggested to me the condition of being snatched back partially into infancy but also an image of the infant picked up from the cot and carried to the bed or

chair for the feed for which he has pined. Indeed, describing the onset of his mescalin experience, Huxley writes: 'The legs, for example of that chair – how miraculous their tubularity, how supernatural their polished smoothness! I spent several minutes – or was it several centuries? – not merely gazing at those bamboo legs but actually *being* them – or rather being myself in them; or, to be still more accurate (for "I" was not involved in the case, nor in a certain sense were "they") being my Not-self in the Not-self which was the chair.' 'There seems to be plenty of it', was Huxley's answer to the investigator who asked what he was feeling about time. But space and distance, he says, 'cease to be of much interest. . . . I saw the books, but was not at all concerned with their positions in space. What I noticed, what impressed itself upon my mind was the fact that all of them glowed with living light.' Whereas, and indeed partly because, the infant may often be fed in the dark, the breast-object, when hallucinated, will surely glow with praeter-natural light like the solitary candle in a painting by Georges de la Tour whom Huxley calls a visionary painter. Huxley refers also to the mysterious force of an illumined figure against a dark ground and to fireworks and other 'vision-like effects' that 'have played', he says, 'a greater part in popular entertainment than in the fine arts'. He instances pageantry, theatrical spectacles as well as jewels and flowers.

Visionary colour, he tells us, has the freshness 'of experiences which have never been verbalized'. He has quoted and condensed Weir Mitchell's account of a peyote-inspired vision. 'At his entry into that world he saw a host of "star points" and what looked like "fragments of stained glass". Then came "delicate floating films of colour". These were displaced by an "abrupt rush of countless point of white light", sweeping across the field of vision. Next there were zigzag lines of very bright colours, which somehow turned into swelling clouds of still more brilliant hues. Buildings now made their appearance, and then landscapes. There was a Gothic tower of elaborate design with worn statues in the doorways or on stone brackets. "As I gazed, every projecting angle, cornice and even the faces of the stones at their joinings were by degrees covered or hung with clusters of what seemed to be huge precious stones, but uncut stones, some being more like masses of transparent fruit. . . . All seemed to possess an interior light." The Gothic tower gave place to a mountain, a cliff of inconceivable height, a colossal birdclaw carved in stone and projecting over the abyss, an endless unfurling of coloured draperies, and an efflorescence of more precious stones. Finally there was a view of green and purple waves breaking on a beach "with myriads of lights of the same tint as the waves".'

The Weir Mitchell vision, it will be obvious, projected symbols of primary objects additional to those of the breast or nipple: but where on balance they are beneficent, the *mise-en-scène* at least of such experiences is the nursing situation, if only because of a stress that belongs to my first point, the pleasurable

absence of self in a merging with the object, a trusting incorporation both of, and with, an object in a dimension of infinite impersonality. As a matter of fact we never lose the sense of such a feeling since it belongs to a variety of normal somatic experiences at their best. Huxley himself remarks that 'in the nuptial embrace personality is melted down: the individual . . . ceases to be himself and becomes a part of the vast impersonal universe'. 'The more than human personages of visionary experience never "do anything"', he writes, 'they are content to exist.' He has in mind, of course, what may be called visions of a New Jerusalem rather than horrors of confusion due to attempted control through projective identification, of splitting failure and of persecution, of violent fragmentation into myriad pieces. But even in Huxley's accounts there is a reference beyond the good nursing situation to one of more dubious, if more ancient, comfort. 'Experimental psychologists have found,' Huxley says, 'that, if you confine a man to a "restricted environment", where there is no light, no sound, nothing to smell, and, if you put him in a tepid bath with only one, almost imperceptible thing to touch, the victim will very soon start "seeing things", "hearing things" and having strange bodily sensations.'

He does not ask why, in this case, environment alone should cause visions. We, on the other hand, are interested in these experiences because of the situations and objects they recall through symbols. But the mystic claims that, unlike other images, they symbolize nothing: their essence is their 'is-ness'. 'Charged with is-ness', writes Huxley, 'the percept had swallowed up the concept.' In a further passage he writes: 'Praeternatural light and colour are common to all visionary experiences. And along with light and colour there goes, in every case, a recognition of heightened significance. The self-luminous objects which we see in the mind's antipodes possess a meaning, and this meaning is, in some sort, as intense as their colour. Significance here is identical with being; for, at the mind's antipodes, objects do not stand for anything but themselves. . . . Their meaning consists precisely in this; that they are intensely themselves and, being intensely themselves, are manifestations of the essential givenness, the non-human otherness of the universe.'

Our author himself remarks that for what he calls Mind-at-large, 'the so-called secondary characters of things are primary. Unlike Locke, it evidently feels that colours are more important, better worth attending to than masses, positions and dimensions.' It seems to me he points here to the film colour of which I spoke at the start, a colour-effect distinct from the predominant chromatic usage in painting where colour is linked with surface as a rule, with texture, with objects in space. Film colour, then, in the Huxleyan context, represents the non-symbolic. He writes: 'Colour (for which we can read film colour) turns out to be a kind of touchstone of reality. That which is given is coloured; that which our symbol-creating intellect and fancy put together is

uncoloured.' In asking why 'in most dreams the symbols are uncoloured', he writes, 'the answer, I presume, is that, to be effective, symbols do not require to be coloured.' What appears to stand for nothing but itself, to exist as a state of being that prevents any attachment to it of symbolic meaning because, all unknown, it represents the very 'is-ness' of the original object, will be highly coloured, it seems, more highly than the external world of ordinary perception also 'given' of course, but upon which, unlike visionary perceptions, we cannot but consciously (as well as unconsciously) lavish, project, our emotions, causing natural objects in this way to be symbols, as well as things other than the inner states they symbolize.

I find this extraordinary point of view that I have interpreted of the greatest interest, not primarily because of the old distinction I had built upon film colour and surface colour in the context of art. For, on the contrary, this claim that there is a non-symbolic chromatic effect reintroduced to me an aspect of aesthetic endeavour, explaining, to my satisfaction at any rate, a very general compulsion in modern art. I will speak of it in a moment.

Art is the metropolis of symbolic manifestations: we practise therein the rites of symbolism. Consequently, we may practise there as well every mode of perception: witness our interest in children's art and the successful enlargement of uninstructed perceptiveness by modern painters. All art rehearses simultaneously, I insisted in 1951, more than one object-relationship, to a part-object as well as to a whole object. It will symbolize not only the gamut of relationship in a favourable union, but also the two kinds of symbolic content of which I shall speak in a moment, fused more ideally than they are likely to be for long in our living out our lives. Dr Elliott Jaques claims that the two kinds of symbolic content are mingled in all perception. I will quote from his Congress Paper on Work (1959): 'The perception of an object is determined by the interplay of the requisite content of the percept with two types of symbolic content which have been variously designated; for example, by Hanna Segal as symbols and symbolic equations, and by Ernest Jones as symbols and true symbols. Whatever the terms used for the two types of symbolic content – and many writers, including Marion Milner and Dr Rycroft, have emphasized the importance of the distinction – the central factor is that stressed by Melanie Klein (and elaborated by Segal), namely, the degree of concreteness of the symbol, and the extent to which it co-exists with the object or engulfs it.' I break off to remind you that whereas we have clearly seen that Huxley's Mind-at-large in general unconsciously symbolizes the breast relationship, we have also discovered that symbolic function altogether is thereby reduced and made narrow: the engulfment of the object is not a subsidiary but *the unique part* of the experience. Huxley quotes Coomaraswamy on the mystical art of the Far East, 'The art where "denotation and connotation cannot be divided". . . . No

distinction is felt between what a thing "is" and what it "signifies".' Huxley also quotes what he calls 'the divine tautology, "I am I" '.

To come back to Dr Jaques's paper. 'The degree of concreteness in turn depends upon the intensity and character of the splitting process which underlies the symbol formation. It is consistent with recent developments in Melanie Klein's conception of the paranoid-schizoid position (and indeed with unstated assumptions in her earlier work) to assume that it is when violent splitting with fragmentation of the object and the self is predominant, that concrete rather than plastic symbol formation occurs.'

I had best quote also from the Paper by Hanna Segal (1957) to which Dr Jaques has referred: 'The early symbols . . . are not felt by the ego to be symbols or substitutes, but to be the original object itself. They are so different from symbols formed later that I think they deserve a name of their own. In my paper of 1950 I suggested the term "equation". This word, however, differentiates them too much from the word "symbol" and I would like to alter it here to "symbolic equation".

'The symbolic equation between the original object and the symbol in the internal and the external world is, I think, the basis of the schizophrenic's concrete thinking where substitutes for the original objects, or parts of the self, can be used quite freely, but, as in the two examples of schizophrenic patients which I quoted, they are hardly different from the original object: they are felt and treated as though they were *identical* with it. This non-differentiation between the thing symbolized and the symbol is part of a disturbance in the relation between the ego and the object. Parts of the ego and internal objects are projected into an object and identified with it. The differentiation between the self and the object is obscured. Then, since a part of the ego is confused with the object, the symbol which is a creation and a function of the ego – becomes, in turn, confused with the object which is symbolized.'

I want to quote as well a few sentences concerning the patients that Dr Segal mentions: they illustrate so aptly the distinction between the opposing methods of symbolization. 'One', she writes, 'whom I will call A was a schizophrenic in a mental hospital. He was once asked by his doctor why it was that since his illness he had stopped playing the violin. He replied with some violence: "Why? Do you expect me to masturbate in public?"

'Another patient, B, dreamt one night that he and a young girl were playing a violin duet. He had associations to fiddling, masturbating, etc., from which it emerged clearly that the violin represented his genital and playing the violin represented a masturbation phantasy of a relation with a girl.

'Here then are two patients who apparently use the same symbols in the same situation – a violin representing masturbation. The way in which the symbols function, however, is very different. For A, the violin had become so completely

equated with his genital that to touch it in public became impossible. For B, playing the violin in his waking life was an important sublimation. We might say that the main difference between them is that for A the symbolic meaning of the violin was conscious, for B unconscious. I do not think, however, that this was the most important difference between the two patients. In the case of B, the fact that the meaning of the dream became completely conscious had in no way prevented him from using his violin. In A, on the other hand, there were many symbols operating in his unconscious in the same way in which the violin was used on the conscious level.'

In the matters of which I am writing, a degree of implicit symbolic equivalence is, no less than the rest of the deeper symbolism, of course, unconscious. We are encountering, in the aesthetic context also to which I now turn, a symbolic projection of a pull towards symbolic equivalence or concrete thinking that has reached consciousness in terms of a violent reversal whereby an impersonal outer object of an absolute and unrelated character, takes the place of a primary object in its activity of overwhelming symbolic substitutes. Even so, in art at any rate, it is not difficult to discern that there is a degree of concrete thinking at work. I am not referring to a displacement, whereby an idol, for instance, takes the place of a god, just as thumb-sucking can take the place of breast-feeding. As well as being the object it represents, the idol is normally, in part, a true substitute though it be thought to accept sacrifices and to resent ill-usage. I do not doubt that the need for such replacement, together with the earlier need of hallucination, has often inspired creativeness. Professor Gombrich brilliantly evoked this point in his paper about the hobby-horse (1951). Insofar as it denies the element of substitution, concrete thinking goes further. We would not value art as we do unless we found there the counterpart of every paramount symbolic function. Before reading Huxley's two books I had not realized how deeply connected symbolic equations are likely to be with the part-object-envelopment aspect of aesthetic form: but it had been certain that both beliefs and phobias, and the consequent taboo, sometimes associated with image-making, no less than the ban still imposed by some societies on the using of proper names, point to this perennial component in symbolism of symbolic equivalence or concrete thinking.

I have written elsewhere (1958) of pronouncements by Braque: they put me in mind of concrete thinking as he described an aim for the artist that has accompanied a fragmentation in representing people and things, well illustrated by the extraordinary achievements of Cubism. Consider now the words of Kandinsky who was one of the initiators, not only in regard to his own circles of Munich and Russia, but to the very various manifestations that come together, if in no other simple way, under the expression *avant-garde*. Kandinsky conceived that a representation of an object might be an unnecessary middle

term between the painter and his picture. 'Modern art', he wrote, 'can be born only when signs become symbols.' 'Point and line', commented Carola Giedion-Welker, 'are here detached from all exploratory and utilitarian purpose . . . They are advanced to the rank of autonomous, expressive essences, as colours had been earlier.' Kandinsky, a student of Rudolf Steiner and Madame Blavatsky, was exploring a theory of spiritual symbolism, a symbolism for the depths (and doubtless the heights) that has nearly always cropped up in modern movements. It is bound to be a muddled thinking: a demand for a more charged, and often child-like, mode of symbolism alternates with a claim, revealed in the use of such words as 'super-real' or 'ultra-object', that a work of art should 'stand' for nothing, should possess a value entirely without reference outside itself, similar to the manifestations of Huxley's Mind-at-large. We are often put in remembrance of visionary experiences: take the case of the apocalyptic occurrence to Kandinsky himself in 1908. I quote this and other statements from Herbert Read's *Modern Painting* (1959). 'I was returning, immersed in thought', wrote Kandinsky, 'from my sketching, when on opening the studio door, I was suddenly confronted by a picture of indescribable and incandescent loveliness. Bewildered, I stopped, staring at it. The painting lacked all subject, depicted no identifiable object and was entirely composed of bright colour-patches. Finally I approached closer and only then recognized it for what it really was – my own painting, standing on its side on the easel. . . . One thing became clear to me – that objectiveness, the depiction of objects, needed no place in my paintings, and was indeed harmful to them.'

Since that time in 1908, to whatever school they belong, whatever else they have contained, we have had many paintings whose mere muddled radiance suggests the Huxleyan visionary experience of 'is-ness'. Malevitch announced in 1912 that the reality of art was the sensational effect of colour itself. Already in 1910 the Futurist manifesto had stated 'that motion and light destroy the materiality of bodies': their paintings of what I would call film colour have made it clear. About the same time in Paris, Delaunay declared that 'colour alone is both form and subject'. His were among the first, if not the first, entirely abstract paintings. Herbert Read describes them as 'fragmented rainbows'. I find it significant that abstract art began with such professions. Of course, many later manifestations are of an entirely different character, intent upon geometry, even depth sometimes, and most of all, texture. All the same, the mystical element, in catalogue, in title, in manifesto at least, is not far away, the element of an unstoppable super-reality. Even Expressionist art, it appears, even that insistence on the externalizing of all that may be most rabid in the artist himself in contradistinction to the abstract artist's existentialist announcement that the cosmos *is* the cosmos, has in the end tended the same way: not without reason Action painting in America is sometimes described as

abstract Expressionism. Herbert Read says about Jackson Pollock's later paintings: 'Of symbolism there is no suggestion: on the contrary a desire to destroy the image and its symbolic associations.' Pollock himself spoke of 'concrete pictorial sensations'. His aim was to get inside his own paintings rather than that his paintings should represent what was inside him. Such projective identification, typified in the novel features of what is undoubtedly excellent art, must curtail the extensive creation of symbolism proper. I think it obvious that *avant-garde* painting of the moment has reached the acme in a fully symbolic representation of symbolic equivalence, and I believe we can discover the same tendency in all the *avant-garde* movements, however opposed, even diametrically, to Action painting they otherwise would have been.

I have indicated that the manifestoes of the artists, and of their impresarios, are extremely muddled. How could it be otherwise, inasmuch as art is the succulent *potage* of differing object-relationships and methods of symbolization? There has been a sustained attempt to project through the symbolism of art naked processes of being and the earlier perceptions, an attempt on all sides: artists, we can be sure, have never tried so consciously to reflect untrammelled perception, at the same time to get behind symbols: they have gone to the length of embracing automatism. Some success in regard to the primitive ego or primary process has not eluded them altogether: in a distorted form the mechanism of symbolic equivalence, for instance, has been proclaimed: thus in banishing, or in attempting to banish, any element of illustration, an abstract artist may dispense with an ordinary symbolic focus in favour of impersonal 'essence', by which is meant a primary state of Being. One is told that the painting, or a collection of chance rubbish stuck on a flat surface, is not a picture, but an object, of extra-object import: it symbolizes or illustrates nothing, for it is nothing so secondhand. Even the Cubists of 1910 were talking already of *le tableau-objet*. We will remember Schwitters's collages or Marcel Duchamp's 'ready-mades' and the anti-art distinction of the Dadaists between the indirectness of traditional art and the ruddiness of (irrational) life. Writing of Kandinsky's later paintings Herbert Read uses these words: 'His symbolic language has become wholly concrete or objective, and at the same time transcendental. That is to say, there is no longer, and deliberately so, an organic continuity between the feeling and the symbol which 'stands for' it; there is rather a correspondence, a correlation. In liberating the symbol in this way, Kandinsky created an entirely new form of art . . . To a certain degree sensibility itself became suspect to Kandinsky; at least, he insisted on the distinction that exists between the emotion in the artist to be expressed, which is personal, and the symbolic values of line, point and colour, which are impersonal.'

The blending in art of two kinds of symbolic representation is always subtlet It could be argued that the *trompe-l'oeil* effect against which all modern art

reacted, affirms a drab symbolic equivalence; that much contemporary art, on the other hand, has consciously aimed at symbolizing states of mind through the means of external forms. I think it likely that the romantic insistence upon the symbolic function of art, and the refusal to regard representation merely as such, has facilitated the emergence of far deeper aspects of the compulsion, which itself has grown much greater, towards representing symbolic equivalence, indicated by Cézanne's emphasis (prepared by others) upon the reality of the picture plane at the expense of the naturalistic attempt to deny it for the sake of *trompe-l'oeil*. The styles of Cubism are, in my opinion, the key study: they will one day be understood to be experiments in new blendings of the symbolic ingredients.

At this point I must interrupt to mitigate two of the misunderstandings that I will seem to have invited. I have often stated a work of art to be a self-inclusive entity that mirrors not only the developed ego's integrative processes but the realization or reconstruction of the independent, self-sufficient, mother, a fruit of the successful outcome from the depressive position. But surely it is easy to grasp that the aim of creating a symbolic self-inclusiveness no less apparent in modern, even abstract, art than in other art, can lend itself to a split-off, ego-object, amalgam that expresses nothing but itself. In many modern styles, independent structure, composition, form, the very skeleton of art, has been freed and isolated, amid the decay of all iconography, from what are felt to be the irrelevant demands of a detailed subject-matter, or even of subject-matter altogether. This dislike of conventional illustrative symbolism has, in my opinion, much bearing on the immediacy of effect, on the 'direct' painting technique, of nearly all our art since the Impressionists and before, an emphasis that is, upon broken surface, upon texture, that co-exists with, and even combines with, a *penchant* for a chromaticism to suggest film colour. Similarly, it is surely easy, as I have indicated already, to understand that there will be communicated under one and the same formal treatment two aspects of primitive ego activity, the suggestion of envelopment (in the nursing situation), together with symbols for the negation of full symbolic projections that accord with a varied, adult world. I have illustrated this connexion in visionary experience as offered by Huxley. You will remember that I find in art also an enveloping relationship. And, indeed, no one, I imagine, in writing about architecture and sculpture, will have emphasized more than I have done the gradual light from within, as it seems, of some limestones and marbles especially, not violently but broadly reflected, the inner light as well as surface colour.

I would maintain that the artist has sometimes been most the artist when representing an object seen or visualized at least at arm's length, up to the span of the middle distance, whereby the separate, limited existence of what will be represented is most happily conveyed (and the separateness of the whole matter

symbolized). But such is not the *mise-en-scène* of Sung landscape painting, for example, under the influence of Zen Buddhism, not of Far Eastern art generally: it is significant that the oriental use of the brush has provided an influence on the work of some of the leading American painters today. I return to Huxley: 'Distance lends enchantment to the view', he writes. 'A Sung painting of far away mountains, clouds and torrents is transporting; but so are the close-ups of tropical leaves in the Douanier Rousseau's jungles. When I look at the Sung landscape, I am reminded (or one of my not-I's is reminded) of the crags, the boundless expanses of plain, the luminous skies and seas of the mind's anti-podes . . . It is the same with the close-ups. I look at those leaves with their architecture of veins, their stripes and mottlings. I peer into the depths of inter-lacing greenery, and something in me is reminded of those living patterns, so characteristic of the visionary world, of those endless births and proliferations, of geometrical forms that turn into objects, of things that are for ever being transmuted into other things.' I find here a parallel with my opening remark about film colour, easiest seen either within the closed eyes or else in the furthest sky. Huxley mentions medieval tapestries in connexion with the close-up mystical effect, a visionary standpoint alien to the Renaissance inventors of linear perspective, no less alien than would have been the Far Eastern objects of nearby scrutiny 'represented in a state of unrelatedness, against a blank of virgin silk or paper'. And yet . . . It was Uccello, the fanatic of perspective, who painted the magical *Hunt in the Wood* at the Ashmolean. For some time Madonnas continued to be offset by monochrome gold backgrounds. Medieval themes were incorporated by the Renaissance painters: and later, who would suggest that the impersonal observation, the studious calm communicated by Vermeer's interiors is not transfiguring? All masterpieces are transfiguring if we mean by this last word that we are taken up into them. They differ in their effect from visionary objects in that they also symbolize an unchanging object-outwardness or sufficiency and an adult integration of the ego. If such are the terms used, art will be defined as a symbolic reduction of experience whereby primitive ego mechanisms, that appear also in visionary experience, reinforce adult perceptions and the adult need to reconstruct a whole and self-sufficient object; an activity, then, whereby an element of symbolic equivalence re-inforces true symbolism. I believe all art, when observed from the side of its form, even anti-humanist art, projects an image of the body and the integrated mind, symbolizes a sensuous object-character distinct from ourselves and from the kaleidoscopic brightness it may include, the unitary undertone, of visionary envelopment. Our own stability walks hand in hand with the stability of objects. When culture is attuned to actual or potential traumatic experience, famine, earthquake, pestilence, to privation and persecution or to cultural chaos, art increases its abstraction. I think the tendency can be sometimes illustrated over

long periods (Abell, 1957). If this is so, then an enlargement of traumatic experience that threatens to overwhelm the ego, wherein the ego's counter-attack and the experience itself are somewhat confused, will entail for art an increase of the symbolic use of symbolic equivalence: direct representations, either of the traumatic condition or of its cause, will yield to a symbol embracing both of them with an air of impersonality and even of 'is-ness'. In any case, in spite of ego-integration, we all of us, as ever, contain extremely good and extremely bad objects that do not come together nor limit each other: we still employ distorting mechanisms of defence that make for some confusion between ego and objects. While art, all art, in whatever degree, separates those terms, it symbolizes primitive states as well: the appeal of form is, in part, oral, encompassing, enveloping.

For epilogue, I ask you to contemplate an experience – I think the apprehension resulting from it should be called aesthetic – of the greatest importance to Ruskin as he himself realized, an experience not unconnected, I feel, with a basket of wild, nipple-like strawberries that I would liken to the 'transparent fruit' of Weir Mitchell's vision.

During the past year the young Ruskin had spat blood and was removed from his college at Oxford. In a state of depression he went abroad once more with his parents, looking for health. He writes in his autobiography, *Praeterita*, that when they got to Fontainebleau: 'I lay feverishly wakeful through the night, and I was so heavy and ill in the morning that I could not safely travel, and fancied some bad sickness was coming on. However, towards twelve o'clock the inn people brought me a little basket of wild strawberries; and they refreshed me, and I put my sketch-book in pocket and tottered out, though still in an extremely languid and woebegone condition; and getting into a cart-road among some young trees, where there was nothing to see but the blue sky through the branches, lay down on the bank by the roadside to see if I could sleep. But I couldn't, and the branches against the blue sky began to interest me, motionless as the branches of a tree of Jesse on a painted window.

'Feeling gradually somewhat livelier, and that I wasn't going to die this time, and be buried in the sand, though I couldn't for the present walk any further, I took out my book, and began to draw a little aspen tree, on the other side of the cart-road, carefully.

'How I managed to get into that utterly dull cart-road, when there were sandstone rocks to be sought for, the Fates, as I have so often to observe, only know . . . And today, I missed rocks, palace, and fountain all alike, and found myself lying on the bank of a cart-road in the sand, with no prospect whatever but that small aspen tree against the blue sky.

'Languidly, but not idly, I began to draw it; and as I drew, the languor

passed away: the beautiful lines insisted on being traced – without weariness. More and more beautiful they became, as each rose out of the rest, and took its place in the air. With wonder increasing every instant, I saw that they "composed" themselves by finer laws than any known of men. At last, the tree was there, and everything that I had thought before about trees, nowhere . . . This was indeed an end to all former thoughts with me, an insight into a new sylvan world.

'Not sylvan only. The woods, which I had only looked on as wilderness, fulfilled I then saw, in their beauty, the same laws which guided the clouds, divided the light, and balanced the wave. "He hath made everything beautiful, in his time", became for me thenceforward the interpretation of the bond between the human mind and all visible things; and I returned along the wood-road feeling that it had led me far; – further than ever fancy had reached, or theodolite measured.'

It was a visionary and also an aesthetic experience: it marked the waning of a period of hypochondria and of psychosomatic illness: in the forms of an exterior perception Ruskin regained the measure of a good incorporated object and of potency feeling, focused by the integrated body of the aspen tree. The occasion was nearest prepared by the manic impact upon him of the basket of strawberries: we cannot doubt it. Nearly thirty years later, two years before his first entire mental breakdown, Ruskin was recording dreams. On the night of 11–12 November 1869, he dreamed of what he calls 'a friend of mine' running a race, who asked for a basket of strawberries from a girl walking in front. 'So I ran and caught her, and she had four little baskets of strawberries, all stuck together and I couldn't choose which basket to take.' Later in the dream he has the same difficulty of choice about cakes in a baker's shop. Two nights after he dreamed again about cakes, some of which were too rich and others too poor: finally a customs man in France drank so much of his, Ruskin's, magnificent old brandy, that Ruskin told him that since he had already had more than half the bottle he might as well have the lot: 'and I came away very angry: and awoke'.

Poor Ruskin's good objects, at that time, particularly the wild strawberries of the child, Rose la Touche, were the centre of unceasing conflict. Art might have saved him – it did so repeatedly – but as a tortured unappeased visionary, entranced by the utterly good, imprisoned without warning by an unutterable bad, he was finally doomed: so it seems at first sight. The last words of the last entry in his diary, the only one for 1889, before the attack of mania that incapacitated him for work during the remaining ten and a half years of his life, most unusually reports the remark of a child he calls Baby, on waking in the mother's room: 'do you know, mother, looking at that beautiful picture of these melons is quite a feast to me' (Evans, 1959). As I have said, this is the

last entry, before confusion descended, of diaries Ruskin had written during some fifty years.

It appears a fair conclusion for the whole of this essay to affirm, or maybe to re-affirm, that the manic defence, insofar as it resumes a process either of splitting or of confounding, in fact flirts with schizoid methods. Such is the bridge, it appears, between the predominantly manic–depressive temperament of the artist and his visionary bent, his symbolic projection of concrete thinking.

PART III
Is-ness and Avant-garde

'I HABITUATED MYSELF,' wrote Rimbaud, 'to simple hallucination: I would see quite honestly a mosque instead of a factory . . . I ended by finding sacred the disorder of my intelligence' (quoted by Wilson, 1931). Any indication of the extremely good and bad in disorderly alternation, of disconnexion and of compulsive equivalence, was sacred. At nineteen Rimbaud turned his back on discoveries of the deeper self through art. Not so Alfred Jarry (1873–1907) whose influence upon Apollinaire and Picasso was considerable as well as later upon the Surrealists. He tried to live, says Roger Shattuck, 'in foolish competition with his own work'. He 'refused the contradictions of which he was so keenly aware and asserted the equivalence of all things'. 'The time,' adds Shattuck of the 1900s, 'acknowledged the vitality of certain areas conventionally called evil and lunatic' (Shattuck, 1959). (Almost a hundred years earlier Géricault had painted the portraits of psychotics not as straight grotesques but as complicated human beings.) The element of what we now call anti-art has arisen from an exaggeration of a single aesthetic component, in the determination, as well as from the compulsion, to regress, to embrace, whatever appears more primary, to disconnect in order to bring extraneous things together so that they sprawl at all angles. These manifestations, however, stress a yearning for simultaneity, singleness, and equivalence, in due proportion proper to aesthetic experience, being an aspect of the romantic merging or identification with the object upon which the art of the last 150 years has tended to insist. Owing to this stress, the concomitant search in art for 'the inner man' has often taken a most regressive form. But the 'primitive' has then become sacred only when romantically shorn of its huge components, guilt and anxiety; in fact, there has been the attempt to deny a developed superego in favour of a freedom that must be negatively defined. Jarry, it seems, felt himself free not to be himself, free to enjoy a deliquescence of his ego in favour of a histrionic personage whose performance was re-created each moment like a work of art.

The birth of the *avant-garde* was a long, prodigious labour: scores of years of research are needed for the critical reconstruction. As always, the nature of art is involved. To the indications already attempted, I add a few from preceding historical phases.

I think everyone concurs about the principal point of departure, the Romantic movement, partly prepared in the eighteenth century and before. The French Revolution was, of course, the epoch-making outer event: the stress upon 'is-ness' in contemporary art is still, it seems to me, a modern version of a romantic reaching for the moon. Not only did the Romantic poet vindicate 'the rights of the individual against the claims of society as a whole', but, 'with his turbid or opalescent language, his sympathies and passions which cause him to seem to merge with his surroundings, he is the prophet of a new insight into nature' (Wilson, 1931): particularly human nature in the manifold 'spiritual' relation-ships with objects which at the same time were seen to symbolize inner states. Thus, portrayal was known to be self-exploration in a manner more intrusive than heretofore. At the end of the nineteenth century the Symbolists were probing intimations of meaning that escaped from descriptiveness, while their opponents, the Naturalists, likewise infused the interstices of actuality with temperament. In all art of worth a new emphasis lay on the character and act of the performer behind the work, because art seemed to be creating culture rather than culture art: the individual's, the artist's achievement with himself, could appear to be more stable than society's achievement; or so the artist felt. Aesthetic qualities, formal qualities, were nearer to becoming the ego-ideal which, according to my diagnosis, they in fact should be, since they have for their subject-matter the ego's integrative processes. An isolating of the aesthetic content had begun. A subject and its treatment in our own day may be com-fortably, or uncomfortably and vulgarly, opposed, whereas in the past a theme might be tragic, petty, or bestial, but its treatment, that is to say, an evident selection in the presentation of incident, had to convey a sense of fitness to which formal qualities will have lent themselves. We now often rely on formal qualities alone for the communication of calm and integration, without any of the helps of conventional appropriateness from the subject. Our artists, then, may forego the air of generality imposed upon the prosaic, or of poetry, the reference to the characteristic, needed hitherto to join with qualities more specifically formal in epitomizing, in symbolizing, the impersonal image of corporeal wholeness and psychical integration. For this reason, not only the selection of subject-matter, but subject-matter itself, has appeared to be of less importance in the making of art; whereas in the past the connexion of form and subject-matter through the medium of generalization or convention has always been the very hinge that connected values purely aesthetic and the cultural values that all art serves.

Today the cultural ideal is at best the value of aesthetic process stripped of the elaboration that precise cultural ideals in the past have inspired. We represent, so far as we represent, a non-ideal conception of our surroundings or situation, confused yet forceful. A harsh and often vulgar disclaimer may intervene betwixt an anti-ideal conception and the beauty of its treatment. Beauty, of course, abject beauty, still abounds, *calme, luxe et volupté*, even in contemporary art. It is true, though, in general to say that 'uplift' or sublimity gained from art, a reconciliation with cultural endeavour, with humanitarian judgment, the titillation of the superego, have been transformed into ego-ideal constructions, *tout court*, into manifestations of an aesthetic process through which an individual, as has the artist, may 'find himself'; into naked models of each kind of striving encounter with our objects. We have in common a complete lack of the iconographic symbols that once enabled the arts to build symbolic structures of an evident cultural ramification. Indeed the wish to cut out all the 'nonsense', to symbolize by art 'the inner man' alone, may be said to have reinforced the ambition to possess by means of art an object rather than the symbol for it, to have stimulated, then, the constant desire for the homogeneous state I have called 'is-ness', and so, an impatience with any symbol for it and therefore, in truth, with art itself, the very means by which it may be communicated through the symbolic representation of symbolic equivalence. Hence the vulgar strain in anti-art movements.

A further paradox follows. I have mentioned that in speaking of modern art we do not call much on the word 'imagination'. Indeed, we think of visions and hallucinations as forced upon the recipient, squeezed in, as it were, between his eye-lids by an outside agency or from the depths of his mind, rather than as an active construction of the image-making faculty. This means that for what we regard to be specifically imaginative we retain the sense of a projection whose contents are better related the further they are transposed into a fictitious context, whereas to visionary experience we attribute no intellectual artifice. Baudelaire based his criticism of pictorial Realism (Courbet) a hundred years ago on a not entirely dissimilar conception of the imaginative role. Nevertheless, Baudelaire, likewise the Symbolists who were his heirs, emphasized a visionary grasp of the Real in aesthetic comprehension; a grasp that enclosed an interchange of effects between the different arts themselves. One need have no such theory in order to say, as I have said, that a unitary or visionary quality with which we may identify ourselves has entered into the creation of all art: the Old Masters' building up of monumental treatment to form a varied experience, very often causes the visionary kernel to be the more magical, an illumination for much circumstance whereby also the spectator's adult ego is notably served and flattered.

With whom shall we contrast Tintoretto? The 'Douanier Rousseau's entire

career was devoted to creating the universe of a grown-up child. . . . He incarnates his universe by a painting it exhaustively and palpably close.' There is 'a single mysterious lighting from all sides, shadowless, without high lights, without any power to dissolve colour' (Shattuck, 1959). Or 'he imagines a strongly lighted distance against which he silhouettes darker forms of tree and foliage. . . . Usually two small figures focus the eye on the foreground. This same "dream picture" haunted him from the days of *Carnival Evening* to the last jungle picture he painted' (quoted in Shattuck, 1959).

Such sentences will call to mind the visionary experiences discussed in the last essay. Picasso's banquet for Henri Rousseau in 1908 was undoubtedly a most significant occasion in the history of the *avant-garde*. Rousseau's pictorial dreams, elaborated in quiet suburbs during an age of some security, crystallize the contribution to *avant-garde* art of the naïve, the bright, and particularly of an unswerving mildness or matter-of-factness in regard to them. It could be argued that this matter-of-factness, often employed for the presentation of even imperfectly induced visions, constitutes one of the characteristics of modern art, separating it from Delacroix's vast visionary exploits, from the last great artist to be taken up with the forging of grandeur. Any masterpiece of the imagination contrasts with a truly child-like matter-of-factness.

The bridge has long been built between what is considered to be child-like and what is considered to be primitive. Champfleury, the champion of Courbet in the 1850s, is quoted by Professor Schapiro as having written: 'The idol cut in the trunk of a tree by savages, is nearer to Michelangelo's *Moses* than most of the statues in the annual salons', because of a vividness in common, because of 'signs of a conception' paramount in children's drawings as Rodolphe Töpffer, the Swiss educationalist, remarked in a book of 1848 (Schapiro, 1941). Some interest, then, even in the middle of the nineteenth century, some respect, had begun to be paid to the art of the child and of the savage. Professor Schapiro points out that Courbet was influenced by naïve popular prints. We can easily see that Courbet's art, so revolutionary in that he was absorbed by aesthetic contemplation of his ordinary experience at the expense of the selectiveness or appropriateness to art which was still demanded, has a mindless, visionary quality: it causes the easy justice in his perception of tone, his extraordinary naturalism, to possess an air, unique for the time, of lack of contrivance. Courbet held some devices in contempt: he was accused of being clumsy, childish, mindless, of discovering 'everything in life and nature equally interesting', to quote a criticism in 1860 of the realistic novel (Boas, 1938). A contemporary critic of his *Young Woman on the Banks of the Seine* remarked that their significance was no greater than that 'of two good white cows with russet markings' (quoted in Goldman, 1959). The very accuracy in the wide sweeps of Courbet's observation, allied to a visionary mildness extended equally to all

parts of a painting, seemed to make his subject-matter of neutral and even of secondary importance. His matter-of-fact attitude to the nude was felt to be particularly unfeeling. Courbet, wrote Zola, 'had the rugged desire to clasp true life in his arms, he wanted to paint in a meat and potatoes way' (quoted in Goldman, 1959). In so doing he did not envisage as a rule, though he was reviled for left-wing sympathies, a parable of peasant life or of poverty, unlike Millet whose more revolutionary social consciousness cast his art into a traditional symbolic mould. Few of Courbet's works 'possess any humanitarian fervour' (Goldman, 1959). It is easy to understand that the broad back of a 'message' serves in art of however recent a date, a similar role to the conscious cultural expressions undertaken by the art of the past. That is why Pissarro considered the transcendental symbolism, re-introduced in a modern idiom by Gauguin and Bernard, to be vulgar and reactionary.

The general reflection in all art, even modern art, of culture is an entirely different case of symbolism. To us it becomes obvious, very obvious, that the Impressionists painted, symbolized by their paintings, 'the good life of the resurgent middle-class', particularly those people as they took their Sunday pleasures. Among artists at work at that time, more than others the Impressionists were the spokesmen of a positive aspect in their age, not merely of a minor spirit in that age. Yet Philippe Burty, one of the earliest admirers of Impressionist painting, justly wrote: 'Man is really an object of interest by virtue of his existence as a fact, the most interesting of all objects, perhaps, but not essentially different from trees, clothes, or the sky.' Thoré, a very perceptive critic, wrote: 'Manet's . . . real vice is a sort of pantheism which values a head no more than a slipper; which sometimes even grants a greater importance to a bouquet of flowers than to the face of a woman' (quoted in Sloane, 1951). The word 'pantheism' is of interest to us in view of the vision we had in the last essay of a transporting and unitary chromatic world. As in the case of Courbet, Realism could be equated by hostile critics with indifference, indifference not only to the object represented but to an acceptable balance of contrasts. An abstractedness, away from the particular object, is not far in the future.

We are at a sufficient distance occasionally to class the great antagonists, Delacroix and Ingres, together (though Baudelaire in 1855 classed Ingres and Courbet) since each was a champion of a narrow cause that piled the fires or cooled the metal of the past. The alternatives of dying traditions were giving less and less scope to the more evident compulsive or personal approach with which they were infused by those few artists who could still successfully improve upon them with stern exaggeration. The difficulty was greatest for the ordinary 'history' painters. 'The nobility of the second Empire, like that of the first, was largely improvised' (Boas, 1938). This once dominant theme ('history' painting) had long been dethroned, at any rate in Holland. Already in the eighteenth

century other qualities in art than nobility had been more esteemed (Schapiro, 1954). As well as the Dutch, supporters of Courbet might invoke Caravaggio, Velasquez, Ribera, Chardin, the Le Nain, and Goya. The ordering of the world by art, we have seen, was now to be attributed to the act of the artist independently of any nobility afforded by selectiveness in subject-matter. The Old Masters were persuasive celebrants: modern art invites the communicant, not to share an established ritual, but to contemplate a personal process. It is perhaps more companionable, no more so than the sublime work of Rembrandt who sent his inner being to inhabit the twilight of the Grand Manner. But much of our painting has at least made it clearer that the artist's work must bear witness to the immediacy of outer objects by which we live, as well as to a system of unified parts in the self. Also, we have seen, there has entered some impatience with symbolic function in favour of original, unrelated states.

These are matters that do not figure specifically in artists' manifestoes. It would even be a considerable mistake to suppose that either Courbet or Manet repudiated as such the wider symbolic functions of art. Courbet called his *Burial at Ornans* 'un tableau historique' and his *L'Atelier* 'Allégorie Réelle', in competition with the old symbolic style. Manet's *Christ and Angels* was exhibited in the Salon of 1864; his *Execution of the Emperor Maximilian* was exactly a 'history' painting. What he felt about the incident will have appeared cool, translated into confronting patches of light and dark material at the expense of supporting anecdotal references. The implications – they would seem entirely unwitting – of any such treatment are more clearly understood in the case of Cézanne. His boyhood friend, Zola, was Manet's most influential supporter. The doctrine of art for art's sake was given in Zola's version by his famous phrase: 'A work of art is a corner of creation seen through a temperament' (quoted in Sloane, 1951). Courbet, he felt, no less than Manet, had set down without preconception his own impressions: the artist was taking a larger hand, were he Realist or Symbolist, in deciding on the very nature of *his* world: otherwise Zola's phrase would be equally applicable to the work of Raphael. More stability or reassurance, it was beginning to be felt, could be enjoyed in contemplating the artist's personal and non-rhetorical emotion than from his protestations however imaginative. Indeed, the very process of aesthetic contriving can be in evidence, at the same time as the painting or composition that results from it: what once would have been judged sketches were now paintings. We see today that the pictorial impact of Cézanne's monumental recreation of objects, in part depends on the concomitant inner adaptation that his re-created objects stabilize. 'The qualities of the represented things,' writes Meyer Schapiro in his book about Cézanne (1952), 'simple as they appear, are effected by means which make us conscious of the artist's sensations and meditative processes of work; the well-defined, closed objects are built up by a play of

open, continuous and discontinuous, touches of colour. The coming into being of these objects through Cézanne's perceptions and constructive operations is more compelling to us than their meanings or relation to our desires, and evokes in us a deeper attention to the substance of the painting.' That is to say, to speak in the jargon I have used, we are very aware in his painting of a noble ego-integrative activity both in itself and in relation to objects, a prime subject-matter as I have repeatedly said, of the formal element in every art.

Professor Schapiro continues: 'The marvel of Cézanne's classicism is that he is able to make his sensing, probing, doubting, finding activity a visible part of the painting and to endow this intimate, personal aspect with the same qualities of noble order as the world he has imaged. He externalizes his sensations without strong bias or self-assertion. The sensory element is equally vivid throughout and each stroke carries something of the freshness of a new sensation of nature. The subjective in his art is therefore no isolated capricious thing, but a manifestation of the same purity as the beautiful earth, mountains, fruit, and human forms he represents.'

'If I think, everything is lost', wrote Cézanne. 'What was lost', Lawrence Gowing commented, 'was the pure character of sensation: his whole pre-occupation was with perception, and not with receiving only – his attitude was far from the passivity of the pure Impressionist – but with gathering and grasping. Every touch on his canvas adds a new segment to a composite definition, uninfluenced by any that went before. The only consistency is the consistency of sensation, the kinship of one observation with another, progressively evaluated by the meditative eye. Cézanne's method, as he once said, was "hatred of the imaginative", and we can feel that the hatred extended to all that was implied in the derived, fictitious contour of the early works. A picture now showed not only form but the history of its perception: the process of representation was made visible. Painting had in fact become the positive, appreciable action which Cézanne sought, an act of self-possession fit to measure against the world. The artist is not inferior to nature; as he said, "He is parallel with it, unless he deliberately intervenes"' (Gowing, 1954).

The reader may find in Cézanne's quoted remarks echoes of a visionary approach as I have described it. Far more significant was the utter devotion to Form's perennial symbolic content in regard to ego integration, the process, it seems to me, that Schapiro and Gowing so ably recount in different ways. The freeing of this content, I would suggest, is the most valuable aspect of the art of our time. I have needed to stress also, however, the concurrent enlargement of symbolic representations of symbolic equivalence or concrete thinking. In this respect there is not, of course, a straight line of development stretching from Courbet, say, to the absurdities of Dada: at every point until this last, various syntheses attempt to weld bareness, immediacy, obscurity even, with

the activities of the developed ego, and vice versa. Thus Gauguin, while he re-introduced a cult of transcendental symbolism, forcing upon his subject-matter generalized meanings other than the aesthetic, employed flat areas of brilliant hue in his paintings, which suggest the non-symbolic 'is-ness' of film colour. 'Beyond the head,' wrote Van Gogh to his brother about a portrait he was painting at Arles, 'instead of painting the banal wall of the mean room, I paint infinity, I make a plain background of the richest, intensest blue that I can contrive, and by this simple combination of the bright head against the rich blue background, I get a mysterious effect, like a star in the depth of the azure sky' (quoted in Schapiro, 1951).

I think it permissible to identify in one of its aspects the 'over-allness', characteristic of so much modern painting, with the visionary stamp of 'is-ness'. This character was stabilized by the immense achievement of Seurat, though he was in every way the antithesis of a mindless painter. There has never been an artist who declared more vehemently a close connexion between art and science, who held with greater fervour that everything in a painting should have resulted from the artist's thoughtful participation. No less than Holbein's should Seurat's work be thought the antithesis of Action painting. Even the smallest of his divisionist paintings are monumental, accumulated, in prolonging a scene or events in a scene. Yet, while he gives painstaking self-inclusiveness to the objects he represents, the striking immediacy of the picture plane insists upon identity of all its parts, an emphasis not so much upon unity as upon oneness.

In discussing the course of modern art it is usual to give more attention than I have done to increasing uses of abstraction. I do not believe that the isolating, which has undoubtedly occurred, of aesthetic formal values, necessarily entails even partial rejection of contingent subject-matter or of its appearances. When I read that the Cubist painter Juan Gris wrote: 'It is not picture x that manages to correspond with my subject, but subject x that manages to correspond with my picture' (quoted in Kahnweiler, 1947); I am reminded that Flaubert, sometimes hailed as the greatest exponent of Realism, could protest that art was more real to him than the events in life. No: one difficulty about subject-matter, however dim or distorted its use, lies with a disturbance that parti-cularization of object-character may bring to bear upon the experience of 'is-ness', upon an experience as well of many things that are yet felt totally to merge into one note.

But some of our most admired younger painters today, whose pictures to the casual glance appear to be total abstractions, repudiate this impression as entirely false. Such an artist claims that he cannot work without the conviction that his painting will be the equivalent, the strongly vibrating equivalent, though in no sense the mere representation, of an outer experience. Both exper-iences are, as it were, equal in authenticity, the secret experience that inspires

the painting and the painting intended to inspire the beholder. The painting is not the symbol of the first experience nor its record: there is no uncertainty on this point: the word used is 'correspondence': the painting corresponds with the experience. This attitude appears to be a form of compromise imposed upon a predominantly 'is-ness' aim.

Few as they are in proportion to the data to be had on every side, I have given sufficient examples, and explained enough, the symbolic projection of symbolic equivalence in modern painting, a quality that, together with the formal values entailed in reconstructing the self and the object, have been cut clear by this art which so nakedly explores 'the inner man' amid cultures that are otherwise disrupted.

I have been using the term 'form' in an unavoidably loose way, to cover the many processes by which the work of art unifies factors for the pleasure of the senses and the mind; to denote, for instance, the symbolic reconciliation of three dimensions with the two of the picture plane, or of contrasted rhythms and movements, or of shapes that are likely to achieve balance in a way that depends upon other modes of reconciliation; to denote the absorption of accents into a whole, the stimulation of bodily as well as intellectual awareness to feel this wholeness; more generally, to denote the bringing together of different kinds and different levels of significance into a cluster: a conception of wholeness underlies every effect. Throughout these essays I have attributed to the aesthetic awareness of wholeness two opposite yet combined *nuances*, the one an experience of singleness or envelopment, the other a recognition of a reconstructed and independent object. The envelopment pull in graphic art, where it notably serves the 'is-ness' asseveration, the confusing of the symbol as of subject with object, I would now designate, perhaps surprisingly, the Pygmalion theme, in honour of the most vulgar of all parables about the nature of graphic art. The life-like statue comes in fact to life; the statue *is* the Woman; *trompe-l'oeil*, symbolic equivalence, can do no more.

On the other hand, naturalistic art, though it incorporates, as does all graphic art, the Pygmalion theme, may honour better than conceptual or iconic styles an artifact's independence and self-sufficiency, as the result of a more 'objective' mode in observing the outer world, a mode wherein a place can be found in art for recording what is incidental. We have seen that, unlike mystical experience, aesthetic experience depends upon a fair modicum of a less appropriating appreciation of the outer world, in combination with the other attitude.

Having thus treated (in the context of graphic art) of two opposing *nuances* belonging to the effect gained from art, I must briefly restore each to the other. The secret of their combination must lie with the very structure of symbol-formation. According to Freud, the primary mental processes (observable in

the analysis of dreams), mechanisms such as those of condensation, projection, and displacement create, at this primitive level, equivalences between meanings that form a cluster of significance in which no one meaning appears to have precedence of another, as does an object have precedence of its symbols for normal and developed consciousness. A grouping of significance, to some extent comparable, figures in art; the very roundness of the aesthetic cluster, even the symbolic reconstruction itself of whole and self-sufficient objects, the aesthetic entity separate from its creator, contains, from the process of its manufacture, more than a trace of the primitive habit of mind, which, while providing the genetic basis of symbol-formation, can be so subject to the paranoid-schizoid stress as to inhibit a continuing development therefrom of true symbolism: in art an outcome may be a symbolic projection of symbolic equivalence or concrete thinking whose poetry becomes disproportionate to an aesthetic end.

We have seen that important aspects of the nature of graphic art, pre-eminently this one, have been abstracted a little from the past and put on view in semi-isolation by our heroes of the *avant-garde*.

Coldstream and the Sitter

First published 1962

MODERN PAINTING EVOLVED LARGELY from qualities of strait-jacket and of deliquescence that Cézanne bestowed upon the model. Neither kind of verve would have had this great significance were it not the accompaniment of his faultless perplexity before the motif. It is possibly sad, therefore, that the slow deliberation in transmitting what he saw, the basis of his art *vis-à-vis* the subject-matter, had to be overrun by those who followed, in favour of the greedy apprehension of its fruits, or else employed with little other compulsion than to ensnare them, rather than that it should have remained more often the mode of utmost homage to the motif as a thing apart. Few artists since Cézanne have depended with comparable necessity upon the long presence and utter stillness of the model: without introduction of a summary or symbolic or decorative element there has seemed in our time insufficient scope for making pictures through the endless art of building up appearances.

The achievement of Coldstream, since it forces us to revise that opinion, cannot be negligible in the history of painting. Cézanne could work without a model, or at times away from the model: not so Coldstream who tends to evade looking at his picture in the model's absence. Unlike most painters he does not allow himself a pointed comment upon her; nor is she there as Venus to illustrate, as a conscious symbol, a cultural generalization: every touch is for her detention upon the canvas rather than for making gestures by means of her; she is not to be interpreted, explained or flattered. She is a thing apart: she signifies the stabilization of a recurring presence; the artist is profoundly concerned with the very existence of her wholeness in unexciting surroundings at a distance from the artist: he is obsessed thereafter, as was Cézanne immediately, by an undeniable architecture of cool and subtle relationships between shapes and tones and contours. And so he is not interested in an illusionist transmission; an illusion of evanescent actuality could not convey his concern as does paintwork that grows from a renewed conning of exactitude in regard to the skeleton of the image. But nothing arbitrary must occur: indeed, the search for monumentality, pattern, surface texture, for the fabric of design, is inspired by

the desire to control the model without in any way appropriating her, to amplify and perpetuate her usual presence within the props of rectilinear bareness, a structural frame to which all else, even the faintest marks, are richness and accretion, so that she develops undistorted into a personage neither idealized nor debased but broadly self-subsistent: therefore the rejection or twisting of basic appearances was inconceivable.

Because Coldstream's aim is austere and disciplined, because he never fills in, never rushes, never forces design but awaits the stricter behests for the purposes of art of what is before him, none of his works has become a superficial artefact; all are good and must be rare. Art, serious art, depends not upon an obsession with form and light but upon a reparative obsession that employs them. I hold Coldstream to be a great modern master, as 'extreme' and isolated as Rothko. Whereas, in regard to representation, Coldstream never ceases to construct broad but true statements possessing formal interest, his monumental naturalism, we see, cannot be explained without ado as a vehicle for communicating an equivalence of forms rather than as an end-result of a consistent, coaxing, attentiveness to the commanding wholeness of the model. It upholds in the nudes, creates from the sitters, a massive unadorned solemnity on which the artist's own dignity *qua* artist, we feel, entirely depends. Were it otherwise his evolution would probably have been, as in the case of many powerful pictorial minds, from impressionism via expressionism to abstraction.

Two of our enduring wishes find satisfaction from this art, a desire for undictated stillness in ourselves, for stable people and things in the outside world. Art must always show, to some degree, an integration of ourselves that cannot be separated from the integration imputed to our objects. There is no clutching in a Coldstream, no greedy clutching at a shape: it is authoritatively gripped, all the same, and will be gradually disclosed: especially in the later paintings we are allowed to watch the process and thereby the renewal of an integrative series. Though we carry away images of compelling plasticity, in front of the paintings we are aware that these are not impositions as much as carved shapes uncovered from a stone. Coldstream considers the canvas surface with the unceasing respect he maintains for the separateness of the model. Observed near to, many of the pictures reveal qualities connected with more seductive aims; were they ornaments, those qualities would mean little: I find it unique that we possess from the exhibition so much beauty, delicate as well as austere, linked unbrokenly with obsessive service paid to the completeness of a model stripped of accident, and to his or her *mise-en-scène*; obsessive yet without a facile, omnipotent slant, generous in the lack of appropriation, civilized in the compulsive acceptance of the echoing otherness of things.

We witness in these paintings the gradual accumulation of images that are majestic yet unforced.

The Impact of Architecture

First published 1961

MY SUBJECT IS AN IMPRESSION gained from most architecture: it became the mother of the arts not primarily in virtue of the frigid balance sometimes expressed by the word 'design'. To a design of any worth there is, of course, an animation even other than the one of its subject, if such there be. I shall suggest that building, the most common construct of environment, has provided a very consistent content, a content in form or design as such, that reappears in formal aspects of other arts. I would ask you to remember this very wide aesthetic scope; because of it I have the temerity to choose an architectural subject.

My theme is illustrated by thirteen of the superb reproductions in Thames and Hudson's *Romanesque Art in France*. Perhaps you are disappointed already that I promise nothing about architecture today. Attempting to sum up a continuous content in the forms of brick and stone, I hope to provide a departure point for discussion about the contemporary aesthetic problems of architecture. I doubt whether these modern buildings oppose altogether the values I isolate; as contemporary styles become more confident, I think we begin to lose some of the acute opposition, imputed to them, with the values from which my subject is contrived.

We now go back 1,000 years. I shall first offer some guide-book information to set the scene.

The place is Tournus, on the Saône, between Chalon and Macon (plate 37). Most of this former abbey dates back – even far back – into the eleventh century. . . . Some of the most important Romanesque abbeys are in Burgundy, particularly in the districts between the Saône and the upper Loire to the west: Cluny, for instance, once the centre of French Romanesque and Benedictine civilization. It was the most famous church in France: little more than a transept remains; the museum is very rich, particularly in carved capitals.

The Tournus Benedictine abbey – or, rather, a predecessor of the one before you – had been occupied by monks fleeing from the Normans and carrying

with them the body of Saint Philibert. In the tenth century the Hungarians destroyed the abbey. I mention these two facts to illustrate how the West was harried and hemmed in: the darkest century of all was the tenth. An additional threat lay in the Saracens from the south, from Spain and in Provence. Thereafter war and disruption lessened. The Cluniac monk Glaber, writing about 1047, said that after the year 1000 all the world – especially France and Italy – was covered with a white garment of churches. It is from this time of resurgence that one distinguishes the beginning of the Romanesque period, though many Gallo-Roman features, as is well known, had persisted in the previous Carolingian art of which so little remains in France. The influences on Romanesque are traced far and wide, by Emile Mâle and Henri Focillon for instance. As so often, in the architecture there was contrived a simple embodiment of the culture's composite nature. The Benedictine monks of the order of Cluny who built an empire of monastic houses of which over 1300 were in France in the early Middle Ages, who ruled as well numerous parish churches throughout France, adopted and developed very widely the traditional basilican plan, an aisled church with a triple apse. This is before the Gothic age of cathedrals and the temporal hegemony of bishops. The centres of civilization were the abbeys, often away from towns. Not many French cathedrals have preserved extensive Romanesque features, so that it is easy to overemphasize this point. Nevertheless it seems true to say that the ecclesiastical culture of that time, monastic or episcopal, was principally the creation of the Cluniac movement, and that the sculpture, though not the frescoes perhaps, in the churches, so far from serving plainly as the Ruskinian poor man's bible, reflect the phantasies of monks whose imaginations had been fed not only by texts copied in their scriptoria but by the illuminations of those texts. Pilgrims contemplated an esoteric bent of small, though centrally governed, communities, attracted by the relics the abbey enshrined. Not that the graphic art, illustrating the local saint, was likely to include a notable degree of showmanship. It happens that the story of the Magdalen whose relics were the especial magnet of Vézelay, the largest as well as the most beautiful of surviving abbeys, is not represented on extant capitals, except one of Lazarus who was considered to have been the Magdalen's brother. Anthony, his fellow-faster Paul, and Mary of Egypt, on the other hand, are much in evidence, saints who would have been well known to monks hearing or reading every evening the *Collationes* of Cassian, that is, conversations with Egyptian anchorites, rather than to people at large. It is as if a phantasmagoric element in the sculpture of capitals sometimes precluded methodical presentation, or do we still lack the complete set of iconographic keys? The Romanesque imagery is pre-scholastic; is characterized by an almost pantheistic absence of a varied differentiation. But if God be everywhere, so is the devil: it was a time of fear in common, fear to which was added the devil's

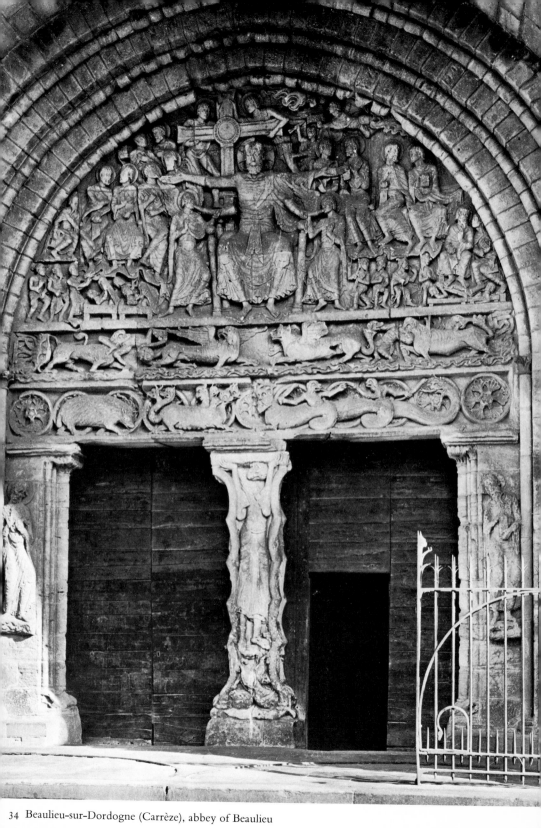

34 Beaulieu-sur-Dordogne (Carrèze), abbey of Beaulieu

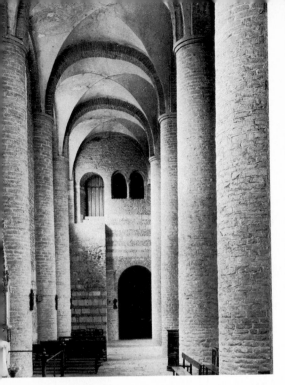
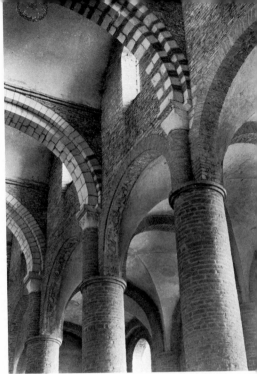

35–37 Tournus (Saône-et-Loire), abbey of Saint-Philibert. The southern aisle; the vaults of the nave and one of the aisles; the central tower and part of the choir from the south

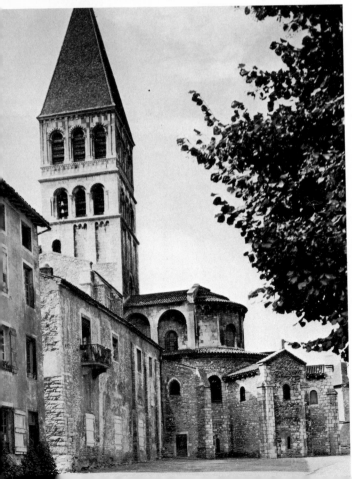

more refined monastic presence. Even so, unlike some oriental religions, this Christianity accepting deeply an incarnation of spirit, modified, at least, any tendency to view as an ideal for all the total rejection of the world's multiplicity. Indeed, I am at pains to suggest that in the architecture of abbeys, side by side with the sculpture's all-embracing visions of stern beatitude or of misery and torture, humanist phantasies of the body are projected; that is to say, we ourselves may find that the changed remains of these buildings, more strongly than do most, stimulate such phantasies. I think that this would be impossible on so wide a scale had such a content been entirely absent at the time. I do not of course suggest it has been symbolized in the way that a conscious symbol will have been projected. Nevertheless, it is obvious, that content was not deeply repudiated: its presence cannot be called the return of the repressed which comes in a less recognizable, in an utterly distorted, form. This content, however, could not be allowed as yet to exert an open influence upon the subject-matter of the representational arts. I am saying no more than that these buildings are beautiful in a manner, unlike the one of Romanesque sculpture, that is truly Western in the sense of exhibiting the quality of humanism, a quality common enough in building, perhaps at its greatest in the Romanesque era.

The sculpture, as well as providing records of sacred incidents, is charged with the wide symbolism common to illustrations used in a sermon. That conscious use of symbolism is for the most part absent, it seems, from the planning of the church itself. There are at least two extant accounts of Romanesque dedication services: they make no reference to an architectural symbolism, except that Abbot Suger, the famous re-builder of Saint Denis near the dawn of the Gothic age, wrote of twelve great columns signifying the apostles.

And so, the aim of my talk is to remark the prevalence, as it seems to me, of a less conscious and utterly generalized symbolism, one that even fits ill with accepted images of the time for which it is both the setting and the supplement. I do not think it romantic to envisage a great spirit of resuscitation, particularly between 1080 and 1140. The Cluniac contribution rapidly declined in the period of the Second Crusade with the rise of the Puritan and more democratic Cistercians who, in the person of St Bernard, ridiculed the Cluniac sculpture, particularly for its monsters, and themselves persisted with a beautiful bare church of differing plan. By the time of the Second Crusade, the most lucrative days of smaller pilgrimages from abbey to abbey were on the wane.

The south sandstone portal to the former Benedictine abbey of Beaulieu on the Dordogne river (plate 34). Christ in Glory or the Last Judgment became the majestic subject of many renowned tympana sculptures. The Atlantid prophet belongs to the column dividing the doorway beneath the tympanum.

I might as well mention here that as well as at Chartres and Vézelay, some of the finest Romanesque sculpture can be seen in the museum at Toulouse, and

that the Church of Saint Sernin, in Toulouse, is one of the largest surviving Romanesque churches of France, having been a pilgrim church, like the great abbey of Conques to the north, on the route to Compostella in north-west Spain. Among the principal French sites of surviving Romanesque frescoes are the former abbey church of Saint-Savin-sur-Gartempe in the department of Vienne: parts of this church date from the early eleventh century. There are extremely important frescoes at Berzé-la-Ville, near Cluny in the department of Soane-et-Loire.

Capitals in the cloister of Saint Bertrand-de-Comminges, not far from the Spanish border (plate 32). I don't know whether their carving can be said to show Mozarabic influence from Spain. I would think so.

The abbey of Saint Michel-de-Cuxa, not far away, certainly does in parts of the church (plate 31). Scholars of the French Romanesque discover not only Gallo-Roman but Syrian, Byzantine, Runic, Mozarabic and Catalonian influences. What is more directly Roman is usually found in the south, for instance the famous front with three portals, like a triumphal archway, of Saint Gilles-du-Gard, near the mouths of the Rhône.

This tower suggests fortification. There are mountain monasteries, particularly near the Pyrenees, unmistakably fortified.

Charlieu is north-west of Lyons, by the upper Loire (plate 30). Except for a part of the eleventh-century cloister, not much is left of the monastic buildings: of the choir and nave of the church only the foundations, but there are rescued remains, including a Carolingian relief of Daniel in the lion's den. And there is a narthex, Galilee or vestibule with a room above that has a sculptured window. This plate shows the tympanum of one of the two extant entrances to the narthex. It dates from almost the middle of the twelfth century: it is sometimes described as a notable example of late Burgundian Romanesque.

Sainte Marie-des-Dames (plate 29), not the more famous Saint-Eutrope, over on the other side of France, at Saintes on the Charente, a place with three Romanesque churches.

In Joan Evans's *The Romanesque Architecture of the Order of Cluny* a photograph of the surviving abbey gateway at Cluny is put on the page above a photograph of the Roman Gateway at Autun, a confronting that bolsters up the term 'Romanesque'. Also a façade such as this with three rounded compartments in two zones has a Roman reminder.

A little-known church nearby at Echillais in Charente-Maritime, of which the Romanesque façade survives (plate 28). Such rich doorways and arcading are characteristic of the province of Saintonge.

Choir and ambulatory of the famous abbey Saint Benoit-sur-Loire, on the right bank above Orléans (plate 27). The remains of St Benedict were brought here in the seventh century from Monte Cassino. Among the curiosities there

is an eleventh-century carving, still adapted to the form of a foliated capital, that calls to mind pre-historic figures from the Cyclades. Another carved capital shows a devil whose face, as well as hair, is made up of leaf forms, as if leaves had been pressed into a loose ball.

The church of Notre-Dame-du-Port at Clermont-Ferrand in the Auvergne (plate 26). The height of this church is extremely impressive since in length it has the extent of little more than two cricket pitches. Having been built throughout the twelfth century, it is therefore a very late example of French Romanesque architecture, since the second half of the century saw the beginning, and after 1180 the rapid diffusion, of Gothic in France. At Clermont-Ferrand there is a Gothic cathedral also called Notre-Dame.

The church of Saint-Trinit is to be found between the Rhône and the Durance, north-east of Avignon and due north of Aix-en-Provence (plate 25). Many villages in this part have Romanesque churches. It was once the territory of the Counts of Forcalquier whose court became notable in the twelfth century for its culture. The church has been recently restored.

These reproductions have not been chosen to bring to you even the principal Romanesque buildings in France – thus, there has been nothing of Vézelay, of St Giles or of the west front at Chartres – but as beautiful examples to illustrate the impact of architecture in an uncomplicated manner. I shall now say what I find in them.

Architectural values are often described initially in terms of the proportion between dominant shapes. I shall not be referring to proportion as such; I shall be remarking the most generalized imagery that, in my view, a due proportion of masses, between textures, of light and shade, of mass and space, void and aperture, serves to express. For, as I have already inferred, it is a mistake to think that formal qualities are not of themselves expressive. Though that expressiveness or content, and the function of form, vary greatly from one work to another of whatever kind, they do not vary so greatly as to reject altogether what I take to be the dominant or constant themes of formal attributes in every work of art, of those same attributes by whose underlying patterning the work of art shows itself to be whole and self-subsistent, that is to say an object of worth however useless, and indeed however dull it may otherwise be, or may subsequently be, as a communication. You will realize in what follows that I see in the mirror of form frequent reflections of a generalized corporeality and of the integrated mind. In this way the dire emotions too become acceptable. But I call that art 'humanist' in which one is more easily aware of integration and health. I attribute to form other generalized emotional bents, but these will not much concern us here. It is surely obvious that our bodily powers and propensities are the points of reference for noting the character of other substance. As well as contrasting with the body, these other phenomena, in the context of

art especially, are often employed by a deeper level of the mind to contain a somatic ascription, just as moods, emotions, are read into landscape. Similarly, I believe that whereas art provides an image of this or that, it always provides at the same time a generalized image of the dominant positive relationships with people and things: for instance, an enveloping relationship that tends to exclude the variety and limited nature of objects, seems to me to be underlined by the calm repetitions so commonly found in geometric or anti-humanist styles of ornamentation. Closely tied to symbols of relationships there figure also in art the symbols for our own integration of contradictory drives.

Saint-Trinit

PLATE 25

Here, in the illustration, I want first to remark a rarefication of rubbish, a crystallization of the forms and material on the ground: the rough masonry of the front of the church suggests an intermediate stage between that of the rubble and the smoothed, squared stones used for chancel and apse. On this homogeneous surface architectural features are better named, recall more readily to mind a transposition of skin and bone. In the division formed by the five pilasters on the apse wall, there is an eloquent articulation of limbs. I see the church as an ideal projected into stone of bodily strength and health; as a symbol for the body, spaced and joined in such a way that we are not troubled by the image of a personage.

In the fusion of stone shapes, then, we may apprehend the symbol of a whole body: a due proportion of darkness, light, rectangularity, roundness, roughness, smoothness, wall, aperture, may provide both solace and reassurance. How can this be, and why do we discover in the triangular roofs a third shape that expresses union of rectangularity and roundness, some hint of a squared circle to cap the cube and arches of the belfry?

We live for the most part in cubes and pass through what are, whatever their shape, holes in the wall. Eye and hand are ever responsive to organized surfaces since we never cease to build, to integrate, as we may, a coherent psyche. The result at any moment will be less calm, far less complete, than this church.

The narrow, arched aperture is navel-like or lip-like, the oblong window with rounded top that lies back within the apse wall. One has no thought of proportion nor of place in conceiving the comparison, and so, not at all of incongruity, of freakishness. The worth that lies in a reminder of the body by the building depends entirely on indirectness, an unavoidable indirectness, exploited by our perennial sensation of corporeality. We attribute to the apertures a justness or serenity because we have attributed to the sensitive smoothness and demarcations of so simple and proportioned a building an

enduring health or generosity. In the case of these constructed stones we are able to do so far far better than in the case of the surrounding ground, because of a few direct links with sensations of health and of love – a smoothness topped with roughness, for instance – in the apse's structured frame that justly swells, we feel, from the body of the church. A further connexion with ourselves and with others evolves from the interrelation of planes, volumes, textures, in that they serve the corporeal image – it can only be a corporeal image – of mental or emotional stability. The effect, I have suggested, of looking at this photograph is likely to be calming.

Greek sculpture projected an ideal mental balance in terms of an athlete's stance. When we speak of a mental aberration, we have to refer to a lack of balance, since there is no way of indicating mental disproportion except by means of symbols with a physiological reference. It is a consideration that seems to me to have a great deal to do with the character of art. In the aesthetic projection of what is ideal whether of mind or body, graphic art, however stylized, however architecturally disposed, cannot rival building whose emotional content, though it may be sometimes markedly personal, must always display easily to us a content that is general in art as a whole, the content inseparable from form. For the first time in graphic art, Greek sculptors constructed an ideal mentality in the terms of physiological perfection. That art, a great by-product of the columned temple, of steps, pediment and fluting, achieved an imaginative particularization of health that has rarely endured for long. But once thus humanism, this image of physical well-being without rigidity or stress, had been attained, we, who are still the heirs, are the more prone to re-discover its rudiments in the courses of any beautiful wall. Whereas Romanesque sculpture, often a supreme art, is by no means humanist as a rule, the church before us, Saint-Trinit, has become a timeless monument of humanism: it does not 'date' since it does not particularize; and since, in Western architecture, there can rarely be found the catharsis of a detailed phantasy – our professors do not extend their iconographic studies to as many buildings as would be needed in India – the broad rules of health have sometimes been affirmed by building, particularly Romanesque building, in ages under the domination of spiritual fear. So much of Greece remained, the part of greatest worth, and even flourished as never before. In art the formal elements always bring of themselves a beneficent content: that is why any fear, any misery, any madness, become bearable if they are projected by an aesthetic process.

Notre Dame-du-Port at Clermont-Ferrand

PLATE 26

I attribute to the light here a quality like the smoothness of honey, to dark areas also. The little staccato accents of the chairs are out of place, incongruous as a butcher's shop in an attic. Being part of so noble an image of our internal organs, the chairs may be seen as ingested sardine-bones, the statuary as exfoliations, excrescences, unlike the needed roughness of the columns' capitals. It seems birth would have been easy from such a body, lit, aerated and very strong, pounding in utter calm. The thickness, the height, the roundness everywhere seem spacious and gradually dominated by a permeating good, particularly in the barrel-vault that we will consider to be replenished with the circulatory darkness of a Rembrandt background. I find myself pinned to the half-columns, magnetized by their rounded surface, and by the square edges of the piers that are to hand, as I gaze at the thickness of the arches far above under which the light from the dome over the chancel proceeds, as well as from the windows of the apse. We cannot see the dome in this photograph, nor aisles nor traverses, but we have, nevertheless, the sensation of a perfect fit for which contexts are likely to be many, mental as well as somatic; suggesting, in sum, the integrated psyche that we struggle to build amid a confusing scaffolding of physiological drives. A dome or head is the home of all our acts. Like perception, like an impact on the senses, light floods through the apse windows, follows the channels of the ambulatory arcade, and will be memorized, it seems, within a mosaic of cellular indentations above the main arches.

We look up open-mouthed, taking in a firm roundness that remains resilient and untouched by our attack. We are practising aggression and love, and their integration.

Saint Benoit-sur-Loire

PLATE 27

We see a lot of wall here, plain but not simple. The unbroken part of it is made to come forward by the second curve on a recessed plane within deep arches. The beauty depends on this step, the beauty in conceiving the thick wall as a volume that has been opened up, cut away to make columns and the narrow voids between them: thereupon the block-like simplicity of the capitals similarly suggests a carving process beyond their own; the apertures and arches of the nave's flank serve to show, in some contrast with later Gothic building, the richness of the uncut wall in their midst. Without the shallow step beneath the arches dramatizing the depth of the wall, an image of a slow probing into a valuable surface, into the arcade above as well, into the apertures above that,

and betweed the columns below, would not have been present to us. A wall's change of plane can cause us to view apertures as entries of great moment into a volume. One sometimes sees the same means to make precious a late Regency house-front that otherwise is of a slum-like simplicity.

Where joined stones or brick suggest that they have been carved to an effect of strength and stillness, building is likely to incur a bodily ascription that in mineral semi-permanence bestows encouragement, heightened here by a light that floods in through ample apse windows of a hopeful width, contrasting with the openings between the columns. The shallow steps, the floors, the barrel-vaulting, gain in smoothness: almost the only broken or rough surfaces are the capitals to the shafts, an even-spaced accent of tremendous effect. Without it one would not be hungrily grasping the smooth plane's nor discovering them to be without severity.

Thus scanning an alternation of smooth and rough, our eyes rest finally on the cylinders supporting the tribune arch.

Church at Echillais, Charente-Maritime

PLATE 28

In commanding two flanks however truncated of the church, we are well placed to relish the seeming growth of a roundness at the corners of the façade based upon the stepped protrusions of horizontal slabs: we attribute this quality of growth and of generosity to the flat planes of masonry: in other words, rectangularity and roundness are linked in an image of organic growth, yet their at union mitigates not all the hardness and fixture of stones. Examples from a few styles only would serve to illustrate as completely as here a brotherly value shared between stone and stone. The centre, the great doorway's wedded archivolts covered with appurtenance, seem themselves to have projected as their issue the rich arcade above. Who would call the façade ornate though crowded with richness, though prolific, though many stones are sculptured?

We can see on the edge of the illustration, at the back a section of the tower's cone top, a form that distributes into the sky the round shapes before us. The element of triangularity is present in the façade where, between the squat main pillars, masonry was inset in a zigzag pattern. As we remark this pattern, sections of plain masonry appear more meaningful than hitherto: for it is of greater significance that each facet, pattern, texture, has an import equal with the rest: none lead. As we observe it in the photograph, this façade might well serve as the kind of object much sought after as a pictorial construction by some schools of modern painting, an object that just *is*, that stands for nothing,

symbolizes nothing it seems, joins with nothing, sufficient to itself. For some time I have thought that this *avant-garde* preoccupation – Braque and Picasso were already talking about the *tableau-objet* in 1910 – is a compulsion partly to be explained by our lack of a satisfying architecture, whose details can often be viewed in this way.

But perhaps you see in this cut-up façade without fragility or grace, only a clumsy charming piece of fretwork, rather than a ready-made that has been come upon among grass and trees. I do not myself transpose design thus. It is not design that speaks but object-pattern, the stone invested by design.

Sainte Marie-des-Dames at Saintes

PLATE 29

In spite of the façade's three compartments, in spite of braided archivolts and reduplicated pillars at the base, you will have the impression, particularly in regard to the vast triangular top, that this is a fine wall which has not been much tinkered with. At the same time its impact upon us rejects one of bareness: the wall has been enriched by recessed surfaces and by the fretted detail of raised planes. We see this façade as a simple wall only because we regard its features as the revelation of a power that they themselves impel us to attribute to it. We are very aware of the union here between straight and curved elements capped by the triangular, and of every change of texture, even to the extent of attributing notes in the texture scale to what is light and to what is dark.

A greater subtlety in these accents has resulted from the blocking-up of the side-windows. The fairly deep niches afford a shelter that entails no disconnexion with the world-at-large, offering both freedom and protection as any open arcade, portico or loggia may do. I once wrote: 'A loggia of fine proportion may enchant us, particularly when built aloft, when light strikes up from the floor to reveal over every inch the recesses of coffered ceiling or of vault. The quality of sanctum, of privacy, joins the thunderous day. A loggia secures the interior to the exterior, it eases the bitterness of birth: affirms that in adopting a wider existence, we activate the pristine peace.'

But this façade's blind arches suggest as well another train of thought: they resemble wheels that roll over a course of smooth stones, a rolling accentuated vertically by the cluster of cylinders at the flanks and by those dividing the façade into sections. The uniform darknesses of door and window in the midst, demonstrating other surfaces to be notched, smooth or lit, are like motionless axel-cases: what allows of light is itself from outside seen to be dark, as the eyes' pupils are. Perhaps we gaze at the broad statement of a health to which we aspire, experience an image of human process, approach what we value most as we clamber and cling in phantasy, holding like molluscs to rough and beaded

rocks, or carried by an easy tide to the smooth flanks of stone. An alternation experienced in the architectural disposition of smooth and rough surfaces, may enliven our awareness of rounded or cylindrical shapes and make poignant the palpability of the wall's jointed flatness, as if in a form of stillness we could witness simultaneously the flatness and the curving lunge of a whale's fluked tail, or as if the juxtaposition of rock and wave were completely fused.

Charlieu

PLATE 30

An effect of coined metal thinned by use: it recalls the moment on the bank counter when, with brass shovel, the cashier collects a discordant heap of coppers to pour into bags. I am reminded also of an open flower. In spite of the ceaseless decoration, first words in describing this doorway should not include the term 'ornament': we do not experience a thus heightened or gratuitous effect: on the contrary, we imagine a flowering from within the surface of the plain wall above, as if we saw the heap of gleaming coins on the bank counter to be a harvest from within it. Such an effect, apparently a manifestation of the stone itself that contrasts with an effect of an ornament stuck on to it, greatly concerned me many years ago when I attempted to distinguish those divergent though often combined characters in the architectural carving of the early Italian Renaissance. We find the first neither in the Antique as a rule, nor in the Italian periods later than 1470; in Gothic, it more commonly belongs to some late effects and to transitions from Romanesque.

The doorway before us is probably of the middle of the twelfth century: at each side the columns here have an unabsorbed Gothic look. Except for the animals, the figure sculptures seem to have haloes rather than heads which, so far as they exist or have existed, suggest lineaments stamped on coins. On the tympanum the angular Christ, seated in a mandorla supported by angels, circumscribed by the symbols of the Evangelists, disposes of semi-circular space with very great beauty: only the tympana at Vézelay and Moissac rival, I think, this rounded and even, yet angular, arrangement. Coin-headed apostles of equal height and circumference sit flattened on the frieze: the directions of their knees and legs make shield-like shapes that harp upon the form of the tympanum sculpture. The fleece of the sheep (agnus dei) that stands upon the top architrave endows with sprouting richness the field of nobs that covers the inner archivolt immediately below. In spite of the vivid, floral and coin-like patterns, there supervenes the awareness of an equality again, a lack of emphasis, a supple interchange, an articulation of the plain wall that we glimpse above. Insofar as a sense of the body-image is re-activated by the contemplation of this doorway, I think the reference points principally to the muscular interplay

beneath the skin, an entirely indirect reference, innocent, therefore, of the arbitrary impress such as we sometimes associate with the abstractions and distortions of a figured imagery.

Saint Michel-de-Cuxa

PLATE 31

A fortress-like tower to a very ancient monastery near the Pyrenees, St Michel-de-Cuxa, provides the most romantic of our examples. Almost everyone would like to have this tower in view from his window, laid against the sky as it figures here. The appeal centres in the mullioned, rounded apertures above, filling the wall-face with velvet darkness, while in the two storeys below the narrower apertures are dominated by lit walls; a castellated cornice on top is pierced with light. The walls of the two lower storeys lie back shallowly – a significance we have examined – from the simple transverse mouldings, and from the vertical masonry that is broad at the edges and thin at the centre of each side. The pyramidal base below, inclined, unopened, fortress-like, causes the squat tower to appear growing, springing from out of it, then to endure against the sky with untapering reach. The shut pyramid, rooted so widely, of course dramatizes the appeal of the apertures above, uniform in their velvet: they, in turn, make us con the stain and variation of the stones surrounding them. Our fingers, once more, our sense of texture, are engaged: our eyes explore further the relationships of volumes and planes, multiply the sensation of substance that started with a surface but proceeds as far as to endow even the surrounding air with a texture, so that it becomes related to the textures of the tower.

We will find more significant now the moody rolling of the sky and the open foreground of thistle field, or the hillside mounting at the angle made by the tower and the pyramid top, a notable element in the panorama, as seen here, of what we call 'design', by which we refer often to a balance particularly of lines, rather than of areas with their evocation of the smooth-rough scale. I think we tend fatally to restrict the meaning of design and composition. What of the comparatively newly-built wall between the church and thistle-field? The square block of these stones is meaningful between thistles and pyramid. Maybe an emotive element attaches to shapes or proportions as such, or to some shapes and proportions of which others are variants, an element that implies a reference to the body. But we do not find beauty in a square but in this wall that is square, whose stones rule over the air-determined angles of thistles. A simple perception of this kind is repeatedly overlaid – indeed, contradicted – by the staccato character of our thoroughfares. We live in a great and insecure age of graphic art: what directions, among many directions, remain unexploited? We have no benignity on a considerable scale, no slow, benign amassing, ruling,

gathering-up, as by this wall, or by the dark tree, at the edge of the hay and thistles.

Saint Bertrand-de-Comminges

PLATE 32

Details of architecture once provided to town dwellers day-by-day experiences not altogether different from those attributed by Marcel Duchamp to his 'ready-mades', objects of use that should be contemplated without reference beyond themselves either in respect to function or as an expression, a symbol, of other experiences. What is felt to stand for, to symbolize, nothing, *ipso facto* assumes the status of an object so primary that it is for other manifestations to symbolize it. No less than of Duchamp's urinal, we can say of these capitals in a cloister that they just *are*, that they communicate 'is-ness'. I would describe such an experience as mystical as well as aesthetic. From the visionary angle – Duchamp is perhaps the inadvertent witness – any object will do: some mescalin takers discover what they feel to be utter *is-ness* in anything they are happening to look at. While, in a small way, we experience here the hypnotic or visionary effect of this close-up, we are likely to be particularly sensitive to the aesthetic, the non-disembodied, values also, to the beauty, for instance, of the grooved reticulation through which we perceive the continuing shaft, or to the rippling loops, carved on the abacus, as they catch the light.

Beaulieu

PLATES 33, 34

We have wood as well as stone here, wooden doors with iron nails and the darkness from within the church, swarming out. 'High' Romanesque entrances are no less packed than famous Gothic churches with figures. Sculptures and architectural facets were coloured: traces of colouring are clear enough today inside some of the buildings and even outside, as in the tympanum at Conques. I describe not buildings but photographs, not the churches at their consecration. In view of what has been said already, I am hoping you see this sleepy prophet, upright on a crazy bed, in the same context of architectural corporeality; that you consider the rough hair and tubular arms as a rustic adaptation of shaft and capital, bent, snapping under the weight of the Last Judgment portrayed in the tympanum above; as if dramatic tension no less than engineering stress have become agents that elicit a particular embodiment out of the more generalized corporeality of my theme.

Tournus

PLATES 35, 36, 37

No sculpture and little detail: the columns are without capitals: the mouldings at the top from which the vaults spring, the patches of shadow in recessed planes or where light lessens on a rounded surface, suffice to create the gradation (pointing to a duality) that evokes our sense of texture as we observe the disposition of mute apertures, as we embrace the vast, smooth height, the piers' untapering girth. Similarly, varied courses of the wall above the lower doorway, and of the steep stairs, make us aware of separateness and self-sufficiency, a feeling that does not arise with such significance from the contemplation of an entirely uniform or homogeneous surface; the grown-up contact with an independent and varied object, distinct from ourselves, is dramatized by a unity of differing parts. At the same time we may find ourselves in alliance with the whole church as with a home, an all-embracing response the more remarkable in that unresponsive people are likely to experience emptiness, bareness, oppressive size. We, I hope, are finding not only the coherence of this bareness but its warmth, simple and so superb that for the time we remain altogether undistracted: as we gaze at this most tireless of our photographs we none the less tend to be without feelings either of envy or of inferiority.

In the illustration of part of the back of the same church at Tournus, with one of the towers, it is as if lightness and darkness were themselves solid and durable; as if the darkness of the apertures were knots of strength, as if the darkness of the tower's conical roof were a reservoir of potency reaped from the sky, as if the foreground tree showed an unsifted and disorganized condition of those materials.

Not trees and vegetation only but other buildings sometimes help in completing an architectural experience. Thus, the great belfry's apertures echo below as far as the houses, on the first of which we see that the reinforcements of the outside wall correspond with the raised planes of the tower's vertical dividing lines. Buttresses and other vertical witnesses to the lying back of the major planes point also to the tower's raised edges.

Do I depend too much on the photograph? One is certain, even so, that this is a tower of very unusual proportion because of which the eye discovers relationships further afield, an extension that I think accompanies, and indeed may be said to comprise, what we call the form in art, a contagion to galvanize any content, any subject matter, however dire, by a felicitous indication of constancy or completeness. Form does not contradict or mitigate a rabid or compulsive content in the endowing of that communication with the stature of a corporeal object whose stability may mirror an integration of the contrary impulses of the mind: without twisting them, form gives self-sufficiency to mood and emotion however extreme.

Similarly, it need not be irrelevant to discover from this photograph an interchange initiated by the rhythmic body of the church, just as formal value in graphic art may dramatize any theme of our experience. But do not think I attempt to anthropomorphize building in a literal sense. It would be most repugnant, and indeed destructive to the architectural significance. Windows do not suggest eyes, not even, as a rule, in children's drawings. If we speak on occasion of an eye-window, it is not to suggest that it sees but that a break in the wall is like a socket. Buildings are images of blindness, as it were blindly perceived, tactile and kinaesthetic images of vents, recessions and protuberances, of scale, direction and differing substance, of the 'feel' of a body surviving in a remote transposition, to which is added the surviving image also of inner working, physical and mental. I think we are bored or embarrassed by an architecture wherein such suggestions do not wholly arise from regular forms that proclaim their hard substance. The witch's cottage made from sugar, to which Hansel and Gretel came, was not of architectural consequence. In the field of architecture we desire to encounter that which appears to be notably self-sufficient. Would it were ourselves, our families and the world.

Painting
and the
InnerWorld

including a dialogue with
DONALD MELTZER, M.D.

To Telfer

ACKNOWLEDGMENTS

In regard to Turner, I would record the help and kindness of the Keeper, Department of Prints and Drawings, British Museum, and of his staff; my very particular gratitude to Mr Martin Butlin, Assistant Keeper at the Tate Gallery. Mr Charles M. W. Turner kindly allowed me to study his collection. I am further indebted to Mr Lawrence Gowing and to Mr David Sylvester for their interest and most useful advice.

A.S.

First published 1963

PART I
Painting and the Inner World

THERE IS ROOM IN THE OUTSIDE world for everybody's mental furniture to be rearranged. The artist is most convinced of it, but we are all psychical removal men on shorter hours: we are surprised to see armchairs and desks in the street before a second-hand shop; it is as if a *tromp-l'oeil* art had revealed an entire unconscious, without any aid from symbolism, without requiring imagery from a transposition.

Since we are removal men who sit down to look over their work, there is no problem concerning the contemplative character of the so-called aesthetic emotion, much canvassed in aesthetics since Kant. The inner world, indeed, perpetually forces its imprint of a symbol upon *all* perception; but art devotes itself entirely to sense-data, to every significance attaching to them, in order to focus steadily on integration of the inner world as an outer image.

Art, therefore, is a refinement upon an unceasing affective occurrence. Those averse to art expatiate upon the inner world through other activities, possibly in a manner far less testing. Art aims a blow at some forms of respectability and often provides a converse to comfort distributed by keepsakes and knick-knacks, by the preference for at least one kind of vulgarity (that sometimes serves to exclude others). A Sung bowl renders no doggy acquiescence: we must come to terms: it does not live up to us and it has lost in our eyes, or largely lost, the emblematic-cultural qualities from which it will have been fashioned. Yet the necessity remains to found art in common experience and the artist in common man. Viewed historically, the separation of the artist from the artificer, of the artificer from the ordinary man, and even of technological advances from aesthetic value, appear to be recent developments. The emergence of the artist as we now think of him implies what will seem to some a wayward emphasis upon the inner life, since our epoch cannot dare to view its technological excesses as symbols of the psyche in a deep sense, nor, consequently, much else that is made.

There is nothing surprising, therefore, that a display which was taken by them to be evidence of the tractable tameness of art, accorded with the wishes of many people who formerly used to crowd into the Academy summer exhibition; they found there illusionist models of careless perception free of deep-set principles of structure, and so of acute reference to the inner life. But those who avoid contemplation even of Nature, are likely to have over-strong defensive attitudes against contact with their inner world, attitudes of denial fortified by holidays in droves, by the reading of the Sunday paper in a closed car parked at a beauty spot, by transistor sets that drown the beach's surf. In such experiences that allow not even for her conquest in an active sense, Nature whose contemplation, whose close presence, mirrors the forms of an inner self, becomes enslaved to transistor-inspired identifications that reduce character to complacent terms. It is one lure of the circus wherein a conscious theme, other than the conventionalized *Haute École*, is the victory over four-legged beasts who, however clumsily and painfully, have been trained to ape their masters. Man celebrates still the conquest of beasts: it would be astonishing, were not beasts equated with what in himself he cannot supervise with comparable satisfaction, and would deny.

Artist or aesthete, on the other hand, cultivates some admitted inflections at least in the outer of the inner world. The artist is under compulsion to repair the inner world in terms of co-ordinating projections upon the outer. A coherence discovered in the meaning of sense-data, innocent of any justification such as the usefulness of the perception, corresponds, he feels, to the gratuitous force, as it will sometimes appear, of his reparative aim. Everyone deplores ugliness and chaos not only for the actual losses they portend but because they are referred to inner losses, inner disarrangement. The reaction on the part of the artist to this inner reference does not always evoke from him a drive for neatness, tidiness, cleanliness: he may hold such more narrowly obsessional glosses in some contempt, may even regard them too as a form of poverty, as thin denial of an evil that lies beneath, dead or dying things that lack help from wider reparative effort.

It seems desirable that I give a precise account of what I mean by the inner world, the one of Freud and Melanie Klein. Apart from the fact that I claim no precise picture, there is always the difficulty that the concepts of psycho-analysis are little known and far less understood, yet it is impossible to inter-polate several treatises available elsewhere.

The aspect of the psyche that most concerns our context is the potential chaos and the attempts to achieve stability whether predominantly through defences of splitting such as getting rid of parts of the psyche on to other people, or through denial, omnipotence, idealization, or whether predominantly by the less excluding method, the prerogative of the truly adult being, that entails

recognition of great diversity in the psyche under the aegis of trust in a good object. The word 'object' may seem obscure but it is used with determination. By means of introjection, the opposite of projection, the ego has incorporated phantasy figures (and part-figures such as the breast) both good and bad. These are objects to us not only because they have come from without but because they can retain within the psyche their phantasied corporeal character. The ego itself may be much split: many parts may have been projected permanently to inhabit other people in order to control them, an instance – it is called projective identification – of the interweaving of outer and inner relationships. Though this phantasy-commerce be deeply buried in our minds, it colours, nevertheless, as I have indicated, the reception of sense-data in much-transposed terms. Form in art, I have urged elsewhere, reconstitutes the independent, self-sufficient, outside good object, the whole mother whom the infant should accept to be independent from himself, as well as the enveloping good breast of the earliest phase, at the foundation of the ego, the relationship with which is of the merging kind. In this reparative act the attempt must be made to bring less pleasing aspects of these objects to bear, parallel with the integrative process in the ego as a whole that art mirrors no less. (Stokes, 1947, 1951, 1955a, 1955b, 1958, 1961.)

Furthermore, within a pattern of integration, there intrude narrow compulsive traits both of offence and defence in sublimated forms. We are likely to observe an obsessional aspect of art within the broad compulsion to repair and to integrate what has been threatened, scattered, or destroyed. Indeed, it is a narrower compulsive element – we shall find it in Turner – that bestows on much art a quality of urgency and inevitability, causing the spectator to feel that a rigid driving force, having attained aesthetic sublimation, becomes most impressive partly because art is never to be divorced, within its limits, from truth and understanding, and partly because a successful sublimation of obsessional attitudes subject to the major conspectus, signifies that some degree of aesthetic (i.e. integrative) employment has been won from tendencies often hostile to any integrative role.

There would be nothing to art could it be exercised in despite of temperament. Not even the framework ordained by culture can be used to contrive for aesthetic expression a rule of thumb: though his working in a settled style will cloak it thickly, the artist has needed his temperament. He may work all his life within a strict convention: on the other hand, a few of the greatest European painters have manifestly rediscovered, re-allocated, more and more of themselves in the terms of their art: their discoveries and extensions of themselves have ensued directly from further aesthetic exploration. Art is built directly upon previous art, indirectly upon the artist's courage about himself and about his surroundings. The student today builds little by rote that he can subsequently dismember, enlarge, and rebuild: he attempts an unprecedented

immediacy of expression: the close of an evolution is tried at the beginning. I believe the fruitfulness to be limited as a rule. This is the context for the appreciation of Turner in Part III.

To return to inner objects. There will have been many visitors to Rome and to the Vatican who will have found daring shapes insistent beside the traffic roar, mingling with the contrasted movements in a street. The painted forms from galleries survive, enter and inhabit the city. The palpable images that we saw welling out of walls and canvasses, touch us profoundly because they reflect figures in ourselves, incorporated figures, whose inner presence is more variable and far less orderly. We relish it that inner tensions be transformed into the outer corporeality of contrasted attitudes amid the simulated breadth of the outside world. For a few people, at any rate, there is a related perception of dreams from which only a limited anxiety remains, a similarity with the salient impressions of shape planted in our minds by Roman sight-seeing; in regard to dreams, that is, whose content we cannot at once recall. Some people may have an impression from the dream, none the less, of density perhaps, or of great space, or of a dominant form: in effect, of an epitome in the terms of substance and space. I call it an epitome because I have found that when this impression has become the surviving imprint, yet, when later, the dream has been recalled in some detail, the sensation of an arrangement of forms had been broken up into this recall, as if these formal elements had synthesized or resolved the contradictions of the content into something not only simple but tangible. Owing to the corporeal nature of the adult's inner objects, it seems that a dream can deposit a residue of sensations of shape, as does art, the more general, and therefore less painful, though not altogether distorted, perception of inner objects.

Much visual art is founded in accumulated designations of outer character and the world of space. This conscious aim provides transcendental dimensions for the inner world, in a concrete form. We do not usually associate the word 'transcendental' with a condition expressly concrete, but it is surely admissible in the case of some methods of outer contemplation, and particularly of art that offers a single object to the senses, a version of inner objects available as one interaction. Inner idols, hated and loved, together with some of the defences or rituals they impose, are compounded. Though the subject-matter of a painting be what the theologians call carnal beauty, in so far as the picture is a work of art, the particular erotic stimulus – no painted flowers seem to have scent, no aesthetic apples cause mouths to water – becomes secondary to a more general awareness of availability that has been heightened rather than dominated by the manifest erotic content. But it is understandable to mistake or to resist the point of art, to find in its scentless flowers no suggestion but of their deadness, at any rate when naturalistic art has been considered as the only norm.

It follows from what has already been said that the inner world encountered under the aegis of aesthetic form, elicits relationships to the basic good objects, namely the self-subsistent mother and the enveloping good breast or part-object. Just as an integrated psyche reads and tempers experience by the light of a firm trust in the relationship to these good objects, so the manifold expressiveness of art, in virtue of its form, figures within their orbit; the wider the expressiveness the better, as a rule, inasmuch as aesthetic form obtains significance from the varied material to be unified of the artist's temperament, of his culture and of his inheritance from art, as well as from his subject-matter. We spectators, prepared to view the modern work of art as a good object, may contemplate in this manner an aspect of our own culture that is anything but good, yet we would not need recourse to denial or to other defence. As is well known, the artist is both the leader and the servant of his time. He is able in some degree – only some degree – in accordance with a new cultural theme or accentuation, to lend himself to the expression of a psychical position that under other aesthetic circumstances (in accordance with other cultural circumstances) might or might not have been available to him. We can have no conviction whatsoever concerning the way that even the greatest of artists would have worked had they lived in other periods. The artist's perspicacity about culture, about what upholds, destroys or ameliorates his society and his art, provides both a condition and an earnest of his truthful comment upon the inner world that he finds reflected while examining any outer situation. It is in line with the common disposal of feeling by means of projection, employed aesthetically for the purpose of insight in regard to both the within and the without and their relationship: otherwise the artist would achieve no integration, no art.

This brings me to the subject of bad objects, of aggression, of envy, of all that is negative. Again, these drives, and the objects imbued with them, could not figure in art – and they figure prominently – except under the sign of co-ordination, of the form in art that stems from the presence of good objects. Tragic art, to be so, must bear nobility. But many appreciators today seem to find it more exciting if formal elements can be observed barely to survive a monstrous expression of, say, greed. What is entirely negative or chaotic, or merely unfeeling, can never be art, and what is near to it is never great art.

I myself often regret that the model, as such, may appear to be obliterated by a painter's omnipotent handling in work of a predominantly representational style; by his attack, particularly in the case of a nude, since we will probably entertain the notion of a sadistic intercourse without the sense that it has been integrated; of a conflagration or annihilation, even though, in virtue of pattern, shape and colour, we are aware that something has not only been saved from the wreckage, but unified, so that the wreckage itself has become a perilous

richness. Modern central European artists especially have been noted for this bravura, characteristic of what is called Expressionist art.

If it appears also as a more decorative kind of representational art, there exists a world of difference between the superb liberties that Matisse took in his painting of models and the cloudy stick of opalescent colour that Matthew Smith inflicted, especially upon his nudes. Here may sometimes – but not always – be found, grandiloquently told, a wealth made useless, a luxury without repletion, movement without a centre. The artist has seized upon a pose and almost painted the object out, that is to say, the symbol of a presence. It is possible that such opinions are a way of suggesting that Matthew Smith was, in a strict sense, but a moderate draughtsman, without entire reverence for the subtleties of figurative three-dimensional construction within the convention of which he worked; without the appreciation that this structure should initially involve (allied though it must be with the modeller's masterful handling), of the independent object in its own space, separate from the self as well as at the self's disposal. Smith's flourishings *alone* – not so Turner's we shall find – often overthrew separateness. He employed an exaggerated chiaroscuro pictorially to overpower a powerful model with an aggression that seems to me to lack much combination from florid love, unlike the Baroque painters who used this weapon. His handling, while it provides a rich co-ordination – there is *some* florid love – in general substitutes itself as the object for the model, for her virtue as the symbol of a presence, external and internal, a tendency of modern painting that is questionable only in the naturalistic language. The abstractions and total distortions of *avant-garde* painting and sculpture are often the means of avoiding the problem altogether: hence the perfection of its best achievements somewhat in the manner of music and architecture.

Like the dominant impressions gained from Rome, we possess in some abstract art an intense figuration for the concourse of corporeal inner objects (and for the restored outer object), though divorced in this case from the significance of their attachment to precise and self-subsistent models from the outside world: and it may well be that in common with most image-making, exaggeration and distortion in modern representational art has proceeded less from aggression than from the need to describe inner states as far as possible as such, in an outer form. But Matthew Smith, together with other English painters of his time, often preferred not so much to re-fashion, as masterfully to override, the model: we glimpse her most sensationally like a martyr among the flames: those are her bounty, for, of course, we have bounty from art, though it is by no means always entirely pleasant. Much painting communicates a richness, a voluptuousness, by means of greedy, masterful attitudes that borrow for their qualification as art the co-ordination of adult feeling. I do not doubt that this is often most popular among those who can 'take' it, even, and perhaps especially,

among aesthetes, or that it provides a common appliance by which the en-velopment aspect of the aesthetic experience may be magnified. For, inasmuch as a part of negative feeling is commonly less integrated, being entrenched in retrograde and split-off positions, a handling of paint that little expresses love in its attack, is likely to bestow upon the object made, and/or the object re-presented, a part-object flavour, though there must survive as well the opposite co-ordination inseparable from aesthetic value. This role assigned to aggression in art, also the enveloping aspect of form in general, has some connexions with an inchoate or unlimited value that transports the 'soul' (whose fund of feeling is equally vast), attributed by some aesthetic theories between Addison and Kant to what was called 'the sublime', a value that came to be opposed, parti-cularly in the guise of contemplated terror and discomfort by Burke in his treatise of 1756 or 1757, to 'a composure of the parts' reserved for the character of beauty, more connected, it seems, with self-sufficiency than with the over-whelming or enveloping character of a part-object.

Of course we must expect, and desire, aggression to figure prominently in art, so as to be integrated there. We shall find it in Turner, but not at all in the terms of an omnipotence. I would be glad to own a Matthew Smith. I am cer-tain, however, that he was by no means a great painter, and consider that his example is unlikely to be inspiring. He often achieved vibrancy, *forcing* upon his art an immaturity, it seems to me, of libidinal feeling: the large-handedness appear spurious when compared with the more generous flourish – generous to the objects depicted – of Smith's Baroque ancestors whose curving line envelops us also. Some 'powerful', straining artists provide a caution concerning the nature of art: ambivalence will not be aesthetically resolved in terms of its waywardness but by an integration that holds the negative as such within view. Great artists, still in terms of aesthetic co-ordination and even of beauty, have shown that behind and beyond aggression there stretches the domain of refusal and of death.

What has usually happened to the co-ordinating factor in this circumstance of stress for the good object? Burke announced in the eighteenth century that sublimity, where it engenders delight – this includes art – involves a 'tranquillity tinged with terror'. I think we must refer to a similar situation many noble styles, stylizations and systems of proportion, withdrawn, ideal and generalized, that can subsume a forthright expressiveness. If, as some people say, a circle is beautiful, or any geometrical figure, they can but mean that beauty resides in the delineation of such a figure on its ground: unlike the idea of circularity, an actual circle is inconceivable without the ground it modifies. I believe we should pay homage not so much to the beauty as to the feeling of order inspired in us by such remote and impersonal figures that dominate, as do the formal elements in art, the often gross particularity of their *mise-en-scène*. Formal authority, we

215

have seen, is exercised in the universal context of ambivalence: it serves in art as an affirmation of generalized, of the least threatened, and therefore of the minimum, the safest, idea of structure. Certainly even the triangle can be broken up into lines, but perhaps the very impersonality protects, so that the identity of these minimum structures surmounts all but the most violent split-ting. It is not unknown in the case of a psychotic child for all his objects to be reduced to numbers and to geometric forms. (Diatkine, 1960.) A reliance upon a minimum yet regular object may well characterize the compulsive aspect of the mathematical or musical prodigy, more certainly of *idiots savants*.

But in spite of the analogies, and even comparisons, with the reduced objects of psychotic defences, I do not for a moment wish to suggest that what I call here the minimum object in art is predominantly the outcome of denial and splitting; on the contrary, the virtue in art of such wide regularity is the capacity to engage contents at loggerheads with each other, or those impossible to reconcile with a less abstracted kind of order based upon the trust in goodness. There comes about in this way stability and safety. True enough, a degree of bare formulation is the prime instrument in art of echo, of pattern and so of *any* co-ordination; it is the means as well for linking expressiveness. Moreover, painting and sculpture will have been much influenced by the formal conditions of music, and particularly of architecture. But when I consider the durability of many aesthetic structures, I want to make a further connexion with a safety imputed to the ego and to the reconstituted object *under all circumstances*. Though at the same time outside objects be delineated, we have seen that the comprehensive yet acceptable mode for recording the pressure of the inner life belongs especially to the part of the construction dependent upon what might be called faceless shapes. We do not, and must not, have in graphic art perfect geometry, but we often need indications of regularity, in terms of pattern and echo, that predispose us to search for suggestions of the simplest geometric figures to which so much subtlety and variety seems to have accrued, inasmuch as descriptiveness of the outside world has here bestowed the element of particularity. Art is warm, intimate, yet steadied by the tremendous safeguard of owning a quality that in isolation would be impersonal and withdrawn. While describing a figure, an artist searches for the larger, the simpler organiza-tion that, in the case of a nude, may overlap even such prominent shapes as the breasts. We are often then powerfully aware of a lively significance based upon a skeletal strength, whereas the abstractions employed in other disciplines can rarely be felt to underline the reconstitution of a particular situation with a comparable thoroughness.

A good drawing may be lascivious, but the artist will have noted the cold facts, for instance the position of the navel in respect to the nose (of course, there is a sense in which this is not a cold fact), the relationship of key points in

regard to vertical and horizontal lines. The character of the pose depends upon a suspicious exactness in such matters, upon a power to dismiss the model, to see her for some of the purposes of draughtsmanship as made up of flat patterns. Thus, an aspect of the draughtsman's talent, meaningless by itself, is his facility to see a hand not as a hand but as areas of tone from which he extracts the pattern, the proportions, as well as the effect of relief, wider truths of its appearance that serve also in this kind of drawing to mirror an aspect of the inner world. These impersonal-seeming preoccupations, together with the austere or 'geometric' elements of design in general contribute to the resistant armature of the aesthetic object. During another part of the act of drawing – it should of course be exercised at the same time – when the artist makes marks for the folds of the stomach, say, he is likely in phantasy to be digging into it. I find it difficult to see how these attitudes could more than co-exist, in that they illumine each other through their co-ordination, did not one of them spell out the impervious endurance I have described under the name of a minimum object.

But not every artist – and no artist all the time – has taken full advantage of the hardiness latent in design and pattern: not every artist predominantly grasps or twists his object while trusting to this safeguard. My oldest contention in this field is that differences of approach between carving and modelling characterize pictorial conceptions as well as conceptions in all the other visual arts. (Stokes, 1932, 1935, 1937, 1949.) The carver, in a manner more nearly concrete, is jabbing into a figure's stomach. The compensatory emotion is his reverence for the stone he consults so long: he elicits meaning from a substance, precious for itself, whose subsequent forms made by the chisel were felt to be pre-existent and potential: similarly in painting there is the canvas, the rectangular surface and the whiteness to fructify, a pre-existent minimum structure that not only will be gradually affirmed but vastly enriched by the coalescence with other meanings. What a contrast, this side of art, to the summary, omnipotent-seeming aspect of creativeness, to the daring, the great daring and plastic imposition that are even more characteristic and far more easily recognized and applauded, qualities that cause us to clutch at them, or that tend to envelop us.

But it has also always been my contention that some exercise of both approaches must figure in visual art. Nevertheless, the greatest exponents since the Renaissance of the rare type of painting that reveres outside objects for themselves, almost to the exclusion of projecting on to them more than the corresponding self-sufficient inner objects, have had the least, or else the tardiest, recognition of their supremacy. Those immense heroes of painting, Piero della Francesca, Georges de la Tour, Vermeer (Gowing, 1952), were forgotten and rediscovered only in the last hundred years at a time when texture, the heightened expressive use of the *matière* of painting, a substitute for pleasures in past ages available from buildings, was much on the increase. Their rediscovery, then,

points to the connexion between this care for material and a non-grasping approach in general, since it is not at all the surface or texture of paintings by these Old Masters that most characterizes, in their case, the 'carving' attitudes to objects.

I end invoking Piero, de la Tour, and Vermeer since it may be opportune to re-assert, in line with much I have written before and with the papers by Dr Segal (1952 and 1955), that whatever the projection of narrow compulsions to which I have referred, whatever the primitive and enveloping relationships that ensue, the reconstitution or restoration of the outside and independent whole object (expressive equally of co-ordination in the ego) whether founded entirely, or less founded, upon what I have called minimum or generalized or ideal and impersonal conceptions, remains a paramount function in art.

PART II
Concerning the
Social Basis of Art

DONALD MELTZER, MD
IN A DIALOGUE WITH ADRIAN STOKES

MELTZER

You have asked me to amplify what I said in our conversations that followed your paper *Painting and the Inner World* (similar to Part I of this book), read to the Imago Group.

As a practising psycho-analyst I shall draw from clinical and theoretical knowledge the implications of Melanie Klein's discoveries, with the aim of adding to what has already been written by Dr Segal and yourself. On that foundation I shall try to extend understanding of the relationship between the artist and his viewer: hence, more widely, my concern, in this dialogue with you, will be the social value of art from the psycho-analytic angle. But first I shall want to comment on art as a therapy for the artist, especially in regard to one of the themes of your paper.

Freud, and other writers following his lead, considered artistic creativity to be a part of mental functioning very closely related to dream formation. They have explained the manner in which artistic creativity, like the dream, is taken up with a working over in the unconscious of the residues of daily experiences, particularly those of the repressed unconscious. The Kleinian approach to art has tended to emphasize a more systematic self-therapeutic process of working over and working through the basic infantile conflicts that go on in the depths in relation to internal objects. The most constructive part of this process attempts to build a firmer passage from the paranoid-schizoid to the depressive position by way of internal object relations, consolidating, stabilizing the internal world.

STOKES

Before you go on, I think you must supply an account of what is meant by the paranoid-schizoid and the depressive positions.

MELTZER

Since later on in this dialogue some implications will be drawn from Melanie Klein's formulation of the two positions, I shall restrict myself at this point to a brief differentiation between the concept of *position* and the other, more clearly developmental, concepts of *phase* and *primacy*, formulated by Freud.

Freud conceived his meta-psychology to have four aspects, topographic, genetic, dynamic and economic. Among the genetic phenomena he discovered developmental sequences that seemed to be biologically based (though open to environmental modification), centred on the shifting of primacy between erogeneous zones, oral, anal, phallic and genital, as the libidinal organization of the infant and child developed. The discovery of the focal office of the Oedipus complex directed attention to *phases* of development, pre-oedipal, the period of oedipal conflict dominance, latency, puberty, adolescence, maturity, climacteric and senescence.

Melanie Klein's formulation of two *positions* does not conflict with these concepts. The emphasis lies with the organization of the self, together with the value systems involved in object relations. The formulation is only secondarily genetic in its reference, since progress from the paranoid-schizoid to the depressive position (or regressions in the opposite direction) fluctuate throughout the course of life: the transition is never complete.

The essence of the transition is twofold: on the one hand there is the struggle towards integration of self and objects, especially internal objects, whereby splitting and exclusively part-object relations are overcome in favour of integration of the self and of whole-object relations characterized by the separate and self-contained qualities imputed to objects. The transition requires as well a shift in values from the preoccupation with *comfort, gratification and omnipotence* characteristic of the paranoid-schizoid organization, to the central theme of *concern* for the safety and freedom of the good objects, particularly again, internal ones, and especially the mother, her breasts, her babies and her relationship to the father.

While this shift in value systems has a link with Freud's distinction of primary and secondary process in mental functioning, it is by no means synonymous with it. Another item of importance, however, presents an identity of concept, though the form is expanded. Freud's categories of anxiety and guilt find expression in Kleinian theory with the conception of two spectra of mental pain, the persecutory anxieties of the paranoid-schizoid position and the depressive anxieties such as guilt, shame, remorse, longing, etc.

Now you will recall that in conversation, talking about your concept of a minimum object, we found ourselves involved in a discussion that turned out to be an investigation of the difference between what might be called 'safety' in one's internal relationships as against 'security'. I put forward to you something

that I think is inherent in Mrs Klein's work. There is no such thing as safety in object relationships to be found in the quality of the object itself. In contrast to processes characteristic of the schizoid position in which idealization, for instance, attempts to remove the object from the realm of interpersonal processes, subject to envy and jealousy, or where the splitting mechanisms attempt to reduce an object to a point where the impulse to attack it and fragment it further, is diminished; in contrast to these mechanisms of the paranoid-schizoid position, the very heart of the depressive position is the realization that security can only be achieved through responsibility. Responsibility entails integration, that is, accepting responsibility for psychical reality, for the impulsivity and affects and attitudes, for all the different parts of the self *vis-à-vis* internal and external objects. Inherent in the concept of the depressive position is the realization that the drive towards integration is experienced as love for an object, that is, as the experience of cherishing the welfare of an object above one's own comfort. It is also implicit in these theories that, for an object to be loved, it must be unique and it must have qualities of beauty and goodness which are able to evoke in the self the feelings of love and devotion. The corresponding inner object that undergoes a development parallel with the self's integration, achieves those qualities as it becomes fully human in complexity. Thus it demands a life of its own, freedom, liberty of action, and the right of growth and development. In relation to such an object the feeling of love arises; the impulse, the desire, is aroused to take responsibility for all those parts of the self that are antagonistic and dangerous to the object. In essence this is the basis of the drive towards integration, towards the integrating of the various parts of the self. It perhaps is also important to mention that love for the truth becomes very strongly allied to the capacities to appreciate the beauty and the goodness of the object, since manic defences, and through them the danger of regression to the paranoid-schizoid position, have their foundations in an attack on the truth.

I think that, in so far as the creative process is an entirely private one, we have learned from Dr Segal and yourself that we should think of the artist to be representing in his art work, as through his dreams, the continuous process of the relationships to his internal objects, including all the vicissitudes of attack and reparation. But if we say that the artist performs acts of reparation through his creativity we must recognize that in the creative process itself, phases of attack and phases of reparation exist in some sort of rhythmical relationship. This implies that the artist, at any one moment of time in the creative process, finds his objects to be in a certain state of integration or fragmentation; he consequently experiences a relative state of integration or fragmentation within the infantile components of his ego in relation to his objects. It must be recognized that this process necessarily involves great anxiety. In

referring to anxiety we must remember that we have in mind the whole range of persecutory and depressive anxieties.

STOKES

You are going on to speak of the role of projective identification in regard to art. Before you begin, I would like to comment on what you have said about the plain projective character. My paper, the context for this discussion, is concerned with the ordinary projection of inner objects (though I had something to say as well about the strong projection into us of haunting shapes). You accepted it as our point of departure for this discussion, with one important exception, in the matter of what I called 'a minimum object', a phrase by which I drew attention to the bare, generalized, sometimes almost geometric, and in general, ideal, plane on which much art-work takes place. In the interests of the fight for integration, characteristic of the depressive position, about which, in accordance with Hanna Segal's formulation, we entirely agree that it provides the *mis-en-scène* for aesthetic creation, you object strongly to a mechanism in art, as seen by me, that forges safety for the object. You have just said, very notably: 'There is no such thing as safety in object relationships to be found in the quality of the object itself. In contrast with processes characteristic of the paranoid-schizoid position in which idealization, for instance, attempts to remove the object from the realm of inter-personal processes, subject to envy and jealousy, or in which the splitting mechanisms attempt to reduce an object to a point where the impulse to attack it and fragment it further is diminished; in contrast with these mechanisms of the paranoid-schizoid position, the very heart of the depressive position is the realization that security can only be achieved through responsibility,' i.e. for 'all the different parts of the self *vis-à-vis* internal and external objects.'

I am very far from wanting to quarrel with that statement, as you know. But you have gone on to say that art mirrors the *struggle* for integration and for an integrated object; and that there are alternations of integrated and unintegrated states in the very process of making art. No one can doubt for a moment that a trend towards idealization characterizes much of the greatest art (nor the aggressive projections against which idealization is one defence). I think that a large part of the reassurance provided by art exists in the service won from paranoid-schizoid mechanisms – the transition is never complete, you have said – for what is, overall, a triumph of integration on the depressive level. Even in the best integrated people, something, at least, of the earlier mechanisms remains active, in satisfactions as well as in the conflicts. Indeed the primitive identifications, with an oral basis, that tie society, are always particularly to the fore. The fact that you are going on to speak of the relevance to art of the primitive mechanism of projective identification among others, makes me

chary of cutting any ground from under foot in the matter of early mechanisms and the production of art. Now, in *Envy and Gratitude* Melanie Klein wrote that it is not always possible to distinguish absolutely between the good and the idealized breast. Someone has said that art brings together the real and the perfect. This is not primarily a question of sugaring the pill of reality as Freud, I think, suggested the role of form to be in clothing the artist's day-dream, since to this element of invitation as he saw it, we attribute a far more fundamental part in the chemistry of the pill. All the same, art can easily be debased into a sugar-coated product that usually has great popularity among those who are hostile to art for whatever reason.

MELTZER

I think Mrs Klein was stressing the fact that only by knowing the genesis of an object can we be certain of its value. The clinical material that I shall present will demonstrate it. First, as you have indicated, I want to talk about the concept of projective identification. This is an essential concept of Melanie Klein's work, very different from the earlier Freudian concept of a projection concerned primarily with ideas, impulses, affects and attitudes. Mrs Klein's concept defines the mental process by which very concretely portions of the self and internal objects are projected into objects in the outer or the inner world. She emphasized both the normal and pathological uses of projective identification, stressing what she called 'excessive' projective identification, excessive in so far as it was primarily sadistic and destructive in intent, or excessive insofar as it was so dedicated to the search for freedom from anxiety and pain as to interfere with the normal working through of conflicts. Bion, on the other hand, has described, particularly in his recent Congress paper, the role of projective identification in communication; he has brought this concept to the fore as the mechanism of primitive *preverbal* communication. However, since we are talking about art, we mustn't restrict this aspect to *non-verbal* modes of communication. Projective identification plays a part in *verbal* communication also where it transcends the syntactic mechanisms for transmitting information, information, that is, in the mathematical sense. What is communicated by this mechanism is the *state of mind* of the projector. Individuals vary greatly in their capacity to use this technique, likewise in their sensitivity to its reception. On the other hand, a strong tendency to use projective identification for very aggressive purposes seems always to be coupled with an increased vulnerability in the face of its aggressive use by others.

If we understand projective identification in this way, we can recognize that the artist during the creative process, when confronted with the anxieties inherent in the flux of relationships to internal objects, at any moment may be impelled by the pain within him to seek relief through projective identification

223

in the sense Mrs Klein spoke of as 'excessive', that is, excessive in terms of the sadistic and destructive intent of projecting it into other people, due to the complications of the guilt involved, or excessive in the sense of endangering the on-going nature of his own dynamic process. On the other hand we must recognize that the impulse to communicate through projective identification, plays a central part in the normal relation to external objects in the depressive position, implementing the desire, as Bion has stressed, to be understood by objects in the outside world, especially where they are closely linked with the primal good objects of the inner world. It plays an important role also in the relationship to siblings, embodied in the depressive concern for all the mother's babies. I shall come back to this aspect later. What I want to emphasize at this point is that the social impulse involved in artistic creativity – this includes the exhibiting of creations – derives in the first place from the pressure towards projective identification. In constructing a theory of art we must therefore consider the theoretical possibility of what I will call at this point *good* and *evil* art in terms of the motivation behind, not the basic creative process, but behind the exhibiting of the artistic product. In order to avoid muddle in language later on, to use *good* in this sense would mean that we would, in talking about what is ordinarily spoken of as good or bad art, need to change our terms to *successful* and *unsuccessful* art.

At this point I want to introduce two bits of clinical material from children that illustrate the impulse towards artistic productivity derived from the need to use projective identification. One of them is an example of the need to project a destroyed object, and the other is an example of the need to project a destructive part of the self. The first material is from a little girl who was four at the time. In her analysis she was very much preoccupied with her greedy relationship to the breast, following the birth of a sibling who was being breast-fed. During the session I have in mind, she made out of plasticine a little hot-cross bun which had many times been recognized as linked with the approaching Easter holiday. As soon as I interpreted to her the connexion between this good breast, the hot-cross-bun breast, and the anxiety about my going away at Easter, she began to stab and mutilate the little plasticine bun. In the midst of it she stopped, her whole mood changed from vicious attacking to one of smiling benevolence, and she pointed to the box in which her crayons were kept. This box had, on its outside, pictures of animals. She pointed to one of them and said, 'Oh, what a precious little robin redbreast.' You can perhaps see that she was attempting to project this mutilated breast by presenting it in a hypocritically idealized form for me to take in, as though it were something good and beautiful.

STOKES

I find your interpretation relevant to a danger in the situation of art. It illumines

artefacts we call pretty or prettified in a derogatory sense. In so far as such artefacts may without exaggeration be called nauseating, it is to be explained in the manner you have interpreted the 'precious little robin redbreast', a clear gain for understanding, especially in regard to the sugar-coated product that deceives the Philistines: or is it that they would like art to be thus debased? I think they are trying to share the pleasures of art in the sickly and contradictory context of denial.

MELTZER

The experience of nausea, as a mental or physical reaction, illustrates the concreteness with which projective identification works. The second bit of material is derived from a five-year-old boy who in the transference situation, following the weekend, was extremely preoccupied with my children at home and expressed his attacks upon them, representing the attacks on the babies inside the mother's body, by taking the crayons out of his box and breaking the points off. He crushed up these points, verbalizing his vicious attacks on these babies and mashing them up, saying he was making faeces out of them.

At this point the viciousness of his demeanour changed. There was first a moment of anxiety, and then he began to smile, became rather elated, and went over to the tap. He got a little water which he poured on the table, and stirred the bits of crayons which are a type that tends to dissolve in water, making a water colour.

After he had mixed the water and the colours, smiling, and in somewhat of a manic way, he went to his drawer and took out a block of wood and dipped this into the coloured mixture, which was now muddy brown. He then went over to the wall and verbalized that he was printing pictures. Each time he made a muddy smear on the wall he would stand back and admire it, confabulating to it that it was a picture of gates, that it was a picture of trees, there were houses and so forth.

I think that you can see what had happened in this play. During his symbolic attacks on my children, very concrete mutilation was being done to his internal mother's babies. He had suddenly become confronted with an excessively painful situation inside himself, particularly the painful responsibility of depressive feelings connected with the attack, as I knew from previous material. In his exhibiting the process of turning these faeces, derived from attacks on the babies, into paints and then into paintings that I was expected to admire, he was inviting me, by demonstrating the process, to relish, and thereby to wish to emulate, the omnipotence of his creativity. By this means also, of course, he meant to project into me that part of himself that tortured mother by making her watch her babies being killed.

STOKES

A connexion between faeces and paints, between the omnipotent use of faeces and of paint, has often been remarked. You suggest one way that the artist may be rid of his faeces in so far as they contain something bad, while at the same time they provide the means of omnipotence, and even sometimes of good communication.

MELTZER

Yes; it illustrates the point I referred to earlier when I said that Mrs Klein had shown that only by knowing the genesis of an object can we be certain of its value. This is perhaps one reason why retrospective shows of an artist's painting are more convincing and reassuring than a single example of his work.

Having now discussed projective identification in both its destructive aspect, and its constructive aspects as an instrument for communication of a primitive and concrete sort, I think we are in a position to examine the psychology of the person who views art. (Of course we are not restricting ourselves to the viewing of visual art only.) I am talking about people who view art as an important, and perhaps even central, part of their inner-life processes. I am therefore excluding the people who view art from more peripheral motivations. It will perhaps be useful to indicate that, in so far as contemplating art is a form of intercourse between viewer and artist, it has an exact parallel in the sexual relationships between individuals. We would want to distinguish here between events in which sexual relationships are casual regarding choice of partner, being in this sense a direct extension of the masturbation process. (By this I don't mean to imply necessarily that it is an extremely harmful or sadistic matter.) In contrast, there are those events of sexual intercourse in which contact with the other person's inner world is central. Here, of course, we would have to distinguish between acts of love and acts of sadism, again in the latter case not necessarily implying that these acts of sadism would have to be carried out in objectively perverse ways. In acts of love we know very well that processes both of projecting love and good objects, as well as of introjecting from the love-partner, are going on. In a similar way, in a destructive intercourse the projecting of bad parts of the self and of the destroyed objects, as well as the masochistic submission of one's self to this form of abuse are enacted. There is a parallel, then, in the intercourse between the artist and the viewer: the artistic production itself is a very concrete representation of what is transported. I think that the viewer we have in mind is not at all at play: while his social relationship to his companions may be part of his play life, towards art he is *at work*, exposing himself to a situation of intensely primitive (oral) introjection through his eyes or ears or sense of touch. That is, he enters a gallery with the aim of carrying out an infantile introjection, with the hope, in its constructive aspects, of obtaining

something in the nature of a reconstructed object. Conversely, in a masochistic sense, a viewer may be going to expose himself to the experience of having projected into him a very destroyed object or a very bad part of the self of the artist. This aspect of masochism I have discussed a bit in my paper on Tyranny.

I would like to illustrate this with clinical material from the same little boy that I've spoken of in regard to the printing on the wall. At a point in his treatment when he was in extremely close touch with me as a good mother who was feeding him the analysis, he was standing by the table, leaning against me, with his thumb in mouth, after having asked me to draw for him a diagram of the analysis and the sessions he would be having until Christmas. During the time he was leaning against me, he was looking at the wall opposite and said, 'Oh, it's so shiny, like a television screen!' And he said, 'Oh, I can see fishes swimming around.' At this point he took his thumb out of his mouth and commented that it was quite shiny too, that he could see in it the reflection of the light bulb that was over my head. He then very carefully, keeping his eye on this shiny spot on his thumb, put it back in his mouth and said, 'I've got it.' What I want to bring out in this material is that this little boy was having an intense experience of sucking on the breast, and you can see that sucking on the breast was accompanied by a particularly vivid experience of feeling able to look inside the mummy's body and to see all her little fish-babies, restored, swimming about – it is implied – quite happily free from his usual attacking impulses. That is the kind of breast and breast-mother he felt himself to be introjecting at this point, represented by the shiny spot reflecting the light bulb that he put into his mouth and sucked upon. I am suggesting to you that the viewing of art is an expression particularly linked to this component of the breast situation, that is, the feeling of looking and listening to the events going on inside the mother, of seeing either the intactness of her inner world, or conversely, of seeing the destruction that has been wrought there. It means an experience of allowing, in the first case, the introjecting of this goodness and intactness and, in the second case, exposing oneself to having destruction pro-jected into one.

STOKES

I think you could say that because an evocation of the breast relationship and of the relationship to the mother herself are built into formal presentation as a perennial basis, we are induced, far more strongly than we would otherwise be, to contemplate the detailed reflections of the processes of the inner life that a work of art may contain.

What you have said about the oral introjection performed by the viewer points particularly to the enveloping action of a work of art and to the breast relationship from which it derives. The work of art is basically a reconstruction

227

not only of the whole and independent object but of the part-object, the beneficent breast. I refer once more to the general, the formal, value rather than to the impact, thereby magnified, of a subject-matter that may be negative, that may invite, as you suggest a masochistic state of mind. I would only add, in part; that even in such a case the post-depressive co-ordination altogether necessary, we are agreed, to the creating of art, will have been affirmed, transmitted, however indirectly. To put it another way; when a discernment of inner states, however horrific, however dispensable by means of a sadistic projection, is stabilized in terms of aesthetic oppositions and balances and other aspects of form, some co-ordination, some bringing together, will have occurred at the expense of denial; and this bringing together will have required, at the fount, the shadow of a reconstructed whole-object and part-object whose presence can at least be glimpsed in the very existence of an aesthetic result. Thus, a painting that represents violence, disintegration, provided it be a good painting, of the full calibre of art, should remain not at all unpleasant to live with, day in day out. Earlier on, you have distinguished between 'the creativity, the projection of it' and 'the exhibiting of the artistic product'. I am not so willing to separate as entirely as you do for some instances, all the motivations in these two activities.

To avoid misunderstanding, I think we should remark that the fact that many people are disgusted or outraged by a new departure in art, does not necessarily have a predominant bearing on the intentions, conscious or otherwise, of the artist. In my paper I discussed the dislike of art from the point of view of the fear aroused by so vivid a comment upon psychical reality. Maybe, though, this is important in putting the artist on his mettle.

As to sexual intercourse as a process identical in its method with relationship to the art-object, while endorsing the interchanges between viewer and picture that you suggest, I would like to add that the relationship exists, as does the parallel, only because of the essential otherness, the character of self-subsistent entity, the complement to the breast relationship, that has been created.

MELTZER

We are agreed that the successful work of art is compelling; it induces a process in us, an experience whereby the viewer's integration is called upon in the depressive position to restrain his attacking impulses, for the sake of a good introjection; it means allowing the good object to make a good kind of projection into one's inner world. It requires judgment to distinguish the good from the bad processes of sadism in the artist and masochism in himself, the viewer. I think it follows, therefore, that the experience of viewing art can be extremely taxing and extremely hazardous, but that the art-world, as an institution within our culture, provides a medium for people to carry out this

introjective process in an atmosphere of relative external safety, corresponding to the safety of the little infant in the relative restraint of the mother's arms. When one walks into an art gallery, one is surrounded by other people and there are guards and so on; all this constitutes a continual external support to one's internal safeguards against attacking the pieces of art that are exhibited there. Similarly at a concert. It is well known that, in contrast to this safe viewing of art, at times of revolution or warfare, pillaging includes a wholesale destruction of everything of artistic value. There are instances when people of extremely unbalanced mental state have attacked priceless works of art in galleries.

I want now to discuss the implications as regards the social motivation in the artist for producing and exhibiting good works of art. I presume that this social motivation is present from the beginning of his artistic development but that it becomes stronger and stronger as his maturity as an artist is achieved, maturity not only of mastery over his materials but particularly of the sense of stabilization through his artistic activity and other processes in his social and internal life, of his relationship to his own primal good objects in his inner world. I have said earlier that it is necessary for a theoretical approach to recognize the possibility of evil motivation in the exhibiting of art, that is, either as a means of projecting the persecutory or depressive anxieties connected with destroyed objects into viewers or, worse, as a means of corrupting and attacking their internal relationships. But I have also stressed that the motivation for exhibiting good works of art is derived from two sources: first of all from the desire to be understood and appreciated by others, as an important element for reinforcing the capacity to carry on with painful struggle toward the depressive position; and second, I have implied that there comes a point of stabilization in the inner world when that element of the depressive position that has to do with feelings of concern for 'all the mother's babies' becomes very dominant. At this point, I believe, the impulse to exhibit works of art, representing the artist's progress in working through his depressive conflicts, begins to take a form that could rightly be called the impulse to *sermonize*. In this sense every work of art, from such a period of an artist's life, has the function of a *sermon to siblings*, a sermon which is not only intended to show what has been accomplished by this brother but is also intended to project into the siblings both the restored object as well as to project those capacities for the bearing of depressive pains which have been achieved by the artist in his own development. Seen from the spectator's angle, the viewing, and the yearning to view, the work of masters would not only derive from the relationship to the product of art as representing the mother's body and the contents of her body; it also represents the relationship to the artist as an older sibling from whom this kind of encouragement and help in achieving a sufficient devotion and reverence for the parent is sought.

STOKES

You have now carried further your contribution on the role of projective identification. It brings me a feeling of light, first in regard to a matter that has been of particular importance. Things made by man please and depress the aesthete through a mode far more intimate than in his contemplation of Nature. You explain it by introducing the projective identifications of which the viewer of art is the recipient. I wish there had been the occasion for you to re-introduce here from your Tyranny paper your conception of the smugness remaining in the projector of evil, and that you had brought it to bear in connexion with a remark you made to me about the effect on us of much Victorian architecture.

As to sermonizing to siblings, I cannot refrain from mentioning that I found long ago that I could provide no other word than 'brotherliness' to denote an interplay of equal, non-emphatic, forms in some of the greatest painting.

In applying psycho-analysis to the social value of art, to the manner of communication and to the role it plays in the calculations and satisfactions of the artist himself, you make a new beginning. It is from your angle, I think, that what appears to be the slavery of the artist will be most fruitfully approached, an aspect, I have pointed out elsewhere, entirely ignored by psycho-analysis. I mean the subjection of the artist to his time, and therefore to the art of his time, inasmuch as art must reflect typical concatenations of experience, of endeavour, in the milieu in which the artist and his public live; otherwise the artist's achievement of form seems to be nearly always without urgency or power. This cultural expression of significant dispositions both perennial and topical (underlying the creation of significant form) that may completely change the emotional bent, as well as the style, of art, will have entailed a novel psychical emphasis. Since we aesthetes are inclined to agree that the creator's prime social task is to help his siblings with their conflicts in a contemporary setting, identifying stress and the resolving of it with accentuations appropriate to a particular environment, just as each individual on his own is bound to do; since the artist's attainment of aesthetic value is understood to be inseparable from what is both subservience and leadership, we realize at once the penetration of your approach.

I fear that this may sound as if I thought a painter's work must include sociological comment. Of course it is not so. He is concerned with value in the inside and outside world, the value of landscape, say, to himself and to his contemporaries, a value that sometimes entails resuscitation of a discarded aesthetic tradition as he looks with new eyes, conditioned by current ideas, not only at Nature but at the art of the past. This application of the inner world to outside situations accords with the sensuous condition of art and especially with some degree of naturalism.

MELTZER

I believe that the question you are raising now is one we must attempt to deal with if this present paper is to make a contribution, for, as I have said to you privately, all that we have been discussing up to this point has been either stated or adumbrated by yourself and Dr Segal. Because of the concreteness of the splitting within the early ego, during the reintegration process of the depressive position the different fragments of the self hold a relationship to one another as siblings. It is characteristic, as seen in the analytic process, that the reappearance of a formerly widely-split-off part of the self, and its renewed availability for integration within the sphere of the primal good objects, are experienced by the already-integrated parts of the self as a 'new baby' situation. The resistance to the admission of this little stranger to the family of the integrated self derives from the spectrum of anxieties and jealousies characteristic of the birth of a sibling. But against these resistances is balanced the pull of the good objects, the determination of the parent figures to nurture *all* their children, regardless of qualities, hopeful of enriching the impoverished, and pacifying the rabid.

Such is the painful struggle in psychical reality towards integration of the split-off parts of the self and towards enbracing *all the mother's and father's babies*. Progress in psychical reality is accompanied by modifications in attitudes and behaviour in external reality. Idealization of the in-group, and its corresponding paranoia, diminish, Guilt-laden feelings of responsibility, mixed always with contempt, give way to more genuine concern and respect for the potentialities of others.

But where progress is considerable – and I think this is often experienced by people in analysis – a very painful disequilibrium comes to pass, where the internal sibling-parts of the self improve, and the security and happiness of the primal good objects correspondingly improve, far in excess of what can be seen to be going on between siblings and mother earth in the external world. Also it becomes evident, as processes of reparation are more firmly established in psychical reality, that its corresponding process in the external world is very partial, limited by the frailty of the human body and its limited power of rejuvenation, extrapolating to zero at death. Further, the laws of psychical reality differ considerably from the laws of external reality where non-human agencies, structuralized as 'fate', play with human affairs, ten tragedies to every farce.

The agonizing problem thus becomes: How to live with a relatively harmonious inner world enriched by the bounty and beauty of one's good objects, in an outside world that mirrors its beauty but not its harmony, *about which one can no longer remain unconcerned*. This, I suggest, is the task from which the mature, exhibiting artist does not flee, but, to borrow Hanna Segal's words,

with his 'cautionary tales', he sets about 'repairing the whole world'. It implies that an artist must sermonize his siblings as they exist *at that moment*: that the formal and emotive configuration of his works must be derived not only from the influence exerted upon him by his culture and fellow artists, but also by the force of his *concern* with the present and future of the whole world. In order to grasp the courage that this requires of such an artist, it is necessary to realize that every act of violence which he sees go unpunished and, above all, smugly unrepented, every cruel stroke of fate in the external world, threatens his internal harmony because of the pain and rage stirred. Thus, concern for the outside world increases the temptation to renew the old splitting and projection of bad parts of the self. The pull of the monastery becomes tremendous as a bulwark against the danger of regression.

STOKES

Perhaps another time we shall construct our version of the artist as hero, with comment upon the growing cult that helps to inspire the present furore for art, especially the acclaim of Gauguin and Van Gogh.

You leave it to me to take up your distinction of good and evil art in the sense that a work of art is either predominantly reassuring or corrupting to its audience, as opposed to good and bad art aesthetically considered. As you know, while I agree with your formulation of reassuring and corruptive projective identifications ceaselessly transmitted through art – evaluatory criticism is inseparable from acts of correct appreciation – I trust more in the fact that a projection cannot be regarded as art unless some degree of an integrative blend of emotion, typical of the depressive position as you have defined it, shall thereby be communicated. Provided that it is deeply understood, I cannot view any true work of art to be predominantly corrupting in its many aftermaths. Perhaps I am the more ready to value very greatly what you have said about the social importance of projective identification since I have already considered other primitive mechanisms, though subject to the depressive position, to be embodied in art.

You emphasize you are concerned only with the social aspect, not with the aesthetic aspect on which we are agreed. But consider for a moment what Mario Praz has called in his famous book of that name, *The Romantic Agony*, consider the nineteenth-century intertwining themes of satanism, sadism, masochism, homosexuality, of Medusa, Salome and the Gioconda smile, of the ruthless and fatal woman, *La Belle Dame sans Merci*, common to Flaubert and to the pre-Raphaelites, or of the Faustian Byronic man; an ethos to frame the savagery of Delacroix, the sudden ambivalence of Berlioz, the perversity of Baudelaire, great artists who were impelled to magnify at arm's length that which, in themselves as in the world, was untoward. By means of uneasy juxta-

positions through their art, of beauty and despair or squalor, they sustained acrid versions of the integrative process. On the other hand, the celebrations of sadism – De Sade himself is the key, said Sainte-Beuve, to the literature of that time – and of masochism in which so many artists joined, did not do them, not to speak of their public, much good. It seems that self-destruction in some cases was the mode of liberation from cruel Victorian smugness. The first theme of all was the one of masochism. We need to integrate Swinburne's obsession with flagellation not only with his public school experiences but, more widely, with the cruelly smug Victorian culture to which he truthfully responded, in so far as his obsession inspired very considerable poems; we need to bring into relation with the milieu what Praz described as 'the lustful pleasure in contamination' that characterized so many romantics and decadents; Baudelaire's confessed aim of seeking beauty in evil; Lautréamont's concentration upon evil to make, as he felt, the reader desire good. As well as a dire creative synthesis often of the utmost beauty and courage, in all such cases one is likely as well to detect a straightforward element of bad projective identification.

A considerable amount of the romantic agony survives today. A mitigation, I feel, is due to Freud, though he has inspired further manifestations. Seen from the angle of art, Freud largely took over from artists the mere ventilation of specific perversions. It is well worth mentioning that a scientific discovery about the psyche could somewhat modify the central position of an artistic subject-matter. It shows in this case that, unlike the perennial reaching after violence in newspaper, popular novel and film, on which so many people have the necessity to feed, sensationalism in art includes as well an attempt at description, at understanding, hence at integration. I am inclined to think that artists, more than any other class perhaps, tend to find themselves unresponsive to daily sensationalism not widely symbolic, owing to the gratuitous quality, owing to a lack of reality or connexion. It is significant, however, that it should be generally felt that art alone justifies a presentation of what otherwise would be unacceptable; art is felt to be a constructive if desperate or daring comment, though the artist may also be projecting into us the aggression by which he and his objects are threatened. What you have said about the depressive devotion to truth and the connexion with beauty, is most relevant here. But if, in this extravagant process, we, as spectators, find ourselves to be losers, then we say that those particular paintings are no good; no good, as far as a simple judgment of acceptance or dismissal is concerned, in your sense and in an aesthetic sense as well, since there is no aesthetic value without co-ordination, or, put negatively, without an overall lack of gratuitousness. Of course people will vary in their estimations of what is gratuitous: the more experienced in art usually find the less experienced to be timid, narrow about the channels through which they gain a positive meaning: similarly – at any rate to some extent – psycho-analysts

may find others to be incorrigibly blind to the pathetic, even, at times, constructive, aspects of delinquency. It is remarkable, surely, that though cultural situations alter, no considerable achievement in art ceases to have relevance. The urgency of bringing together, of making one thing out of what is diverse, remains unique just because the material varies yet continues to give echo, to make itself felt and thereby to encourage us, even in those instances where we have reason to deplore emotional ingredients on display.

MELTZER

This view of the artist, that he mobilizes powerful psychological equipment and that he exerts a great influence on his culture seems tacitly accepted; it is evidenced by the reverence (dead) artists receive, by local and national pride based on their creativity. But of course the more open attitude toward (living) artists is very different. Where grudging admiration is given to their craftsmanship, their characters are condemned: where the social and political importance of their work is not sneered at as the mere embellishment of history, the state or patrons may attempt to exploit and control them: where they are not beggared and neglected, they are treated as pets or *enfants terribles*. To sum it up psycho-analytically, until they become 'masters' they are treated as new babies at the breast, by a world full of siblings who, while deriving hope from the new baby's existence and performance, cannot control their envy and jealousy.

Now, the aspects of psychical reality acted out through the socio-*economic* structure of society, are in part related psycho-analytically with the impulses to master and exploit the breasts and body of the bad, deserting and begrudging mother, fickle and selective in the granting of her favours, united to the powerful and punitive father. Flux in these aspects of group life, with ever-accelerating tempo, is constantly induced by technological advance (note, I speak of the application of knowledge, not of advances in knowledge itself, i.e. of technology, not of science). The phantasy of plundering this bad mother's body, of tyrannizing over her inner babies, is the driving force, I believe, behind economic aggression.

Juxtaposed to this unstable situation, constantly stirred by technological advance, there exists the socio-*aesthetic* life of people, presided over by the art-world. Here the internal reality of the good, or, as you point out, often idealized mother and her breasts, united to the good, creative and reparative father and his penis, find expression, reminding the children of the bounty of life and the relative insignificance of the differences in Nature's gifts when compared with the great expanse of biological equality in the human life-cycle. The art-world is the institutionalization of the social forces towards integration. Earlier I have spoken, for the purpose of exemplification, of the viewing of art as if it were

something limited to museums, concert halls and libraries. In fact the art-world monopolizes expression of the beauty and goodness of psychical reality, the craving for which no riches of external Nature can gratify. In Nature we can find reflected the beauty we already contain. But art helps us to regain what we have lost.

PART III
The Art of Turner 1775-1851

ART OPPOSES SELF-CONCEALMENT; painting should reveal its student. Nudity, an absolute achieved so often in an instant without rebuff, furnishes no reference to the endless mind. On the contrary, great artists deepen the search in themselves, pierce for a moment a hardly won aesthetic integration in order to disclose and to re-align the detail of which it was fashioned. This further self cannot fructify into masterpieces except through the manner of uncovering more art within the art that the painter, and other painters, have already achieved. Subject to patronage, to social needs, the Old Master had to provide *from his beginning* a stiff apparel of stable co-ordination. Did he then probe concomitantly the self and its art, he sometimes introduced less polished, more weighty, 'sermons to siblings'. Though ostensibly, in the final phases of Rembrandt and Turner, the artist was working more to please himself alone, the exploration of his art cannot be removed from the desire to communicate by means of it.

But what if there is no achievement to explore but only the self and art in general? A modern student's rather noisy searching of his canvas for a dynamic aspect of himself is by no means the consequence for intensifying a compulsion that was already implicit within his work, since he is just starting to paint. He seeks a mode for what psycho-analysts call 'acting out', of living upon the canvas in terms of brush and paint and strength of arm. This is not a fair description since his activities are symbolic: I use the expression, 'acting out', because although the process of sublimation, upon which art depends, is present, it can be minimized in the reckoning. With serious, perhaps painful, attention the student searches the face of the canvas for what he supposes to be barely hidden within himself. At the same time he may regard the physical act of painting as if it were a therapy applied to objects, just as the right tune in the right ambience seems to agitate surroundings towards a dynamic concord. Communication, the learning of means of communication, are at a discount. Since we are rich in

photographs and in museums, poor in cultural stability and settled style, and even of patrons' commands, we fragment the interwoven values of art, tend to use one piece to mirror a sum of compulsions. In the past, on the other hand, a narrowly compulsive element would encounter from the beginning, would emerge, perhaps only finally to overlay, a hundred matters other than the canvas and the paints. That process encouraged aesthetic power, especially the enveloping factor in form, since a hoard of self-sufficient experiences and achievements would therein be embraced. The modern tendency inclines towards a series that together, and only together, as a whole exhibition, can rival the impact of a single masterpiece.

There is a long history of indistinctness in Turner's art, connected throughout with what I have called an embracing or enveloping quality, not least of the spectator with the picture. The power grew in Turner of isolating the visionary effectiveness that belongs to a passing event of light: it entailed some loss of definition in the interest of emphasis upon an overall quality. To one who complained, Turner is said to have replied: 'Indistinctness is my forte.' I shall attempt interpretation of a narrow compulsion that I attribute to a predominant aspect of his embracing effects: my aim will be to suggest how minor this theme would probably have proved had it been abstracted from the lengthy apprenticeship of its intrusion, had it not been long attendant upon contrasting achievements in picture-making. His supremacy lies not in his compulsions but in the links established for them, subsidiary yet vastly enriching. It is a matter of degree, for otherwise it is the same with every artist. Our interest today in aesthetic directness, though in many senses estimable, in another can be not a little vulgar. Aesthetic directness, so far from always enjoying a lack of limitation, may itself be inhibited by an expressiveness that casts away the many links for a compulsion, that avoids contrast, the means of sublimation as well as material for integration. But we cannot summon at a wish what I have called subsidiary and enriching aims: should they be potential, however, understanding will encourage their presence.

Turner's visions founded on Rome and Venice developed gradually over many years. When he first went to Italy he had concentrated on topographical drawings and sketches, no less than 1,500 or so in probably little over two months, of Rome, Naples and the surroundings. The habit of drawing must have asserted itself every day, and often all day. One reason why in the sketchbooks there are so many drawings of Dover Castle and the coast, will have been due to his waits there for the continental packet. Do we have comparable disciplines? Moreover his memory for natural effect was no less fully rehearsed than his power to observe it.

We shall find that the accustomed objects of his art, buildings among foliage,

trees, mountains, ships, eventually shared their qualities with their media, buildings with the sky, ships with the sea and vice versa: finally, sky and water were equated with the paint itself even for large works: the equation had long been brought about for some drawings and sketches, including oil sketches. In a word, the homogeneous effect we admire so much, supervened upon a thousand studies amassed from many kinds of objects under the aegis of contemporary styles for picture-making and of a naturalistic bent that was never lost: the artist with the mood of Nature were first established by the paint, and in the end, as the paint, a contemporary effect that seems far less comfortable as a first endeavour. The chief of all painting problems is here: the journeyman starts at the point where a supreme master lay down the brush, not one master but many; many more today than at any time before.

A first reference should be to the social determinant of Turner's art, the studies to provide whatever patrons would admire and, as the result of unceasing industry, to earn a good living. The early topographical watercolours and others from which engravings were made – the first was published when he was just nineteen – depended for their value, of course, upon the sentiment infusing their fact, upon the element of communicated 'truth', the theme everpresent in art that Dr Meltzer brought into relation with care and love for the object conceived in the depressive or post-depressive position. Viewed as a 'sermon to siblings', visual art seeks to reflect and embody some of the needs or tensions of a society, and of the artist's inner world, *vis-à-vis* Nature, in terms of the outside world. The painter is he whose inner world, everywhere intertwined with the outer, will be projected in such a way as to communicate to his fellows a freshness of feeling about objects; ultimately, though often most superficially, the feeling of being more at home in a grown-up world. We have seen that the scale of aesthetic integration will vary with conditions of culture and of preceding art. If we believe in the truth for him of what Turner wrote in a margin of Opie's lectures, from the viewpoint of today we shall consider that he was extremely fortunate regarding the historical context. . . . 'every look at Nature is a refinement upon art', he wrote: and he continues by saying he conceives the painter as 'admiring Nature by the power and practicability of his Art, and judging of his Art by the perceptions drawn from Nature'. (As to Art, it has been said that the last ten years of the eighteenth century, the time of Turner's youth, was the best there had yet been in London for students of post-Renaissance European painting, due largely to big sales following the French Revolution.)

The study of Turner, then, is a robust yet romantic subject: part of the attraction is his silence, the devotion to his work from the early morning; each year for many years the tours that uncovered the rewarding aspects of the English scene at a period when many English towns and villages were astonish-

ingly beautiful, at a moment of poignant beauty inasmuch as the threat of great
changes was sometimes implicit: at a period when the smaller country-seat
domains were multiplying in number and optimism; when the achievements of
Trafalgar and Copenhagen fortified ordinary pride. It is the countryside as we
still want it to be; consequently, in spite of what I have said about the uniqueness
of the moment of any art, we do not often think of Turner as an eighteenth-
century or a Regency or an early Victorian figure. His vein of romantic
mastery was embodied also in the prescient, was somewhat committed, Kenneth
Clark has pointed out, even to the baby triumphs of a growing mechanical age.
With the vigour and cockiness of small stature he embraced the huge variety
of a scene as we would have it not altogether nostalgically, because we cannot
altogether believe that it no longer exists: a gleam from what remains recon-
stitutes an unaltered conviction about the countryside, reinforced especially by
Turner's panoramas of the coast from out at sea or from near the beach where,
often, there has been no change. On the other hand the early sea-pieces, and
views of shipping that he discerned with a naval eye, are among the more
'dated' of his works.

Turner's encircling contemplation was for long closely tied, except in
sketches, to the adjunct of several old pictorial traditions, particularly the Dutch.
An astonishing factor in his development was the direct rivalry with Claude to
which he felt himself constrained; it is only emphasized by his preference for
Punic rather than for the Roman and Grecian heroes. For a long time, perhaps
to the end, Turner chose to regard *Dido building Carthage* (exhibited 1815) as his
chef d'oeuvre. Involved today with pictorial 'break-through', we are astonished
not so much that Sir George Beaumont objected to them as that it was apt
enough, in spite of their incipient romantic unity, for him to judge Turner's
earlier oil paintings in terms of Cuyp, Ruysdael, Claude, artists who had been
dead for more than a hundred years. Due to a variety and development that
spans such distance, Turner contrived connexions that we find reassuring.
Moreover, as I have said, he made out of many-sidedness more powerful
ammunition for very personal bents or compulsions: incorporated thus with
perennial psychical requirements, they furnish most important lessons to us his
siblings. Of course the message of truth in Turner's work was not at all the one
of a sociological survey. His nightmares are by no means specific to that terrible
age. He gives us what he, as an artist, felt, but rarely what others, figuring
in his paintings, might be feeling. Of this, we shall realize, he was almost
incapable. Not that he did not often admit its propriety on a small and
crowded scale, sometimes with passable result, for instance *The Shipwreck*
(exhibited 1805).

But before considering the more extreme aspects of the Turner subject, we
must take some cognizance of tension in the aesthetic situation. What we can

view as a spanning – by Girtin as by Turner – became a struggle, a tension seen in the rival advocacies of light and darker paintings, largely as a result of the influence upon oil painting of the effects and technical inventions in watercolour. Turner was accused most variously of being hesitant, of sacrificing the precept of art to the vulgarities of Nature, of vagueness as of brittleness and, even as early as 1798 when he was twenty-three, of a mannered approach.

Crabb Robinson entered in his diary for 7 May 1825: 'Went to the Exhibition, with the advantage of having my attention drawn to the best pictures which, for the most part, equalled my expectations. Turner, RA, has a magnificent view of Dieppe. If he will invent an atmosphere, and a play of colours all his own, why will he not assume a romantic name (for his pictures)? No one could find fault with a garden of Armida, or even of Eden, so painted. But we know Dieppe, in the north of France, and can't easily clothe it in such faery hues. I can understand why such artists as Constable and Collins are preferred.' It seems that Turner's effects of light and atmosphere did not appear to correspond with their natural phenomena because the eye of the cultured spectator was still viewing Nature, in front of pictures at least, through the glass of an older art. On the other hand, Crabb Robinson perceives that Turner's overall paintings of light and atmosphere could pass as his version of acceptable pictorial manipulations that belonged especially to the eighteenth century. Even in many of his earlier historical paintings that aped the past, or were meant to rival it, mythological incident took but a small place, not only in area as in Claude's, but in regard to the mood of a landscape or of a meteorological happening. A more truthful, because more transitory, natural effect was the vehicle in his hands of an emotion that was less restrained, yet without the entire loss, all the same, of the feeling for a contrived magnitude in virtue of which we at once recognize a classical composition. The presence in sketch book numbered 90 in the Turner Bequest of contiguous studies, suggest for a few instances a possibility that the conceiving of a classical composition may have included its projection upon familiar Thames-side scenes, particularly the pile of Windsor Castle. It would be in tune with Turner's literary orientation, powerful to the end, from the eighteenth-century sublimities of Thomson. At that time Turner was living in Sion Ferry House, Isleworth. A few years before he had painted many oil sketches on the Thames direct from Nature, a rare procedure for him, infrequent in the case of watercolours as opposed to pencil drawings. I feel that he was able later to conjoin the London Thames as such with Venice as such. I must repeat that the greatness of Turner, and indeed the originality, was first of all the product of the diversities he linked as he drew upon much experience. I shall soon suggest that a savage compulsion dramatized his power of linking, absorbed into homogeneous effects the varieties of connectiveness. The variety of homogeneous effect is itself astounding. Applied to Turner's painting, the

adjective, 'homogeneous', suggests very late brilliant, light-toned canvases with hardly a perpendicular feature, or else a whirlpool envelopment by fire, flood, incipient in all his landscape styles except the first and in some degree, the last. Yet at the very time of his enlargement of a direct, panchromatic oil technique in the 1830s, he was still painting grey sea paintings sometimes of limpid scenes, one of his versions of the Dutch tradition. These, it appears to me, though undemonstrative, no less than the all-devouring dramas hot or cold, prefigure the unified substance of the later canvases whose breadth has needed dual lineage. Thus, Turner's application was wide. He gained some victories even in the field of calm, contemplative genre (*Blacksmith's Shop*, exhibited 1807, culminating in *Frosty Morning*, exhibited 1813): nor can one forget, though far less successful, what may be called (cf. Rothenstein & Butlin) the Rembrandt and Watteau figure compositions of the 1820s.

Doubtless attracted by Watteau's colour as by Stothard's, Turner was no more suited to emulate rococo elements than in verses his much-beloved Thomson, poet of the picture-like or picturesque. A measure of incongruity, it seems, added fuel to his ambition: what grew in him, what he fostered, consorted ill in some respects with the physical impression he made, with a rusted, hard-bitten (by persecutory fears) man of business; yet he joined them, in his art not least a sometimes stilted version of eighteenth-century sublimity with the inordinate ranging of romantic verve.

Venice was part of his inheritance, particularly the Venice of Canaletto. His three visits probably amounted in all to about six weeks: the first, on the journey to Rome in 1819 when he made some detailed topographical drawings and many sketches, will have subsequently intensified a mythology of conflagration and reflection. But whereas, hitherto, he had romanticized the strength of building, architecture in some very late Venetian paintings serves no more than as a grandiloquent sail amid the suffusion of sea with sky, a medium for the riding of blanched or darkened boats. I think Turner gained confidence for a lengthy elucidation of light from his encounter in 1802 with the Old Masters at the Louvre. The criticism written in his sketch-book is concerned almost entirely with falsity of light effect and poverty of colour combinations. He was to dissolve the kind of chiaroscuro that dramatizes the world's actuality, in favour of a diffused light that took actuality to itself, even in finished drawings, particularly those he made for their engraving where an equality of effect often overrides most subtly, without undermining, the strong chiaroscuro and sturdy relief, even though the initial terms to be unified within the envelope were alternations of the topographical or romantic classical stones, the buildings he had so long studied, towering stone, so often towering above, offset by the dark density of foliage. Precipitous building led to the appalling paths of tossed sea, to mountains and cloud and to towering effects of light. The first link

between early and late Turner is the one between the mutual enhancement of textures to which he was very sensitive, and of those of colour or light: in painting, texture and colour sensations can be very close. To my mind Turner's perceptiveness for building – the unreliable Thornbury reports Mr Trimmer the younger as having heard Turner wish that he had been an architect – and for the sense of suffusion in ordered stone with water that much Italianate art had diversified on the example of Venice and of Rome, inspire the slabs of iridescent colour we think of when we call to mind his late works, no less dynamic in themselves than the imaginative drama and sense of doom and other obvious instruments by which he engineers an overall effect of a majesty to approach the gravity and balance attained by earlier Masters. His poetic discernment first fed upon, then diversified as the pictorial instrument, the close enhancements of texture or of colour, and so of shape.

If the deepest aim was transcendent, Turner employed for it his vast experience of measure. There is small appearance of the arbitrary in his drifts of mountain, sea and sky: they formulate an erratic architecture or a superb natural habitat, no less than an irresistible phenomenon; soft and tenuous, warmed as well as cold. It was as if catastrophes were carvings on the sky: they stem from the delicate use of the pencil in thousands of drawings, slight touches to enrich the paper as if it were a volume invoked by this touch, remarkable not only for delicacy but for selectiveness, even in so early an architectural drawing as the sketch of Stamford, Lincolnshire, of 1797. Unity of treatment is matched by that of feeling: what is grasped from the subject is accorded with the projected strain of feeling that encompasses and adjusts each detail with another. Turner not only thought of himself as a poetic painter but attempted poetry, at times to introduce his pictures. He may have intended to preface the *Southern Coast* series of engravings with a long narrative poem. His use of words became stiff, repetitious, very confused; so also, very often, the delineation of people in his landscapes.

His growing love of overall effect without loss to the representation of endless distance, the palpability for many ripe works of the picture plane, prime overall unit, suggest some parallel with our own preoccupations: many drawings, often of the earlier years, prefigure in this respect late Turner oil painting. For instance the 'Salisbury' sketch-book of about 1800 (TB 49) has two scribbles of sunset, clouds and water, integrated as one mass: another early instance (1802) is a wonderful little drawing – the Finberg catalogue says probably of Brienz – made up of abbreviated hooked strokes (TB 77). The minuscule mosaic of angularity, the richness in the poverty, suggest Klee to us. Much earlier, in 1795 when Turner was twenty, he could achieve a not dissimilar compositional effect of the greatest delicacy, such as the twin drawings of two mounted figures descending a hill-side path near the sea (TB 25). Other drawings conjure up

Cézanne: even in many grand paintings some values of the sketch are obstinately maintained. Although there is evidence that Turner would not allow rough pencil sketches to be glimpsed, he seems to have had more faith in his handling than had Constable in his, an artist, we may suspect, who was on less good terms with himself. Even the technique in some last oils where calligraphy overlays an unbroken cake of paint, is foreshadowed by very delicate pencil drawings on paper prepared with wash rubbed out for the lights, such as in the beautiful 'Dunbar' sketch-book of 1801 (TB 54) or the 1802 'Schaffhausen' folio set (TB 79) or, better still, the radiant drawings of the 1819 'Tivoli' sketch-book (TB 183). On the other hand there are prosaic finished watercolours of the middle period that have very low value, such as *Saltash* in the Lloyd Bequest. Until much later, Turner was still apt to demarcate his work for the public in agreement with the traditional genres.

A price had to be paid for the homogeneous effect, a price on which Turner's critics were agreed; not only that: his flattening of figures and tempering of foreground in the interest of overall effect corresponded to a lack of *inevitable* interest in relief, shown by the playing down of figures as a result of his growing concentration upon the enveloping landscape. We shall find that these attitudes are possibly linked in deeper layers of the mind also. On the other hand, early studies of buildings, hills, and especially rocks, are often very notable for their relief. Turner was a phenomenal draughtsman in several genres, but particularly for choice and disposition of accent and bare space in a finely controlled sea of detail; for a pointilliste employment as a youth, in company with Girtin, of the pencil's point within a pattern of short strokes. His drawings of the figure at the Academy schools were no more than adequate Some later drawings of the nude are considerably better, but do not obtain high significance. Except in the case of cows and of the early self-portrait in oil, his delineation of faces seems wooden. We cannot discover in Turner's art much affirmative relationship to the whole body, to human beings. They tend to be sticks, or fish that bob or flop or are stuffed. The prejudice is sometimes allowed such freedom, that many figures who should be dignified appear to be rustic, to be approached by the artist with unconcealed because untutored naïvety, though this is in fact very far from the case. To use the psycho-analytic term, they suggest part-objects. (A part-object, it may be recalled, is an organ or function that on the analogy of the first object, the breast, has been split off from an object's other organs and functions: a part-object, therefore, is a concept at a great distance from the one of a whole, separate person for whom, in a regression, it may come to stand.)

Turner's chosen relaxation was to fish. (The drawing of young anglers for the *Liber Studiorum* is among his most engaging figure-groups.) He saw the feminine in cows but upon human life he tended to bestow a phallic cast. He himself was

small, rather Punch-like, deliberate and usually taciturn. (His father, even more Punch-like in appearance, was more talkative.) Ruskin found elongated figures, oval elms and flat-topped pines to be typical Turnerian shapes. Also typical, after 1820, is the curvilinear form of crutch or thigh bone along the side of which, as in the *Palestrina* painting, there runs a narrow vent. Very upright figures, such as the one of the strange *Letter*, may amount to the crutch-shape with attendant valley. They include Phryne at the edge of the huge painting named after her. The many Turner- or Punch-faced people who inelegantly, if wraith-like, throng *Richmond Hill on the Prince Regent's Birthday*, are also of the species. It is astonishing that on the watercolour Turner painted in 1802 after the woman of the double portrait in the Louvre (No. 1590), then known as Titian's mistress, the copyist should have grafted the Punch-like quality. It so happens that we have knowledge of Turner's long and compassionate devotion to but one person, his barber father who, for years a widower, acted as his son's factotum. (It is conceivable that there is an affinity, as Thornbury suggested, between some of Turner's figure-painting and barber's dummy heads that had probably once crowded his father's shop window in Maiden Lane.) F. E. Trimmer gave Thornbury this description of an unfinished portrait by Turner of his mother: 'There is a strong likeness to Turner about the nose and eyes. Her eyes are blue, lighter than his, her nose aquiline, and she has a slight fall in the nether lip. Her hair is well frizzed – for which she might have been indebted to her husband's professional skill – and is surmounted by a cap with large flappers. She stands erect, and looks masculine, not to say fierce; report proclaims her to have been a person of ungovernable temper, and to have led her husband a sad life.' At the end of 1800, when Turner was twenty-five, his mother was taken to Bethlehem Hospital and discharged uncured the following year. She died in a private asylum in 1804. Other than the parentage, that is all we know of her.

Ruskin mentions Turner's favourite kind of declivity, founded, Ruskin thinks, on his early Yorkshire studies, where he draws the precipitous part of hill or mountain in the lower section and a gradual slope on the top, a (phallic) formation that reverses the one typical in Rhine and Alps. When in 1792, at the age of seventeen, Turner recorded Magdalen bridge and tower at Oxford (TB 11), he worked from the bank below as he was so often to do in renderings of ruins, churches and castles. A strong towering above, a cascading below, were needed to give power to a delicate, almost pointilliste, drawing. The viewpoint was common enough, almost a convention, but we attribute to Turner an intoxication in its use since the imaginative range grew so wide in the treatment of wave, of masted ship and terraced, celestial palaces from whose thrust the sky but slowly withdraws its vapours. His first (1817) among several voyages to the

Rhine with the crowd of precipitous castles, when he made drawings, and from them later, watercolours, will have particularly intensified a grasp of towering masses, natural and architectural, to which he had been long attracted; to which he could pin the utmost circumstance. Two years later Italian hill-towns impressed on him their broader affirmation: at that time he studied a variation he would always remember of the theme, the cascades, ravines, antique remains and ruins, propped among the prophetic trees of Tivoli. Before the end it ousted a stepped, orderly, Poussinesque type of composition such as we see in the superb, finished watercolour, *The Medway* (TB 208).

Turner's use of the old-fashioned viewpoint from above is more powerful still and more prevalent, the means of survey, of the bather's deliberate contemplation from the diving-board. We are given opportunity to linger there, and through our own volition we are thereupon immersed and enveloped by the scene. This appears, so often, a jump into our own past, heroically presented. The suspicion is surely strengthened if we consider subjects of his most ambitious work fire and water, the disasters of fire and water or the wastes of ocean populated with giant fish and with the gestureless bodies from *The Slave Ship*, or by the near-swamped sailors of many a canvas such as the *Calais* and the *Trafalgar* or *The Shipwreck*, 1805. Not a few of Turner's predominant interests coalesced in Venice, boats, buildings, suffused by light and by the literary associations of Byron or Rogers, but a sea populated naturally, as it were, without shipwreck, a sea for the first time filled by people in a context without fury, since in Venice alone countless undistressed individuals are lying on the water, perhaps for *The Return from the Ball*. In his latter paintings of the city, Turner relaxed the piling-up trend of his phantasy: rush and fever subside into sad dreams of restless ease.

It is another miracle performed by that city. I must recall that the relationship to a part-object has the character of a complete identification, of a whirlpool envelopment into which we are drawn. Of such kind is Turner's more usual conception of doom and disaster, of the *Fallacies of Hope* (his poem, or pretended poem, from which he quoted in catalogues), the conception, in one aspect, of the infant who believes in the omnipotent and scalding propensity that belongs to his stream of yellow urine as it envelops the object so closely attached to himself, an object split off in his mind from the good breast with which he is also one. Whereas the two trends are integrated in Turner's art, he must emphasize with less vigour the long-studied separateness of self-sufficient and whole objects, other than as the pictures themselves, with a viewpoint, maybe, from above, now removed from the artist. The overall emphasis upon the canvas is predominantly the one of envelopment. We are likely to think first of late Turners in this connexion. Though the approach be traditional the same quality is rarely absent from any but the earliest drawing and watercolour

sketches. In a sketch-book of 1800-2 (TB 69) there are pastels on coarse blue paper one of which, a castle on a hill, presents but a pyramidal slab of slightly diaphanous colour, nearly of one tone. Though early oil set-pieces are particularly dark – eventually they lighten, first into greyness – and full of detail, they are not without a characteristic fluidity; hence, in all probability, Farington's description of 1796, 'mannered harmony'. After considerable and continuous success as a very young man, Turner's first great triumph was in 1801 with the Bridgewater sea-piece; already in 1802 (elected RA) he is accused of lack of finish; later, it will be of offering his public mere blotches. These, as a matter of fact, he kept to himself. In some cases, attributable mostly to the years 1820-30, of what Finberg in his Turner Bequest catalogue calls 'Colour Beginnings' watercolours (especially TB 263. There are also uncatalogued oil sketches), one is aware of experimentation with paint, yet of discoveries sufficient to themselves, though they can often be read without difficulty as first sketches in colour of landscapes and seascapes or as records of natural effects for which his memory was phenomenal. But it is impossible at this point, the crux of the Turner enigma, to remove his technical and aesthetic probing, probings into landscape design, from pressures anterior to them. All obsession has a vivid aspect of self-sufficiency. Anyone who looks through items, other than the earliest, of the vast Turner Bequest, will be amazed at the number of these 'beginnings' and pencil sketches, often monotonous in simplicity and sameness in regard to a raining downward of a top area upon a receptive area below: so many sheets in later times have no other feature, while others have a reverse surge from the lower section made up of vibrant stripes parallel to the picture plane, or of piercing forms as from an uneven sea. It appears that with the latter years, Turner brushed in large oil paintings for exhibition upon such preparations, sometimes their entirety as representations during the varnishing days. One element assaults the other in the simple, zoned beginnings. Concentrating upon sky with land or sea, the artist was under compulsion to record faithfully and repeatedly a stark intercourse, then to reconcile, then to interpose, perhaps with a rainbow. Among the 'studies for vignettes' of the 1830s (TB 280) there is a watercolour sheet of rose with touches of ochre, saturated at the bottom, thin above. Underneath this apparently abstract design of melting colour, Turner has written – so runs the guess – 'Sauve qui peut'. It is to be expected that such delicate interplay of two colours enfolded already for him the terrors of a flood, equal to the chromatic balm in virtue of which the inevitable alternation of the terror could be allowed to appear. With comparable obsessiveness in his middle and final years, Turner would draw rapidly a tower ensconced on a hill-top, over and over again from every angle, perhaps six line-drawings on one small page, doubtless with an eye to the best design for a painting, but also to make far more than certain from every long approach how the one element fitted

into the other: he often drew next day another tower and hill-top with this fervour. An approximation, a drawing together, the forging of an identity, so to say, out of evident differences as is revealed by a fine use of colour, was a constant aim. In his catalogue Finberg wrote of sketch-book 281 in the Turner Bequest: 'A number of these pages have been prepared with smudges of red and black watercolour, the colour then being dabbed and rubbed, with the object apparently of producing suggestions of figures, groups etc.' Maybe, but no figure or group suggestions are to be seen, only the reconciliation of the dense with the less dense. They resemble another common type of beginning that is diaphanous and equal throughout. For, naturally, rather than a prime imposition of contrast, some coloured beginnings pre-eminently possess, like lay-ins, the opposite or complementary value, that of the carver's elicitation upon the stone's surface of a prevalent form attributed to the block. Turner often used a rough blue or grey paper on which his panoramic pencil drawings (even more than watercolouring) suggest messages that have appeared from within a wall upon its surface. An eloquent surface in this sense was integral to his art and became increasingly an influence upon its content. Divorced from that bent, his flamboyant confrontations would have lacked their union, the ease of interchange and coalescence, the issue of light, so often sunset, that floods.

In a region of the mind, as I have indicated, properties of fire and water (scalding) are not at variance but united, the hose of the fireman with the fire he inflames and, indeed, initiates. 'All his life,' wrote Kenneth Clark of Turner in passages to which I am much indebted, 'he had been obsessed by the conjunction of fire and water.' And: 'He loved the brilliance of steam, the dark diagonal of smoke blowing out of a tall chimney and the suggestion of hidden furnaces made visible at the mouth of a funnel.' Earlier, in *Landscape into Art*, Clark had a heading: 'Fire in the Flood', a quotation from *Beowulf*. 'Throughout the landscape of fantasy,' he wrote, 'it remains the painter's most powerful weapon, culminating in its glorious but extravagant use by Turner.' I think he enlarged upon fire in the flood far beyond this context of a Nature that was feared on every side in a dark and insecure age; it was a fear that must always have existed everywhere for irrational reasons alone, since there are bound to be phantasies of revengeful attacks issuing in kind from a scalded mother. Turner, it seems to me, largely denied this fear, pursued the attack but accepted the doom: he was possibly eager to discover those phantasies 'acted out' by a happening that he could represent as realism. In January 1792, when he was sixteen, he soon visited the burnt-out Pantheon in Oxford Street. A feature of his watercolour of the site next morning are icicles clinging to the façade, frozen water from the hoses. (In late life he attended to the processes of whaling – one instance is the boiling of blubber while the boats are entangled by a flaw ice – and, of course, to giant sea-monsters.) It is the first occasion of which we know that Turner's

pencil, to use an expression of the time, was employed upon smouldering disaster. He was on the scene when the Houses of Parliament were burning in 1834: he made watercolour sketches and then two oil paintings: the sketches are among his great masterpieces. Flames enwrap the highways of the sky and of the Thames. Vessels coaling by torchlight, *Keelmen heaving in Coals by Night*, is another lurid canvas of this period. When he returned to Venice, probably in 1835, he painted several sketches of rockets fired from ships during a fiesta. A criticism of his *Juliet and Nurse*, executed on his return, in which fireworks figure, was to the effect that he made the night sky far too light. Another writer said that *Juliet and Nurse* was nothing more than a further conflagration of the Houses of Parliament. Turner exhibited in 1832 *Nebuchadnezzar at the Mouth of the fiery Furnace*. 'Fire' or 'Heat' and 'Blood' were words commonly used in contemporary writing on him. It is surely unnecessary to remark, in respect to fire and water, the many watery sunrises and bloody sunsets or *Rain, Steam and Speed and Fire at Sea*. Turner himself wrote 'Fire and Blood' in the sky of a drawing that may be dated 1806–8 (TB 101). The onrush of ivy, and other leafage in his best architectural drawings are profoundly related with effects of rock and water such as the wonderful watercolour of 1795, *Melincourt Fall*, where the unbroken slab or wedge of water licks the fractured rock like a flame. Soon after reaching Rome for the first time in October 1819, Turner hurried to Naples where Vesuvius had become active some days before.

Allied with the one of fire there is often conveyed by his work a sense of explosion, in the famous *Snowstorm* (exhibited 1842), for instance, or even in the earlier snowstorm of *Hannibal crossing the Alps* of 1812. One sees from afar an atmosphere of paint and detonation, then one searches for the benighted human beings who, when found, remark the processes of meteorological might rather than of individuals who endure them. On the other hand, Olympic vistas, calm temples, survive in our general impression of Turner's art: in view of a ceaseless lyrical bias it is a humane art. We learn from him that calamity is asymmetrical.

Ruskin deplored Turner's lack of interest in the detail of Gothic architecture (despite the numerous, astounding studies of, say, Rouen cathedral). A brooding attachment to the classical orders is strangely suggested by bawdy lines he wrote eroticizing the Ionic. (It is not altogether surprising to discover there a punning use of words that could reflect the infantile oral phantasy of the *vagina dentata*.)

In connexion with my mention of scalding attacks I think it relevant to remark Turner's liberal use of yellows. *Dido building Carthage* was originally thought too yellow. Turner himself writes to a friend in 1826: 'I must not say yellow, for I have taken it *all* to my keeping this year, so they say.' And later that year: 'Callcott is going to be married to an acquaintance of mine when in Italy, a very agreeable Blue Stocking, so I must wear the yellow stockings.' Rippingille reported from Rome a *mot* about a retailer of English mustard who

was coupled with Turner: 'The one sold mustard, the other painted it.' 'A devil of a lot of chrome' is how Scarlett Davis described to Ince the *Burning of the House of Lords and Commons*. (Van Gogh, a more aggressive handler of everything fiery, and his passion for yellow, are better known today.)

I find it fair to say that the compulsively unitary, forcing side of Turner's art strengthened, indeed largely inspired, a further linking by his late paintings of elements already long harmonized through the delicacy of his touch, through his heightened sense of texture and colour relationship, a building, for instance, and its foliage, the structure and its attenuations, what is rough with what is smooth, the perpendicular with the transverse by means of the ellipse. I have emphasized primitive and aggressive compulsions in Turner's art, but I have wanted to suggest that in admitting them, in giving due place to ferocity and the consequent despair, his very powerful lyrical vein was not impaired: throughout his oeuvre it was enriched: in many, very many, supremely lyrical works, a linking, a co-ordination, an integration, of different degrees of compulsion and different tendencies of the mind were achieved. In the great last period, not only is the world washed clean by light, but humidity is sucked from water, the core of fire from flame, leaving an iridescence through which we witness an object's ceremonious identity: whereupon space and light envelop them and us, cement the world under the aegis of a boat at dawn between Cumaean headlands, or a yacht that gains the coast.

Together with Turner's whirlpool of fire and water we experience beneficence in space. There abound calm scenes that would be sombre or forlorn without the gold, without the agitated pulse and delicacy in so light a key.

Beneficence is very widely scattered; encompasses from afar.

Turner's accomplishment, so large, so various, easily falsifies an investigation whose author singles out this or that upon which to base appreciation, as I have done after studying the several thousand sketches in water- or body-colour, the countless pencil drawings (British Museum) of the Turner Bequest and the near 300 oils (Tate Gallery).

There is abundant evidence, for instance, to show that Turner could both record and improvise figures or groups in any attitude and in a variety of styles. His sketch-books reveal that he was attracted by crowded scenes and new forms of animation. On his first visiting Edinburgh he, most unusually, almost filled a sketch-book with figures, largely the girls with giant shawls and bare feet. It was much the same during his first visit to Holland in 1817 and to Switzerland in 1802: on the first page of TB 78 there is a watercolour of two nude girls on a bed. The watercolour he exhibited in 1799, *Inside the Chapter House of Salisbury Cathedral*, contains figures on the floor about a pillar, youths and a girl, realized with very apt draughtmanship. If brilliance in this genre be not uncommon, if

in his watercolours an adequacy for figures is the rule, it seems the more reasonable to remark as most significant the wooden and childlike element in the presentation of some of Turner's crowds especially, though this quality is not shared by a later group of oil figure compositions, such as *Rembrandt's Daughter reading a Love-Letter* (exhibited 1827) or *Watteau Study* and *Lord Percy under Attainder* (1831) nor by an earlier history or myth painting such as *The Garden of Hesperides* (1806) or the *Macon* of 1803. Nor is it shared by his rapid figure sketches, though they fall short of a corresponding calligraphy for landscape and architectural jotting, of sublime notations too for crowded shipping with masts (e.g. TB 206 & 226). On the other hand, feminine fashion that emphasized an answering slope of bare shoulders and the pin of the head, fired Turner's droll, unflinching portraits. Even though earlier landscape and genre masters had been content to offer no more than an abrupt consort of lay figures, it is surely interesting that one of the most facile, as well as the most imaginative, of artists whose forte was the rendering of fluidity (apparent even in these portraits), should, in the course of development, have sometimes populated the seas and declivities of vast canvases with variegated dolls. I therefore offered in the earlier part of this essay psychological interpretations that so far from increasing the contrast, sought to unify a fluidity in handling Nature with part-object, doll- or Punch-like conceptions, a viewpoint that might allow us to discern the aspect of Turner's genius wherein an evident compulsive element, close, at times, to the childlike, was not ousted by his manifold abilities nor by an extremely professional *savoir faire*. He found a way to employ the whole of himself, the immature as well the mature and to fit them together. First he was the complete servant of the art taught to him, the art and culture of his contemporaries and predecessors. (As late as 1821 Turner was bidding at a sale for sketch-books, with notes on Old Masters, by Reynolds.) Meanwhile and thereafter, in the interests of wider co-ordination, he continued to amplify the resources of his own nature, as of Nature outside, for an aesthetic purpose.

I contrasted very cursorily what appears in Turner's case an ideal evolution, with the dilemma of the art student today. It was said of Turner's later exhibited oils that it had no bearing on an impression of soap-suds or poached eggs that the title of a painting read 'Whalers' or 'Venice': the scene was unrecognizable, the picture ever the same. But 'pictures of nothing, and very like' was Hazlitt's famous criticism as early as 1816. It could be said to have a witty pertinence to a few 'extreme' canvases that Turner would be painting some twenty or thirty years later, though not in one instance of work carried through, are we in doubt as to the type of subject. Hazlitt's stricture on the exhibited paintings of 1816 and before can be comprehended only in the historical setting.

Even in a very late 'all-over' painting – others, the watercolour exemplars, had dared it only on a small scale – that at first sight seems abstract, since it is

featureless in regard to vertical shapes, in the last sea-scapes for instance, at the Tate, we acknowledge almost immediately that here is a record, an intense record, of an outward as well as an inward scene: we are aware that in virtue of familiarity, detail has been undone by a virtuoso performer who, conscious of power and information, has no fear of too great a freedom that might result in an overriding of the object and cause the artist to construct shapes, to use colours, dictated solely by his design. Turner's reverence for the objects he studied was intact. He employed freedom to realize movement, depth and interaction, without major recourse to the arbitrary. He has seemed to relax where, in reality, he has broken down or eschewed trite constructions in himself as in the object after long apprenticeship and ceaseless observation.

According to Hazlitt, Turner was more concerned with the mediums – the light – in which things appear than with the localized aspect of those things themselves. He wrote: 'The artist (Turner) delights to go back to the first chaos of the world.' These words suggest not only subsequent canvases such as *Morning after the Deluge* (exhibited 1843), but also the thunderous calm implicit in an unravelled golden mist that characterizes many earlier classical subjects and *Crossing the Brook* (exhibited 1815). I would prefer to say that inspired with traditional poetic feeling, he was rehearsing the chief relationships of the psyche to its objects, particularly an enveloping relationship associated with the breast. In the late or extreme 'all-over' oil paintings, liquid and light-toned, we sense more easily what might be called a breathing or palpitation of the sky, water and land: touches of contrasting colour, scattered masses, seem to furnish a source for the nurture of this ambience, a treatment evident in some drawings and sketches of all periods except the first, from which – and from the best of the earlier English watercolour school – these oils eventually derive. A light, pulsating, ambience where buildings are sometimes treated almost as clouds (*The Piazzetta; Venice*) makes possible the accomplishment within the key of a startling foreground relief, or of masses lying back, in the Venetian Ball paintings, for instance, or in *Norham Castle: Sunrise*, the most beautiful.

Once more, the late Turner exists in some aspects of the earlier work. For instance, *Kilgarran Castle*, exhibited at the Royal Academy in 1799, projects, under the influence of Wilson, flanking hill-clumps and a towering yet misty or enveloping distance. Clumps and iridescent clefts become an unavoidable jargon; they provide the principle of most of the early sea- and subsequent estuary-pieces; they are allegories for feminine form and function, but often a base as well for the element of counterpoint, for a union of directions and oppositions, for the fusion of *The Sun rising through Vapour*, if I may instance the title, in addition to the famous painting itself. By means of low sun or moon in low sky, Turner has furnished in his studies an expanded world, soft, vaporous yet certain, not once but a hundred times.

I must enlarge upon clefts and clumps before referring to the counterpoint. If these be allegories of feminine form and function as a whole, yet the nuzzling, the enveloping, the part-object symbolism, is their stronger facet, so often dramatized in representations of vast space, by Turner's own small figure also, in top-hat and tail-coat (*vide* the Parrott portrait) with nose almost pressing it as he works a considerable canvas at the Academy or British Institution, without stepping back. Though it is written by an artist who was usually hostile and malevolent about Turner, some of the account, confirmed in the main elsewhere, is worth remark of Turner and his *Burning of the House of Lords and Commons* on a varnishing day, 1835, at the British Institution. 'He was there at work,' wrote E. V. Rippingille in a reminiscence of Callcott (*Art Journal* 1860), 'before I came, having set to work at the earliest hour allowed. Indeed it was quite necessary to make the best of his time, as the picture when sent in was a mere dab of several colours, and "without form and void" (Hazlitt), like chaos before the creation . . .' Etty was working at his side (on his picture *The Lute Player*) . . . 'Little Etty stepped back every now and then to look at the effect of his picture, lolling his head on one side and half-closing his eyes, and sometimes speaking to someone near him, after the approved manner of painters: but not so Turner; for the three hours I was there – and I understood it had been the same since he began in the morning – he never ceased to work, or even once looked or turned from the wall on which his picture hung. All lookers-on were amused by the figure Turner exhibited in himself, and the process he was pursuing with his picture . . . Leaning forward and sideways over to the right, the left-hand metal button of his blue coat rose six inches higher than the right, and his head buried in his shoulders and held down, presented an aspect curious to all beholders . . . Presently the work was finished: Turner gathered up his tools together, put them into and shut up the box, and then, with his face still turned to the wall, and at the same distance from it, went sideling off, without speaking a word to anybody.'

We can take it that in the act of painting, even his vast distances were pressed up against the visionary eye like the breast upon the mouth: at the same time it was he who fed the infant picture. In these embracing conceptions, no wonder that figures glue themselves on banks and bases, variegated figures, salmon-like, dully flashing films of colour, perhaps floating beneath a cloud-like architecture, perhaps pressed to the ground like the catch in baskets upon a quay, glistening at dawn. Ruskin remarked on the accumulations of bric-à-brac in Turnerian foregrounds – I would include bodies and jetsam in seas, or on an earth so flattened in some late canvases as to suggest a pavement of rippled water – and referred them to the grand confusion of Covent Garden where Turner lived as a child. An equation persists, as is well known, between nipple and phallus. The above description of Turner at work in 1835 at the British Institution may

recall the couplet twice used in his incomprehensible verses entitled *The Origin of Vermilion or the Loves of Painting and Music*:

As snails trail o'er the morning dew
He thus the line of beauty drew.

He sought daring expedients for his sense of fitness: in the case of persons especially, I repeat, they were based on part-object models. The companions, the siblings, he projected, are often like shoals; as mere members, as mouths perhaps, they may flit about the declivities and rises of an encompassing breast, much of it out of reach as palace, torrent, ocean, mountain or murderous sky.

No wonder Turner criticized Poussin's *Deluge* in the Louvre for lack of 'current and ebullition' in the water, though he was much influenced by Poussin at that time (1802). Ruskin wrote as follows for the first volume of *Modern Painters* about *The Slave Ship*: 'The whole surface of the sea is divided into two ridges of enormous swell, not high, not local, but a low broad heaving of the whole ocean, like the lifting of its bosom by deep-drawn breath after the torture of the storm.'

These are mounds, clumps, of terror and benignity; within one of the shapes, a pyramid of pearly monsters has been confounded with the black, disappearing bodies. The pyramid of *Fire at Sea*, huge, massive, is thrown upwards against a mound of cloud. Swart, irregular pyramids characterize the famous *Snowstorm* whose ship is like a broken caterpillar, whereas the engulfed mariners of *Fire at Sea* are near to having become, as if protectively, globular, saffron-coloured fish. A subject for Turner's attention, particularly in the neighbourhood of Plymouth during 1811, as numerous drawings and two canvases at Petworth testify, lay with the tall curving ribs of naval hulks, ruined globes of timber, derelict hills that rode upon the Tamar. The *Téméraire* would later achieve amid sunset fires superb apotheosis for hulks, unruined, full of distance from the funnelled infant steamboat by which it is tugged, to which it is closely attached.

It would be tedious to enumerate the recurrence of a fluidity that possesses clumps, mounds, pyramids and clefts, though I am fascinated by this theme, especially in paintings that Turner showed at his last Academy of 1850, *Visit to the Tomb* and *Departure of the Trojan Fleet*, among his ultimate Punic paintings. I must remark the extraordinary volume of such unmoored shapes, since there was earlier mention of poorness of relief in another context. Had he been primarily a figure painter – in this matter it is no contradiction to imagine so – Turner would have attained poignant compositions in terms of that theme: the so-called *Costume Piece* at the Tate suggests it.

To summarize Turner's clump or mound conception would be, I think, to isolate a parting of the ways, a rustling or seething withdrawal as in the biblical passage of the Red Sea: to many mythological scenes an opalescent, warm

passage is common through the centre, and on one side, maybe, the silent arm of a tall pine.

It remains to speak of the tension, the counterpoint, the bringing together of storm with sun, disaster with beauty, melancholy with protected ease in many, many, parkland expanses, and, in general, the good with the bad. Formal contrivances that suggest their union are not of course themselves symbolic in the immediate conscious sense of the rainbow, for instance, of the *Wreck Buoy*. More significant, however, even here (as deep-laid symbol), the high, lit, sail-tops, ghostly against a sky that falls in curtains of rain, cleave to the rainbow's half-circle triangularly, in contrast with foreground water, wastes rich in light flanked by darker mounds of sea, that topple over towards the spectator yet seem at the back to climb up to the boats and to the falling sky. The meeting of these movements occurs near the centre of the canvas from where one has the sense of extracting the heart of so vertiginous, so desert, yet so various a scene, in terms of the red-rose jib on the nearer sailing boat: at either side verticals incline outwards and thereby stress that centre. Awareness of a centre in great space will favour a *rencontre* of contrary factors in whatever sense. Turner was no stranger to the manipulation and perhaps even to the confusion of contrary factors. I cannot help remarking, as shown to me by B. A. R. Carter, that two demonstration sheets, illustrating a triangle fitted into a circle, that he used for his Perspective lectures, are each headed 'Circle (or circles) within a Triangle'.

A motif more constant in the work of Turner even than the one of clumps with their clefts, is the rhythmic use of a rebuttal, very commonly of waves blown back as they break on a lea shore, apparent already in early sea-pieces and in mountain brooks whose drums of shallow water rolling over boulders provide the effect of a reversing power, a break. He often represents the force of natural agency by demonstrating that it is engaged, sometimes thwarted by another. *The Falls of Terni* drop as one body, then are broken, buffetted. A stoic pathos, inherent in the beauty, sustains those great last light canvases wherein hardly a boat interrupts the grappling of sea with sky, wherein naked oppositions and their reconciliation supply overall bareness to the opulence of the effect. Yet even in narrow paintings of flat scenes, *Chichester Canal* or *Petworth Park with Tillington Church in the distance* (sketches at the Tate for the Petworth landscapes), at the meeting of ground and sky there is the effect of a scooped-out pomegranate or apricot common to the pictures of Petworth interiors, a benign application of the whirlwind principle, at the picture's centre, at the centre of interest. (The theme is at least as old as exquisite studies for *The Sun rising through Vapour*.) Maybe a low sun is there to help us seize upon the otherwise faintly indicated fruit, both soft and fierce, romantic in promise as in muted danger and elusive distance. Amid the embraces of hugeness, we have seen that figuration, men more than cattle, are sometimes a

startling variant, like fossil traces that vivify a rock. The infant's experiences have been similarly engraved by him upon the sudden breast.

Clasping natural immensity, Turner lent a hard-won grandeur to the distance, so irregularly spanned by each of us, between self-destruction and forgetful, infantile love.

As he elaborates an insight conditioned by his time, the artist, I have supposed in the first essay, may project images that need not correspond altogether with his most native bent. Naturally, the correspondence will have been very close in the case of superb individualists. All the same, it is impossible even to guess how potently Turner's uniqueness could have survived abstraction from the historical context, and it is impossible to know how deeply, how widely, the primitive obsessions that were exploited by his art, qualified the structure of his ego. In making an end, therefore, not only to this brief examination of his peculiar genius but also to wider issues in this book, a word or two are required for the other side of the balance.

A broad issue has been the artist's ambivalence, the bringing together he imposes on it. Turner pre-eminently dramatized that *rencontre* when he applied it to a state where it does not truly belong, to the earlier emotions of over-powering alternations before ambivalence has been admitted, embracing the then current notions of 'the sublime', of what is rapturous, transporting yet often vast and terrible, in a word, enveloping. Through chromatic wealth, through the brilliant identity between great differences that colour can create, an equation habitually survives in Turner's major work between dissolution, disruption and suave continuity, between richness and the bareness of distance: neither term suffers from their union; neither is overlaid, disguised. While light that dominates so many of his landscapes is rich and bounteous, it obliterates also, flooding building, water and mountain to the length, sometimes, of their near-extinction. Accepting his sublimity, entertaining thus a merging experience, the spectator shrinks as a complete or separate entity but regains himself as he absorbs the stable self-inclusiveness of the art object.

Now, an open landscape or sea-scape will sometimes induce the first part of this affect more fully than the second: the artist's treatment of such a landscape, not only Turner's, often disposes shapes that I have called breast-like clumps. What he developed from this arrangement in a light key is unique, but Turner was much under the influence of Wilson when, as a young man, he painted *Coniston Falls*, exhibited in 1798; the picture shows a grouping of masses typical of Turner's late canvases.

The Romantic Movement as a whole welcomed an equation between an envelopment through a state of nurture and through the ungovernable moods, the overpowering forces of Nature. The long reach of the inner life,

particularly in an infantile form, when projected on to Nature, directed Words-worthian pantheism. The Romantic Movement had been preceded by the speculation of a century upon the character of 'the sublime', in the case of art upon some feasible irregularity or excess intruding within the well-controlled relationships of an acknowledged tempo. In the later part especially of this period there was also an attention to Nature where she herself suggests the interlocking attributes of a painting; to the picturesque. This was an aspect, discussed by Richard Payne Knight at least (in whose company J. R. Cozens probably made his first journey to Italy in 1776) as independent to some extent of association, as 'merely visible beauty abstracted from all mental sympathies or intellectual fitness' (*An Analytical Inquiry into the Principles of Taste*, 2nd edition, 1805). Though Knight had restricted his pure qualities of vision to those of light and colour, this early version of 'significant form' calls to mind particularly Francis Towne's and Cotman's best work where they have concentrated without ado upon the bones of structure. The forms even of the Campagna landscape predominate, in the hands of the two Cozens, not only over details of antique remains but over elegiac or pastoral associations. Their drawings and watercolours communicate emotion, albeit poetic emotion, more generally. 'Cozens (J.R.) is all poetry', said Constable who described him as 'the greatest artist who ever touched landscape'. Many monochrome or wash drawings at the turn of the century, such as the blue wash drawings of evening common to Girtin, Turner and Cotman, are closely related to his work (Oppé). For three years, probably from 1794-7, Girtin and Turner were employed by Dr Monro to trace and then colour after J. R. Cozens (among others). Mountains are hardly more substantial than the clouds in many Cozens's wash drawings, such is their poetic accent upon breadth and homogeneity. Alexander Cozens, the father, had insisted 'that the true character of a subject lay in its boldest and broadest aspect' (Oppé). As in the work of the non-literary Girtin later, precept for his compositions was based less upon old pictures or literary association than upon the categories of landscape itself. Alexander Cozens devised a system for unravelling compositions from blots made boldly with a brush while an idea of landscape was present in the mind (*A New Method of Assisting the Invention in Drawing original Compositions of Landscape*, 1786. More than one story about Turner shows that his procedure had not been forgotten. cf. Hamerton.) Brought up in Russia he may have seen monochrone, free flowing, examples of Far Eastern brushwork. We know that he was given a sheet of calligraphic Persian drawings in St Petersburg: it passed into his patron's, Beckford's, possession. It is most likely that Turner examined major work by both Cozens when he was at Fonthill in 1799. He will have noted the slowly insistent (rather than rapid or sketch-like) breadth of treatment in a finished, long-worked watercolour, this the only contribution ever made by English painters to a

broad or grand manner all their own, a manner enlarged at times by Girtin with the invention of a more direct attack, bound up with better papers and new colours, by Cotman and, throughout, vastly by Turner who, at the same time, neither spurned a combination with an imaginative, literary approach nor lost his zest pursuing a far wider public by means of continuous engraving.

These very few references are sufficient to remind the reader concerning the danger, a necessity of so short a statement, of treating an artist for one moment in isolation.

But of course the greatness of Turner lies not only in his opportunity and in his temperament adapted to it. 'Turner was gifted', wrote Laurence Binyon, 'with a hand and eye of incomparable delicacy; he had an amazing visual memory, an inexhaustible appetite for observation of the subtlest kind. He was immensely ambitious, and his ambition was equalled by his patience and docility. By nature close and secretive, he was bent on learning and never ceased to learn, ready to take hints from any of the masters, while accumulating within his mind store upon store of first-hand knowledge through his eyesight.' Yet it must be added that at least some of these propensities and of this application might have been withheld from art under different cultural conditions. In the event, no other English artist has been so deeply, so intelligently, informed of Nature as well as of the Masters. 'The sense of England', wrote Binyon, 'which pervades the drawings of his youth and early manhood has expanded into a sense of Europe: but in the end this also merges into something wider and profounder, a sense of the whole related universe.' I would add that this 'universe' serves to reflect strongly what I have called the inner life, particularly the inner life at a very early and comparatively simple level.

But amid every febrile deployment Turner kept his head. 'One marvels,' says Binyon, 'at . . . the evocation of complex forms, however submerged in aerial hues, the fullness of the distances. It is the same with the Alpine scenes, where the mountains retain their sculptured form yet seem built of light and air.'

Maybe Binyon had particularly in mind chosen watercolour sketches – there was still a gap between sketches and work commissioned from them – allotted to the early 1840s, some, for instance, of Lucerne lake and its surroundings (where Cozens too had excelled). I consider these latter-day lake watercolours – not of Lucerne only – to be Turner's crowning achievement, and therefore the best things by an English painter. With their height, reduplication and reflection below, the Alps were translated into infectious forms of stupendous chromatic beauty. What Cézenne would later achieve before the brow of Mont Saint-Victoire, Turner lavished finally in a few small-scale works upon endless, enfolding prospects.

Turner integrated eccentricity with the demands of adulthood: in the situation of successful creativeness, we have seen, compulsion and obsession need not debar breadth: nor did they in Turner's life. Miserly and extortionate with small money, acquisitive of culture, he commanded many generous feelings and wide interests. He was always very loyal, particularly to his parents, to their want or poverty. Gruff, kind to children and to many others; morose, cheerless in a preferred shabbiness, dry of humour, he often enjoyed company away from home. He was astute not only in his own business but over the Academy's business to which he gave much time in association with others. Often a recluse, we know he suffered deeply on the death of his friends. Unregenerated by ridicule, in seeking what he felt he remained without veneer. His painting of set-pieces enshrines under fustian an incorrigible body of primitive vision, transforming an eighteenth-century argot for grandiloquent nostalgia into epics of naked need, subordinating rhetoric to an unbroken immediacy attributed to Nature, unbroken, however refurbished; and therefore unbroken rather than refurbished. Hard, not to say cruel, in the requirement from engravers, he caused them to become the best in Europe. A very rich self-made man, he spent £3,000 buying back plates, lest they fall into inferior hands; yet unwanted masterpieces, and those he had himself bought back at huge prices – he meant all to go to the nation – rotted in a damp gallery, often sure to lose colour due to impulsive techniques. As well as supreme goodness, he will have attributed to his accumulated canvases a corruptible aspect that swelled his sense of loss and decay.

In his later years there is an episode that seems the happiest. Not long after the death of his father in the autumn of 1829, he appears to have spent much time with Lord Egremont at Petworth, occupying a studio. Rothenstein and Butlin have written of the 'liberation' of his colour in the luminous interiors he is thought to have executed there, remarking that it is strange that this even bolder attack should be realized first in figure scenes such as the studies of music-making, rather than through his landscapes.

I hazard the guess that under the aegis of the unpretentious, far-seeing Egremont and his vast collection, the early Turner household, together with an accumulation of artefacts dating from the crowded Covent Garden days, were momentarily reconstituted in a monumental and perfected version, in a version, as it were, of classic stone. Not only are the landscapes that Turner then painted for Petworth among his greatest and calmest, but in the subject-picture sketches, in the interiors, he was approaching nearer – also Rothenstein and Butlin remark it – than at any time we know of since his self-portrait as a youth, to a colourful appreciation through his art of entire human beings, at any rate of his companions rather than of strangers. There are signs in a few drawings of the late twenties of such a development; it is heralded by the *Jessica* he had painted

during the second Roman visit; a development encouraged by Egremont inasmuch as he bought *Jessica*. The famous *Interior at Petworth* whose scattering chromatic lights disperse, dispense with, bric-à-brac, animals, birds in the grandeur of a hall, may mark, as has been suggested by David Thomas for barely discernible iconographic reasons, Egremont's death in 1837, and so the completion of this happier phase.

Turner died in 1851 at the age of seventy-six, in a small cottage on the river bank at Chelsea, as far as his surgeon and, presumably, his neighbours were concerned, under the name of Booth, the one of his widowed housekeeper there.

The Invitation in Art

AUTHOR'S NOTE

I thank Eric Rhode for his useful advice on an earlier version of my text.

First published 1965

Introduction

FREUD JUXTAPOSED FEELINGS, activities, concepts that for the most part had always been disconnected. He brought together, for instance, the belief in God, or, rather, some of the constraining beliefs about God, with the young child's submission to a stern, all-seeing father whom he incorporates as his conscience in the process of resolving the Oedipus conflict and the threat of castration. Although such correlation has somewhat disturbed very ancient accepted values, I believe that this aspect of psycho-analytic discovery, namely, a precise correlation of attitudes, of emotions that have at first sight appeared entirely diverse, is both the outcome and the reflector of a perennial striving in all cultures to embrace, to bring together, and, better still, to integrate, experiences. This attempt has closely determined the nature of art.

Culture depends upon communication, communication upon the employment of symbolism, upon the lying together of meanings, this with that, this standing for that. Religion has tended to treat connectiveness wholesale, to bring things together with irresponsible speed, wresting them into a much longed for, homogeneous embrace by discounting much of their true difference. A religious correlation of the highest and lowest can exist only in the name of what is judged to be the highest, whereas a parallel psycho-analytic correlation employs the name of neither. Surprising patterns, the co-ordination of contrasted experiences, an integration of the scattered and the split-off, make sense for this science in terms of the biological human organism; not at all in terms of a dynamism beyond it, that is to say, of a power much less complicated and resourceful, since it is unlimited or omnipotent.

By any reckoning, human nature, like the body, is a story of growth and decay, and the infant's emotional experiences are the stem from which other experience radiates. We are not outraged by Wordsworth's 'The Child is father of the Man', yet the remark, I think, has become proverbial not only because of neat paradox but because that turn of phrase hints at the father

incorporated by the child as part of his super-ego or conscience to his dying day; none the less, the line means superficially little more than Milton's 'Childhood shows the Man'. If the first dictum is less banal than it might seem, it is also less fanciful. Such felicity is an aim of art.

It is unnecessary to refer to the unconscious and to resistance. As long as what is put out about the unconscious remains generalized, acceptance is now wide on the part of those who have not debarred consideration of the matter. But I wish to refer to the work of Melanie Klein, the psycho-analyst who died in 1961, to indicate in what manner her findings have advanced the sense of correlation that has always been, it is suggested, the hallmark of a culture. In the true line of Freud, as I think, she has very largely added to his empire.

If 'The Child is father of the Man' be regarded in the Freudian sense above, the accompanying Kleinian dictum would run: 'The Infant is mother of the Man'. As a result of her analyses of children, a neglected field up to that time, Mrs Klein concluded that aspects of the parents or surrogate parents, particularly of the mother, were incorporated by the infant long before the onset of the latency period and the resolution of the Oedipus conflict. In effect, the beginnings of Freud's super-ego were traced to early infancy. And she declared that a firm incorporation of a bountiful feeding object – part-object in psycho-analytic jargon, contrasting with a whole-person object – was of first importance for the ego's strength. Regarding the first point, she wrote:

'I found that the frequent nightmares and phobias of young children derive from the terror of persecutory parents who by internalization form the basis of the relentless super-ego. It is a striking fact that children, in spite of love and affection on the part of the parents, produce threatening internal figures. . . . I found the explanation for this phenomenon in the projection on to the parents of the child's own hate, increased by resentment about being in the parents' power. This view at one time seemed contradictory to Freud's concept of the super-ego as mainly due to the introjection [i.e. incorporation] of the punishing and restraining parents. Freud later on agreed with my concept that the child's hate and aggressiveness projected on to the parents plays an important part in the development of the super-ego' (Klein, 1963, p. 27).

Mrs Klein's elaboration of the theory of projection and introjection was by no means confined to the matter of the super-ego. As well as introjection, she discovered far more projection to be a method of defence, and the imposition upon objects by a mode that entails the splitting of their aspects and of the self – typical schizoid activities – she found to be an earlier, yet no less universal, way of defence than repression. Psychosis is a reversion to an extreme confounding of subject with object by such means, a regression to an organization that is a disorganization of experience to which none of us is altogether a

stranger. But there is a contrasting aspect of this initial stage when seen in the light of what it brings to subsequent development. From our confusion of subject with object, founded in the first place on relationships with part-objects wherein the demarcation of subject and object is always blurred, we emerge beings who still partake of one another, not only out of love but out of hate. The capacity to learn, to identify ourselves, to communicate, cannot be divorced from contributions by primitive emotional mechanisms: they can equally inhibit those activities.

It is commonplace to say that we are partly made up of others and they of us. Viewed by psycho-analysis, however, the interchange can have the precision of a timetable and of formidable engines enacting it. Unconscious motivation is not, as it were, an uncharted swamp of the mind, being largely embodied, on the contrary, by what is called concrete thinking whereby a person introjected becomes in unconscious phantasy a harboured bodily form. Similarly, if through projection we rid ourselves of envy or greed, we pay for it by an unconscious sense of structural incompleteness. I envisage in such matters what may be called a hard-currency interchange between subject and object, as if the formless, spongy unities of mystical thinking had been transformed into many little objects of a resistant substance. This analogy is suited at any rate to describe a situation wherein an attribute of one person is greedily abstracted and then projected into another person of opposite sex, to the eventual confusion of sexual relations. There had existed safety in such splitting or in any long-distance control of an object through a part of the self by means of what is called projective identification.

But why safety? What is so threatened? – it will be asked. Late in life, for a revised metapsychology, Freud found it essential to posit, as a companion for the libido, a negative principle that he called the Death Instinct. The proposition did not involve him in a wholesale redeployment of his clinical findings: repression remained the chief defence, directed, as before, against the flooding of the psyche by libidinal stress. Not so for his successor. According to Melanie Klein the infant organism would be at the mercy of self-destructiveness were not the destructiveness projected as aggression without ado. From the outside world – in sum, the mother's breast in its frustrating aspect – this now bad and persecutory object is inevitably introjected into a separate compartment, as it were, split off from the good internal object that must be preserved at all costs. Hence Mrs Klein's formulation of the paranoid-schizoid position that charac-terizes the first months of life, giving way slowly – never completely – to the so-called depressive position, since the ego now takes responsibility with great pain for all the harm projected on to the object, suffers depression, sense of loss and of guilt, rather more strongly than the sense of persecution that is older. The object, the mother in chief, is now seen as a whole and separate person,

frustrating as well as beneficent: she was previously an alternation of disconnected part-objects. At the same time there occurs the counterpart integration of the self and of its internal objects. Now that we have so much evidence for the early diffusion and splitting of the self, for denial in general, the painful and truth-seeking integrative process of subsequent development is valued as a sane figure of very considerable achievement, self-subsistent yet communicative like a work of art.

Yet we continue, of course, to split objects, groups and their causes, into the very good and the very bad; for good as well as ill we continue to project and to introject. In harness, maybe, with impartial or practical observations, we lend continually to our relationships and to our views the likeness of early situations, inner and outer. In the glare of a more precise knowledge, it would seem that what has long been called the *argumentum ad hominem* should not be reinforced. But even supposing all data to be available to an interlocutor, that form of argument usually gains no more power to convince in so far as the motive for a projection is the disowning of its content. This is the last realization that can be expected from the projector, at least outside psycho-analysis. All the same, wherever we have fought free of rough embraces by transcendental principles, even the admission of such a projective mechanism as a generality tends to vivify awareness of more subtle correlations between aspects of behaviour. What is desirable, what has always been desirable, is a milieu fit for adults, for true adults, for heroes of a well-integrated inner world to live in, a society to support that inner world, to project, to re-create its image. The artist is, and always has been, concerned with that image, attempting to assimilate into structures varied aspects of himself and of the world outside. In my view there is no transition to bridge between psycho-analytic findings that are so general and the demonstrations of art with which this short book is concerned; that is to say, with the formal demonstrations, the insistence by its form that distinguishes the communications of art from other embodiments of phantasy or of imagination.

These pages, in common with my last books, attribute a content to form that consists of very various harmonious junctures in the evocation of part-object together with whole-object relationships. I have written before of an enveloping relationship with the work of art that it strongly induces, and here attempt to give more precise indications about this incantatory element, or invitation, as I now call it.

A kindred theme is our emotional relationship with environment that beckons us, in the last chapter with landscape as a history of ourselves, in the second and, to a small extent, in the first, with the metropolitan surroundings of today that influence our art. In the light of projective mechanisms I contend that art is based upon the need to correct all man-made things especially, with which,

as such, our emotions or the imagination are particularly implicated; institutions as well as, the same as, concrete objects: hence the aesthetic core in rituals.

I envisage only one insight by which I have worked for nearly forty years. It seems that what I wrote long ago about Italian fifteenth-century art, about the contrast, for instance, between a painting by Verrocchio and one by Piero, between overriding stress, violent transitions, and the laid-out, 'revealed', equal-glowing effects of Piero and of the architect Luciano Laurana; effects that minimize represented movement or any suggestion of a process in train; what I wrote, in sum, about so-called plastic or modelling as opposed to carving values, both of which, I said, must figure with the same means in every work . . . demonstrates that there has been no hiatus separating the old from more recent books.

And if in this book I attempt to trace the permeating role of a plastic, enveloping element, my preoccupation is not at all exercised at the expense of those other values, the equal emphasis, the flowering, radiant compactness, that evoke the re-creation of a whole, independent object, the utter demonstration of its brotherly yet differing parts, none of which is overborne.

PART I
The Invitation in Art

SINCE THE TIME, NEARLY FIFTY YEARS AGO, that Marcel Duchamp sent to an exhibition in New York a porcelain urinal (described as a fountain) with the signature of the manufacturer that he, Duchamp, had attached in his own writing, we have had an excellent occasion with which to associate new reflections upon the values of art. We realize that adepts at scanning an object for the less immediate significance of its shape, a manner of looking at things that has been cultivated from looking at art, will contemplate a multitude of objects, and certainly, in an august setting, the regular curves and patterns of light on that porcelain object, with aesthetic prepossessions. With less thought for the object's function than for its patterns and shape, we project on to them a significance learned from many pictures and sculptures. But are we projecting separate experiences of art; are we not projecting an aspect of ourselves that has always been identified with them; and is not the identification an integral factor, therefore, of aesthetic experience and an aim for art? This has seemed even more likely since psycho-analysis uncovered a mechanism called projective identification by which parts of ourselves or of our inner objects may be attributed even to outside objects that, unlike artifacts, at first sight seem inappropriate for their reception. It is possibly in this manner as well that we might discover ourselves to be assimilated in an active aesthetic transformation of the urinal, an object that does not itself communicate to us with the eloquence of art. We, the spectators, do all the art-work in such a case, except for the isolating of the object by the artist for our attention.

Structure is ever a concern of art and must necessarily be seen as symbolic, symbolic of emotional patterns, of the psyche's organization with which we are totally involved. This reference of the outer to the inner has been much sharpened by psycho-analysis, which tells, for instance, of parts of the self that are with difficulty allied, that tend to be split off, and of internal figures or objects that the self has incorporated, with which it is in constant communication or

forcible ex-communication. Pattern and the making of wholes are of immense psychical significance in a precise way, even apart from the drive towards repairing what we have damaged or destroyed outside ourselves.

In distinction from projections that ensue upon any perceiving, aesthetic projection, then, contains a heightened concern with structure. The contemplation of many works of art has taught us this habit. I think it is so strong only because in every instance of art we receive a persuasive invitation, of which I shall write in a moment, to participate more closely. In this situation we experience fully a correlation between the inner and the outer world which is manifestly structured (the artist insists). And so, the learned response to that invitation is the aesthetic way of looking at an object. Whereas for this context it is simpler to speak of structure, of formal relations, such a presentation is far too narrow. Communication by means of precise images obtains similarly in art a wider reference whenever the artist has created for the experience he describes an imagery to transcend it, to embrace parallel kinds of experience that can be sensed. Poetic analogy or image is apt; felicitous overtones coexist; the musical aptness of expression hazards wider conjunctions than those immediately in mind.

In visual art, too, we see without difficulty that form and representation enlarge each other's range of reference. Similarly, the same formal elements are used to construct more than one system of relationship within a painting itself, and with us who look at it. Whatever the total meaning, the perennial aspect reveals a heightened close connexion between sensation significance, that is to say, impact on the perceiving instrument as it organizes the data, and more purely mental content that we then apprehend in the outside terms of sensation significance.

Referring to the character of perception, I have in mind what might be called the prejudices of vision uncovered by psychologists. I take these 'prejudices' to be an important link between the outer world and the empathic projection thereon, in ordinary and in aesthetic perception alike, of inner process. The 'forces' uncovered by the psychology of vision provide the words, the language of visual art. Whereas wide disagreement exists among psychologists as to the way that the visual world is perceived or constructed, none would deny, I believe, that the perceiver participates in what might be called the quandary of units of the visual field, which do not, or do not easily, achieve restful status. Thus, there is tension in any perceived obliquity, in any departure from an open framework: there is pull, direction, the sense of weight and movement. Even a vertical ellipse strives upward in the top half, downward in the lower. A vertical line seems to be far longer than a horizontal line of equal length; and so on. Such forces, such bents, I repeat, are the words, the language, of visual art. Not only are their implications of direction, compression, weight,

pull, interference, employed by the painter to communicate the sentiment of a pictorial subject-matter, but they mirror, in their inter-working, the power that one part of the self, or one inner object, can exert over the others. Indeed, I hope it is not an outrageous conjecture concerning perception to say that stereotypes for psychical tension may be projected thereby, and that these projections in some part may have reinforced the perceptual bents to which I am referring. In any case, whether or not immured biologically in perception, internal situations remark themselves therein. We are dynamically implicated with visual stress, particularly with the enveloping use that art makes of it. When the final balancing, the whole that is made up of interacting parts, is suspended for a time by the irregularities of stresses, these same stresses appear to gain an overwhelming, blurring, and unitary action inasmuch as the parts of a composition are thereby overrun, and inasmuch as the spectator's close participation, as if with part-objects, removes distance between him and this seeming process. Much of the attraction of the sketch lies in this situation, which arises also whenever we think we find the artist at work, in his calligraphy or flourish, his gesture or touch, and, even more generally, in the accentuations of style. I have particularly in mind the extreme example of Baroque paintings with a diagonal recession, invaded by a represented illumination, cast diagonally, that cuts across figures, that binds the composition as a movement of masses, without respect for integrity of parts of the scene, of distinct figures, voids and substances. A principle, a process at work, seems to override the parts. It is one aspect of the 'painterly' concept formulated by Wölfflin, in which values of what some psychologists have called 'the visual field' dominate certain values in 'the visual world' of ordinary, everyday, perception. We very often associate creativeness first of all with an ability to disregard an order elsewhere obtained, to ignore an itch for finality in favour of a harder-won integration whose image may still suggest an overpowering process, no less than its integration with other elements.

Hence the invitation in art, the invitation to identify empathically, a vehemence beyond an identification with realized structure, that largely lies, we shall see more fully, in a work's suggestion of a process in train, of transcending stress, with which we may immerse ourselves, though it lies also in that capacious yet keen bent for aptness, for the embracing as a singleness of more than one content, of one mode for 'reading' the elements of its construction, to which I have already referred in regard to form and image. Though they always have the strong quality of co-ordinated objects on their own, the world's artifacts tend to bring right up to the eyes the suggestion of procedures that reduce the sense of their particularity and difference; even, in part, the difference between you and them, though the state with which a work is manifestly concerned be the coming of the rains, or redemption and damnation, or the

long dominance of the dead. Most painting styles are what we call conceptual: objects are rendered under conformity to an idea of their genus, to hierarchic conceptions (with a comparative neglect of individual attributes and changing appearances) favouring the power to lure us into an easy identification with an expression of attitude or mood. The depicting of incident thus receives a somewhat timeless imprint, offers a relationship that at first glance saps the symbolism of an existence completely separate from ourselves. As we merge with such an object, some of the sharpness that is present when differentiation of the inner from the outer world is more accentuated, the sharpness and multiplicity of the introjectory-projectory processes, are at first minimized. Yet I shall note, on the other hand, that under the spell of this enveloping pull, the object's otherness, and its representation of otherness, are the more poignantly grasped. But I want also to stress the opposite point by indicating in naturalistic styles, which boast far greater representation of the particular and of the incidental, that these works, if they are to be judged art, must retain, and indeed must employ more industriously, procedures to qualify the intimation of particularity, to counter the strong impression of events entirely foreign to oneself by an impression of an envelopment that embraces distinctiveness.

I now call the envelopment factor in art – this *compelling* invitation to identify – the incantatory process. I have often written of it, principally in terms of part-object relationship, particularly of the prime enveloping relationship to the breast where the work of art stands for the breast. I adopt the word 'incantatory' to suggest the empathic, identificatory, pull upon adepts, so that they are enrolled by the formal procedures, at any rate, and then absorbed to some extent into the subject-matter on show, a relationship through whose power each content in the work of art can be deeply communicated. I shall try to indicate further methods and characteristics of visual art whereby the incantatory process comes into being. I believe that much formal structure has this employment, beside entirely other employment, and that a part of the total content to be communicated is often centred upon unitary or transcending relationships, though they contrast with the work's co-ordination between its differing components, this, another content no less primary, whereby the integration of the ego's opposing facets and the restored, independent object can be symbolized. I believe that the incantatory quality results from the equation enlisted between the process of heightened perception by which the willing spectator 'reads' a work of art – often with a difficulty of which the artist makes use to rivet attention to his patterns – and inner as well as physical processes; an equation constructed or reinforced by at least an aspect of the formal treatment that encourages the sense of a process in action. There is vitality in common that suggests an unitary relationship, as if the artifact were a part-object.

I shall continue to touch on a few manifest elements in the case of naturalistic

art. For it goes without saying that dance, song, rhythm, alliteration, rhyme, lend themselves to, or create, an incantatory process, a unitary involvement, an elation if you will. Thus when I wrote of this matter in 1951, I did so in terms of the manic. During the next year, 1952, there appeared in the *International Journal of Psycho-Analysis* Marion Milner's paper, renamed in the Melanie Klein Symposium of 1955, 'The Role of Illusion in Symbol Formation', where, not only in matters of art, she emphasized a state of oneness as a necessary step in the apprehension of twoness. Her key-word here is 'ecstasy' rather than 'part-object'. Her paper derived partly from ideas she had already put forward in her book, *On not being able to Paint* (Milner, 1950).

Of the principal aesthetic effects an incantatory element is easiest grasped. By 'grasp' I refer also to being joined, enveloped, with the aesthetic object. But whereas we easily experience the pull of pleasant poetic, pictorial subject-matter – classical idylls, *fêtes champêtres*, and so on – there is not so much readiness to appreciate the perennial existence of a wider incantation that permeates pictorial formal language whatever the subject or type of picture. Similarly a poem, like a picture, properly appreciated, stands away from us as an object on its own, but the poetry that has gripped, the poetry of which it is composed, when read as an unfolding process, combines with corresponding processes in a reader who lends himself. Therefore my description is the incantatory process, since I feel that all art describes processes by which we find ourselves to some extent carried away, and that our identification with them will have been essential to the subsequent contemplation of the work of art as an image not only of an independent and completed object but of the ego's integration. Since, as a totality, it is an identification with the good breast, I have often submitted that the identification with processes that are thought of as in train allows a sense of nurture to be enjoyed from works of art, even while we view them predominantly in the light of their self-sufficiency as restored, whole objects, a value that thereby we are better prepared to absorb.

The first power that the work of art has over us, then, arises from the successful invitation to enjoy relationship with delineated processes that enliven our own, to enjoy subsequently as a nourishment our own corresponding processes, chiefly, it appears to me, the relationships between the ego and its objects, though concurrently the unitary power, inseparable from part-object relationship, that transcends or denies division and differences. To take the instance once more of this last relationship from painting, light and space-extension can be employed to override each particularity in favour of a homogeneity with which we ourselves are enveloped. And so, such effects in the picture – their variety is vast – construct an enveloping *mise-en-scène* for those processes in ourselves that are evoked by the picture's other connotations.

It is easily agreed that pictorial composition induces images of inner process

as we follow delineated rhythms, movements, directions with their counter-directions, contrasts or affinities of shape with their attendant voids, as well as the often precarious balancing of masses. Predominant accents do not achieve settlement without the help of other, and perhaps contrary, references: hence the immanent vitality, and a variety of possible approaches in analyzing a composition; hence the ambiguity, in the sense of an oscillation of attention, that others have noted in the interweaving of poetic images. It may be thought that this will hardly apply to the representation of balance between static, physical forms as opposed to the representation, in which naturalistic art excels, of movement or of stress and strain. Such immobility, however, often involves a sense of dragging weight, of the curving or swelling of a contour with which we deeply concern ourselves, since we take enormous pleasure, where good drawing makes it profitable, in feeling our way, in crawling, as it were, over a represented volume articulated to this end; many modes of draughtsmanship, or of modelling, may invite a very primitive, and even blind, form of exploration. In one of their aspects, too, relationships of colour and of texture elicit from us the same sense of process, of development, of a form growing from another or entering and folding up into it. And, as I have said, we find ourselves traversing represented distances, perhaps enveloped by an overpowering diffusion of light. Finally architecture, possessor of many bodily references, mirrors a dynamic or evolving process as well as the fact of construction.

It is necessary to repeat that the unitary relationship between ourselves and on-going processes represented by the aesthetic object contrasts with the integration of its parts, for which we value it as a model of a whole and separate reconstituted object. In a combination that art offers, we find a record of predominant modes of relationship, to part-objects as well as to whole objects.

I want now to remark an aspect of visual art connected with what I have called the quandaries and prejudices of visual experience that provide the possibility of a stressed language. One exploitation of these quandaries lends itself to catharsis of aggression, even of a mutilating urge that, paradoxically, is sometimes more characteristic of naturalistic art than of any other. Extreme foreshortening has been described by Arnheim (1956) as 'contraction, like a charged spring'. He also speaks, not altogether without justice, of 'the re-arrangement of organic parts through projective overlapping – hands sprouting from behind the head, ears attached to the chin, knees adjoining the chest. Even the most daring modern artists have rarely matched the paradoxical reshuffling of the human limbs that has been presented as an accurate imitation of nature', doing violence to simple patterns of structure, a desired norm – it is sometimes thought – for vision.

It may be useful to specify for a moment, if only with a handful of examples.

I refer very briefly to the place of the unitary breast principle in proto-Renaissance and early Renaissance naturalism. John White (1957) has described a 'growing tendency to move from the idea of things surrounded by space towards that of space enclosing and uniting things' in much art of fourteenth-century Florence and Siena. The representing of space would much later become wholly an enveloping agent, sometimes an aggressive scoop to carry us into distance, to go far beyond the canvas. But earlier, in the protoperspective space bedecked or jewelled by Giotto, Duccio, and the Lorenzetti, there exists no such manipulation or destruction of the picture surface. Moreover, at the very same time that geometric perspective was institutionalized as a cult in the first half of the fifteenth century, there came about at the hands of those who worshipped there, particularly Piero's, a supreme use of colour, an echo between forms and intervals, whereby an equality for each shape, a lack of emphasis throughout the patterning, preserved an unified complexity of picture plane: a miraculous solution of conflicting data, perceptual and psychical, and hence of picture-making. Piero's own books reveal that he estimated perspective not at all for the new power at the artist's command of *trompe-l'oeil*, but for the extension of harmony and proportion, of the laws of optics, and, indeed, of a mathematically ordained universe to be learned now fully from the image, the painting, no less than from visual experience of which it served as an image.

Thereafter, overpowering uses for perspective have sometimes been developed. Similarly, though little apparent until much later, from the time of Leonardo there has been some breaking down of the constancies that characterize the visual world, by means of the full employment of chiaroscuro, by means of insistence on a full tonal range that disregards the conventional aspect of an object usually seen to be constant whatever the illumination, just as perspective often utterly distorts, neglects, a characteristic shape of an object on which conceptual art lingers. Developing from this, we have had of late from painters the idea of a pure sensation of colour or of light. Although the psychology of ordinary vision does not support it, the abstract quality of such observation, analytic and truthful, has ennobled pictorial incident. Indeed, out of the requirement for enveloping values amid the pursuit of naturalistic detail, European artists particularly have uncovered a degree of triteness in the constancies through just observations and through the bold, embracing techniques to which they could then proceed. If what they have thus isolated in the name of naturalism has tended to disrupt both the picture plane and the enduring character of the represented objects as such, these same events have called forth unparalleled efforts for their restoration in a new, and indeed more truthful, situation of quandary, truthful especially in regard to the conflicts of the inner life. Hence

the greatness, on the whole, of our art since the Renaissance, as well as the utter degradation to which it is prone.

I have been describing the suggestion of an overpowering process in the painter's deployment of perceptual truth that has been largely ignored in the exercise of practical perception. I use the word 'process' because the overpowering is felt to be going on by the spectator. I turn now to the major overall process, a reparation, in which both the good breast and the whole, independent mother must figure, a reparation dependent, it seems to me, upon initial attack. I believe that in the creation of art there exists a preliminary element of acting out of aggression, an acting out that then accompanies reparative transformation, by which inequalities, tension and distortions, for instance, are integrated, are made to 'work'. I have long held the distinction between carving and modelling to be generic in an application to all the visual arts. These two activities have many differences from the psychological angle, first, I think, in the degree and quality of the attack upon the material. Similarly, this difference of attack is relevant to the old distinction between the decorative and the fine arts where an increase of attack calls forth an increase of creativeness. But if decoration titillates, ornaments, the medium, and if larger creativeness may to some considerable extent oppose its native state, I believe that every work of art must include both activities.

A painter, then, to be so, must be capable of perpetrating defacement; though it be defacement in order to add, create, transform, restore, the attack is defacement none the less. The loading of the surface of the canvas, or the forcing upon this flat, white surface of an overpowering suggestion of perspective, depth, the third dimension, sometimes seems to be an enterprise not entirely dissimilar to a twisting of someone's arm. I am inclined to think that, more than anything else, the defacement involved of the picture plane accounts for the tardy arrival in pictorial art of an entirely coherent linear perspective. From many angles, extreme illusionism is an extreme form of art, not least in the aggressive and omnipotent attitude to the materials employed. Many – every month many more – materials are now consciously respected, set-off, in our art today; thus made purposive, their naked character bears witness to an independence of these objects. We often deprecate an entire disguise of the canvas's flatness; we advocate 'preservation of the picture plane'. But whereas the paint, for instance, stays paint in such works, a large part of the impact upon us may proceed from the fact that the canvas is so heavily loaded and scored. Always the strong impact of which defacement, I am convinced, is an attribute. It is 'seconds out of the ring' for every writer as he opposes his first unblemished sheet, innocent of his *graffiti*. It is even harder to begin to paint. With the first mark or two, the canvas has become the arena in which a retaliatory bull has

not yet been weakened; no substantial assault, no victory, has begun. If a painter be so blatant, so hardy, as to fling, almost heedlessly, upon the canvas, a strong impact, he will at best create an enveloping or transcendental effect of omnipotence.

Pictures in a gallery, even the pictures in the National Gallery, make an ugly ensemble; as an ensemble the bare walls would be more pleasing. There is no doubt that the most beautiful ensembles of paintings are of those that are abstract and thinly worked, unaggressive in colour. A Ben Nicholson exhibition vivifies the walls on which it is hung. Some kinds of abstract painting, then, employ a very subtle attack. But we soon reach the strange conclusion that if attack be reduced below a certain minimum, art, creativeness, ceases; *equally, if sensibility over the fact of attack is entirely lulled, denied.* The plainer tricks of perspective drawing can be easily learned and then imposed, should the knack be greedily appropriated without a thought for the numbing distortion of the surface thus worked, and so without aesthetic sensibility. A practised artist will have become habituated, of course, to his bold marks. But he cannot be a good artist unless at one time he reckoned painfully with the conflicting emotions that underlie his transformations of material, the aggression, the power, the control, as well as the belief in his own goodness and reparative aim. The exercise of power alone never makes art: indeed it reconstructs the insensitive, the manic, and often, strangely, the academic. Art requires full-dress rehearsal of varied methods that unify conflicting trends. Such presentation causes composition, the binding of thematic material, to be widely evocative. This is more clearly shown in music than in the other arts. Musicologists tend to discover that, whereas construction is easily analyzed from a variety of angles, the creative element, that distinguishes a coherent web from clever dovetailing, in general eludes analysis. Hence a vague appeal, sometimes, to 'organic unity'. I believe that it is possible to be more specific in speaking of the deep charging of these sense-data with emotive significance, whereby the deployment of formal attributes becomes a vivid language, that is to say, symbols of objects, of relationships to objects and of processes enwrapping objects, inner as well as outer. The word 'symbol' here does not indicate parallel structures, but structures wherein the component parts, though possessing no correspondence with the component parts of the original objects, are interlocked and interrelated with an intensity, sharpness, regret, or other feeling-tone that belong at least to one aspect of the original object-relationships, especially to the fact of their coexistence, interpolations, and variety.

Whereas the finished work, or the work as a whole, symbolizes integration, once again while we contemplate and follow out the element of attack and its recompense, we are in touch with a process that seems to be happening on our looking, a process to which we are joined as if to an alternation of part-objects.

At the beginning of this chapter I said that naturalistic art had need, *ipso facto*, for particular exertion in initiating the incantatory process, since its apparent aim sharpens the otherness of a represented incident or scene. In conclusion, and to sum up, I think I can now better make clear, in one instance of a representational aim on which everyone is agreed, how these two objectives are combined.

Consider in painting the third dimension, the suggestion of depth. No painting of whatever kind, with any merit, is absolutely flat in effect. There will be at least a suggestion of oscillation; something tends to come forward, in a manner that intrigues the senses, in front of something else, though, in general, there be no attempt to disguise the flatness of the picture plane. The surface itself seems to have bulk. Thus, at any rate to a limited degree, illusionism, a mastery in isolating generalizations that convey it, are inseparable from painting and from the artist's sense of a creative act in his determination to discover effects for the paint that are revivifying. More clearly in naturalistic painting, the first test of its merit is the degree to which we become attached to the turn of the contours, the degree to which we are compelled to feel our way into spaces, whether populated or whether empty of shapes. This matter is at the heart of painting on a flat surface, distinguishing its appreciation from an apprehension of landscape itself which the eye constructs and contemplates without ado as a three-dimensional datum.

But there are many more ways of intriguing the spectator of a painting with space than by a pedestrian representation of depth. I have emphasized the desirability of preserving the picture plane. Yet I want now to restrict the matter to the traditional aspect, the aspect dear to art schools at any rate until very recently, the aspect of which I have been reminded by a gay bit of painting of a Mediterranean harbour that I saw in a café. One often sees such decoration, boldly painted, perhaps without much effort and even without a visit to the south. The interesting point is that the example I have in mind, and probably most examples to be found in similar places, have no aesthetic merit, far less than photographs which, for the most part, lack that element of assertive handiwork by which the artist points to his invitation. What is so wrong with the painting, what is the most obvious reason for lack of worth? Colour, design, and application of paint are not objectionable. But the aesthete would sacrifice these merits, if such they be, to the slightest poignancy in the suggestion of space. Don't misunderstand me. There is a quay, and a boat with gay sails in the water just behind it. You can't mistake the scene. The aesthete attaches not the slightest merit to that: nothing he values can be read into the scene since, for the moment, he places no value on blue waters, slim boats, and pretty sails in themselves. Before he can estimate and relate these things, he wants to be induced to feel his way over the stones of the quay, bit by bit. Again, he is not interested in the

stones of the quay: he *is* interested in the breadth to the water's edge, and then in the breadth of the water between quay and boat; he wants to swim, as it were, in the empty air above them, yet again he won't mind if that which he contemplates does evocative service for, but hardly looks like, the width of a quay. There are so many ways, and always new ways, of commenting upon space, and any one of them for the moment will suffice. We want to be certain that the matter has absorbed the artist and to identify with him; we want to feel volume, density, and the air it displaces, to recognize things perhaps in the manner of the half-blind; we demand to be drawn in among these volumes, almost as if they were extensions of ourselves, and we do not tire of this process, the incantatory process at work. It is at work only because the canvas face is, in fact, flat. At the same time the restored otherness of things is asserted by these same means of true draughtsmanship, the means of all good drawings whether of things or of the figure; at the heart of aesthetic value. Surface value and depth value go hand in hand. For it is obvious that the representation of space, of depth, reflects a metaphor so unavoidable that one suspects it to be the consequence of a very old piece of concrete thinking concerning 'the layers in depth' of our mental life and individuality.

Nevertheless, incantatory rhythm and movement should be approached as well from an opposite viewpoint that reveals the vibrancy and volume of objects endowed with these qualities. The felicity of art lies in its sustaining power, in a markedly dual content, in multiple forms of expression within one boundary that harmonize. It demands usually very hard work on the part of a mentality not easily seduced and satisfied by its own products. Self-expression and art are not synonymous. Art, we have seen, is mastery within the mode of certain emphases upon reconstruction. Whatever else it makes known, art transmits an enticing eloquence in regard to the *varied* attachment to objects, and in regard to the co-ordination of the self.

Since the context has been created, I want to add a note concerning an emphasis in our surroundings. I think that normal environment has always brought home to inhabitants both the otherness of things and the sense of processes that echo or amplify inner processes as such, and even dreams as such, though these meanings may merely alternate. On the other hand, I believe that everything we feel to be out of harmony with the body's image and with the ways of natural growth or change, everything we feel today to be harshly mechanical, mirrors, in a one-sided manner, an unsettlement of the inner life. In his paper on 'The Uncanny' (1919), Freud constructed an equation between the psychologically primitive and what appears weird, outlandish, *unheimlich*, unhomely. Similarly, when contemplated as a series, the mechanical apparatus that surrounds and supports our modern living, instead of stimulating a preponderant

sense of otherness in the light of an unparalleled organization of outer sub-stances, tends rather to suggest abrupt experiences that are both stranger than this and nearer to us, though without the insinuating quality of the incantatory process in art, a setting for further content. In the environment to which I now refer, there is no provision beyond the shock of it. The beauty in our streets is mostly the one of glitter, of flashing lights; surprising, momentary signals of a confusing ramification within, yet we are arrested by a sense neither of depth nor of surface. I have spoken, in regard to art, of an enveloping effect that accompanies a represented movement. In our towns today we are largely strangers to stillness, to apparent deliberateness and silence. From the street, even buildings appear to be but boundaries or targets for the movement of traffic, whereas, in the days of the horse's clop-clop, one moved within the circulation of a whole mother who still reigned fitfully. The same harsh hallu-cinatory quality, from the angle of utter contemplation, that is – not everyone is prepared to contemplate it at all – inevitably characterizes much modern art of merit.

The words 'humanist' and 'humanism' are hard to define. Whatever may be meant, I am convinced that a desideratum for the humanist is an environment stimulating awareness of otherness in harmony with hopes of an integrated object, outer as well as inner. If the depressive position itself implies humanist attitudes for the adult who has embraced it well, the paranoid-schizoid position, to which the enveloping mechanisms and disconnecting noises of limitless cities pay court, certainly does not. In the old days, art was a means of organizing the incantatory element that had been felt in the length of land or in the restless sea. Today art is entirely outmoded in the choice of such phenomena by the scintillating lack of limitation of urban things in general, though it strains all the time to keep up. But, of course, in art there exist contemplative purpose, organization, a degree of wholeness. That is why art is no less a solace now, and perhaps little less an achievement, than in great ages.

PART II
Gasometer and Tower

I ASKED MY NEIGHBOUR at the Oval cricket ground where a gasometer obtrudes, why it was ugly. The gasometer at the Oval makes itself deeply felt. He said it was full of gas. I mentioned the ridiculous scale imposed on already small houses with steep roofs by the stubby yet towering gasometer behind them. Without conviction my neighbour agreed. He may have thought the consideration too subtle since it reflected on the houses as well as on the gas-holder. While specifying the unpleasant flatus in the fat body, a gas whose eager pressure regulated the very size of the container, he was perhaps not prepared to consider relations for it, relations to other subjects. He was not ready to admit that this squat, erectile cylinder could be destructive even to the look of homes. Doubtless beyond unwillingness there survived images of the child's impotence in conjunction with monstrous phallic attacks on the mother by a monster father. Those who do not modify unwillingness will not demand the making of amends in the search for fine proportions; they cannot, at first, become absorbed in art, examine it with fervour for relations between objects and for their relations with the spaces they occupy.

Innocent of tapering, the gasometer suggests explosive girth. A bad mother as well, possessing a bad phallus, it does not attempt to pierce and mingle with the vaporous sky but takes on bullying duties, namely to outrage the houses of the poor (with small apertures) that miserably cluster near the naked plant.

The attacks are ours: of course it is we who have put badness into this mother. I want later to refer to a plainer phallic theme, since the symbolic projections for it are far more widely admitted. I shall maintain, too, that whereas building projects at times notable whole objects, it always projects part-objects, the basis of any style, although a projection of the body more unified than in architecture does not exist on the emotional side. The essential, the medical, view of the human frame, magnificent emotional achievement though it be, at best restrains

280

the confusion of our feelings that are not very notably immersed with whole things, including our entire selves.

Melanie Klein has shown that splitting is employed to the full by the infant as a first psychological necessity, a splitting essential for the infant's survival and eventual health. I submit also that the huge degree of splitting that remains ever after, even after the greatest integrative successes, argues for the antithetical primacy of what are sometimes called life and death instincts. 'Man's greater consciousness implies both an increased fragmentation of experience and a restorative unity' (Stokes, 1951). We cannot conceive of thinking without its power of abstraction that divides and isolates. One of the difficulties of agreement, even in an argument in which major connexions are common ground, is the individual reverberation belonging to those connexions, influenced by patterns of emotional splitting and by the degree of compactness in perhaps inordinate emotional connexions that have followed the splitting. Every analysis should reveal such patterns which – to return to my subject – confuse or prevent a stable image of the body, of the self, and of objects. Whereas it is general that phallic power somewhat fuses with aggressive activity, it is an inordinate connexion if ejection of faeces becomes equated with putting the penis into the mother for murderous intercourse.

It seems to me that there is every reason why we should not resign ourselves to the perpetuation of inordinate public images of the body such as the gasometer, even though this public image will have been constructed from our corporate phantasies, which, in turn, are modified or intensified by these cultural images that they have created. Things have not always been as bad. Contemplating Hellenic art, we sense, I believe, that this idealization of the body as we call it, the classical serenity, is less the fruit of denial than a celebration of that greatest of attainments, a condition of mind in regard to the contemplated body for which there is nothing extreme, nothing immoderate: that is to say, uncouth ascriptions, exotic connexions, that have succeeded the direct splitting, are far from dominant, counteracted by the restrained yet varied eroticism of an ideal beauty. We may find the Hellenic image cold: we need at the fount of the ego a faith in the good rather than in the ideal breast. I suspect that art may not divide its good breast theme from the emphasis upon diversity. I need not urge again that art is taken up with a complex of dominant relationships, not least with enveloping relationships that derive from attitudes to the breast. Construction entails some contrast and diversity.

Art and all the images of the body now tend to be fragmented. The scattering takes the place of tremendous divisions into good and bad imposed by the judgments of religion upon the body, tempered by an enlightened paganism, or contradicted by cyclic Saturnalia. All the same, religion has projected sublimations of the whole body as well as of the good breast. Freed from religion

and from the defiance of it, our culture encourages emotional fragmentation.

For a moment, consider oral and genital aspects of sexuality widely bodied forth today. It must be a surprise in one part of their minds for some young men to discover that a girl is not in fact altogether the peach suggested by advertisements. Drink, perfume, girl, cigarette are not allied only: there is an attempt to identify them; or perhaps the girl is processed for the evening meal: her clothes make the packaging; we are commanded to taste her as an aspect of the food that is advertised. Such conceptions are doubtless encouraged by aids to hygiene unavailable in other times. The whole human being appears in some contexts to disappear with the dirt.

Consider also the overriding male genital symbols of our time, the engines, rockets, guns: they, too, are clean, gleaming, unpocked but, in contrast, unyielding, like the spaces they occupy such as the stripped bareness of the barrackroom. Are they symbols of the entire male? Man is even less armoured in the sexual area than woman. It is reasonable to suppose that, as compensation for his vulnerability, an additional phallic boasting takes place. The testicles are not much treated of by psycho-analysis: castration anxiety is rightly referred to the penis, the instrument of power. Yet it must also be significant that the much increased vulnerability of the enlarged testicles makes itself felt at the time that real sexual power becomes paramount: together, on a larger stage, potency and castration threat are re-dramatized. Hence, maybe, at least some of the metallic insensitiveness of our admitted phallic symbols, which, of course, also have other determinants. Again, I see no reason why we should agree that this public and cultural image is expressive of the maleness of the male. There is the phrase: 'Be a man' (never: 'Be a woman'), as if it were an exotic role, perhaps because the implicit concept of maleness is manic and overwrought. I do not refer here to the counteraction of bisexuality because I have nothing to add to what is generally accepted on this score, whereas the related condition of physical vulnerability appears to have been overlooked. The flight of the arrow goes back thousands of years, the immaculate, metallic penis that pierces not the woman but a vulnerable man, leaving the sender, or the sender of balls and slugs, invulnerable. As with bisexuality, I ignore the aggression that certainly demands outlet; and hunting has been entirely necessary for survival. I do not underestimate these far more important considerations nor the congenital weapon-aspect of male sexuality. I am concerned only with the common and most powerful symbols for maleness projected in our time. Their utter, shining cleanliness, their increased insensitiveness and armoured strength, above all, their lack of decoration, suggest to me that in this manifestation, which, of course, has other determinants as well, a manic counteraction of vulnerability, of the existence of the flesh even, takes precedence of the enjoyment of potency. Peach, gun, barrack-room, and a journey to the moon in an insulated torpedo:

what miserable fragments for the young in relation to an integrated sexuality.

It seems to me that the price paid to guilt and castration fear is often not the loss of potency but the loss of the power to bestow beneficence by this potency which has the goodness only of an aggressive missile potency, the sign of potency. Is this not the burden of most 'dirty' stories and of other manly talk? Much in our environment and in the ethos of our culture suggests it, a message by no means obscure to conscious apprehension. My neighbour at the Oval would not have found it incomprehensible had I described the gasometer there as a stubby, grotesque penis filled with bad things; brutal, blunt, of a horrific gleaming strength, indulgent and mocking in so slowly reaching over many hours from base to full extension. He would have thought I had a dirty mind, dirty, that is, in a common way, a way in common.

I prefer the phallic tower, the towers of Seljuk Persia especially, to any spire that affronts the sky. Towers, it might be said, are more nearly bisexual symbols, as in a bad sense is the gasometer. Towers can be inhabited: their interiors are more notable. But man's genitals are also a source of new life: they can confer pleasure. Replenishment is to be associated with tall vases and jars sometimes used to house long, blossoming branches. Since such a symbol is more complicated, embraces more than one theme, it may serve to encourage integrative processes rather than to augment identification between widely different objects to which the same quality, as a result of splitting, has been attributed.

I refer to obvious phallic symbols because they are recognized in circles wider than the psycho-analytic. I would like to infuse this understanding with a more active, more demanding mood. Art, it is said, no longer has an agreed iconography; much more than figures of Apollo or Venus is outworn, largely owing to the strength of unwitting images that surround us. Now is the moment to urge that our conviction about the heavy onus on symbolism, about the responsibility, be harnessed to the evaluation of the look of our surroundings in so far as they are man-made.

What of the gasometer? You tell me that, if we are to have gas, we must also have gas-holders of this shape. I have seen in France an example of some beauty in the fretwork of struts against the gleaming cylinder, of some beauty, at least as one went by on a bicycle. One would hate no less to live in the smelly shadow. We can imagine skyscrapers to dwarf a gasometer to the extent that it would be seen as a columnar drum. But will the air above be purer than the air below? Very likely not. A key is the explosive nature of the gas. Strong metal of the integument saves us, a precious surface that should be hung, as it were, with medals. It could be made an admired surface with colour the reverse of camouflage, yet an ally to the air. Should architects be instructed in the projection of symbols? It is more important that they be convinced of the integrative purpose of art. An increase in the humanism of our surroundings –

it has increased considerably in the last twenty years – may depend upon an art galvanized by the demonstrations of psycho-analysis concerning the integrative aim of all art, concerning confusion, splitting, and the profound need for art. In sum, though it be understood that shapes as projections, as symbols, derive from the body and the activities of the body and the psyche, it is still little realized that these symbols impinge on daily life. The projection of much of the frightening and disruptive symbolism that surrounds us would otherwise have been a little more difficult, even in the names of functionalism, efficiency, and reasonable cost. Naturally, it will be said, psychical considerations – they are usually called aesthetic considerations – cannot be of much account in matters of mere practicability, particularly the economic. But why do those products so often express disintegration or a lack of proportion? It looks as if an absence of art is itself an expression. A household object of utility for which there is no other claim than that it serves a useful or necessary function possesses many reverberations. None of us regards man-made things remembering only their utility: it plays in contemplation little part. But we tend to split off machine-made from man-made, as if man-made referred only to hand-made. And so we come to think that mankind is at the mercy of an anonymous power, in general the machine, together with the fast, recurring, *ad hoc* adjustments that the increasing use of it entails, as if it were a strange power thrust on us rather than our own product; as if it were a projection of an alien phantasy life as well as of our science. That is to say, the aesthetic effect is usually split off in our minds from immediate benefits, sometimes dubious in the long run, that accrue. Art and popular culture, of course, seek to join the split, to reconcile us, to make us elated with our urban environment, or to devise other attitudes by which we may 'take' it. There would be even a stronger spur to art were the deeper causes understood of restlessness, refusal, dissatisfaction with this home we cannot leave.

Hence a plea that our environment should be gradually purged of symbols of the most grotesque part-object significance. But I am at fault if I have appeared to suggest that architectural features in themselves have symbolized whole and varied objects. As I have said, I believe that the dominant note of any style about which whole-object constructions cluster is itself invariably a part-object construction.

To put the matter the other way round: how Gothic is the female genital. Think of the pointed arches, fold within fold, of a cathedral door, of turret slits and narrow apertures. We pass into vaulted chambers of a foliate if chastened exuberance. But more than plants the animal, animal function, sustains this soaring, religious style. The Gothic female nude with low-sloping shoulders is a chastened animal, weasel-like, of an indomitable bestiality at the behest of God. Gothic iconography juxtaposes the sublime and the very bad: angel and

gargoyle attend entry into the mother's body; even the Virgin is a dimpled weasel.* Temples and sculptures of classical India display with corresponding richness a more phallic architecture. Our responses to architecture, mother of the arts, show best that the whole-object constructions of art are based on part-object symbolic representations or, more generally, part-object relationships; perhaps only architecture is so tied to part-object representations. Some years ago I wrote of the smooth and rough motif that is native to architectural composition, that is perennial for all styles, for every type of building however modest, in terms of the breast and nipple (Stokes, 1951), a theme of contrasting textures that characterizes music also, particularly concerted music.

These contrasts have now been much reduced. Part-object representations projected by engineering, and a great deal of modern building, often seem to reiterate somewhat inordinate connexions with the original part-object, good or bad, the breast. In so far as fantasies are confirmed by this environment we are neither happy infants nor composed adults. In 1936 I wrote that only the psychopath might discover in our urban environment, looked at straight in the face, i.e. aesthetically, the homely resonance that everyone seeks from surroundings (Stokes, 1937). The aesthete, perhaps to a greater extent than anyone else, constantly demands an exacting resonance. He is unlikely, even so, to go far in encouraging psychopathic inclinations, though I have wondered whether the first promise of the industrial age did not partly cause their deviations to be cherished by the urban Romantic artists of the last century.

The breakdown of architecture in the latter part of the century had little to do, directly, with machine-made materials and a great deal to do with manic pretentiousness or hypocrisy. It is very remarkable that the insensitive mix-up of proved styles could of itself provide an invasion of designs with the quality of a nightmare, whether in the fine or applied arts.

Most urban individuals today seem to stomach well a predominantly hostile resonance from the visual world. For instance, we know of a particular warmth cultivated within the reserve of those who live among the overcast wastes of the industrial north. I have written elsewhere of an attachment to ugliness as a defence against the feeling of absolute loss (Stokes, 1956). None the less, most wait also for something better in regard to inanimate objects. Once the individual has been properly housed, fed, and cared for, the better thing appears to be a better car or television set. For this there are excellent reasons; but I wonder whether the enjoyment in controlling gadgets would be as great were we more at home among larger engines that empty our horizons.

Some complain that popular culture is so 'material' and overlook the dispiriting 'spiritual' reference imputed to the man-made materials surrounding us. But aspects of our new metropolitan environment are of considerable and

* The French for weasel is *belette*, little beauty; the Italian, *donnola*.

exciting beauty. Things, I have said, are far better than they were. The fascination is considerable, the fascination of modern Milan, let us say, revealed in an Antonioni film. Almost everywhere light and shadow can bestow beauty, a *mise-en-scène* so often lacking in London.

I make this point. We tend to contemplate Nature rather more as a given statement than we do the works of man, as we communicate with both of them in pre-verbal fashion (Bion, 1962) by means of projective identification. We project ourselves into both experiences, but in the case of the man-made thing with which we have increased complicity, there is more projective identification. When the man-made, usually machine-made, object is uncouth, painfully removed from any image of wholeness, when it suggests fragmentation in the very glance that perceives it, the appropriate projective identification may tend to re-create what Bion has called 'bizarre objects', which stem, or have stemmed, from the psychotic part of the personality. A bizarre object is composed from a minute particle of a true object 'encapsulated in a piece of personality that has engulfed it' (Bion, 1957). If I am right about the intensity and variety of projective identification stimulated by many man-made things – Meltzer has spoken of it first in regard to a communicative use by the artist (Stokes, 1963) – then it would be sure that the major role of art is to rescue man-made objects from bizarredom on behalf of both the object and the self that have there combined, to make with a man-made object a re-integrated part-object resonance and then a whole object that is self-sufficient, that shows itself independent of our projections as it receives them, repudiating their tendency to engulf it. There is a sense in which the crux of art can be recognized in a completely satisfying progression from a cobbled thoroughfare to the smooth base of a building that grows upward from it; a sense in which graphic art, even the greatest, is the prolonging, or the decoration, of the simplest architectural effect.

I have no doubt that tardiness in the exploitation of the machine, the deeper resistance to it, has been connected with the psychological dependence upon slower crafts, upon the often safer resonance from hand-made things (Stokes, 1951). Art has been the accompaniment to craft. Building is the most extensive and unavoidable of man-made things. Hence architecture once again is seen as the mother of the arts, and art itself not only as an act of reparation that arises from depressive anxiety for the object, but as an attempted counteraction of partly psychotic experiences that may visit our contemplation of man-made things in the environment. A notoriety of art in a régime may argue a wide protective function as well as functions that are more positive or boastful or politic. It is no new thought that a disposition of the external world before our eyes has effect even upon the power and keenness of connexions in the act of thinking. Artist and aesthete, however, appear to have greater need than their fellows of the suggestive counteraction by art of a relationship with objects that

is partly psychotic. They seem more nearly aware, more able to admit, that there is a psychotic part.

In sum, I think that the enveloping relationship promoted by the work of art *vis-à-vis* its creator and spectator has had, as a forerunner and antithesis, confusing and hostile projective identifications with anti-aesthetic man-made things. Introjection follows, providing for art the opportunity to elaborate an invitation to partake of a better close relationship. Thus the engulfing that takes place issues from the side of that strong and integrated entity, the work of art.

Since I discussed in Part I this aesthetic process of insistent invitation, the way is now clear for a brief expansion of the reference above to the role of modern art *vis-à-vis* the urban environment.

Renoir held the same opinion concerning the influence of buildings. His son wrote of him: 'We know that in Renoir's opinion the ugliness of buildings towards the end of the nineteenth century and the vulgarity of design in articles in common use were a far greater danger than wars.' And he attributes these words to Renoir: 'We get too accustomed to those things, and to such a point that we don't realize how ugly they are. And if the day ever comes when we become entirely accustomed to them, it will be the end of a civilization which gave us the Parthenon and the cathedral of Rouen. Then men will commit suicide from boredom; or else kill each other off, just for the pleasure of it' (Renoir, 1962).

I have written before that a strong determinant of the direction taken by modern art was the need, from the time of the Impressionists, pictorially to demonstrate evident textures and a satisfying geometry in the face of the new aesthetic poverty of streets (Stokes, 1958). Support for the spirit from meaningful walls and movement was often at first directly prolonged by some Impressionist paintings of modern scenes, such as Monet's in the Gare St Lazare and Pissaro's views of Paris boulevards with their traffic and their crowd. No less today the ancient outdoor impact of stepped masonry or simple walls evokes uses of paint on canvas that are intended as architectonic surfaces whether or not as representations also. I believe that the swift evolution of modern art, and its desire for the shock of the ever new, reveal an attempt to reach a compromise with our disjointed urban environment, with the illimitable enveloping quality of the startling chaos around us. Of course deeper and wider causes exist, but this one, the environment of everyday urban life, is the more immediate when juxtaposed with truthful perplexity and directness in regard to emotional life. The new in art, like our environment, is always illimitable, the envelopment by a new shock into which we hope to tumble.

We have seen of late an aesthetic clinging to an object, to material as such, to reduction of any meaning to the terms and look of a wall, a clinging that

repudiates reverberation from symbolism (Stokes, 1961). A thing to contemplate is provided: contemplation must fill it out. Each kind of synthesis and contrast that goes to make formal value has been isolated over and over again, has been distilled into an essence. And so, warily at first in early collages, but today with entire freedom, fragments of our puzzling, homeless environment are themselves juxtaposed in works of art: steel constructions, for instance, less beautiful and less exact than machines, unexacting machines therefore, as well as litter and a fluttering cobweb of nails. Even the 'acting out', the aggressive preliminary of art to which I referred in the first chapter, has been isolated as Action painting in which, most interestingly, the artist's initiative is imagined by him to have been largely handed over to the surface on which he works. It is found that the surface tends to flower and that it radiates the discovery to the artist's self. We attend upon material; whether or not we project an emotional, perhaps idyllic, conjunction with it, we are beseeching a piece of environment arranged as art for the meaning that our streets refuse to us.

Much else converges in the ferment of modern art whose chief figures are massive. Even so, an underlying and growing tendency is the presentation of the work of art as a fact made out of facts (materials), rather than as a fact that also variously records matters other than an architectural use of material. Psychic reality, the confusion that must be sorted out by aesthetic form, alone is real – hence the greatness in our art – while urban environment teaches us little concerning our development; the one is not the symbol of the other, though they clasp. There is, however, the further connexion in that the unresolved outer confusion has reserved our courage to probe, to be honest with, inner confusion. Even if the two cannot be equated, we know that these surroundings obtain our projections and that they provide an image of our culture; yet, when snatches of the environment are abstracted into art, we must stomach in such unexampled closeness the fact that what we clasp permits no other reverberation of itself. Once more, all the virtue is in the act of aesthetic appreciation which, we have seen, has its own wide significance as a symbolic system. Apart from wry comment on the cultural position, art can do little more, it seems, than keep step with what it can neither sum nor symbolize. This is surely very courageous. The artist cannot turn his back on the dominant environment even though, in using it, he neither forges symbols for it nor comments deeply. But there are heroics also, baldly sung: if there is to be singing, plainsong cannot be bettered in this age; or else the peasant's and the child's voice. Expressionism has strongly survived, it is true, emotion put upon an external world that usually responds with surprise and rejection. In disjointedness and singleness of mind the schools are one. All exert the incantation dependent upon some effect of shock, at the expense of any object or state beyond itself, save the interwoven relationships that provide the perennial symbolic content of aesthetic form.

I remember the flood of happiness I felt when it was represented that Pop art showed affection, warm contact, with the urban environment. I mean an affection inspiring the terms of art, recording deep, rather than contingent, impressions. But my own conclusion is that we remain homeless in our culture. Art, valiant as ever, cannot claim it for our home yet seeks to reconcile us with this environment in terms of any astounding if unresolved affiliation that can be made. We thus find ourselves in very close touch with it, though not in confabulation. We welcome these gifts though they tend to exile us from the past and to suggest a mere suspension amid the present. Yet they improve an imprisonment we undergo among the freedoms of stellar space, for example, or in reckoning quantities very far beyond the range of the senses.

None of us could wish to have lived before instead, since we know in our own age of a colossal lessening of pain, disease, and early death, with an increase of nourishment in more fortunate countries. To balance the uncontrollable changes brought about by physical science, in short, by the disruption of an easy limitation in the use of matter, we should put the potentiality of greater stability that emerges from mental science, for instance the realization of the limitation inherent in all-embracing emotions. If in the course of centuries mental stability materially increases, we shall forthwith take charge of our condition and declare more effective war upon surroundings that are bizarre.

PART III
Landscape, Art and Ritual

WHY DOES AESTHETIC CONTEMPLATION demand closeness as well as detachment of the viewer? Some principal points in this book and in *Painting and the Inner World* (p. 207) can be summed as follows. First, the need for correction or re-alignment of projective identification with man-made things that has created initial closeness to them. Then the fact that contemplation, even crystal-gazing, the inducement of hypnotic conditions, is to some degree an awareness through an outer form, as in art, of an aspect of our inner states, particularly in the sense of the varied attachment to objects both internal and external. The work of art is concerned, especially from the angle of its form, with relationships. To appreciate them we project parallel constellations of our own relationships on to them. I am referring here to simple projection, not to projective identification. It follows that there is also an introjection which the work of art in fact solicits and facilitates (Part I) by enveloping us with the delineation of overriding processes at work. And so we are immersed, a part of ourselves is immersed, in communion, though it be far short of a hypnosis, since our separateness, and many kinds of judgment, are evoked at the same time.

There is difficulty in conceding art to be concerned, even partially, with symbiotic relationships. To say so is to affirm not only that these primitive forms underlie the development of the later forms of relationship, but that they persist with them, in contemplative states very intensely. Now, part-object relationship and the plethora of projective identification that tends to confuse, to split open, both subject and object, are characteristic dealings with the real world in narcissistic or schizoid illnesses. On the other hand, these illnesses are not to be associated pre-eminently – the contrary is the case – with either the making or the appreciation of art.

Melanie Klein has shown that the paranoid-schizoid position, wherein complicated employment is found for such splitting leading to such fusions, not

only antedates but serves as the inevitable preliminary to the development of the depressive position during which whole objects are, at times, given their independent due, when the psyche accepts responsibility for the injury that has been done to them. But she has stressed at the same time that this outlook will always require reinforcement against a regression; indeed, art is itself a supreme affirmation of self-sufficiency and separateness attributed to objects as distinct from the self (Segal, 1955). I believe that art tends to epitomize the process, the history, of the depressive achievement, to celebrate also thereby the blessings, more than the ills, of symbiotic relationship. It follows, however, that in terms of this model, paranoid-schizoid mechanisms, even of the most disruptive kind, can find embodiment in art as long as the overall ceremony of integration, and indeed that of reparation, have been instituted at the same time. What is thus both comprehensive and coherent possesses therapeutic value. It is why form can be called significant, form of every kind considered even *in vacuo*. No other practical explanation has been offered. Compare the artist's obsessive concern with objects, however softened or clothed, to the preoccupations of a strongly schizoid person who, altogether unaware – otherwise his world collapses – projects a part of himself into objects, often a bad part of which he can thus remain ignorant, while what is good in the object seems immediately to be himself. Just as such a person has little or no realization of the character of other people, so he is debarred, not only from making a developed art but, still more, from any aesthetic appreciation worth sixpence. For, whatever the use by the artist himself of such mechanisms, he and the art lover alike employ continuously in their *judgments* the norm or standard also of full object-relationship on which rests finally aesthetic composition or wholeness.

To both artist and appreciator art is a therapy. Increased knowledge of art, if it is true knowledge, entails a more varied appreciation. This valuation is basically recognition of therapeutic power (though it would be more accurate to say, Dr Meltzer has pointed out to me, of integrative aim, since the effort to reach integration is sometimes so gruelling as to be self-destructive). Freud found that art provided some catharsis to repressed sexual wishes, in the manner of the dream. But there is an additional therapy in art that discovers a degree of integration for the ego and its objects, a process dependent upon more profound appreciation. This attempted therapy, the crux of art, is not allowed much scope by the majority of viewers, even by many who profess attachment.

We should look at the process, of course, from the side of creation. Perhaps, as a therapy, painting is the simplest of aesthetic activities; perhaps for that reason the artist has come to signify the painter foremost. Shapes, colours, fitting into one another like bones and their sockets, remain in the painter's mind after working. Skill, command, mastery, feed on the necessity of such imagining. I believe that this integration and mastery of shapes have occupied

afterthoughts of every graphic artist whether the style be naturalistic, or conceptual and in each detail traditional, or in the highest degree experimental. The same haunting pursues all manual work. Shapes, pieces, directions, potatoes, visit the land-worker's sleep. Residues from the day enfold an interaction of internal objects. Whereas art shares this mental activity with all work, for art it is not the by-product but the crux of the manual activity, linked with further contemplative aims. The artist puts tone against tone, colour against colour, shape against shape and line, contrasting yet bringing each in communion. These are 'values', things of worth from juxtaposition, meaningless in isolation. The word 'integrate' is as weak as the word 'appreciate'. Neither suggests enough the strength, the courage, and the love, above all, the active truth, symbolized by relationships that must never be divorced.

Whereas the artist attempts to rival the biological process by which the mother forms her child, the pictorial process also re-creates loved objects and re-integrates the self. When the artist is predominantly the seer, he, like a god, fashions omnipotently, projecting this omnipotence which he then introjects as 'inspiration' (Kris, 1953). While the mechanism persists in the creating of art, it characterizes altogether the fashioning only of fetishes, magical images that serve as the gods all the better for lack of any attempt to command impressive bodily appearance.

Psycho-analytic theorizing about art tends to lag far behind psycho-analytic theory in general. Little of extreme moment had been written by analysts on art since Freud's pioneer references in the 1900s, since his *Gradiva* and other writing in Vol. 9 of the Collected Edition. In those days Freud's momentous discovery of the unconscious and of repressed eroticism tended, for practical purposes, to make the terms synonymous. Much later, of course, he discovered that the greater part of the ego is unconscious and that Thanatos is as powerful as Eros. It might be thought that under the influence of these discoveries of Freud's old age, psycho-analysts would have searched art for the reflection of the ego's accumulated structure, of the erotic, aggressive, and anxious relationships, the vast concourse of relationships to objects that flow from all the ego's functions. Indeed, in rare cases this has been so: such names as Sachs, Kris, Milner, Segal, and Meltzer spring to mind. But has it meant, in the place almost entirely of literary phantasies, that the predominant aesthetic outlay, the architecture, ceramics, decorative functions, music, the strength of the communication in terms of structure or form that distinguishes art from other phantasy weaving – has it meant that these perennial matters have taken the centre of the stage from the point of view of psycho-analytic investigation? Not a bit. The easy atomizing of the patently imaginative is still the preferred subject.

Art grows from art and has a history. Such difficulties and demands, belonging to the understanding of art, press upon cultured people at large. They expect art to please; and, indeed, a great deal of art has been made with pleasure the paramount purpose; it must always, as Freud saw, be part of the purpose. This call to pleasure has sometimes been taken to mean the recounting of beautiful, elegiac, romantic experiences or dreams. More safely, we can say that art is ennobling: whatever the compulsions and projections on view, a vivid affirmation of wholeness, self-sufficiency, is communicated. Once more, this is to think of art as an appealing therapy that denies splitting to be wholly desirable, the schizoid fragmentation of an object's self-inclusiveness. Soutine's early landscapes, the Céret series, engorge the spectator through their furious whorls (Sylvester, 1963). One-sided, they are, if you like, mad; yet no less beautiful than extraordinary: they, as we say, 'work'. I cannot think what this estimation may mean except it indicates a supervening wholeness in spite of the violence done. It is the same with the repellent and manic protest of the self-portrait that was in the Arts Council show of 1963, the reverse effect of his portraits of crumpled boys. It must be rare for an expression as strongly manic to underlie a work of art. The constituents answer each other so subtly as to temper violence with containment. We feel that Soutine's paintings were the artist's best, though perhaps tenuous, link with a self-inclusive object; that a therapeutic act of great honesty and courage has been performed. Since we too possess the seeds of disintegration, those paintings serve us as well, whatever the nature of our state.

Some art, then, insists on this fact, which casual spectators find hard to 'take'. Yet I see all art, even the most restrained and idealistic, as an admission of the developing ego proclaimed by some epitome of contrast that we experience in the relationships which the work demands from us, primitive, embracing, enveloping part-object relationships as well as whole-object relationship; that is to say, when appreciation is both unfettered and mature, when we pine for yet more idiosyncratic variations on this uniform theme, for the submission to it of personal experience, and especially of cultural aims.

Architecture has always provided my first concern or preoccupation. I have written of the pleasure, close to a sense of a gradual crystallization from very low marble relief, gained from architectural forms welling up or flowering from the wall; from façades divided by their apertures and other features, visualized as incrustations condensed from the springs within; to be like a body, a countenance. We have the same effect from much carving, nowhere more than from Michelangelo's two high relief tondi, where we sense most strongly the deep erotic attachments of this mode.

Another theme on which I have concentrated referred to the primacy of architectural design in many styles of the other visual arts. It will be easily understood, therefore, especially since of late I am concerned with the means,

largely formal, whereby the work of art includes contrasting relationships, the process of their coexistence; it will be well understood how keenly I have responded to observations by Dr Meltzer concerning the relationship between figures and their background, particularly in architectonic paintings such as the landscape Madonnas by Bellini (Meltzer, *Figure and Ground*). He divines in the background the child's exploration of the mother's inside; between mother and child, it can be added, a later external relationship is reconstructed by the foreground figures. Here, then, is another homely interpretation of distance. Psychologists of vision have remarked that figures tend to appear convex and their background concave. I believe we will understand best on Dr Meltzer's lines yet another incantatory power in many works of visual art that we clamour to enter in the pursuit of a part-object relationship, while at the same time we are standing back in full acceptance of self-sufficient figures or – to take the case particularly of some landscape – in an acceptance of the work considered for its entirety.

While we may sense in a painting a greedy appropriation, an envious exploration of the mother's internal mysteries, it can, at the same time, reveal to us things distant, vast, governed by their own laws, that support figures: these emerge in architecture as pillars, stepped surfaces upon the outside wall; in one sense or another lineaments of the body (Stokes, 1956, 1961). Again a beautiful façade provides apotheosis for varied life within it. Each facet of art, as of the dream, will serve more than a single meaning. Art lies with the orderly process of their reconciliation. In psycho-analysis, the most felicitous interpretations achieve the same effect, whereas the dislocations and lack of proportion that characterize dreams become usually, in part, inartistic. The best analytic interpretations *are* works of art, ennobling both analyst and patient. If we view the latter as the history of his experiences, he then himself momentarily assumes the status of a work of art.

Every aesthete has artistic prepossession, however wide his appreciation. Mine centres on an unbroken, a gradual, condensation of features upon wall or canvas, the spreading of a plant from within the earth that thereupon appears rich, fertile. It embraces, I think, a perennial artistic theme, an image of various kinds of development, particularly of psychical development, since it is this that we strive to understand, to recapitulate, in order to maintain. But, more narrowly, the theme preserves an image of a development from sadistic exploration inside the mother to the wish, perhaps despairing, of reversing the damage; and sometimes to a calm contemplation of the surface life nourished by those hidden springs, those caves of plenty that our envious selves can never overlook.

Art dramatizes the sense of process discovered in landscape and in history. We

saw in Part II that art especially supplies us with a needed resonance for man-made surroundings. A natural medium of this resonance is, of course, landscape itself, though little of nature in the raw, as we submit to it, suggests the adult psyche. The Greeks, those of them who abhorred the sublime, feared this Nature. We have imbued classic lands and seas with their society so that they now reflect for us the order and limit of things. Geological time is out of scale with our own weathering, unlike traces of culture. The most desolate continent is Australia's outback not only because of deserts but also from the strangeness of an extensive land to which man has belonged in such small numbers. A bowl of Cornish cream can epitomize the pale, rich canopy of stone-hedged fields, can uncover warmth in Celtic remoteness, in sheltered, protracted farmhouses, in the sudden mildness of a valley, in the wealthy, separated stones – signs, one and all, of the breast but not of the family; signs of nurture but not of a person nor of a domain. Over sea and air another part-object, the blanched seagull, presides.

But even traces only of the human past keep us in touch with our own development. In Cornwall again, very old and less old civilizations are every-where apparent, in names, in dolmens, in mines. Our contemplative feeling as visitors to this country would otherwise become little broader than the sensa-tions I have indicated. Of course the realization of the past-living-in-the-present that I have in mind is not at all a matter only of antiquarian, or of cultural interests in a narrow sense. An awareness of the continuing generations, however arrived at, is enough. People often talk of 'roots' as a necessity, of a conservative well-foundedness that betrays, I submit, the need of the psyche to project into surroundings a history of its development, to receive from this projection an image of the psyche's architecture constructed upon firm and ancient founda-tions. The Roman tin mine – there are the remains, it is conjectured, in Corn-wall – may pre-figure for us a dawn of relationships, of the commerce between objects. To be strong we need a substantial past. History, continuity, though thus vaguely felt, tend to mitigate denials and splits. Could we join, live with, our past and present selves with all their objects, we would feel continually at home. But the fury has gone from this past recovered in terms of homely land-scape, whereas the ache survives of early situations. I would not call the land-scape experience a total denial. The past is there petrified: we see ourselves as if dead, as if completed.

My interest in this matter springs from the character of art which so often embraces as the present the history of ourselves and of our objects that I have now ascribed to the traces we see of the past in landscape. Of course old art shows us both, that is to say, something of the past, and of the present belonging to an older time. I want to speak of it in reference to the aesthetic character of ritual.

In an identical reference to what he calls 'the aesthetic object', Donald Meltzer has defined ritual as: 'the psychological equivalent of a vestigial organ whose existence, as it were, celebrates an ancient usage, while at the same time giving evidence of the individual's correct development through devoted repetition of the route created by the ancestors'. . . . 'Pyschological rituals have this same structure, as a celebration of past events in the individual's history and as a record of unconscious infantile parts of the self and of the internal objects. The rituals express the internal processes by which these parts of the self and the objects are restored to vigour and integration' (Meltzer, *The Aesthetic Object*).

He goes on to say: 'Ritual-formation plays an important role in the developmental process between infant and mother in particular, and its misappropriation in this relationship contributes structures known to psychopathology, particularly the obsessive and compulsive symptoms. What happens in the mother-infant relationship is that items of essential service become gradually replaced, through symbolic formation and communication, by rituals that celebrate their relinquishment. Thus, the breast-feed becomes the good-night kiss, the play-period becomes a smile, a term of endearment.'

Of course almost every activity is the substitute or symbol of another. The ritualistic element lies in the regularity, in the repetition, in the reminder. As far as religion and art are concerned, it lies also in the great width of their ritualistic embrace whereby sometimes all roles in life obtain the dignity of a ritual, so that each individual taking part rehearses his own development in terms, not of his own part, but of the total ritualistic meaning created also by his ancestors and his fellows.

Doubtless it seems strange to claim for some purely aesthetic experience this endowment of communal ritualistic meaning, yet I have felt it very strongly throughout adult life in broader aesthetic experiences whereby surrounding life obtains ritualistic gloss. Even now, on a good day in a good Mediterranean place, I have the feeling that much sound, sight, and act contribute to the perfecting of an Olympian figure: they reveal a sum of meaning that will not be dissipated, an eternal present into which the past has gathered. More narrowly, stage characters, the marionette-like figures of the Commedia dell'Arte; or the stock-in-trade of opera buffa, as they appear in works by Mozart, Rossini, and Donizetti, offer so closely knit and, therefore, ritualistic, an environment that one may think it happier to be the least blest of the characters rather than to be excluded. Such a world is not heavily confined, yet things and people and incident have sure place in relation to the whole.

We are most at home when the bell of a church appears to conspire with balcony, doorstep, and sky. We feel no less strongly that some environments are entirely forlorn, broken, distracted.

It is clear that architecture, buildings, are the most evident expressions of an embracing cultural *mise-en-scène*. In Venice, even today, we feel ourselves to be partakers in a dramatic version of a wider history than our own under the aegis of so many good objects seen about us, unforced objects, we find, adapted to the necessities of the past and even of the present. When music occurs, the environment tends to become furniture, objects with which we have more than a nodding acquaintance. Art invites recognition of more than it ostensibly shows. An environment of art elicits the musical propinquity of our objects. As they develop their presence, we rehearse at least an aspect of our total development.

The desire to belong, to become part of the larger body or society, has many roots. I refer only to a contemplative aspect, the ritualistic celebration that involves the inscription of our past, since therein is found one of the purposes of art.

The largest, the oldest, the most varied aesthetic object that has survived today is the city of Venice among intrusive waters. Nature, it seems, conspired here to serve our rituals that need have no connexion with those of dogma and belief. On the other hand, it is not difficult to comprehend that art has almost everywhere derived deepest inspiration from communal beliefs at the foundation of the polity, and has primarily served the rituals of religion. For our eyes, however, the religions, the rationalizations of the need for ritual, fall away, whereas the art, the ritualistic core, the document of those beliefs, of those rituals as far as we understand them, remains to encompass us, to brighten our tenebrous objects, to radiate our present with our past, single, immediate yet old, like a great building that has survived intact.

My use of the word 'projection' may have become linked uncomfortably with a recent use indicating emotional aims unwarrantably ascribed by us to the imagery of art. Professor Gombrich will have convinced us that there can be no accurate estimation of a work of art's expressiveness without full understanding of the cultural, stylistic and technical context or conventional framework on which we so easily impose the terms of our own (Gombrich, 1963).

In regard to the kind of expressiveness with which I am principally concerned, the framework required for communication is foremost the sharing with the artist and his patron of the human state, of body and mind in aspects that are held not to have varied for many thousands of years. But we are likely to misinterpret the actual imagery and even the dominant mood in the light of our own conventions, to attribute emotive accents that did not belong to the artist's intention or to the iconographic system. The aesthete, however, values old art less for these alleged communications than for aesthetic testimony to a cultural position of which he may be otherwise little informed. He may be thus

led to acquire some scholarly knowledge, to accentuate the record of the past, since it is equated with his own that has been even more hidden. Indeed, our love of the aesthetic object is partly founded in our need to inquire of its context or framework, which serves to epitomize our own status as the product of a framework. There can be no history without a potential history of ourselves.

Consider the folksong, a long, often anonymous, accumulation of an enduring bent or sentiment. We do not necessarily attribute this bent, as we perceive it today, to the generations who made it; we listen empathically for connexions with our ancestors; we try to discern experiences, circumstances, that contribute to the partiality of that epitome. In so doing, or in tracing stylistic development, we evoke our own past at a deep level as if it were the past of our own society or of societies from which it has grown. In the case of societies, particularly very cultivated societies, of which our own is not even a distant variant or growth, this empathic attempt may often at first be entirely misplaced.

But though every object be estimated for the degree of identity, thereby exaggerated, with the familiar, with what we possess; though we tend to hoist judgments, choices, on to old creators, that would only be valid were they living now, it is no less true that each object is estimated for the contrast and difference from what usually surrounds us, notably so in the case of a work of art whose significance includes self-sufficiency, uniqueness, while it serves as an important figure, indeed an apparition, from the past. I have most in mind building, architecture, the mother of the graphic arts, innocent of detailed iconography. Surveying the Doge's palace, the average Westerner is surely aware that when it was built there was no need to consider garages. He will even be aware that the building has been created by a seigniorial society, an aspect of which he can imagine from the presence – if of nothing else – of his own super-ego in correspondence with a slow, embossed deliberation suggested by the windows. He is similarly aware that a Byzantine mosaic offers little suggestion of an enclosed space. From contemplation of such a mosaic, aesthetes tend to derive an experience of hierarchical unity into which they are drawn, that contrasts with our own society though not with a yearning for the simple scene of infantile envelopment by its object. In the most generalized aspect, aesthetes do not misinterpret pictorial space and volume. The wider expressiveness of visual art exists here, in combination with a strict iconography that we may at least know not to be ours. But do we entirely misinterpret the nude in our ignorance of rationalizations that have allowed it to be an object of contemplation in societies less permissive, or differently permissive, from our own? Even to the ignorant, clothes, ancient fashions, embody social clues. Did we possess a perfect summary of Greek history, thought, and science, but no scrap

of Greek language or art, or of art derived from it, we would be bereft of all that resounds, more accurate and less accurate, and has resounded for two thousand years in naming the Greeks and the origin of our civilization.

We scan our past for our present: for our past we need landscape, history, and art. Art, as we ourselves, is of past event surviving into the present.

Reflections
on the Nude

AUTHOR'S NOTE

The brevity of *Reflections on the Nude* is the first reason for the appearance of the lecture that follows. Although the two are not directly connected, there will be found in the lecture – written earlier – variants of the essay's argument that are now tinged, it seems, with a contrasting and conversational tone. For the first time in the volume paintings are examined singly.

Acknowledgments are due to the editor of the *British Journal of Aesthetics* in respect of the lecture and to the editors of *Art and Literature*, published in Paris, in respect of the original draft of the first chapter.

First published 1967

PART I
Reflections on the Nude

1 Reflections on the Nude

Vis-à-vis the objects both of the outside world and of the inner world it is rewarding that psycho-analysis distinguishes two kinds of fundamental relationship; yet one of these relationships can be constructed at the expense of, or more usually in addition to, the other form of communion. The two modes are the part-object and the whole-object relationships. The infant's first relationships are with part-objects only, that is to say with objects that are not felt in their own nature to be foreign and altogether separate from himself. The mother's breast and his own stool are primary part-objects, the entire and separate and self-sufficient mother the primary whole-object from whose self-inclusiveness there evolves the realization of the outside world of objects as such, whatever their special functions for the perceiver and although he continues, howbeit to a lesser degree, intruding projections into them, an activity that underlies part-object relationship. Not a philosopher, as was Berkeley, the infant is able in normal development to give ground on the question whether there is an outside world which is real, that is to say, separate at least, if not yet indifferent in some contexts to his own activities. But it will have been no more true of Bishop Berkeley than of other human beings that the object conceived as a whole-object may still be treated emotionally more as a part-object.

The tendency to treat whole-objects at the same time as part-objects is very strong. It involves a degree of merging with, or being enveloped by, the object. In view of the ceaseless projective and introjective processes by which we apprehend, control, and learn, it appears extraordinary that a comprehensive emotional admission of whole-object configurations is attained even fitfully.

On the other hand self-preservation will demand a recognition that the outside world is indeed disjoined, concrete; moreover the infant's growing integration depends on separateness from it. The infant's progression from the paranoid-schizoid position to the depressive, to the feelings, for instance, of loss, guilt, and responsibility rather than of persecution, is bound up with the

full admission of self-contained objects in the outside world, in the first instance of the whole mother herself. The relationships to other people and to things of all kinds will partake, if only by contrast, of the relationships to her.

This must be the seemingly heartless opening to some reflections stimulated by an aspect of the nude. While the nude is by no means the whole-object prototype, it can provide imaginative translation of that prototype. Yet the word 'nude' will seem harsh to many when it does not suggest nakedness only.

We cannot discover in our own bodies the nude entirety. Narcissistic sensitivity obscures contemplation. Sex-organs often continue to be viewed as part-objects unintegrated with the tenor of the body; appendages of a temper and need averted from the delicate interaction within the organism, even to the extent of the body being conceived as an attribute of the organ, an attribution that does not dominate at least the conception of the nude, which is here thought of as enduring figuration (though the object of many intense passions) and as identical with the object that was for long the object *par excellence* for art students.

But if the nude in this sense is a somewhat rarefied conception, it remains an immense power. The human body thus conceived is a promise of sanity. Throughout history the totality of the nude may rarely have shone, yet the potential power will have made itself deeply felt. I propose that the respect thus founded for the general body is the seal upon our respect for other human beings as such (and even for consistently objective attitudes to things as such); an important factor, therefore, in regard not only to respect but to tolerance and benevolence.

As well as for basic drives the world of objects is the setting for our projective, introjective, and splitting processes. These processes do not of themselves in many instances give rise to tolerance and respect for the objects employed. On the other hand the self-sufficiency where it is allowed to the nude, who may be the target of intense sexuality also as an independent object, accompanies our own integration or totality, our own integration of drives and character-traits. The respect for self-sufficient objects is the extension of self-respect. From this brotherhood, as it were, of the potential nude the fellow-feeling can extend at least contemplatively to every variety of psychical construction however misguided or inadequate.

It was more difficult in the past when the world was full of utter strangers, particularly in regard to their values, to culture, or to one class in contrast with another. If we are now on the way to a multi-racial culture it is partly because no custom, no ritual, no thought nor act is as incomprehensible, as distant from ourselves. Those with whom we can initially somewhat identify have multiplied even while we use them, as they have always been used, for projective purposes.

Such broad identification is the result of contact not with an aspect that a

person presents to us but with the idea of his wholeness or potential wholeness since he is an inheritor, however far removed, of the mother who originally evoked our solicitude, our anxiety, as a precious whole-object that could be lost and destroyed for ever. Thus the fellow human being is by definition a whole-object who may command initially – of course it is only initially – a degree of our solicitude. This is, however, a very important adjunct of humane attitudes. Whereas there are many closer forms of identification, none of them applies this to the stranger *qua* stranger to whom in his capacity as a human being we are likely today to be most polite not only for atavistic reasons. This tie we have with him will probably lessen as we get to know him since he now looms very largely as a series of attitudes and aptitudes and certainly as the object of our projections which may be negative. We may then translate him in addition into a part-object, the possessor of some trait or function the over-riding emphasis of which becomes almost a fetish. It is as if we had entered a party, joined a conglomeration of heads and straining faces, ours among them, a succession of presences and absences with which we are compounded, that advance in answer to our call but do not always as easily retreat. Yet this merging with an object is often the tritest form of intimacy though at other times the mode of deepest sympathy and of capitulation or control.

Our constant projection and introjection tend to increase, I have indicated, the part-object aspect of relationship; not however exclusively, since in the majority of adult contacts we have already acknowledged as whole-objects, that is to say in feeling no less than in conscious judgment, what we may also treat as part-objects. The dramatic example, once more, is the temperate artist painting the nude, an act still preserved in at least some rooms of art schools. All endeavour should be to contemplate this object as entire, together with the surroundings. The face and head are but part of the body for that contemplative work in which we do not seek to reduce the form to the terms of mouth or eye, to the terms of a single function. I myself prefer the model to be, to remain, a stranger. One will consult her comfort but not the concerns that are less immediate. She is an entire presence engaging the allegiance produced in the act of drawing. Artists sometimes harbour a love or brotherhood that binds them to strangers in the light of their mere presence (whereas other people tend to provide at once for strangers a narrower context, however mistaken). Nevertheless aesthetic construction itself entails an envelopment also in the re-creation of a whole-object. I have called this aspect the component of invitation, the invitation to merge with the object.[1]

How hard it is, then, particularly in social life to amplify the realization of whole-objects that we try to sustain. Indeed it often appears that we best foster a contact with whole-objects from a distance. Hence a perennial attraction of spectacles, of the theatre, of games, of all happenings in which people speak

with their bodies as well as with their mouths. In such experiences if we ignore the crowd we can strengthen the norm of adult relationship with fellows and with Nature. And if it is difficult to value our neighbours for their wholeness, we may be able nevertheless to personalize the hive to which we belong. Further, we keep and constantly observe domestic animals who live out their lives as complicated bodies from nose to tail. The domestic animal, though not the pet, is an antithesis to the face and voice of the crowd. A crowd is no more than one fibre of a person who will never be constructed.

I do not mean to deny that face or head is by far the most expressive attribute of a person; expressive, that is, of the whole person. This succinct documentation, however, of wear and tear or of their absence may cause us to overlook the even circulation that animates a complicated structure.

Possibly the nakedness of some primitive peoples will have strengthened their grip upon sanity even though their nudity will have dramatized an extreme part-object attitude to conceptions contrasting with the whole body, namely the mask, the ceremonial face, together with a figuring forth of Spirit or Mana and the ghosts of the dead. A construction of whole-objects in primitive art has force but not a pre-eminent force. Whereas the wrapped, muffled Eskimo, deprived of nakedness, has probably been in worse case, the deformation of the body and its camouflaging fragmentation by painting and tattooing on the part of naked tribes have shown that a possession of the nude epitome of whole-objects has largely been gratuitous; a possession to be minimized. Of course clothes redress the balance since they are apt to dramatize the body's contours. However, as Greek art and Greek Olympiads suggest, a conception of the undivided nude is an unique attainment of tremendous import.

We realize insufficiently how rare have been potent symbols of whole-objects outside art and science and constructiveness in general. The history of ordinary building is a saga of tomb-womb-house.[2] Another part-object, the good breast, is the common fount of all that is good. But without a concomitant development of the good breast into the good whole-object we cannot be at home in an adult world: we cannot discern sufficiently between ourselves and objects nor feel the respect and brotherhood of which I have spoken with the stranger.

Where there is no call for fear or envy or the projection of hate – even today this must be a rare situation – the usage, I repeat, of extreme politeness to the stranger is a tribute to the whole-object model. Such goodwill, of course, is no guarantee of true fellowship: it often evaporates upon any intimacy, as if we were discovering that this self-sufficient entity, though entire, is not the prime whole-object, not the mother from whom we derived the good breast. Any communication with the stranger can dim even this connexion; we no longer have on our hands the embodiment only of an entire human being but sectional

demands and compulsions, his and our own. But I submit that the side-tracking emphases of intimacy are happiest if that first impersonal love for the whole figure at the root of respect has not been completely overborne. I call this love impersonal not because it did not arise with one person, not because it is not principally lavished still, let us hope, upon one person and one family, but because it can extend also to each individual initially, to animals, to the forms of Nature, and the artifacts of man.

I have suggested that much wider fellowship is today a possibility. I want to emphasize also a turning away from an impression of whole-objects associated with our urban environment which will soon be much expanded. By 1990, it is said, half of the greatly increased population of the world will live in conurbations of 100,000 or more, another prognostication arising from a technological development that has become a riotous growth incognisant at its root of the human needs that nourish it. The outlook for the daily spectacle of perfected whole-objects is bad. An envelopment with objects by means of predominantly part-object phantasies has for most of us ever-fresh lavish provocations, particularly in the use and guidance of machines. I won't recall instances of which I have written elsewhere that are characteristic of the scene.[1] In the past – to mention one detail – physical expenditure in craft and manual work more frequently reinforced the impression of physique: likewise the common modes of travel. As far as concerns the spectator, much work has lost in dignity, though from the point of view of the operator, of course, the constructiveness belonging to any work that has not become automatic entails the figuring forth, the repairing, of whole-objects. In this connexion I have referred already to public spectacles and to the theatre; but I do not think that cinema and television should be added, largely dream-screens, poor in spatial volume and embodiment, media that contrast with sound radio wherein we may reconstruct the person at the instance of the voice, a form of recapitulation in which we have been practised since the time when from cot or pen we heard the mother who was out of sight. The case is often similar for reading.

Where there is sanity, the progression to whole-object apprehension will have been accomplished and to some degree emotionally sustained. I am discussing encouragements only towards regression, exterior inducements that attach themselves to regressive tendencies in adulthood. It is a matter whose influence we cannot calculate. But surely we admit that the figuring forth of whole-object relationships in spheres wider than the home or social life has a likely impress on the quality of contact in those narrower and more primary spheres. I therefore find it disturbing that we have constructed an urban environment the character of whose undertones does not feed back to us the plain symbols of sanity; the configuration of whose objects has no emphasis for the observer upon their wholeness. The immense reduplication of our appliances,

such as switches, denotes harsh nipples instantly presented when they are work-ing, a chaotic pattern of commas when they are not; unrelated alternations of the good and bad breast, the earliest homework of splitting and projection. The machine's power is vulgar, in tune with the most infantile phantasies, without prudent reference to human physique. Will personal relationships intensify among disjected pleasures, among the harmless drugs that induce regression, and amid a mere relic of the use of limbs?

Certainly the future will need societies devoted to the contemplation of whole-objects. Hence an ever growing importance of art. But aesthetic creative-ness functions in the terms of the environment. An artist's work can give the spectator cause to be more at home with himself just as he, the artist, has become more at home with himself within the surrounding environment as a result of his work. In the long run he needs to envisage his environment as the prolonged scene of indubitable whole-objects in correspondence with the self-sufficiency of his artifact, however enveloping its theme. No one can have the slightest idea what will happen to art in the future. There must be danger that it cedes importance to hallucinations induced by drugs. We have already ex-perienced from art a great deal of anti-art in the sense of anti-whole-object themes, in the sense of everything-on-a-par following the breakdown of distinctions, in the sense of a hypnotic envelopment by part-objects. I saw lately a huge plastic thumb, a mechanical enlargement of a cast of the artist's own thumb. (The fact that I judge it to be an original and even beautiful work is not to the point here.) The Canadian writer, Marshall McLuhan, 'has spoken' – I quote Karl Miller – 'of the eclipse of the Gutenberg Galaxy, of the poor old printed word, ushering in the electronic age with its images and media, and the space age with its still stronger devices'.[3]

For the many people who cannot altogether sustain satisfactory whole-object relationships it will become ever easier to embrace, or with a reverse of emotion to reject, the universe. Symbiosis can be employed to obscure both the intrinsic self and its object, to whirl them together in a manic hum. This brings me back to sound, to modern sound. What chance have we in cities today to reconstruct the whole mother from her voice? Here in London in the Burlington Arcade one can attend to people who stand and converse amid leisurely sounds of other people walking. A variety of echoes come back from the walls. It seems to me a measure of our plight that such an experience is a luxury to be treasured; apparently a haven from unending explosions of traffic that uncover no space, no amenable distance.

This theme is not the dilemma of art and of other aesthetic experiences. For I do not presume that the situation I have indicated is of importance only for the imaginative who may be more aware of it. We are but at the beginning of the cheating or, rather, recheating of whole-objects: the residues of an ancient

environment, very largely destroyed already in the youth of us who are older, linger a little.

The fact is, again, that an uniformly robust awareness of whole-objects as such has always been rare, always hard-won. For neither has an environment of raw Nature, where practical life is restricted to a few simple operations, confirmed that awareness; a Nature all-powerful in every respect, whose dictates and whose look cannot be modified. This absence of scale or limit suggests for itself and tends to elicit from man omnipotence or other inordinate familiarity, often paranoid, a relationship with an invading-invaded object that at no time has been dissociated from individual and group projections. Attempted symbiosis with Nature in primitive societies discovers harmony by means of animism, of rites, of tabus, and even by means of the disfiguration of bodies to which I have referred. A specialized form of such partial and therefore absorbent relationship with objects is mysticism. Naturally we do not know whether the future promises a great extension of exotic religions. In an environment strictly ruled by technology, manic states produced by drugs will probably dispense with complicated faiths: except about the immediate needs of men there may be little stimulus to argument as far as cosmology is concerned. Therein lies a hope. On the other hand, just as it was inconceivable to an Australian native that the searching interior of that vast continent could be of a limited character, so the environment created by technological advance appears omnipotent. Already there is no way – worse – there is no reason in the light of which to modify or arrest. Practical benefits have been overwhelming.

But every perky car mascot has a whole-object under its belt.

2 Michelangelo's *Giorno*

IN CHAPTER 11 HAVE given reason for thinking that the future role of art will be even more important provided that culture continues as strongly to need vivifying symbols of whole-objects. We cannot be certain of continuation and it is not too soon to prepare ground for a struggle. We are in excellent position for corporate aesthetic resistance, for closure of ranks scattered throughout contemporary art, following the great dissemination of knowledge of art and of its understanding that modern methods of communication have caused. I believe that the first sign of that readiness must be the reinforcement of links that connect diverse manifestations of our contemporary art not only with the art of Oceanic or Cycladic culture, for instance, but with Western European art since the Renaissance; at the point, that is, where rupture has been celebrated and thereupon presumed; with the art of the past that we know best, the one perhaps the most varied and prolific and ambitious, the art of the societies that have gradually evolved our own.

The connexion between our past and modern art that occupies this book is solely of a general kind. It embraces a theme common to all art, but in Europe the assertion of it has been the most daring or challenging whether we consider Michelangelo or collage, with which the next chapter is concerned.

To us the representation of correct musculature, however detailed, is no longer emotive in itself: we no longer associate naturalism *tout court* with the promise of aesthetic value. It has become more interesting, therefore, to ask why the spectator may be intensely moved in Michelangelo's Medici chapel, San Lorenzo, by the musculature of the elbow of *Giorno*'s twisted-back left arm and by the extraordinary bulges of the flattened hand. The spectator has the sensation not only of seeing clearly but of having thereby unravelled a complicated physiological structure that for most of us, even with the help of a photograph of an arm in this position, would seem vague and therefore unremarkable. It is

moving and pleasurable to feel that we may possess in such a vivid detail the essence of Michelangelo's creativeness, an impression that would survive, I believe, if the detail were isolated from the figure and if we had no other experience of Michelangelo's sculpture. For there are rhythm and density that articulate for us, as well as the physique, the mind imputed to the figure or to its fragment: these are together not only a single but a crowded unit in our eyes.

Further, there is another and equally powerful concatenation of breathtaking virtuosity related to the first. To see it we must contemplate the whole marble block.

We are very conscious that as well as a piece of enlarged and powerful verisimilitude *Giorno* is undisguisedly an emaciated stone, partly rough. When viewed from the back the reclining, mountainous figure with long unsupported feet suggests the squat penury of a pebble. The reconciliations of the unsettled pose, an outcome of naturalistic aim at its most ambitious – and what was most ambitious technically tended at that moment of art to be most expressive also – are themselves subject to another astounding equilibrium between the extreme articulation of much of the figure and areas that have been, or partially have been, left as roughly chiselled stone. The restless Olympian *Giorno* emerges from the substance of the mountain with which the mattress of his hair and his roughed-out bearded face and angry eyes are cognate. All four *Times of the Day* are shrunken blocks: seen from the front the wide blunt knob of *Giorno*'s head ruminates beyond a deep crater and beyond the ridged right arm like peaks of the Carrara range that have been reduced by ancient quarrying, the scene for Michelangelo of many arduous months.

As a mountain may appear to transmit to itself the presence of its peak, so *Giorno*'s square head, sunk in the shoulders, impregnates with thought feeling the body's bulk: as if the brain were entirely a transmitter rather than the receiver also of corporeal sensations. *Our* sensation is that muscle speaks; there is speech not from the mouth but from contours and bulges that ripple at the behest of a reckless verisimilitude.

Now such communication more commonly proceeds from figurations that are greatly modified or generalized forms of physiological intricacy. Those partial abstractions have a closer correspondence with the visual residues left in the mind's eye when we contemplate our own feelings. That the unquiet real marble body, so to say, can have been made to reflect, to enlarge, this inner life becomes a triumph, not only for Michelangelo but for everyone: we are exalted.

We look to things for confirmation of cohesiveness and power. Here before us is a marble body not rarefied by the spirit but exhibiting the spirit, the inner life, first as a concrete, but then triumphantly as a naturalistic, form. Such grandeur of the intricate body, companion to the mountain, is dear to us.

Indeed, nothing else in art offers as multiform a reassurance in spite of the huge melancholy inherent in the Medici sculptures.

It is considerable satisfaction when we feel in sculpture of the human body that the inwardly-conceived cylinder, let us say, an image-residue of contemplated mental states, has been translated into the outward terms of thigh and arm. Many experiences are brought to bear on any projection of the body that we judge to be somewhat comprehensive in this respect. And we often find in primitive or conventionalized art that a geometry of the inner life pervades an astonishing likeness to the outward model achieved by simplification, in terms of an essence distilled. But the developed Antique, much of the Renaissance and pre-eminently Michelangelo have dispensed with essences with those startling abstractions that encircle a particular likeness, in favour of conceptions of naturalistic truth infused with more grandiose abstractions borrowed from architecture and, in the case of Michelangelo, from a mountainous mineral strength as well. Instead of an adjusted cylinder for arm or leg we experience the elucidation of an anatomical network that refers fiercely to the inner life as do conventionalized schemata more slowly: we imagine an inner configuration to have now become no less palpable than a most intricate body and its daylight. Also we discover that between the rough mountain and ourselves there is the bridge of the countless stones broken and organized in a humanist architecture. Apprehending the sculpture's connexion with mountain and with architecture, we embrace more material, more of the outside world, within the corporeal ambit of art. I shall suggest later that so extensive a corporeal realm corresponds both with the general compulsions of phantasy, and specifically with a main aesthetic component that results from what I shall again call 'carving' activity or conception.

These are connexions which, when we view the Antique, may often appear dormant: they are instantly aroused by the low relief of the early Quattrocento and at the behest of Michelangelo. The period between the Antique and the Renaissance plays a very important part: we have in mind not only Giotto and Giovanni Pisano but huge monuments such as Pisa cathedral where the captive marbles of which they are made seem to affirm union not only with religion but even more with man's demand to see himself in their arched progressive tiers. The bias of the Antique and of the Renaissance towards verisimilitude is to be understood or appreciated only when beheld in harness with this intense feeling of ideal communion with ordered stone. The great innovator in painting, Masaccio, is inconceivable without that awareness. Carved mineral mass was felt potentially to correspond with the *varied* riches of a monolithic self, to inspire in graphic art and sculpture a reconstruction of psyche by means of the complicated terms of anatomical animation. The material of art itself was for art corporeal substance. The originators in chief on the visual side of the first

Italian Renaissance period were architects and carvers. There is emblematic justice in an old conception of fixing the inauguration of Renaissance art by the date 1402 or 1403 when Brunelleschi and the young Donatello are reputed to have paid together their first visit to Rome, that is, to the Roman ruins and sculpture.

The verisimilitude, the perspective, developed at that time, was a liberation from less vivid conventions whereby to project this birth of the freedom-loving body from the mother stones of architecture. Figures boldly emerge. The representation of movement was of its essence not only for this reason but because a turning body allowed of a more complicated and dramatic articulation. The twists of *Giorno*'s arms, torso, and legs upon the inclined plane of the sarcophagus would emphasize a position of extreme discomfort were it not for the superabundant impression of power and control. Another art, not unrelated with European naturalistic sculpture, the classical ballet, similarly displays the body in open poses that do not excite a sense of strain but yet are, however static, never of a temper that is relaxed. It cannot be said that sculpture which followed Michelangelo, a giant of restlessness, conveys, as should ballet, an absence of strain. Yet if in the Medici chapel there is agony, or at least a top-heavy melancholy, there appear even so an overriding density and calm as well. One is reminded a little of both roots of this art, of Masaccio, who in the Brancacci Chapel combined what were to be the two great themes of fifteenth-century painting; movement, chiaroscuro, stress, with an emphasis upon spatial interval, upon what was soon to become Pieroesque calm. No accomplishment in painting is as comprehensive as Masaccio's. So often in art the greatest moments are the first.

It is dismaying, it appears mean and puritanical that some of our experts should still be antipathetic, as a matter of principle, to Florentine achievement in cases where they are so conscious of the striving towards naturalism upon which the attainment partly depended. Other aims in art have been less vulgarized without a doubt. But the fearsome aesthetic person is perfidious who rejects on principle the non-decorative fulsomeness of the early naturalism. He is rejecting a basis of art where it has been shown ambitiously, with many more aspects if also diffusely (except at supreme moments), the identification of inner organization of the spirit with the wholeness and articulation of the nude, and the identification of this image itself with the actuality of the substance or materials, especially meaningful in the case of carving, from which it is made or imaginatively derived.

3 Collages

SPECTACULAR AND EVEN PANORAMIC figuration, especially in the close-up, has now gained unlimited scope of a kind by means of the cinema, by means of photography.

The stricture that ends Chapter 2 does not embrace a plea for naturalistic art here and now. It refers to the connexion that in my view is untouched – surely it could not be otherwise; it is hurtful to the understanding of art to deny it – between advanced illusionist techniques that used to thrive and their partial abandonment in the present. The qualification, 'partial', comes about because a total abandonment in painting is impossible. Wherever a two-dimensional area, wherever a surface suggests even a most shallow depth, the fabrication of visual illusion occurs. Indeed this tends to happen if any mark is made upon it.[4]

In the developments I am about to discuss there is, however, entire abandonment of the studied imitation on a painted surface of objects in the outside world. What, then, is the crux of this revolt? I believe it centres on the fact that imitativeness, in that it involves the magnification of illusory effects, can be thought to separate the work of art from actuality and even from the actuality of the objects represented. But this has become obnoxious because illusion itself, in the form at any rate of phantasy, is regarded as necessitous or actual equally with the actuality of outside objects. Their wonderful mingling in naturalistic art was an imaginative creation no longer apposite to their alternation as we now experience it without much help, and without a present possibility of desiring the help, from reductive cultural filters. I hope to make this clearer.

Professor Isaiah Berlin pointed out in one of his lectures on *Some Sources of Romanticism* that just before the turn of the nineteenth century, Tieck asked the actors for an interruption that destroyed the dramatic illusion in a play he wrote. The actors would then talk together in a matter-of-fact or cynical manner that rejected the play as such. Isaiah Berlin pointed out that this qualifying of

make-believe by actuality to the extent that they were interchanged, achieved a full expression over a hundred years later at the time of Dada.[5]

The reaction against unrelieved make-believe persists. Neither real objects nor the phantasies they stimulate are now felt necessarily to be as uniformly pliable as their transformation into the ingredients that furnish a make-believe. The simplicity of this amalgam has undergone many attacks, many vicissitudes, in the last eighty years. Actuality and phantasy can be regarded as partners, and equal partners at that. Reduce actuality, and you are reducing the character of phantasy as such. Phantasy, projections, symbolic constructions, are no longer considered gratuitous, 'unreal', even imaginative. They reflect psychic structure and hence form the root of art. Phantasy and actuality do not only curb each other: 'straight' actuality is in fact the origin of 'straight' phantasy. Thus the modern sculptor does not begin to disguise the stone that he works. There is the stone and there is the stone that is made evocative, an incipient dualism of factors that more usually have been in varying degrees in closer amalgam, for the comprehensive culture of the fifteenth century especially, and for the subsequent art of Michelangelo.

It was in fact poets who first of our time employed a bared dualism. Since many words have numerous overtones, it became important to allow to them their varied actuality even while they were pressed into the service of a narrow theme; a consideration that has led to an employment of images forged from juxtaposed, previously dissociated parts, of metaphor divorced from simile, an interplay of matter-of-factness with a poetic intent. Much fragmentation – Dadaist inversions even – attributable to *avant-garde* art in many media is due to some loosening of the ancient cultural amalgam that in make-believe compounds figuration with everyday, contradictory experience and with actual substances.

Art for a century has often assumed a form that the past would have considered practice dress: in the highly theatrical presentations of the conventional ballet it is this that of recent years has sometimes been the costume.

For a long time now painters of *all* reputable schools have had no interest in disguising the flatness or actuality of the picture plane for the sake of *trompe-l'oeil* alone; or in concealing the process by which art is made: an undisguised and even exaggerated process has become a prime instrument of aesthetic value. We have had poems that for many readings remain little more than words and music that to an unsympathetic hearing is literally only sounds, only disjointed, far-separated noises even; but it is obvious that visual art, commanding sight and touch, is strongest in the presentation of actuality, with far the widest range.

As the sole framework for European painting massive illusionism was bound up with biblical and historical recreation; with the rendering of stabilizing

myths and beliefs that could appear to encompass actuality. None of this would now possess a cultural incisiveness and a reference also to the psychic actuality of the inner life: in sum, such representations, though they were made for us with distinction, would not serve with urgency as symbols of whole and self-sufficient objects. An arrant, personal employment of symbolism by many artists, very notably by Picasso in *Guernica*, may appear to mitigate that situation. Not even Picasso can help to stabilize a culture that lacks a systematic and deeply-founded symbolism. He, as much as anyone, has shown us that as a result of the protesting Romantic Movement, culture no longer controls a symbolic language of comprehensive use.

Today, instead of the steady arms of culture we have juxtaposition, in the first place the juxtaposition, often in preference to the mingling, of actuality and phantasy. Moreover the confusing juxtapositions inherent in our experience of the technological environment have to be stated, if only because they cannot be fully comprehended or interpreted. Surrealist art, of course, is contrived out of unexpected juxtapositions. Often, it seems, they misfire. It is of particular interest that any such condemnation has not always been considered of the first importance, at least theoretically. An emptiness, a destruction, has been exhibited as such. So called anti-art has had an important place in pioneering. A chance conglomeration might amplify the ceaseless meaningless shocks from the juxtapositions to which urban life is subject. That the shock of juxtaposition – the juxtaposition even of destruction or evanescence with construction – in contemporary art has become a requirement prior even to the often very evident poetry desired and discovered in the process, is perhaps illustrated by the fact that the power of an antiquated *trompe-l'oeil* imitativeness has served as an *avant-garde* method in Surrealist hands when used to transmit the shock of unexpected conjunctions.

The brassy element of shock, impact, or arrest has of course always been present in art. Craft to the ends of verisimilitude partakes of this surprise quality that is often the necessary preliminary, the very form, of the invitation to join and merge with the presentation. It is significant that even the academic art of the day tends to disrupt any value it might transmit by the imposition of grating vulgarity or crudity. What has gone, what cannot be recaptured, is a cultural or subsuming style, native to the art of more integrated, less questioning societies, by which to arrest, to invite, and to figure forth. And whereas the creation of art has always depended upon a successful bringing together of the divergent, upon unifying effects that contrast, we must now make art out of confronting elements that tend to evoke for themselves, it seems, a cultural principle that only in an obscure, non-masterful sense can be said to have been imposed. A sign of this humility or partial capitulation, certainly of the dominating experimental verve, lies in the process of making a collage compared with the

process of painting. A new piece added to a collage may most forcibly re-direct the structural and emotional conception to a degree that could not have been anticipated.[6] There are compensations in the strong impact and often in the purity of composition released from a variety of trammels, particularly subject matter; in the employment of actual, formed objects or of an unexpected weighty substance as implements of the urgent spirit however vague its voice. The actuality of heavy sanded surfaces created by Dubuffet and Tapies brings their work of this kind close to collage. On the other hand some artists, as I have mentioned, seek to make capital out of the fugitive propensities of matter, to harness decay or destruction to the purposes of art, a pile of distorted mineral rubbish. All these faceless insistent products crowd in upon us as if we were blind. Pygmalion's model now carries off a far more vivid dash than does he. We are up against the modern artifact as if our own paler history were composed of confrontations that produced their dominant overtones as a result of a similar transposition of the context. Indeed, that is a fair generalization about the development of psychic structure.

At the same time the employment in collages and assemblages of actual objects points not only to the reiteration of whole-object nature in a void created by the abandonment of representations that truly imitate them, but also to our particular hunger in modern environment for surrounding objects that we may contemplate in their possession of the wholeness and self-sufficiency of which the nude was once the presiding symbol. For it will be said in the final chapter that our attitudes to actuality as such, at any rate to the concrete media of the arts, project a continuous reference to a rudimentary body that corresponds with the corporeal content of phantasy in general; the more so where the actuality of the medium is stressed.

Blindly, like the infant with his part-objects, we grope for those attributes as this art pounds us. We have come to conceive from such works that they possess a significance in their quality of bright or insistent objects prior to their particular value of which that fresh impact could be the proof. Hence in general their great if often unfocussed power over us; and it is to the impact, it seems to me, rather than to the ordering of the cosmos, that we attend in looking at a Mondrian or at constructivist art in any form or, indeed, at the first great Cubist art; though, naturally, there follows the significance that is in line with the artist's aim without which a meaningful object could not have been created.

'When, as in a primitive cult object, a shell becomes a human eye because of its context, the accepted hierarchy of categories becomes disrupted': the confrontation wrought by a changed context. This principle of collage and assemblage is by no means new; not the principle. What of the scarecrow, of Valentines, Ex-votos, intarsia, gold keys and haloes in Gothic paintings? What of mosaic? The question could be made very long. A confrontation and a

degree of correspondence have always been sought, by sculptors particularly, between physical material and the complication, aggregation, and resolving of mental states which may be suggested particularly by natural objects in a new and varied context. The thread of this activity has not only not been broken but has been strengthened by modern artists. I have tried to show that naturalism, a varying degree of illusionism (though in truth very rarely its most complete expressions) could manipulate this thread no less than other styles; but in so far as naturalism of all kinds has now gone by the board, painting approximates more literally either to sculpture or to architecture, to the arts in which the materials themselves have always manifestly retained their own significance whatever their transposition to a new context. Not, I repeat, that naturalistic painting was without what I have long called 'carving' values, that is to say the values in which especially colour and disposition of space play the part (in combination with other parts) that can be summed by the expression 'enlivenment of the surface', an activity in contrast with, no less than in combination with, what I have called modelling activity that creates the looming of forms, rhythm, movement, stress, and strain. In actual carving the intrusive chisel enlivens the stone, a material of unrestrained imaginative value unlike the clay, a more homogeneous substance of which nothing is expected in art except a pliability, a wholesale lending of itself, for the fashioning of the artist's imagery. I have often suggested that with the breakdown of deeply meaningful stone or brick architecture in the middle of the last century, the role of providing satisfying surfaces was first taken over by painters: it is shown by the increased interest of the paint's textures as if that tinted mud were a vivifying agent of canvas or board. Collage has enlivened the picture plane with salvaged pieces of our staccato environment adapted to the role of a prolixity upon this plane.

A substance to be carved, I must repeat, unlike the moulded clay, is a potential ready-made, an object fit to be contemplated in isolation, to some degree an *objet trouvé* an overriding sense of whose actuality usually persists whatever the sculptor does with it. It may be the grain of stone or wood of which we are so persistently conscious, the texture, and it can be the marble landscape or mountain when the hand is Michelangelo's. We are at times even more aware of that combination in great stone architecture where forms and adamantine material connive. The arts of collage and assemblage, it is easy to see, are not of a different genus though the pieces of the external world are taken from their usual context and stuck together not in order to create, it is true, an illusion of some other natural object nor a shelter, but a meaning transmitted by physical objects as such that in their combination is wider than their own. Hence the often abrupt evocative encounters of differing flotsam, imitative or reflective of emotional collocations among the accidents and contradictions to which environment subjects us, the fleeting amalgam that this art both satirizes and

attempts to pin down, to make poetic, whole. So great has been the influence of collage that much painting now combines with sculpture, or at least with materials used in a relief that bear witness to a predominance of 'carving' values as has been said, though the reliefs are usually made by impositions. There is a similar connexion with collage in the work today of many pure sculptors. I see in this context the generous steel constructions of David Smith. His delicately abraded piled cubes provide a countenance for steel and for welded construction, but not at all an expressionist countenance for robots. His is a deeply satisfying achievement that enlivens our sense of a substance forced on us today, making for its use a connexion with the anthropomorphic carving of stone and even more widely with man's vivification of the landscape through several thousand years, particularly with his cutting of the trays of mounting terraces. Out of fire and shrill piercing, out of sharp usage, an anatomy has been forged of great breadth for metal.

This liberty to serve materials as such has hitherto been rare in the arts outside those that are professedly assistant or decorative; whereas today the independence allowed to actuality, to materials, immanent in what I have called the 'carving' principle which magnifies interpenetration with an expressiveness beyond them, is the root of much excellence in our art. For it is no time not to use stuff as such, no time to sublimate material, disguise the medium or even to have a medium in so far as this word implies its utter subjection. Submission to some extent to the medium is a method by which the artist seeks to construct a home for us in an environment that is as yet far from being a confident projection of the body with its eyes that we can see. It is as if we were blind and as if what hits us so hard is blind also. New art is not out of step with the old though the gap be wide between our faceless art of material and the lengthy bodies that the paintings in the National Gallery have imposed on existence.

We sometimes mistake a collage for a painting, and we find that our feelings about the object alter materially when the truth is known. I become aware in that situation of closure as if a writing on the wall has itself been walled up. The entire collage that successfully counterfeits a painting tends, when we know, to diminish our sense of a transmission between artist and spectator. The material has won over the artist: the work has now become at one remove like a print, though in the case of many prints the handiwork is no less evident than in front of a painting. But in the case of collage we are aware also of a craft that is self-concealing, of a fitting together that we associate with furniture-making rather than with an expressive use of paint. Even Matisse's cut-outs, though they show his subtle manipulation of the scissors, do not convey to us the continuity in organizing *matière* for which we look in his painting: a comparable conspiracy with the canvas has not occurred; indeed the background is not canvas but paper, the same material as the gummed papers. It will seem

arbitrary, therefore, that I have associated collage so strictly with the 'carving' aspect of visual art. Moreover collage is always superimposition like one piece of clay worked into another. On the other hand it is not difficult to see that Schwitters's collages cause waste material, as well as the surface on which it adheres, to be precious. He elicited gems: it is as if not the stone but the dull ungleaming clay had been made to irradiate. In carving, no part of the material should serve only as a foil to other parts: the gems transmute the character, exalt the potentiality, of the setting. Carving tends to moderate the overriding gesture to which the clay easily lends itself. Intrusive though it be, perhaps in compensation, the act of carving tends to favour gradual forms, a wider spreading of accents and emphases: the material, like space in a painting by Piero della Francesca is uniformly valued, just as each of his colours is uniformly valued, that is to say not considered dominant, nor subject to, but brotherly with, the other colours. In an earlier book I have associated this aspect of visual art more closely with the re-creation of self-sufficient or whole objects in distinction from the incantatory power of modelling, a partner that extends our grasp of objects and thus reinforces and inspires part-object relationship. In my view, then, in spite of the superimposition entailed, the art of collage and the influence of collage upon painting and upon sculpture have strengthened the 'carving' approach to visual art, the sense of the independent object, the actuality of the material whose actuality, we shall see, symbolizes both the body and naked mental structures.

The Cubist art of Braque and Picasso wherein collage first appeared, can now be reckoned as the most intense and most varied 'carving' attainment of modern art. Those artists' introduction of *papier collé*, of more substantial objects also, were means – never forgotten since – that they invented to increase object-nature partly in the place of direct imitation. Thereafter substances, objects, stranger to each other than the announcements with emendatory diagonal strips on advertisements boards, insist on the assimilation of rival gestures and new contexts.

The intrusive character of collage – we have seen that this too connects with carving – has been exploited far more widely than the efflorescence of surfaces which appeals to me more. The latter has influenced the painters who sparsely stain canvases of the finest grain, whereas the former aspect has influenced painters – Picasso at one time among them – who intrude a flat shape that at first sight seems foreign to the rest:[8] so imported does that part of the surface appear that we approach in perplexity to discover whether collage has in fact been used.

A combination of an impersonal element with expressiveness, collage has become the most distinctive invention of modern art. Nauseated by the bill-board – one of the progenitors, to be sure, of collage as of pop art so much

later – we continue to find solace in a beautiful mosaic of paper scraps or in *collage déchiré*. An impersonal weathered surface is precious to us, a record of our past that cannot signal through a precise semaphore, a residue of the life from within that once informed as secretly the stones of well-worn towns.

In the first chapter I have hinted that for modern urban life our eyes and other senses no longer receive nor as easily construct the broader symbolic impressions of whole-objects in terms of that environment: there appears to the contemplative mind a drag upon many individual things as such, a partial dissolution of a self-sufficiency that depends from the imaginative angle upon the notion of a wide organization, as well as upon the frequency, of valued things. Modern art shows that we must search for mere fragments of an organization and that we have an entire impatience with cultural symbolic systems: they would lack impetus. They cannot be applied now to the order or, rather, to the lack of order, of things.

It is certain that in the figurative sphere no artist has rivalled Giacometti's hunt for an intrinsic residue among his life-long companions of what in other times might amply have been the stranger; the stranger with the meaning attributed to him on the first pages; a symbolic whole-object briefly encountered, a unit within a self-supporting *mise-en-scène*. Much visual art today has abandoned this direct search for an unconquerable quiddity of the self, an occupation of Romantic thinking right through to the Existentialist version of the present time, in favour of the sifting for the parallel term, for the unconquerable natural or manufactured object, the ordinary objects of the outside world stripped or cleaned of our easier modes of appropriation by projection and of their subservience from the imaginative point of view to facile emotions and memories. These are now held to be lying side by side with the objects that stimulate them, a small but meaningful separation. One aspect of Alain Robbe-Grillet's novels illustrates it. Things are; they are out there: as seen with the eye of an artist they are meticulously described again and again for their cursory form at the cost of dramatic progression. From time to time we experience in reading Robbe-Grillet the wonder we would feel if actors on the stage were to say nothing, were to abandon acting as in the Tieck drama, an ideal situation to which several of Beckett's presentations approximate.

And so there is now a code of aesthetic reverence for the mere presence of things, for a residual presence in whatever way this may be formulated. Such formulation, of course, betrays more than an element of projection: it makes meaningful, as always in art, a new appraisement implied for the opposite arm, for inner or psychic structure difficult to seize and little known. Hence an impatience with all myths enveloping the physical world, a disquiet not over the sublimation of this or that tendency but over the cultural veils by which

sublimation has dulled the ache for psychic actuality, for psychic truth as far as repression allows us to entertain it. Self-knowledge has been obstructed not only by ourselves but by the wholesale interpretation of behaviour and of objects presented by all societies. We feel it to be so today only because we have science together with a culturally bare world. Once, every form of knowledge and understanding tended to coalesce. They are more likely today to be disparate. The findings of psycho-analysis have been very little accepted beyond their generality; yet the rejected rumour of them has been enough to curb, to eliminate even, much systematic rationalization of omnipotence.

Some painters explore relationships to objects so manifold that the attempt is sometimes made *not* to conceive the work of art as a closed system, closed against the contingent circumstances of its viewing.[9] Will art press on to join all the accidents of Nature and, through an excess of the 'carving' principle, expire?

Meanwhile there is considerable pathos, there is even an element of drama, in any comfort gained from an imaginative permissiveness that extends to objects an opaque identity that has eluded our possessiveness. Objects have become mysterious; we are sometimes unable to establish a progressive visual system from part- to whole-objects. Not only the urban environment but even technological exploration projected on to paper tends to blur divergence between them. I instanced the magnified form of the artist's thumb, a reversal of scale that seems to tally with our new universe though a part of the human body is not usually in question. Indecision multiplies; it was the artist's aim to transfer that indecision to his thumb since the enlargement of objects by magnifying aids, particularly by photography, has forced on us startling units of organization not apparent to the unreinforced senses. The result in much pictorial art has been the exploitation of the disruption of scale, and the great modern invention of sparse design on a huge canvas (with or without a sea of paint). Totally ambiguous in scale, these works may appear to expand further, to grow over us, very complete though they be in themselves as well. In this way an extreme part-object possessiveness returns. Tobey's minute working also cannot be kept at a distance: we don't know whether his marks approximate to big things made small or to things smaller than his forms made big:[10] without figuration or without an architectural format, an architectural context, this ambiguity becomes likely in regard to scale, and consequently the overreaching effect that is much valued. It has stemmed in the first place from the intimate quality of naïve or primitive art wherein the attempt is made to mirror the artist's active as well as contemplative involvement with objects for which, whether they be animal or mineral, he discovers a manner of communal arrest that brings them closer into our possession. Scale is sometimes reversed in this art. It is absent again in the equivocal yet blinding chromatic researches of Op art: it is absent in aesthetic products that have in large part been derived from

engineering and mathematical elisions: these works can entail also a perplexing reference to an inner world that the wary artist seems to have circumvented: they may even brandish a simplicity that appears to have no bond either with ourselves or with object-nature as formerly envisaged.

But though we are unable to establish objects in an ordered hierarchy that satisfies the imagination, most artists still proclaim that objects are 'there', that the world 'is'; that any amplification might qualify, might confuse, the impression of 'is-ness'. I believe this attitude could be interpreted as follows: the faith persists that the good inner object, the core of the ego, survives (cf. p. 306); but it is unlikely to dominate. This good object has insufficient power to integrate with itself all the other psychic factors in so far as we tend to destroy the integrity, as we conceive it, of objects through excessive projective identification and other schizoid mechanisms that eventually bring about chaos in the inner world.

The manner of our art betrays a mixed condition; it is, of course, overdetermined. I do not go back on what I wrote about 'is-ness' in *Three Essays on the Painting of our Time*. Thus as well as some humility before objects, some idolatry of the actual, an old omnipotence may be exploiting a manic and predominantly dismissive rule especially over those artistic happenings wherein the only figure is the wilful engineering of chance effects at the expense of selection, at the expense of scale.

But I think there is a sense also in which the abandonment of imitation for the use of actual things in collages and assemblages partakes of a stubborn, unidealized affirmation that the good objects, whole and part, survive, if barely; exist, if fitfully. From that beginning – pious hopes are cheap – we may in art eventually proceed to construct more generally whole-objects that are rich; to re-construct the nude; to revise in the name of psychic truth a sober conception of the integrated being.

4 Art and embodiment

THE BIOLOGICAL AIMS OF the instincts that drive us are often imagined to possess some other meaning. Yet the processes of thought at the service of instinct (even when led to think otherwise) do not dispose any explanation of living and dying beyond the terms of instinctual necessity. The deeper purpose of living is but the common factor in all the contingent purposes, and truth about dying is the dying.

It may be best to enter into some harmony with that conclusion: a momentary acceptance comes by brooding on the fact that many valued states of being are self-sufficient. Those that are contemplative sublimate instinctual drive and yet in some degree they mirror the narrowness of instinctual purposiveness since these states are valued as ends-in-themselves even though their merit has a considerable repercussion on our lives. Our enjoyment of aesthetic value entails contemplative acts which can be held to reconcile us somewhat to the narrowness of biological necessity: they are emotional and intellectual exercises largely innocent of teleological tautology.

But contemplation of such 'useless' objects is not alone in possessing so wise a value. Even team games can sometimes show that there is a premium in ritual though it be shorn of its occasion: the game has become intensified as a spectacle though outdistancing the express purpose of a contest: the value is now wholly in a wider symbolic happening, in following the rules, in being subject to the climate and to other forms of chance and 'natural selection'. So withdrawn an event is often refreshing; and the appreciation of art is particularly so whenever the self-sufficiency of other experiences has been at the greatest discount.

But of course it is impossible to reserve the value of contemplative states only to their correction of unbridled teleological attitudes that are themselves in large part necessary to living. We can sufficiently rearrange the picture if we think for a moment of the projections that will be induced during the

contemplation of a natural scene, as we look at leafy laden trees, for instance, that appear retreated into happiness: they hold for us our belief in goodness and love by which we live: we personalize thereby attachment to objects. The attempt to explore the good beyond its first objectives, beyond its first necessity for the continuance of living, reflects the number of enemies to which the good is exposed. On the other hand the contemplative state denotes as well a power of potential detachment, of a detachment not from life but from some of the compulsions to simplify the forceful yet ambiguous stream. Contemplation, it appears to me, indeed consciousness itself, implies the potential attainment of a degree of acceptance, of a viewing that divides us from some concern at least, doubtless in the interest of the death to which we are no less subject than to the compulsion of sustaining and improving life. Some total acceptance will also be implicit in the apprehension of those happy trees.[11]

Contemplation implies reference to the forms of the outside world: even the self as the contemplated object requires the recall of sensations: in art there is no attempt whatsoever to separate the person from his body: the body is so primary an object that a sense of it will not be absent from the relationships to any other object. All the detail of this obvious admission – it is the detail, of course, that provides force – will have been derived from the researches of psycho-analysis. If we try to contemplate the psycho-analytic literature as a whole, we might conclude that the extent of reasonableness and emotional stability in our attitudes vis-à-vis objects, human, animal, vegetable, and mineral, depends in the first place on the degree to which, under the stress of frustration, conflict, fixation, trauma, and so on, we have integrated our love, hate, and envy of bodily function, the degree to which thoughts about one zone of the body have not been confused with thoughts about another zone,[12] the degree to which all functions are *felt* in the recesses of the mind as parts of a single and varied entity.

The balanced emotional estimation of the body is an ideal. One may doubt whether any human being has attained entire integration of those hidden feelings. It remains the quest, an impetus of adult search including the one of art. Indeed the contribution of art is quickly apparent; for instance in regard to the huge concern particularly of the infant and the child – a concern, therefore, that will always considerably persist – about the inside of the body, though the nearest even to an intuitive formulation at which most people arrive is in the context of hypochondria and psychosomatic illness when these conditions have been recognized for what they are.

Whereas the art of the written word is with difficulty and indirectedness centred on this matter, portraits and paintings of the figure are less hard to interpret. Rembrandt, it seems to me, painted the female nude as the sagging repository of jewels and dirt, of fabulous babies and magical faeces despoiled

yet later repaired and restored, a body often flaccid and creased yet still the desirable source of a scarred bounty: not the bounty of the perfected, stable breast housed in the temple of the integrated psyche that we possess in the rounded forms of classical art, but riches and drabness joined by the infant's interfering envy, sometimes with the character of an oppressive weight or listlessness left by his thefts. There supervenes, none the less, a noble acceptance of ambivalence in which love shines.

This is not necessarily to hint at Rembrandt's emotional equipment nor to stigmatize a bias in seventeenth-century northern European culture. On the contrary the contrasting classical conception is very rare: it is far more common to discover in art the implication with the inside of the body: we accept it that the Athenian achievement is without parallel and that the emptiness and falsity to which the Greek ideal would often be reduced (though the inspiration will never disappear) could cause it to be less accessible even to some who, like Rembrandt, studied and borrowed from classical composition, learning especially how to achieve the look of inevitability whereby to dominate the larger aspects of design.

Rembrandt constructed a stable format out of contrary emotions, from a varied human condition to which he allowed by the granular additiveness of his technique, the progression to a munificence that crowns other impressions like a gratitude that has finally overcast an envy. He has shown in sum, as Kenneth Clark said of his portraiture, 'the raw material of grace',[13] strands of negative feeling, for instance, about the body limited to the original zones, a process that will have entailed some withdrawal of those parts of the self that have been sent into the object to plunder or to command; for otherwise the affirmation that I am I and they are they, an objective of art, cannot be clearly stated.

We are intact only in so far as our objects are intact. Art of whatever kind bears witness to intact objects even when the subject matter is disintegration. Whatever the form of transcript the original conservation or restoration is of the mother's body.[14] And whereas pictorial art employs and stimulates those infantine phantasies – they are many – that utilize the eyes for omnipotent projections, for omniscience, it enlarges upon the reassuring endurance of objects in the shadow of this attack: they are enthroned by the artist by means of a pictorial settlement wherein they may surrender themselves only to that multiform composition which symbolizes the integrated elements of the self no less than of the other person.

And yet almost every product of the body as well as disease, malformation, malfunction, and the inside itself (apart from ancient bone) continue to revolt us since we are implicated; not so much because we belong to a similar vulnerable organism but because attacking wishes have caused the imperfection of

others to appear revengeful: that imperfection is likely to reflect also our own, split off in accordance with the necessities of narcissistic estimates. Every virtue resides or is symbolized in the flesh together with all humiliation, threat, and squalor. A moment of active grandeur may come with birth of the baby from inside; birth is sometimes a supreme event for the parents' reconciliation of phantasies about the body. Adult sexuality, adult love, can make every endowment commensurate. On the other hand an access of virtuosity for confusion and splitting may characterize this sphere. Success, full satisfaction, depends upon the disposition thereby involved of the early psychic structures regarding the body. As heretofore, not only do we project but we introject, including our own projections with their objects. Others, or parts of others, are inside us; parts of our bodies sometimes merit a double nomenclature: nor are these strangers likely to be at peace.

The medical view of the body is the most vivid and careworn of unemotional systems, a routine insistence that the body is a valuable machine. Concomitant with the growth and triumph of science there has occurred in culture a boastful surrender to the omnipresence of phantasy and finally in our own time a plain admission of compulsiveness. This, in my view, is the essence and origin of the Romantic Movement in the shadow of which we still live. The growth of science and the first rumbling of the Industrial Revolution killed the Enlightenment, the Age of Reason. As we have noted in the use to which actuality is put by the art of collage, actuality, and therefore the gaze of science, isolates and elicits phantasy as a stupendous force. A part of the aesthetic stress upon the actual is stress upon the corporeal content in phantasy.

We have learned that to examine how scored and pitted smooth skin looks under the microscope does not help us to conceive the satin flesh as leather, to link conceptions of youth and age, to join our feelings about attractiveness and about repulsiveness in a form of truth or just accountancy. Yet even the handshake points to the expectation of a fundamental warmth, a requirement that never passes though it conflicts with a variety of contrary feelings about the person. Many have tried, therefore, when genital attraction is not notably involved, to value not the body but its animation, the life infusing the carcase that cannot in fact be separated from it. The once useful conception, the 'soul', is entirely outmoded in an age whose range of actualities continues to increase. We cannot dissociate people from their physical presence and we may sometimes fail to dissociate the presence that they present to us from the life of their persons under all circumstances. Narcissistic esteem, self-love, a fount of warm and generous estimates, does not confine its dealings to the soul. Love is as comprehensive as hate, though even within the narrow gauge that we are set by our compulsions there is much concerning which our feelings fluctuate. The intact objects, works of art, are a model for the direction of those feelings,

327

not so much in reference to people specifically loved or hated but in the matter of the persons of our fellow-men more generally. A degree of education is possible and any profit from it may accrue to the intense relationships also. It is therefore important to discover in art the recounting of all aspects that the body has possessed, the inside (as seen from without) as well as the outside. (Thus the glimmering or tufted finery that clothes many sombre Rembrandt figures can mirror the character of *inner* objects for whose state the individual is massively responsible.)

It is for such communication, however recondite, that we scan good portraits. At any rate we learn to see the spirit, the animation, in terms of art's inoffensive material. That material stands for the body whether or not it has been used to represent the body. Art, truly seen, is never ghostly; and art, truly seen, does not so much educate us about animation, about the mind or spirit, about the intentions of others good or bad in which we find a source of persecutory feeling or of trust, as about the resulting body-person, about the embodiment that is much more than an embodiment because bodily attributes have always been identified with those intentions. A painting of the nude, therefore, is but one of the corporeal lessons set by art. There is a sense in which all art is of the body, particularly so in the eyes of those who accept that the painted surface and other media of art represent as a general form, which their employment particularizes, the actualities of the hidden psychic structure made up of evaluations and phantasies with corporeal content.

Though the emotion aroused may seem infinite, the variation of form is restricted: there is no merit in two heads or three legs. The forms that embrace what is most desirable and most rejected partake of an extreme limitation like the picture within its frame, like the meagre repertory of forms that are available to the artist. The grey haberdashery of an old man's loose flesh against a pillar of a swimming bath seems to negate the tie with the column's marble corporeality, while upon the stage in the second act of *The Sleeping Princess* the bodies of the radiant dancers transcend the paste-board palace and the very light. In both settings it is the architecture that provides both a mean and a continuo.

The thinking of art about the body is not hurried: the 'carved' medium and the animation are affirmed together as well as separately: the reaction-formation that divides the sensuous from the mental or spiritual is denounced. Art, and art alone, always haunted the position that of late psycho-analysis has fortified impregnably with deep-dug entrenchments; particularly modern art, at any rate in regard to an insistent respect paid to the prevalence of un-organized and confusing phantasy that encircles actuality; the raw material to be organized.

I have stressed the whole-object nature to be envisaged when painting a nude.

At the same time the artist attempts to formulate a coherence between the objects of which the self is partly composed and even to recall those parts that were split off and sent to live in other objects. We have seen in the context of collage and assemblage that contemporary art sometimes rejects imitation and employs an actual outside object brought into contact with other actual objects. Thereupon collage joins up with all art since it is ensemble, not the constituents, that constructs the whole-object we call a work of art. Behind the making and appreciation there is the hope of estimating human beings, at the very least the mere interaction of body and mind, in the way we contemplate and love artifacts, as well as in the light of other models.

The word 'contemplate' indicates at this point a state wherein further projective and splitting activities are at a discount in favour of the wider recognition of the object as a complete object. Nevertheless whatever aesthetic object we contemplate, it serves also as a symbol for an aspect, or for many aspects, of our accumulated feelings and projections and introjections in regard to the body to which in our own selves and in the case of others we are tied not only indissolubly but without a solution, without an integration continuous and stable; that is to say, incompletely when compared with a work of art *per se* whose medium is always broadly of its fabric. It is surely a modest and indispensable ideal that art proclaims.

A word finally about the great classical art of Western Europe that seems outdated. It cannot be too strongly emphasized that at best this ideal treatment of the psyche and of the body has not involved denial and an averted gaze: it would otherwise be of no value. A perennial shapeliness in classical art affirms a resolute hold upon the figure of the good breast installed in the psyche, enduring under the circumstances even of death and tragedy. Wherever the belief convinces, the tenacity corresponds with psychic truth in regard to the core of the strong ego and the fount of integration or successful development. To have been able to subsume under the aegis of so grand and active a manner in art a huge diversity of emotional experience has surely been among the greatest achievements of man.

There are many aspects: the alternative need not be between classical and anti-classical. In the *oeuvre*, for instance, of Matisse we witness an angular, pointed attack bent, even forced we may feel, into the round by his wry contentment with the enveloping rays of the sun. He contrived sumptuousness from colour so that the angular subsists as a simplicity in harmony with elegance. He reconciled the sumptuous with the meagre, the lavish and monumental with the tin, and the easy contentment of the decorative with what is stark, with an expressiveness that is circumscribed but not suppressed by the range of his opulence. That opulence would appear a surfeit were it not so neat

an expression of the clinging to beneficence amid an angular and impatient world.

This lesson, the sharp lesson of Matisse who was neither classical nor expressionist, has not been overlooked by countless modern painters.

Art, we have seen in these pages, has always employed concrete, indeed corporeal, conceptions. The attempt has once more been made to exalt the truth and wisdom of art particularly in the light of its 'carving' component. The lesson that all art teaches rather than the survival of a living style is what matters first. But the present aesthetic submission to natural phenomena, even to chance confrontations, whereby art tends, closer than ever before, to embrace the process of Nature – kinetic sculptures are physico-bodies that 'live' with us – might portend in the course of time a disappearance of art as we have understood it. This would matter not at all if a dilution of art proper were to mean that almost everyone has become an artist in the way of his work, in an area of his interests, in the manner that he views the world.

PART II
The Image in Form
A LECTURE

Often in a talk[15] about art we get at least a partial division of formal attributes from representation. We say the formal relationships organize the representation, the images, on view. That's the traditional approach. On the other hand, in the theory of Significant Form, form is isolated from imagery, from the construction of likenesses in visual terms.

I am going to argue that formal relationships themselves entail a representation or imagery of their own though these likenesses are not as explicit as the images we obtain from what we call the subject matter. When later I shall refer to Cézanne's *Bathers* in the National Gallery, I shall suggest that there is far more imagery in this picture than the imagery of nudes in a landscape, a more generalized imagery, with references to all sorts of experiences, which proceeds from the formal treatment. Now I think one can say that that's obvious and indeed that it is presumed in the work of all the best writers today on current art; but it doesn't seem to have given rise to a really wide investigation of what is involved. I am going to make some suggestions about this.

The phrase 'the image in form' cropped up when I was asked to decide between two constructions at a Soto exhibition. They are made of projecting square plaques against a background of black and white lines. I said I thought one communicated a stronger image than the other. It suggested an image for an amalgam of experiences, even though that impression had not been achieved by the creation of a correspondence with recognized events as is the case where you have a subject matter. I found this abstract work to possess an image all the same, whose character would not be altogether dissimilar in the long run for those who are able to lend themselves to abstract art.

Formal arrangements can sometimes transmit a durable image. That is not merely to say that they are expressive. There is a sense in which every object of the outside world is expressive since we tend to endow natural things, any piece of the environment, with our associations to it, thereby constructing an

identity additional to the one generally recognized. At heightened moments anything can gain the aura of a personage. But in art it should not be we who do all the imaginative work in this way. The better we understand art the less of the content we impose, the more becomes communicated. In adopting an aesthetic viewpoint – this, indeed, is a necessary contribution on our part – which we have learned from studying many works of art, we discover that to a considerable extent our attention is confined to the relationship of formal attributes and of their image-creating relevance to the subject matter. The work of art should be to some extent a strait-jacket in regard to the eventual images that it is most likely to induce. Obviously any mode of feeling can be communicated by art, perhaps even by abstract art. Nevertheless the personification of that message in the terms of aesthetic form constructs a simulacrum, a presence that qualifies the image of the paramount feeling expressed. That feeling takes to itself as a crowning attribute more general images of experience. Form, then, ultimately constructs an image or figure of which, in art, the expression of particular feeling avails itself. A simple instance lies with Bonnard, with the shape of hats in his time that approximated to the shape of the head and indeed of the breast. He seems to co-ordinate experience largely through an un-envious and loving attitude to this form. He is equally interested in a concave rounded shape. Again, when we know well an artist and his work we may feel that among the characteristic forms he makes some at least are tied to an image of his own physique or of a personal aspect in his physical responses. This also would be an instance of form as an agent which, through the means of the artist's personality as an evident first step in substantiation, allows him to construct from psychical and emotional as well as physical concatenations a thing that we tend to read as we read a face. A face records more experience than its attention at the moment we look at it.

Perhaps all we demand of a work of art is that it should be as a face in this sense. But form in the widest sense of all, as the attempted organization that rules every experience, must obviously give rise to a strong and compelling imagery so generalized that it can hardly be absent from a consciousness in working order though ordinarily present in nothing like the aesthetic strength, since were it otherwise refreshment and encouragement that we gain from art would not be necessary. Form must possess the character of a compelling apparition, and it is easy to realize that it is the icon of co-ordination.

Integration or co-ordination of what? it will be asked. Some aspect, I have argued elsewhere, of the integration of experience, of the self, with which is bound up the integrity of other people and of other things as separate, even though the artist has identified an aspect of himself with the object, has trans-fixed the object with his own compulsion, though not to the extent of utterly overpowering its otherness. These perceptions of relationship that are the basis

of a minimum sanity demand reinforcement. Outwardness, a physical or concrete adaptation of relationship, spells out enlargement, means certainty.

It must appear a strange suggestion that art is in any way bent upon constructing an image for sanity, however minimal, in view of the wild unbalanced strains of feeling that have so often been inseparably employed in making this image. But surely if art allows not only the extremity of expressiveness but the most conclusive mode, if it constructs of expressiveness an enduring thing, that mode must incorporate an element to transcend or ennoble a particular expressiveness of which otherwise we should soon tire. We are encouraged to experience a many-sided apprehension in art. Expressiveness – it may be infantile – becomes valuable in evolving the mature embrace by form.

In the case of abstract art we are sometimes told by the artist – and it is very understandable – that we entirely mistake his work if we insist it expresses this or that. It is itself, the artist says, it does not stand for, it does not express, anything: it is not meant to suggest associations. I think he is right in the sense he means it. He is providing us, however, in his work with an experience of spatial relationships. Now it is obvious that no experience is entirely isolated, or else it is traumatic. The experience communicated by the abstract artist, on the contrary, invites comparison with other experiences and, to some extent certainly, will point to common ground with a particular aspect of visual experience in the first place or of the relationship between experiences. Abstract art would otherwise be virtually meaningless. Hence we have here an amalgam of meaning conveyed by material that transmits an image not only optical but for the mind or memory as well; unique for the eye but generalized for the mind. Here too the form constrains us to an image, and it is not merely one of our choosing.

Aesthetic experience can be defined as the opposite, indeed often as a palliative, of traumatic experience. But I am not going to try to probe the conditions of being of which this aspect of form is the symbol. I have attempted this elsewhere, as I have said. Some of the preliminaries are straightforward – for instance, the connexion with the body-image. I shall partly be confining myself to this aspect.

I have often before referred to the rough-and-smooth values in building, in architecture, that are carried over into the other visual arts and, indeed, into the textures, as we have to call them, of concerted sound. Why otherwise are we forced to speak of texture to describe appositions of instrumental sound? In truth, we cannot but speak of the surface of any work of art, and equally of shape and volume, of the articulated body, metaphors by which we assert the dynamic effect of its impression and the self-completeness. Formal values vivify such images; the inevitable metaphors derive from inevitable images that accompany our apprehension of the formal qualities. In the fifteenth-century

courtyard of the palace at Urbino designed by Luciano Laurana, in my opinion one of the greatest masterpieces of architecture, we surely see the same thing, a justice and fairness in the smoothness of the pilasters on the brick wall. The strength of this wall is measured by the eloquence of its apertures and by the open arcade beneath. Each plain yet costly member of this building has the value of a limb: in the co-ordination of the contrasting materials there is equal care for each: together they make stillness that, as it were, breathes.

One must agree to a generalized and meaningful content in the relationships of the Soto construction and in the Laurana courtyard. But are they characteristic works of art, that is to say so characteristic that they can be used to illustrate a content available in all art? What of the agony, violence, irregularity, flippancy even, that appear to be inevitable in some art today, or the restlessness, the explosive disruptiveness that is also common to much of the art of the past?

I have said that the generalized content of form, an element of co-ordination as well as of allusiveness, not only does not inhibit but makes an enduring thing or body of any kind of expressiveness however extreme. When, as has been common in this country, we use the term 'expressionist' in a pejorative sense, we mean that unmistakable expressiveness figures in this or that work but is by no means richly integrated throughout the formal relationships on view, and that therefore the effect is transitory rather than enduring. It encompasses no more than one or two notes. From Picasso's *Three Dancers* at the Tate, on the contrary, we derive a shattering image that coheres. It merits a lot of study. In the Tate *Annual Report* for 1964–5 there is a remarkable analysis, I think the best account I have read of a modern painting. It shows that every piece of the canvas is emotive, contributing to the whole, and even that there are resumed two of the most expressive themes in the iconography of Christian art. I need not go into it: in fact to do so would not help my purpose at this moment, the purpose of reminding you that we are instantaneously convinced by this agitated scene, though it is disruptive and difficult to understand. But we see that every line and tone and division helps in the setting up of various relationships across and down the face of the canvas. In front of an insistently imaginative painting this tends to convince us that an emotive or poetic whole is there expressed, since the expressiveness is transmitted by a rich language of form. Were it not so it would be a bad picture. The echoes and relationships make expressiveness ring, reverberate. Poetry may be plain and simple: the reverberations, even so, are many. Similarly with the nude in visual art. Form encourages further meaning because it is itself the container of a sum of meanings; the nude has already a variety of intense meanings, even apart from art and apart from the connexion between the body and form.

In the mechanism of this reverberation prime objects, however transmuted, will figure. Parts of the body and the body itself are prime objects instituting

relationships at the root of subsequent relationships of every kind. Our aware-
ness of the violent distortions and the formal elaboration of the breast in the
Picasso *Three Dancers*, leading to a round void in the middle of the dancer on
the left, illustrates that the body is an object we are likely to follow keenly in
transmutations imposed by the artist. I am eager to point out that an ideal
Madonna by Raphael is no traitor to this wide connectiveness.

But first Cézanne and the other very great painting that we have of late
welcomed to this country, *Les Baigneuses*, in the National Gallery. At first sight
these figures could suggest a quorum of naked tramps camped on top of railway
carriages as the landscape roars by from left to right; except, of course, that
studied, monumental, they altogether refuse the character of silhouettes. They
absorb, and in absorbing rule, the environment. Beyond the long seal-like
woman who regards the depths of the background, the standing, studious,
twin-like girls with backs to us lean across towards the trees and clouds as if to
be those upright trees. All the same the stretching across the picture plane is
more intense, the stretching of these governing bodies that now seem poised on
the easy rack of a level moving staircase. But movement to the left is blocked
by the striding figures on that side, and since movement is braked at the other
end as well it is as if shunted trucks were held between two engines. The tall,
contemplative figure on the further bank remembers for us the stretching
movement that, in effect, has crammed the centre where the two groups of
bathers meet. Rich with dynamic suggestions, the movements coalesce into a
momentary composure so that even within the crowd there appears to be
airiness and space. It is now that we contemplate the broad back, laid out like a
map, of the sitting woman with black hair on the left. Only in art, in an image,
in a concrete realization of emotional bents, such powers with their recon-
ciliation are found perfected.

Another image comes to us in terms of the heads of hair of walnut and
stained oak. It speaks to us of the strength of the trees in those women and of
the tawny arena on which the bodies lie and, by contrast, it includes the cir-
cumambient blue, the knife-like blue day that these nudes have crowded to
inhabit. They feed on the blue, on the distance at which the seal-woman ex-
claims. The close, clumsy yet heroic flesh sips the sky. These nudes are blue-
consuming objects and blue is the only colour almost entirely absent from all
the varieties of nourishment. The dissociation invites us to examine them more
for their sculptural value, to grasp the monumentality not only of the group
but of the knife-sharp, simplified faces without mouths, the alternations be-
tween astounding bulk and summary, distorted sharpness that both underwrite
the compositional movements and, from a faceted flatness, heighten the picture
plane. The sky too is faceted, spread thick like butter.

The distorted angularity of many shoulders, the insistence upon angle and

strength of line, oppose with ferocity a facile mingling of these bodies, in order to rejoin them sharply; with the result that our apprehension of the bulky, answering v-shapes is a startled apprehension, as if experienced by means of the extreme flare of a forked lightning flash. Coupled with the contrasting monumentality, this sharpness persists in the impression however long we gaze. Another reconciliation is between the sheet-lightning of the enwrapping towels and the slow swathes of blue daylight that dwell on ochre-tinted flesh and ochre hair and the ochreous strand.

For me the blue embrace is the final impression, withstanding a hurricane-like flattening of the light-toned foliage and a suggestion in the shape of the right-hand bathers' group of a petal-shaped volcanic orifice erupting into a steamy cloud beyond. But the group as a whole does not appear settled or rooted to the ground. The figures almost slide on it. We sense the possibility of fresh forms burrowing up from the ground's lightness to meet the blue embrace. This sense of lightness and fruitfulness balances yet enhances both monumentality and angularity.

The left-hand group is pyramidal; incline of the tree-trunks is an important element of the design, in the arrest and, on the right, in the reversal of movement. But especially in regard to so great and complex a picture I am the more unwilling to speak in the plainer functional terms of composition and design. I prefer to insist that the formal elements not only enrich but enlarge the subject matter. The fact that you do not agree with every image that I have associated with this picture does not invalidate my point. The emotive arrangements carry a number of such interpretations. Form is the container for a sum of meanings while it is from a concatenation of meanings that form is constructed, meanings that have been translated into terms of spatial significance. Without appreciation of spatial value, of empathy with bodies in space, there can be no understanding of the emotive images that form conveys. I believe that there is a nexus of meaning that we all recognize however various our explanations; it is composed from experiences otherwise divergent. The experiences will be largely individual but the power of an integrated communion between trends in concrete or corporeal terms is palpable. Let us agree that the material for creating this nexus is drawn from the artist's experiences and intentions, particularly, of course, his aims in regard to art. There are also broader limitations upon the realization of form without which we have no licence to conceive of art, matters of style, of the moment in the history of art and of the culture it mirrors, the many-sided limitations that are the concern of art history. But here, too, proper understanding depends upon an acceptance that cultural aim has been translated by all art, even sometimes without the help of iconography, into the concrete terms of the senses and within the range of our long memory for sensory experiences wherein traces of the first and primary objects

are preserved. One more word about *The Bathers*. Some of the faces parti-
cularly are conceived as a series of ledges or blocks, wooden, primitive, strong.
The tendency exists throughout Cézanne's development from the seventies. I
believe this aspect of his work, especially in the last compositions of Bathers, is
the first of his influences upon the evolution of Cubism. This same aspect of his
influence is far more obvious upon *Les Demoiselles D'Avignon* and upon all those
works that were so soon to forge the easiest of links with Negro sculpture. I
cannot help speculating in the most far-fetched manner whether one day it will
be possible to claim for *The Bathers* that it is among the first and perhaps the
greatest works of a deeply founded cosmopolitan art which was to pre-figure
the eventual evolution of a multi-racial society. That would indeed be to
specify a very pregnant image implicit in form, the compulsions of which in the
Industrial Age had substantiated out of the inner life a compulsion even of a
history to be.

No manifestation, particularly psychological manifestation, no behaviour, no
ritual, is as foreign as it was. We found a new culture from remnants that
remain of our own and possibly from what we have understood of other cul-
tures past and present. If one had to choose to say only one thing about modern
art, it would have to be in relation to this, it seems to me, not as a matter of
ideas, of rationalizations, but as avid necessity in regard to an externalization of
the inner life, deeply qualified, as for an art activity it must be, by the social
setting, by the look, by the quality of the external world on which the social
setting has been projected.

The controlled tenderness of Bellini's Christian piety, as seen in *The Dead
Christ supported by Angels* (National Gallery), embraces an illumined land. That
view of the body had come down to him from Attic Greece. Pentelic sanity
confronts muted eloquence. The stillness of the candid dead torso dignifies life
without separating it from grief. Dead, the body of Christ connects with the
living who take into their minds the image of Christ as an ideal body, it is
suggested here, as a chest in part, smooth, sloping, elephantine in wisdom;
breathing, it seems, a warm silence. More generally we are offered images of
life and death, deft angels and the mortified head of the corpse. The habit of
bodies, whether sensitive or dead, is disclosed once more: we are told that in
the variety of meanings to which it points a body is as expressive as a face. The
partial nude always conveys the sense of disclosure: it is appropriate here to the
Christian meaning. At the same time the angels perform a slow gentle wrapping
of the corpse.

Many characteristics of flesh are suggested by this delineation, but only one
characteristic is omni-present to which other delineations are subordinate: shape
against a background. The spaces thus contrived are roughly triangles. The
angels' heads both echo and vary Christ's head, the cylinders of their arms the

337

corpse's arms. The element of geometry or of reduplication is an armature, the aesthetic armature, to which our feelings, as if they too could be solid things, as if they could be clay, cling; that is to say our feelings of contact, our meeting with a separated object or with ourselves now encouraged to separate from the splitting of ourselves. We feel in ourselves the tautness of the angels' feathered wings, the wrinkled clinging sleeve, the arm covering in the making for the corpse below those wings. We feel in us the corpse's beautiful listless hands. Christ's right arm droops but it is half-supported by a ledge on which the fingers bend, and by the angels' enwrapping grip. That demonstration of gravity serves less the effect of momentum than of poise, so nearly compounded of compensations as to be rest.

How often is this the effect upon us of the Old Masters, particularly of paintings with nudes. In my own mind I revisit early years abroad, the sense of discovery in many galleries, the predominant effect of the pictures in relation to the discomfiture of loneliness. Art meant oasis for the body as well as for the mind but also a ritual that affirmed unalterable contact, on the whole in a fully adult sense, rescued from the excess that had obscured or depleted an embrace.

Rembrandt's *Belshazzar's Feast* in the National Gallery is far from conveying this involucre of Pentelic marble; on the contrary, it shows human beings with the incorrigible character of scored, used pots. A darker conception of the body assumes a vivid clay. Hence Belshazzar's imposing pallor even though he suggests a richly feathered hen or turkey amid a treasury of filth, though the quilted magisterial stomach mounts to a plucked neck and head. Leaden with the threads of gold and silver, turban and diadem reiterate the blindness of heaped matter as does the great weighted see-saw of Belshazzar's outstretched arms. The woman recoiling on the right who spills from a cup herself suggests a rounded, stoppered vessel. The clattering gold, like all treasure, has its threat or is threatened. Amid the fur of light upon the wall incomprehensible letters speak out the traumatic counterpart sometimes associated with these bodily products.

I believe that strong feelings of such a kind, or feelings derived from them, possessed Rembrandt; they are one root of his power; and that otherwise he could not so magnificently have imposed the weighty articulation, for instance, of Belshazzar's right hand.

Many of us find Rembrandt to be the greatest of artists, I think because no artist approaches him in projecting the feel I have spoken of, the feel of presences not only substantiated from observation in the outside world but substantiated equally from the hazy presences in the mind. We are aware of a lineage for his every face far beyond the range of iconographic study. These presences are charged, weighty, condensed from the light and from the dark literally and metaphorically, with a finer drama than the apparition of writing

on a wall. They are compendia, bodies that manifest the history of their growth: each speck gives power to an opaque fellow. In a very remarkable book about Soutine, just published, Andrew Forge has written of Rembrandt in similar strain. He has this sentence: 'This is his (Rembrandt's) measure, that his architecture is as ambitious as his material is earthy.'

We are sometimes shown in contemporary art heads as helmets. The projecting plane for forehead and nose folds sharply back. How beautiful the helmet-shape in Raphael's[16] *Madonna of the Tower* (National Gallery) of the shoulder's overdress, the suave shoulder bone above it, the rounded neck, the geometrical expanse of face and head turned towards us! Were the helmet-shape armour, it would not allow smoothness to the firm skin, nor stillness above the straining child. The shoulder's rotund slope is developed across the picture by the child's undeveloped, trusting arm; we give a more than usual value to the continuation since we are even ready to connect the discontinued in view of the felicity to each other of helmet-shoulder and Virgin's head, an unarmed Athene. There is added poignancy too in the more rounded head of the child pressed and tilted away by the contact with his mother's cheek, and in her hand that comes round the child's middle and in the other hand that holds his foot. The curved line of the Virgin's cheek against the darkness where the child's temple flares – there is much triangularity as well as roundness in the composition – possesses an eloquence of eyelids. The faint encircling veil that depends from the summit of the Virgin's head reinforces the group's monumentality, not least this gravity of warmth and love.

The picture's ruined state makes one wonder the more at the beauty of the whole, at the regularity of the head, at the Michelangelesque *contrapposto* of the sitting body; at the cliff-like excesses and irregular caverns of the voluminous outer garment that consorts with the smooth flat hair, with the calm landscape and the simplicity of the Virgin's face.

In considering thus the composition's sentiment we touch other states of mind as bodily things, even an account of acceptance and rejection, since visual art works pre-eminently with contrast, with relief and background, with light and dark, with emphasis and its curb, with the play of opposing surfaces and degrees of volume. The ceaseless metaphors of language are physical and physiological. We stretch them painfully in pure speculation. Art corrects abstraction. Even the good and the bad mirror their physiological derivation: what is physiologically good gives rise to what is bad when we are deprived of it or when – and that is always – it is the object of our envious selves. The language of disdain, hatred, and rejection discovers the utmost denunciation in the terms of putrefaction. We speak of the currents of our feeling as dismembered, split, or perhaps they are not crippled.

Abstractions tend to become presences in dreams. Parents from the earliest

times and other people are presences within, and when the self projects part of itself it projects an object. There are images in our lives to which we hold tenaciously; we rediscover them in their variants. These are embodied operations that allow to art a universal language.

What great demands, then, we make of the artist, and how supremely great is the great artist! This painting satisfies as a reconstruction of mother and child. The sentiment is forthright but with it the artist has forged wider attachments that continue to fascinate our reflective selves. They helped the artist to typify his theme in accordance, of course, with the development and state of art at that moment, in accordance with the influence upon him from his art and from his culture, not to mention requirements of the patron. The culture served by Raphael obtained expression in his image of the subject matter that was determined also by much that he attributed to relationships in space. Or these last, it could be said, were the vehicle of a particular Christian sentiment. It makes no difference to my point which way round the matter is put. And my point is that we have not only the image of Virgin and Child presented in accordance with Italian iconography and pictorial style of the early sixteenth century but also 'the sixteenth-century iconography or pictorial style of relationship in man's inner world in the concrete terms of space applied to, and modified by – even inspired by – the subject of mother and child.

I can think of no other Old Master landscape painting beside Hobbema's *Brederode Castle* (National Gallery), unless it be the *Amsterdam Herring Tower*, also by Hobbema, also in the National Gallery, and equally jewel-like in colour, that gives as strongly an impression to be discovered in most landscape, namely the impression that though one is scanning the open, the distant, at the same time one is imaginatively attending to an interior scene, an aspect of the inner life. This castle landscape, stepped from blue to red, to the dark bank, to the pink ruin and to the incontinent clouds like the disordered roof of a cave, is yet so softly and closely organized that the castle may seem to have the function of a high altar at a cathedral's end or, more simply, to suggest the centre of a cupped flower. The central mass is echoed by the forms of the bank and trees in the left foreground though they are much darker, larger, flowing or ragged. The Amsterdam townscape is somewhat similarly composed in this respect. I suggest that as well as looking on the outside world we are looking at personable figures ensconced in the mind that exert intermittent influence on the pliable forefront of our attention.

In a changing landscape the pink buildings are these static personages, or rather the good personages who have survived every attack, whom we wish would never surrender their places; whom we want to be static even as ruins. They are shown here as receivers of the passing light and of the seasons. But there is sap in the trees, in bushes and grasses: the dark river, like the blood,

like circumstance, flows in a circular channel: the river birds are community members, while the buildings are bare of all except simple structure; apertures, buttress, walls with an accretion only of fern.

Viewed as an image of mind and body the painting shows the flesh, with the forces that animate and those to which it is subject, as divided, as mingled in new combinations. Yet owing to the compelling insinuation of tone and colour a totality emerges from these divisions and admixtures, having learned from them an intimacy or warmth that now serves the central structure and its surroundings; a totality that the eye reassembles and communicates at each look.

Of such kind, I believe, is the reckoning demanded of us by the just accountancy of great paintings in regard not only to masses but to the use of paint, to tone and colour relationships, to the representation of texture, movement, light. An image of building as generic structure, rich in itself yet palpitating with the cursive endowments also of the surrounding world with which it abides in relation, has been an inherent theme of our culture and of our art since classical times, to which even this seventeenth-century northern landscape must be referred. Building has figured in nearly all our landscape painting up to the middle of the last century when architecture for the first time ceased to epitomize the co-ordination of the body and thereby the integration of the ego, of the person or the mind. Yet while the old theme was notably exploited by Corot at times, he and those who accompanied and followed him have continued to provide through the texture of their paint, or through other insistence on the picture plane, many of those surface values that an environment of architecture once had lavished.

I end on a favourite note after developing the argument with the help of a minute fragment from the variety of art. Nothing, for instance, from outside Europe. I have offered images that are, at best, sometimes appropriate to the formal elements of the pictures described – in association of course with their subject matter. Once more, as a last word, I ask you not to identify these images, these derivatives, with what I have called the 'image in form', that is, where I have spoken of it as a generalized happening implicit in all the differing manifestations a few of which I have tried to interpret. The proof of this generalized happening that seeks to dispel chaos does not rely only on such speculative, subjective assertions. Now the chaotic is at best only just behind all of us, and we discover certainty largely by a massive projection of ourselves on to the external world which we then reabsorb. This generalized happening, it seems to me, has direct bearing on the correspondence between sensuous arrangements in the outside world and the conscious – I have spoken so far only of the less conscious – images we sometimes form of our mental processes. For we find in our reflective states that simple emotions or complicated wishes both to

have and not to have something, states of tension, capacities of the mind and so on, have themselves implanted as we contemplated them a residue of spatial imagery that we can watch; intersecting lines of conflict; stubborn, seemingly material, obstacles; rhythms and intervals that correspond with the order and tempo of events, the punctuation of time; spatial images, these, of sensation and a sum of experience which, when transposed into an art activity with material, provides the means of a concrete language whose expressiveness depends upon firm links with the continuous inner images substantiating and ordering complicated experiences of the body and of the mind; but hitherto substantiating in an unfixed manner. And so we see why painting, for instance, is primarily concerned with projecting the third dimension, why we value so highly the whole range of disposition from shapes that loom to those exactly disposed, the obstinate suggestion of volume or of depth magnificently achieved in all my examples, even the Soto.[17] In any visual construction we require not only provocative nouns, so to speak, of insistent shape but equally interconnexion, the action one upon another, analogous to the role of verbs upon which a statement depends. Since the glimmering nouns behind the concrete forms are strongly comprehensive yet ambiguous, the fixing verb-function of composition is likely to be many-sided. Moreover all the statements of whatever kind in a picture tend to be very closely interconnected since they are apprehended together, since their contents are simultaneously revealed. A great painter like Seurat is able to extract the utmost significance for his compositions from the slightest variation in a few dominant forms or directions.

An easy thing remains to be said; a *caveat*. Pictures are not problems. Nothing I have put forward, even supposing it to be correct, alters the fact that the Hobbema is a landscape painting wherein the artist communicates his pleasure, his record of a natural scene containing castle, ducks, trees, and people. This topographical value is the only value admitted by some who, for whatever reason, are entirely impervious to art. We should be in little better case than they if the considerations I have advanced, instead of supplementing or interpreting that immediate aspect of the matter, undermined it.

NOTES

Michelangelo

1 'A portrait aims by definition at two essential and, in a sense, contradictory qualities: individuality and uniqueness; and totality or wholeness.' (E. Panofsky, *Early Netherlandish Art*, 1953.) Whereas this judgment might belong to any epoch of art criticism, it cannot be said of other passages in Panofsky's book that are close to my theme. For instance: 'From the sheer sensuous beauty of a genuine Jan Van Eyck there emanates a strange fascination not unlike that which we experience when permitting ourselves to be hypnotized by precious stones or when looking into deep water.' Panofsky finds this hypnotic or suffusing effect to be immanent not only in the Eyckian technique but especially in his use of the miniaturist's naturalistic diversity of detail. We are drawn into the painting, we are hypnotized by a style of slow verisimilitude that embraces all. The Eyckian form of transcendence contrasts coldly with the broad, less intimate, naturalism of Italy where classical styles uncover transcendence in terms of a humanist, robust, if more patently ideal, synthesis; or thus it appears to me, even though, as Panofsky says, 'The High Renaissance and the Baroque synthesis were to develop a technique so broad that the details appear to be submerged, first in wide areas of light and shade and later in the texture of impasto brushwork.' For, as he goes on to say, Jan Van Eyck evolved a technique so minute that the number of details comprised by the total form suggests infinity; and thereby, it seems to me (though not to Panofsky), often bestowed upon these details an infinite yet intimate loneliness or incompleteness that is almost hateful to the humanist.

This very brief reference to a contrast within European art of the Renaissance will serve perhaps to indicate that the kind of subtlety which I consider most pertinent, already flourishes in the work of some acknowledged masters in the history of art.

2 If Michelangelo entertained such a fancy so in tune with myths then current explaining the incidence of great art, in tune, as we shall see, especially with his own art, it is likely to have become topical at the time he was suffering from stone, particularly in 1548 and 1549, from a painful difficulty in urination. Reporting the progress and relief of the illness in letters to his nephew, Lionardo, he speaks of the skin of the stone coming away and the throwing off of chips. It is apparent, on the other hand, that the diagnosis of stone is not considered certain: later, however, he expresses the general agreement that the illness was, in fact, the one of stone. The same suffering is reported to Lionardo in 1557. (M. pp. 225, 242–5, 335.) In a sonnet (F. p. 8) Michelangelo referred to the Pope as his Medusa (i.e. he turns him to stone). If this is worthy of remark, it is only so in the light of the next chapter upon the sculpture when I entertain the image of Michelangelo digging himself, or rather, the loved figures inside him, out of the stone, the aftermath of an overwhelming attack. As well as the agonies endured, the sculptures came to possess the strength of this assault as their own strength.

3 The same matter had been referred to five years before (M. p. 172).

4 On the occasion of Leo X's visit to Florence in 1515, Buonarroto, who received from Leo the title of Count Palatine (perhaps in order to honour Michelangelo) as well as an addition to the family arms, wrote a long account of the festivities to Michelangelo (F. *Briefe*, p. 24). Buonarroto excuses this prattle: 'I know it doesn't much matter to you whether you hear about it or not.'

5 On the other hand, probably some years later when he was over eighty, he complains of an apparent mistake of Michelangelo's in no uncertain terms. It means, he says, that he will have to come into Florence from Settignano and he had thought he would never have to do it again. Cf. part of an otherwise unpublished letter. Tolnay, Vol. I, p. 44.)

6 A. Gotti, *Vita di Michelangelo Buonarroti*. (I, p. 207, 1875.)

7 But see note 9.

8 I give the letter of reproof to Giovan Simone (M. p. 150), another brother, as translated by J. A.

Symonds on pages 225–7, Vol. I of his *The Life of Michelangelo Buonarroti*, London, 1899:

'Giovan Simone – It is said that when one does good to a good man, it makes him become better, but that a bad man becomes worse. It is now many years that I have been endeavouring with words and deeds of kindness to bring you to live honestly and in peace with your father and the rest of us. You grow certainly worse. I do not say you are a scoundrel; but you are of such sort that you have ceased to give satisfaction to me or anybody. I could read you a long lesson on your way of living; but that would be idle words like all the rest that I have wasted. To cut the matter short, I will tell you as a fact beyond all question that you have nothing in the world: what you spend and your houseroom, I give you, and have given you these many years, for the love of God, believing you to be my brother like the rest. Now I am sure you are not my brother, else you would not threaten my father. Nay, you are a beast: and as a beast I mean to treat you. Know that he who sees his father threatened or roughly handled is bound to risk his own life in this cause. Let that suffice. I repeat that you have nothing in the world; and if I hear the least thing about your ways of going on, I will come to Florence by the post, and show you how far wrong you are, and teach you to waste your substance, and set fire to houses and farms you have not earned. Indeed you are not what you think yourself to be. If I come, I will open your eyes to what will make you weep hot tears, and recognize on what false grounds you base your arrogance. I have something else to say to you, which I have said before. If you will endeavour to live rightly, and to honour and revere your father, I am willing to help you like the rest, and will put it shortly within your power to open a good shop. If you act otherwise, I shall come and settle your affairs in such a way that you will recognize what you are better than you ever did, and will know what you have to call your own, and will have it shown to you in every place where you may go. No more. What I lack in words, I will supply in deed.

Michelangelo in Rome.'

'I cannot refrain from adding a couple of lines. It is as follows. I have gone these twelve years past drudging about through Italy, borne every shame, suffered every hardship, worn my body out in every toil, put my life to a thousand hazards, and all with the sole purpose of helping the fortunes of my family. Now that I have begun to raise it up a little, you only, you alone, choose to destroy and bring to ruin in one hour what has cost me so many years and such labour to build up. By Christ's body this shall not be; for I am the man to put to rout ten thousand of your sort, whenever it be needed. Be wise in time, then, and do not try the patience of one who has other things to vex him.' (Cf. letter on the same events to Ludovico. M. p. 13.)

9 It is interesting to speculate on this 'turning out of the house', an accusation which the father prefers even against Michelangelo (cf. p. 27). Perhaps the phrase should not be taken literally. There is, however, evidence of a small incident (near in time to the accusation by the father) which may have been the grounds for Michelangelo's charge. In a letter of 1516 to Michelangelo in Carrara, Buonarroto refers to his second wife, Bartolomea, whom he had married some months before: 'She behaves well, her manners are so good that she might be our sister. She has made a great success of everything so far.' He goes on to say that he thinks he will find that he has joined himself with a good and prudent woman: others think so too: he has felt anxious in the matter, largely because it seemed to him that Michelangelo had not been pleased about the marriage. Buonarroto wants to have his mother-in-law to stay for a month or two if Michelangelo has no objection. He is confident she will give no trouble nor add noticeably to current expenses. Ten days later Buonarroto writes again, having had Michelangelo's reply. Buonarroto says he is surprised at Michelangelo doubting, in effect, whether there would still be room for him when he comes back. You, of course, have a better right in your house than anyone, comments Buonarroto . . . Had Michelangelo thought himself displaced by the introduction of the new women, it would not have been out of character. (F. *Briefe*, pp. 42–3, 45.)

10 We have seen that he would have liked his nephew to have voiced a similar exhortation. As late as 1550, Michelangelo is saying that men are more important than things (M. p. 270). The particular voice in the use of such conventional expressions may be considered to have their origin in the tones of the father. For instance, F. *Briefe*, p. 1. In this letter Ludovico refers to a pain that Michelangelo has in his side – probably an appendix pain – and says that he himself and his brother Francesco and his son Gismondo also suffer from it. There is a particular tone of concern held in common that seems unlikely to be a conventional expression only. Thus, in 1518, Buonarroto writes to Michelangelo in the quarries of Seravezza, anxiously bidding him to return: 'You must give the first thought to yourself rather than to a column . . . because everything goes on the same except life itself.' (F. *Briefe*, p. 118).

11 And, of course, his mother, and probably Ludovico's second wife, Lucrezia, who had died in July 1497. It is perhaps worth remarking in view of this date that in the letter to Ludovico of 1512 already quoted (M. p. 47), Michelangelo exclaims:

'It's now about fifteen years since I had one hour of peace, and all is done to help you.' In the letter quoted above of 1509 (Tolnay II, p. 227) to Giovan Simone (M. p. 150), he reckons his miseries from twelve years back, again from 1497. This was a year after he first went to seek his fortune in Rome (June 1496). Doubtless that was the event he had in mind, but Lucrezia's death could have been a hidden cause of increased anxiety to restore his family. One object of Michelangelo's charity in later years was the endowment of needy but noble girls in Florence. He asks Lionardo to send him the name of an appropriate family (M. p. 270). Injunctions to his brothers, Giovan Simone and Gismondo, attest Michelangelo's solicitude, after Ludovico's death, for the welfare of Mona Margarita, a dependant of his father's.

12 The artist's bisexual constitution is always notable, but that is not to say that it is necessarily abnormal. Obviously, as well as works of art, many manly productions share the creative character of parturition.

13 It is probable that Michelangelo's father died in the early months of 1531, not long after his last extant letter of January 1531, at the age of eighty-six. Cf. J. Wilde, his note on p. 249 of *Italian Drawings at Windsor Castle*, London, 1949. Condivi states that Ludovico reached the age of ninety-two: in his poem, Michelangelo himself attributes to his father ninety years. Since it is known that Ludovico was born on 11 June 1444, all commentators writing before the Windsor catalogue of 1949, have assumed on the evidence of the poem that Ludovico died in the late summer of 1534, not long before Michelangelo departed for Rome. Wilde's reasoning is based on an autograph memorandum, printed by Gotti (1875), which mentions the funeral expenses. Wilde noticed that later in the memorandum there are listed two sums paid out for Antonio Mini, the assistant who left Michelangelo's service to seek fortune in France in November 1531. He died there in 1533. It is therefore highly improbable that the memorandum is of even a later date, whereas the date, 1531, is most probable, before Mini's departure, especially since the first payments on the list undoubtedly belong to 1530.

This change of date for the father's death does not, however, affect the old surmise of a link between his death and Michelangelo's permanent removal to Rome in 1534. He was already in Rome from August 1532 until the early summer of 1533: he first met Cavalieri during this time. I suggest that one of the deeper services of this young man could have been to act as a substitute father. The anxiety springing from the fresh demands over the Julian tomb in 1531 and Michelangelo's overwork and new haste on the Medici chapel (Tolnay III, p. 12), perhaps mingled with an unfettered inclination to be more free of the Medici and of Florence and reinforced the old compulsion of the Julian image, once the father substitute in chief.

Michelangelo was in Rome again from October 1533 until May 1534: in September he left Florence, as it happened, for ever.

14 Savonarola, whose voice, Michelangelo remarked in old age he could recall distinctly (Condivi), was doubtless an inner figure that reinforced the severer aspects of the father image. The thunder of Savonarola's personality, it has often been said (not his doctrines necessarily, nor his fulmination against the nude in art), may have served to swell the masterful assonance of the Sistine vault.

15 I hope it will not be concluded without further hearing that these preliminary flights of 'criticism' evolve from pure guesswork concerning Michelangelo and his father. It is the art which has given me the temerity to pronounce, in a few generalized respects, on the life, as an introduction to the art. Michelangelo's depressive and persecutory anxiety is apparent in many affairs of which we know. The patent anxiety in dealings with his family provide at least a good context.

16 In 1518, Michelangelo wrote in despair from Pietrasanta to Buonarroto: *Io ò tolto a riuscitar morti a voler domesticar questi monti e a mettere l'arte in questo paese.* (M. p. 137: see also M. p. 394.) Condivi relates that Michelangelo conceived the idea of carving a figure from a mountain which would be visible to sailors at sea.

17 Sebastiano del Piombo, for whose art he had regard, wrote to him: 'No one can take from you your glory and honour. Think a little who you are, and remember there is no one who can do you harm but yourself.' In Sebastiano's coaxing letters there are many such references to Michelangelo's undue anxiety and to his melancholy. Cf. G. Milanesi, with trans. by A. le Pileur, *Les Correspondants de Michelange*, Paris 1890.

18 Cf. *The Art Bulletin*, September 1950 and 1951. Hartt asserts that after his election, Julius identified himself with St Peter in Chains. (He had been cardinal of San Pietro in Vincoli for thirty-two years. Cardinals were known by their churches as Shakespearian kings by their countries. . . . In view of the Julian tomb's bound slaves, it is curious that Hartt does not forge a link for them with S.P. in Vincoli.) St Peter's bonds were to be thrown off and amend was to be made for his denial of Christ: there would be a much-needed house-cleaning and, of course, the Papal dominions were to be won back. . . . This dynamic old autocrat was, according to Hartt, the close prototype of the Sistine God the Father. Indeed, in the autumn of 1510, Julius began to grow the beard which characterizes him in Raphael's *Stanza d'Eliodoro* frescoes. (According to

Tolnay's chronology for the ceiling (Vol. II, p. III), the *Creation of Adam* belongs to the section executed between January and August 1511, but the *Creation of Eve* to the period immediately before September 1510.)

E. Wind was the first scholar to question radically the famous letter to Fattucci of 1524 (M. p. 426) wherein Michelangelo tells how he was left to his own devices in the Sistine decorative programme. Michelangelo may have been tempted to exaggerate his independence in view of the demands upon him by the Julian heirs over the tomb and the money that had been paid for it. This letter is a statement of Michelangelo's case in the matter.

A less tendentious view would ponder Michelangelo's original disappointment over the tomb which the Pope had allowed to lapse, in so far as this incident alone would have been likely to leave an ambivalent attitude towards the potentate of the past, a tendency to discount his influence, especially a vague, intangible influence rather than one which had led to a cut-and-dried iconographic programme as envisaged by these commentators. But I will mention some of Hartt's iconographic trappings for the ceiling. The *ignudi*, it is a relief to discover after some other interpretations, may be regarded as acolytes or servitors. The Rovere acorn garlands are identified with grapes, with wine, with the Mass as well as with the Tree of Life. (This last nexus of symbolism is the point of departure for E. Wind's interpretation.) The bronze-coloured Medallions represent the consecrated Host which in the sixteenth century was of no mean size. . . .

It is not necessary to accept his interpretation in order to feel some gratitude to Hartt for reaffirming the influence of Julius on the vault.

This is the best place to refer to the same author's interpretation of the Medici chapel (cf. *Essays in Honor of George Swarzenski*. H. Regnery & Co., Chicago, 1951). Hartt is the only scholar to put forward an acceptable reason why the tomb for the *Magnifici* (never executed) was not put in hand instead of the tombs we have of the *Duchi* or *Capitani* who were, as great men of the Medici family, of far less importance. When wall tombs were decided upon, the *Magnifici* were allotted a monument with twin sarcophagi ornamented with patron saints but without the portraits that were finally developed for the *Duchi* monuments. In fact, the scheme for the *Magnifici* tomb did not develop far. It was to be the *sepoltura di testa* as it is called in the documents, the setting for the Medici *Madonna* and *Saints* which are today against that same entrance wall.

Hartt has this comment: After the expulsion of 1494, the Medici had revived their power in Rome, in the church. 'From the breast of Mother Church, the Medici family, exiled since 1494, had derived its sustenance.' (In the interests of his entirely different interpretation of the sculpture and architecture, Tolnay has pointed out that the eyes of the sculpted *Capitani* are turned in the direction of the lactating *Madonna*.) In 1513, Leo X, the first Medici Pope 'in brilliant ceremony had Roman patriciates conferred on Giuliano and Lorenzo (the *Duchi*, Captains of the Church) on the Capitoline hill amongst Roman trophies and Medici symbols, while Mass was said at the altar.' It can be argued that the most *representative* figures at that time among the Medici were not the *Magnifici* nor the Popes, Leo and Clement, who had commissioned the work at San Lorenzo (the tomb or tombs for all of them had figured in various plans), but the composite Captains of the Church. And perhaps Michelangelo argued similarly in order to devote himself to a more impersonal subject that lent itself better to heroic portraiture.

Much of the projected sculpture and painting for the chapel was either not completed or never begun. It is perhaps reasonable to suppose that some of this residue, if not all (over which Michelangelo no less than circumstances, gave cause for delay), even the River gods (to one of which he had originally given a priority) at the feet of the Captains' tombs, came to possess for him an aspect of superfluity. Leaving Florence for ever in 1534 – Clement died two days after his arrival in Rome – Michelangelo himself did not see the *Times of Day* in place upon the sarcophagi.

Tolnay who, following up the work of Popp in particular, threaded together clearly the complicated evolution of the plans (op. cit. Vol. III), has this to say concerning Michelangelo's method of work. 'Starting with a traditional scheme, he was compelled by an inner urge to unfold completely all the inherent possibilities. Only after arriving at the limit of the traditional solution did he impart a new spiritual content, transforming all the existing elements. This was the development of the Sistine ceiling . . . and of the *Last Judgment*, which he first conceived as a representation of the act of judgment only to transform it into a revelation of cosmic fate. He always conceived his ideas on the basis of Renaissance conception, but, not content with this solution, was in each case again and again compelled to re-create his works according to his new idea' (p. 40).

19 Cf. F. *Briefe*, p. 77. Buonarroto says he is glad Michelangelo is taking on the San Lorenzo commission because it appears that the Medici are well on top of the world again. But Michelangelo must see he gets good pay for all his work: Buonarroto reminds him how easy it is to be side-tracked by these exalted persons.

20 *Les Correspondants*, p. 21.

21 G. Gaye. *Carteggio inedito d'artisti dei secoli XIV, XV, XVI*. Florence 1839–40. Vol. II, p. 489.

22 The excellence of Michelangelo's manners is attested by Donna Argentina in writing to her husband Malaspina, Marquis of Fosdinovo, in 1516 (F. *Briefe*, p. 28). *E persona tanto da ben costumato et gentile et tale, che non crediamo che sia hoggi in Europa homo simile a lui.*

23 Bramante, the rebuilding of St Peter's, had originally caused the blasting of his hopes for the Julian tomb. There was justice and recompense for him in being charged now with the making of the new church. Instead of Bramante's insistence upon a clear-cut, self-sufficing entity, Michelangelo, though he valued Bramante's style (M. p. 535), invented a more turgid image.

24 He once answered the hyperboles of an insignificant but ambitious admirer (Niccolo Martelli) with these words among others: 'I am a poor man of little worth and I want to wear myself out in the art which God has given me, in order to prolong my life as much as I can' (M. p. 473).

25 Wölfflin. *Classic Art*, trans. 1952. 'If any one man', wrote Wölfflin, 'may be held responsible for major changes in the history of culture, that man was Michelangelo, who brought about the generalized heroic style and caused place and time to be disregarded.' . . . 'The sixteenth century did not idealize in the sense of avoiding contact with actuality and seeking monumentality at the expense of clear characterization: its flowers grew from the old soil, but they wax bigger. Art was still a clarification of everyday life, but it was felt that the greater demand for dignity of presentation could only be satisfied by a selective choice of types, dress and architecture which were hardly to be found in actuality.'

26 Cf. Michelangelo's Dantesque Madrigal (F. p. 205). The sense is as follows: Just as your image has long been engraved on my heart, now that I am soon to die, engrave your features on my soul. . . . Like the Cross against demons, it will make my soul secure. . . . On attaining heaven, this image should be returned to the celestial powers so that they may use it again on earth. (Survival of the good object after death.)

The Madrigal (F. p. 200), starts: 'The more I fly from the altogether hateful me, the more I turn to you' (the part of me I love). Similarly, with the loss of the good object, the poet has no light, no salvation (F. p. 108). In another poem of loss, Michelangelo describes himself as a piece of coal away from the kindled wood. Without the bright wood near it, the black coal consumes itself in darkness until it becomes cinders.

Such pertinent images of a good object *within* the self are common to all love poetry. The state of being in love is the flash that strongly illuminates this continuous necessity of our 'spiritual' being.

Much of Michelangelo's poetic grammar is extremely difficult to fathom. I have found invaluable C. Guasti's literal prose renderings in his pioneer's edition of the poems (Florence, 1863).

27 For one variant out of a multitude in the combination between the two kinds of feeling, cf. this sentence of Susan Langer's (*Feeling and Form*, Routledge & Kegan Paul, London, 1953, p. 268), 'Lyric writing is a specialized technique that constructs an impression or an idea as something experienced, in a sort of eternal present; in this way, instead of offering abstract propositions into which time and causation simply do not enter, the lyric poet creates a sense of concrete reality from which the time element has been cancelled out, leaving a Platonic sense of eternity.' In other words, there is a combination of precise things or happenings with a timeless all-inclusiveness. One parallel is with Egyptian funerary art, more or less static for 2000 years from the time of Narmer, an art, like Michelangelo's, specifically of the body to which were attributed both the present and the timeless, all-incorporating, aspects of things. Private tomb paintings suggest without mystification that ordinary, everyday activities have kinship even with the state of death; that there is no tension whatsoever between the expression of the timeless and ephemeral. Thus, a keen sense of individual life could be rendered in combination with an appearance of inorganic rigidity; individualized heads were joined to articulated yet nerveless bodies. The bare mythology of art as I conceive it, appears to have provided Egyptian culture with a predominant conception of the universe.

28 The representation of space, of course, has not as a rule depended upon perspective science that enlarges both the distinctness of the relationship between objects and the homogeneity of this medium. The styles of many cultures, however, have eschewed or contradicted this space in a desire to isolate the object, even more to bestow on the object an overriding transcendent significance.

29 The following is a very brief psycho-analytic summary of the theory of Form I have adumbrated: Emotion of every kind is presented by art in terms of objects of the senses (without the major use of projective identification or 'concrete thinking'), under the aegis, therefore, of object-relationships (inner and outer) whose combination underlie the Form, the mode of aesthetic expression. The range of relationship with objects extends from the part-object relationship with the breast to full or genital object-relationship. We can distinguish a compound of these two extremes at any rate, in the object-relation emotions that underlie the character of Form. In view of the reparative function (here assumed) of art and in view of its admittedly regressive

nature, the latter object-relationship is typified by the relationship to the whole mother of the depressive position.

The artist is, of course, reconstructing also by his art his own body, his own ego, an identity which is bound up ontogenetically with the conceptions of outside objects. But *see* my formulation printed in the volume already referred to, *New Directions in Psycho-Analysis*, where will be found Dr Segal's important paper on art and depressive states.

30 The mountains of Carrara where Michelangelo spent so many months excavating marble and the roads to transport it, provide the only landscape we associate with him. Those white slopes are likely to have influenced him profoundly. They were the early scene of his command of many workers and of the stone midwifery, of the sometimes dangerous raising of roughed-out columns (M. pp. 394, 403), a barren scene, almost lunar, which he sought to master with his own austere fertility (cf. note 16), where, likely enough, omnipotent notions seared in the quarry were translated into an identification with the untouched peaks.

31 Cf. Anthony Blunt. *Artistic Theory in Italy*, 1450–1600, Oxford, 1940, p. 74.

32 This power of visual memory was the fruit of an extreme susceptibility and openness to impressions. Vasari found an interesting way to emphasize it. Michelangelo could make use, says Vasari, of the work of others even though he saw it only once, and in such manner that scarcely anyone has ever noticed it; 'Nor did he ever do anything that resembled another thing by his hand, because he remembered everything that he had done.' Vasari then tells an anecdote of the young Michelangelo 'playing for supper' with other artists who competed in outlining a clumsy, puppet-like figure similar to those scrawled on walls, a thing difficult to do, says Vasari, for a man steeped in design. Michelangelo exactly remembered one of those absurdities.

This light episode or allegorical story will today start a train of thought concerning the extent of the appeal of a primitive form to the greatest of artists (steeped in civilized design). Similarly, it is not so much the absurdity that interests us in Vasari's story of the Roman prince who, fancying himself as an architect, caused huge square niches to be built into his walls, with rings at the top. On being asked by the prince what ornaments should be placed there, Michelangelo answered: 'Hang bunches of eels from those rings.'

33 Cf. my *Stones of Rimini*, 1934. (Vol. I, this edition).

34 I have long thought that the appreciation of this element of *disclosure*, particularly in many Quattrocento low reliefs to be indispensable for the understanding of Renaissance art. Here is an example of an unformulated motif of which the right-minded art-historian, hunting for a precise and once overt derivation of each plastic and iconographic theme, can take little cognizance.

No other art rivals the Renaissance, particularly the early Renaissance, in this quality of disclosure, an effect dependent on our sense of contrasting yet supporting textures. But the direct use of this effect is common elsewhere also. Exiguous drapery, for instance, put to such fine use in the Renaissance, is a usual means in much figure art (particularly in the Antique from which the Renaissance made so many adaptations) for suggesting not only movement, but more comprehensively the smooth-and-rough textures that vividly enhance the burnished palpability of the body.

In view of the well-known erotic appeal (in life) of the semi-nude, it appears possible that the excitement aroused by partial concealment, an excitement which suggests the hungry infant's massive impatience for the uncovering of the breast, may, in some cultures, sharpen the aesthetic awareness of texture that is rooted – so I think – in the infant's oral needs.

35 It is likely that Michelangelo expressed himself forcibly on this matter. He is made to do so in the dialogues on painting of Francis of Holland, a miniaturist who came from Portugal to study design in Italy. (Extracts from the MS. were translated into French and published in Paris in 1846 as part of a volume entitled *Les Arts en Portugal* by Count A. Raczynski.) Francis, who wrote his dialogues some ten years after, was present during 1538–9 at a time when Michelangelo and Vittoria Colonna used to meet with their friends in San Silvestro. The first dialogue introduces a conspiracy on the part of the company for the benefit of Francis who naturally wants to hear Michelangelo (not yet entered) on the subject of painting.

Vittoria Colonna leads the discussion into deeper waters with a remark which would seem likely to have been well in character. 'As we are on the subject, I would very much like to know what is your opinion of Flemish painting which seems to me to possess more piety than does the Italian manner.' Michelangelo is made to answer slowly as follows: 'Flemish painting pleases the pious better than any Italian style. . . . This is not due to vigour or merit in the painting but is entirely the fruit of pious sensibility. This art pleases women, especially those who are old or very young, similarly nuns, the religious and a few nobles who are deaf to real harmony. The chief aim of Flemish painting is *tromper la vue extérieure*, to represent either objects that charm or those of whom one can think no evil, such as saints and prophets: otherwise, stuffs, ruins or very green fields shaded by trees, rivers and bridges, in fact

what they call landscape with plenty of figures dotted here and there. Although this appeals to some, it contains in truth neither reason nor art, no symmetry, no proportion, no taste, no grandeur. It is an art without body and vigour. Not that they don't paint even worse elsewhere. If I speak disdainfully of Flemish painting, it is not because it is entirely bad but because it aims at treating so many things with perfection when one important thing would have sufficed. The result is that none of these things is presented in a satisfying manner. . . . Good painting is noble *in itself*. . . . It is nothing else but a copy of God's perfection, a shadow of his brush, a music, a melody.'

In the second and third dialogues, Michelangelo uses the words 'design' and 'painting' as interchangeable. Painting in this sense, he says, is at the back of every kind of manual skill, 'in every movement and action'. All they left behind shows us that design was the basis of Roman civilization, as useful in war as in peace. The trained artist can turn his hand to any craft or science, and quickly outstrip the accustomed practitioners. . . .

(I do not know whether readers will have momentarily felt as I have done in translating these sentiments attributed to Michelangelo. Here is the programme, the manifesto, of Italian Renaissance art: so vivid a programme may cause some difficulty in believing that it was in fact achieved, that sculptures, paintings, defence works, drawings, buildings, poems of Michelangelo exist; since we have been battered in the last thirty years by aesthetic manifestos.)

Disegno, then, is the basis of engineering: the force of *disegno* gives proof of *rapport* on the part of the artist with the structure of organisms designed by God. . . . It is implied in the dialogues, particularly in the criticism of Flemish art, that the human body must be the prime vehicle for the learning and for the exercise of *disegno*. The study of the human body equips the artist for engineering by means of an architecture founded upon human form.

The relationship of painting with sculpture is discussed in the dialogues. Michelangelo's authentic views (tempered with ironic fulsomeness?) on this matter are stated in a letter to Varchi (M. p. 522). 'I affirm that painting is the better the more it tends towards relief, and relief is the worse the more it tends towards painting. However, it has been my custom to think sculpture was a lantern to painting, and that between them there was the difference of the light from the sun and the light from the moon. But now that I have read your essay where you say in philosophical language that things which have the same end, are the same thing, I have changed my opinion. And I say now that what requires more discretion, what is more difficult, what contains more obstacles, does not necessarily result in greater value. If that is so, then no painter should

despise sculpture nor the sculptor painting. I mean by sculpting, the art of taking away material, while the art of adding to or putting on, belongs to painting.'

36 An identification with the body is, of course, employed in architecture to procure effects of transcendence. The measure of mass, of organization, of gleaming stability, is ourselves. In terms of wall and aperture, of projection and recession, architecture records the sensitiveness of our breathing organism whose life, physical and mental, is a taking in and a putting out (cf. my *Smooth and Rough*, 1951). But this transcendent replica of our condition, would not be greatly significant were it not that in the very same terms of the body we were offered by architectural effect the pleasurable versions of those fundamental attitudes to the outside world which I have already described in connexion with the dichotomy of space, combining a transcendent, all-inclusive element with the element of notable particularity.

It may be thought paradoxical that I refer to Michelangelo's own architecture in no more than a few sentences. In spite of much invention, in spite of the magnificent beauty of his Capitol design (cf. Stefano du Perac's engraving of 1569, reproduced in A. Schiavo, *Michelangelo Architetto*, 1949), in spite of the interrelation of smooth and rough surfaces, particularly in the Laurentian library, vestibule and staircase, his architecture remains indeterminate for me, in the sense that it contains but the residues of his style. Stripped by architecture to abstraction, a history, an evolution of feeling, apparent in the sculpture and painting, disappears: we are left, abruptly as it were, with an euphoria and a grandeur not always happily combined with their agitation, in a manner that was to become far more convincing in the Baroque age that Michelangelo initiated. Nevertheless this Baroque element (as opposed to the Mannerist affiliations of the Laurentian library) must be connected also with Michelangelo's sculptural *non-finito* (see note 39). His architecture shows that *non-finito* is the medium not only of synthesis but of a scattering or disruptive force that will lend itself to effects that mirror those of flood-water or of lightning. The flood force met opposite currents that also derive from Michelangelo, the power of classical pomp: hence the Baroque joinery of broken massiveness, the rushing together, the tearing apart, basic movements that provided a theme of extraordinary contrapuntal development in all the arts.

37 Cf. my *Smooth and Rough*, 1951. (Vol. II, this edition.)

38 This was in harmony with the Aristotelian conception of potentiality in the object (cf. Varchi's commentary, 1546, on the sonnet), and also with Neoplatonist tenets (Plotinus). A less modest view

of art is to be found in a madrigal and a sonnet (F. pp. 152 and 194). Michelangelo refers to the physical durability, at least, of his work which will survive long after sitter and artist (the works of Nature) have passed away. *Onde dall'arte è vinta la natura:* 'Thus Nature is overcome by Art.' Elsewhere he speaks of the uncut stone and the blank paper as vehicles to be used as one wishes (e.g. F. p. 111). Indeed, from the point of view of Michelangelo's latter-day aesthetic ideas, the attribution in the sonnet, F. p. 89, of Form to the stone, may be partly a poetic projection on to the stone of his belief in beauty as a divine image implanted in the mind: whereas the Quattrocento thinkers had felt that beauty was the underlying coherence belonging to the nature of things. But we have seen (and we shall see again) that for the most part Michelangelo was not without the earlier trust in the virtues of the object *per se*. His achievement is based upon the Quattrocento achievement.

Whereas this sonnet (F. p. 89) in honour of Vittoria Colonna is intended to express aspiration towards the neo-Platonic idea of goodness, it is also a statement, at what commentators call the superficial level, of the deep difficulties in accommodating the power for good of the beloved with her power for dispensing misery and death.

Other poems too indicate how close are the activities of love and art for Michelangelo. This connexion is apt: for, every lover feels at one with more than his sweetheart; both are elemental in his eyes of universal stuff. No less vehemently he experiences the uniqueness of the beloved, the acme of otherness, the essence of not-self: hence the possibility of barter, of imaginative interchange; hence, more generally, the Wordsworthian object for contemplation, primrose or peasant, a point of singularity, an unique situation, that prompted the poet's sentiments of pantheism: hence, as I have tried to indicate, the qualities in art, both static and dynamic, that underpin each formal and stylistic conception, echoing adult love, precipitating, as does adult love, far older relationships with the outer world.

J. Jacobs (*The Listener*, 1 April 1954) records that Robert Frost has said of his poem *Stopping by Woods on a Snowy Evening*, a description of a particular scene (the gradual uniform canopy of snow) which the poet has rounded off by a single-rhyme verse impounding the previous happenings and a new activity within the all-absorbing layers of sleep: 'That poem contains all I know.'

Whose woods these are I think I know,
His house is in the village though;
He will not see me stopping here
To watch his woods fill up with snow

My little horse must think it queer
To stop without a farmhouse near

Between the woods and frozen lake
The darkest evening of the year.

He gives his harness bells a shake
To ask if there is some mistake.
The only other sound's the sweep
Of easy wind and downy flake.

The woods are lovely, dark and deep,
But I have promises to keep
And miles to go before I sleep
And miles to go before I sleep.

<div align="right">From Collected Poems of Robert Frost,
Cape, London, 1943.</div>

39 There are, of course, differing qualities in Michelangelo's use of lack of finish (*non-finito*). St Matthew and the *Slaves* or *Giants* of the Accademia were discontinued at a time when they had (and have) the effects of entities no less broken than are their stones, yet of entities that are at the same time unbreakable (plate 19); whereas the *Apollo* of the Bargello is a delicate instrument on which the air plays: *non-finito* contributes to this music a figured base (plate 20). Would anyone wish that Michelangelo had gone on with the *Apollo*'s hands, the one jointed to his side as if it were a tool that polishes, the other to the strong neck? Even more than articulation of the feet, fingers would have broken the singleness of pose. The slow ecstatic look of the face would not have survived a burnished angularity; we do not require to see all the torsion of the back, as would be visible were the straight slab of the matrix cut away on the spine.

40 Our iconographic lack today (see Appendix 1), or impoverishment, contributes heavily, I think, to the loss of the beautifying element in art, owing to the absence of poetic systems in symbolic expression. Beauty in the narrow sense, of course, is by no means essential to the work of art; without much iconographic interposition, symbols are the more personal, more direct, more lively. But we should realize that this directness is neither a better nor a worse method *ipso facto* for attaining the sense of merging and the sense of particularity which underlie the creation of Form: and whereas the range of expression may seem the wider in modern art for being more 'free', the absence of a strong convention of the beautiful may tend to narrow rather than to enlarge the possibilities of Form, since the lesser kind of beauty has served as a step more often than as a hindrance, to the larger kind of beauty.

Works of art epitomize self-containment, offering to the senses well-organized objects that are singular vessels of emotion: yet only in some humanist art – a minute segment of the world's production – do we encounter so strong an emphasis upon

corporeality as to elicit from the undifferentiated component that also inspires Form, a tempered idealism, a health attributed to man which has at times accompanied without falsity the use of an unique naturalism. Art is, of course, on surer ground in cultures that do not seek to exalt man's rationality or command (albeit within a religious setting), that serve a totalitarian conception of Fate, good, devil, the future life, Pharaoh, rite, or it may be death, the spirits of the departed. For here is the home ground of art whose paramount rôle, on the formal side, is to furnish a feeding from universal principles: the spectator absorbs them through the physical object: even change, ceaseless metamorphosis, becomes static, absorbable when thus identified. Of all art we become the sucklings, viewers of an architecture whose alleys have been crowded with experience: in this ideal light we can see the chaotic as chaotic and as peace.

It is safer, then, with a better insurance against banality and prostitution, to carve in the Polynesian manner, best of all to be subject to a constraining fiat. There is not the slightest doubt that anti-humanist art which possesses so fine a grip upon the dynamic, non-differentiated element at the back of Form, is likely to ensure a longer run of acceptable artefacts, innocent of the humanist euphoria, in closer touch with the less differentiated, that is to say, unconscious, motivations; possessing even a better grasp of reality, in the sense that the child is nearer to inner reality than the adult. Stylization, simplification, distortion are needed for the processes of art. But beyond a certain point they are apt to be employed at the expense of conveying a notable otherness (something over against ourselves) in the figures or scenes represented, though the artefact is itself a model of self-sufficiency. Humanist art re-embodies the otherness of objects, rejoices in articulation of actuality at the expense, very often, of depth of feeling, at any rate after religion and iconographic systems have lapsed. Yet, shocked as we must be with the banalities of our academic art, however loudly we protest freedom, we recognize (though it may not be admitted) that some kind of realism is still the point of departure in the West, and that this norm will remain, not in virtue of longevity nor of naturalism, but because the great humanist periods discovered the only profound employment for *both* the qualities that underlie formal creation. In the work of Michelangelo, a man's predicament, conflict, are not only explored but embodied by means of the 'rational' nude in rivalry, as it were, with the precise actuality, separateness, solidity, of another human being or of ourselves. (The whole *oeuvre* of Surrealist art reveals nothing in comparison.) Viewed from the angle of art and culture as a whole, the daring sanity of the Western Masters can be compared only with our corresponding science.

One of the original aims of André Malraux' book (*The Psychology of Art*, trans. London, 1949) was the justification of contemporary anti-humanist art. (There are, naturally, all degrees between what is humanist and what is anti-humanist.) But Malraux was a humanist. 'Every period of retrogression is linked up with a return to the domination of bloodshed, sex and death, to a world of the diabolic and numinous. . . .' 'Styles pertaining to happiness are among the least striking; but the more art is concerned with all that transcends man – with the diabolic or sacred – the less man enters into its portrayals. Thus Polynesians mask with the symmetrical lines of an elaborate tattoo, the ineluctable disintegration of the faces of the dead.'

Not all contemporary art is occupied with transcendence (often equated with disintegration). Better schools affirm almost exclusively the otherness of the object. We lack – we must lack – the equality of each term that promises fullness in their blending.

41 B. Berenson, *The Drawings of the Florentine Painters*, 2nd ed. Chicago, 1938. All students of Michelangelo should record their huge debt to Berenson's most evocative scholarship. In the first edition of his book towards the turn of the century, he brought order to Michelangelo studies by classifying many hundreds of drawings scattered throughout Europe, all of them all that time attributed equally to the master. Before the days of easy reproduction (and easy access), such a work entailed an inspired feat of memory, more especially in the case of drawings wherein the smaller characteristics are often the most revealing aspects for comparison.

42 J. G. Phillips (*Michelangelo: A New Approach to his Genius*, Metropolitan Museum of Art Bulletin, 1942) has pointed out the uses of casts in revealing sections of the sculptures that are hidden in their settings. Thus, it is gratifying to find that the Bruges *Madonna* sits on a pile of rough stones that contrast brilliantly with the texture of her back.

43 But there remains classical ballet, sole inheritor in our time of Renaissance art.

44 The group was mutilated by Michelangelo himself, restored and continued by his pupil, Tiberio Calcagni. The Magdalen must be almost entirely his work.

45 A suggestion of overpowering Bacchanalian frenzy, derived from Antique art, has often richly contributed, particularly since Renaissance times, to the manic component in Form.

Nicodemus' head, perhaps the most moving detail in all Michelangelo's sculpture, completes a *figura serpentinata* (spiral shape of a moving serpent: note especially the frontal peak of the hood in

defiance of the head's inclination), surely his drama-tization, conventionalized by the Mannerists, of a yearning for phallic omnipotence. This group is by far the most weighty example.

The phrase '*figura piramidale serpentinata*' is used by Lomazzo in his *Trattato de la Pittura* (1584) where the author describes alleged advice given by Michelangelo to one, Marco da Siena. 'The maxi-mum grace and lightness of a figure lies in move-ment of the sort that painters call "abandon" (*furia*). This movement is typified by a flame, the element which, according to Aristotle and all the philosophers, is the most active: the shape of a flame is better adapted to movement than any other; for, it has a cone and a point with which it seems to want to pierce the air, to ascend to its sphere (the heavens). So when a figure has this form, it will be most beautiful.'

46 The sculpture is not only unfinished; an un-attached arm draws attention to an earlier version on which the later version is superimposed. Michel-angelo altered the group to the effect I have under-lined in the last year, perhaps in the last weeks, of his life.

Condivi says that Michelangelo's father dies rather from failure of will than from disease, so strong was he; and that Michelangelo used to tell how Ludovico kept his colour after death so that he seemed merely to sleep.

47 This pen drawing of the Ford collection, London, showing a careful study for the middle of the body and the faintly sketched arm and head, prefigured the division of labour in the execution of the second marble figure. For it would seem that Michelangelo made over the execution of many less central parts in the first place to his assistant, Pietro Urbano (Tolnay II, p. 89).

Vasari states that Michelangelo drew a half-length life-size portrait of Cavalieri, his young Roman friend, but that otherwise he abhorred portraiture. This may well not be exactly true: for instance, there are possible references to a portrait bust or painting of Vittoria Colonna in one or two poems (F. pp. 152 and 194), but it does seem likely that Michelangelo did not care to confine his work to a study of individuality. The heads of the *Duchi* and of *Brutus* (Bargello) are by no means portraits. In contrast with Imperial Roman statuary, Michel-angelo tended to particularize the body, while the head, though there be no other to class with it, has the suggestion of a type.

When his friend Luigi del Riccio besought him to design a tomb for his nephew Cecchino de' Bracci, whom they both loved, Michelangelo was in no hurry, although he had once made a drawing of Cecchino (Steinmann, *Michelangelo e Luigi del Riccio*, Florence, 1932, p. 39). He was glad to exer-cise himself writing forty-eight epitaphs for the boy and a sonnet to Luigi (F. p. 67) in which he suggests that since art cannot furnish Cecchino's portrait when he is dead, it would be better to sculpt him (Luigi), as the beloved lives on in the lover. But finally a sepulchre was erected in S. M. Aracoeli (where it is today) with an extremely dim bust of Cecchino (of no appeal whatsoever) exe-cuted by Michelangelo's faithful henchman, Urbino.

Duke Cosimo was wanting to sit for his head in 1544, Michelangelo wrote to his nephew (M. p. 173) saying that he had excused himself and that he had too much to do: moreover, there was his age and he couldn't see light.

48 The bound prisoners were to stand in front of herms or terminal figures. It is noticeable that in the monument finally executed for San Pietro in Vincoli (St Peter of the Chains), the arms of these herms themselves are crossed and closely im-prisoned by their own bandages of drapery.

49 Cf. R. Money-Kyrle. *Superstition and Society*, London, 1939.

50 Cf. the first line of the madrigal, addressed to Vittoria Colonna, F. p. 229: *Un uomo in una donna, anzi uno a dio*. 'A man in a woman, a god in truth, speaks through her mouth.'

Too much could easily be made of the fact that Michelangelo was in the habit of using drawings of male models for female figures, sometimes so evident, even in the final version. It is generally agreed that a youth must have sat for the Madonna of the *Doni Holy Family* (Uffizi). The torso and left thigh drawing (Wilde 48 *verso*), thought to be a study for the *Leda* painting, betrays no feminine characteristic, nor do the drawings for the *Libyan Sibyl* in Oxford and New York, Tolnay has re-marked (III, 108). Masculinity is even more sur-prising in the rapid sketch in the British Museum (Wilde 56) for the *Venus and Cupid* cartoon (Naples) from which Pontormo executed a painting (Uffizi).

Wilde (p. 84) points out in reference to the male models of preliminary sketches that a sculptor 'is particularly concerned with the effect of the muscles on the surface modelling'. This would seem especially true in the case of the kind of physique in which Michelangelo delighted.

51 E. Tietze-Conrat in *The Art Bulletin* (Septem-ber, 1954) suggests that the initial programme for the sculpture including, of course, the *Times of Day*, was based upon the theme of general, corporeal resurrection, a theme chosen by Cardinal Giulio de' Medici, later Pope Clement VII.

52 In spite of its name, poetry seems to be the art most apt for the expression of things done to the individual.

53 Cf. J. G. Phillips, op. cit.

54 Benedetto Croce (*Poesie Popolare e Poesia D'Arte*, Vol. 28 of *Scritti di Storia Letteraria e Politica*, p. 393) says that the four sonnets of two major opposite senses on the subject of Night are a literary palinode, an exercise in the conventional antitheses or set answers of the time. . . . This may be so but it is not merely so. The contrasting identifications with the night reflect a continuous mood of the poet. At a deeper level the contrast barely exists. Much else goes to suggest that night, melancholy, even the thought of death, have for Michelangelo their link with creativeness as well as with eventual calm.

Croce's general opinion is that Michelangelo was not much of a poet, but that the great Michelangelo does exist in his verse.

55 Cf. the epitaph, F. p. 74, for the young Cecchino de' Bracci whose beautiful form is said to animate the artifice of the sepulchre as the soul the body. The last of the four lines is: *C'un bel coltello insegnia tal vagina*. Cf. also F. p. 25, from the burlesque stanzas the lines:

C'una vagina ch'è dricta a vedella
Non può dentro tener torte coltella.

56 Some commentators have classed this fragment, also F. p. 108, with the mourning poems for Vittoria Colonna's death. Other critics however, following Symonds' printing of the Febo di Poggio letter to Michelangelo, in relation with the artist's letter to Febo (M. p. 471), have insisted on the play on the words Febo (Phoebus) and Poggio (summit) in these two poems. For a comment concerning this young man, and for translations of the two letters, see Symonds op. cit. Vol. II, pp. 154-9.

Symonds points out the extraordinary humility that Michelangelo displayed in writing to the young men, Febo di Poggio and Cavalieri. The artist felt that their appeal entirely outshone his own gifts, so that he was worthless, ugly and bad. It follows that some critics have found Michelangelo's features to be represented in the executed head of Holofernes of his Sistine fresco and in the flayed skin that St Bartholomew of the *Last Judgment* holds up, as well as identifying Michelangelo with the position of the vanquished old man on whom the Victor kneels (Palazzo Vecchio).

It was in accordance with Michelangelo's wish, Vasari states, that Leoni's medal of him has on the reverse a figure of a blind man led by a dog. We shall see that to attribute blindness to himself would have been the acme of self-depreciation. (Cf. pp. 125-7.)

57 In his commentary Frey considered that at least the first five stanzas as he printed them are consecutive, except that he was uncertain whether his number one or number thirteen should come first. (Op. cit. pp. 321-3.)

58 It is perhaps interesting to remark the following though not necessarily relevant detail. Michelangelo concerned himself greatly about the choice of a wife for Lionardo. At the age of seventy-seven he was exercised as to whether or not a particular candidate was shortsighted (*no mi pare picol difetto*, M. pp. 277-81).

59 Cf. E. Steinmann. *Michelangelo e Luigi del Riccio*. Florence 1932.

60 It is not necessary to believe the description in his sardonic burlesque poem (F. p. 86) of the mountains of ordure accumulated by the public at the entrance to his house, in order to appreciate that Michelangelo's domestic surroundings were not only gloomy but verging upon genuine squalor. Coupled with lack of convenience, with austerity and a melancholic sparseness of furnishing, squalor perhaps provides the chief reason for his difficulty in retaining reliable servants. His *Ricordi* show that once at least he engaged a girl with a child in the modern manner (M. p. 605).

61 Cf. *De' giorni che Dante consumò etc., Dialogi di Messer Giannotti*, ed. D. R. de Campos. Florence, 1939.

62 Cf. especially the activities of the figure of Ludovico – within, Part I.

63 He had been more sociable as a younger man: he had sometimes discovered that the feared distraction of social gatherings had separated him from his melancholy (M. p. 446).

64 H. Wölfflin, *Classic Art*, translated from the 8th German edition by P. & L. Murray, London, 1952.

I have stressed the fact that early Cinquecento art is the child of Quattrocento art without which Michelangelo's achievement would be unthinkable; and that both are dependants of a growing culture. Wölfflin is the famous guide to this change of style. His analyses in front of early Florentine Cinquecento works will not be surpassed; so, it is excusable that in his constant comparisons he should have belittled, and, indeed, should have disregarded the syntheses effected in the great Quattrocento works. A progression undoubtedly exists from one style to the other in terms of scale, simplification, a larger-handed complexity and, above all, a more avowed homogeneity at the expense of gravity in details, at the expense of a less hurried union whereby exacting homage can be paid to the singularity belonging to each represented object. There is a negative or, at least, an excluding aspect of the Cinquecento aesthetic discoveries, inseparable from the so-called advance. But certainly, Michelangelo's and Raphael's works are the logical peaks in Renaissance art; they rise from a neat earth of cultivated fields and terraces. Such change of style, dependent directly upon

cultural development as well as upon the processes of aesthetic growth, always signifies a changed mode of balance between the two emotional rallying points I have attempted to isolate at the back of Form. Wölfflin has greatly simplified his analysis; the examples he selected of fifteenth-century art in order to contrast them with Cinquecento style, are drawn overwhelmingly from what has been called the Florentine proto-Mannerist style of the second half of the fifteenth century, to the virtual exclusion of those works which in previous volumes I have characterized by the term, 'Quattro Cento'.

65 Sebastiano del Piombo suggested to Michelangelo that a fresco of Ganymede would look well in the lantern of the Medici chapel cupola. If Ganymede, he wrote, was given a halo, he would serve as a St John of the Apocalypse being borne to heaven (Milanesi, *Les Correspondants*, p. 104).

66 In a letter to him Michelangelo speaks of Cavalieri's name (Knight, presumably visualized with sword or spear) as the food on which he lives. M. p. 468.

67 According to H. B. Gutman (*Franciscan Studies*, 1944 and 1953) a prime iconographic source for the Sistine decoration was the then popular commentary on the Scriptures by the Franciscan, Nicholas of Lyra. Gutman's overall interpretation is less strained than those of the neo-Platonists.

68 I have referred to Michelangelo's suffering from stone (Note 2) but I have not mentioned the expression used by Condivi, repeated by Vasari, of the gaining of the propensity for sculpture from his foster-mother's milk. According to them, Michelangelo said he drew in the instruments of wife and daughter of stone-cutters. Cf. note on Cavalieri's name, p. 72.

Reflections on the Nude

1 Stokes, A., *The Invitation in Art,* 1965.

2 Nield, L., *Architectural Forms originating in the House*, lecture in Cambridge University School of Architecture, Easter Term, 1965.

3 *New Statesman*, 4 March 1966. The Gutenberg Galaxy, London, Routledge, 1962.

4 Wollheim, R., *On Drawing an Object*, London, H. K. Lewis, 1965. I place much reliance on this finding.

5 BBC Third Programme, August-September 1966. A recording of the lectures given under the auspices of the Bollingen Foundation at the National Gallery of Art, Washington, in April, 1965.

6 Forge, A., in conversation with the author, who owes to Forge the suggestion that he should write about collage.

7 Seitz, W. C., *The Art of Assemblage*, New York, Museum of Modern Art, 1961.

8 Melville, R., in conversation with the author.

9 Forge, A., *Rauschenberg*, New York, Harold Abrams, 1967.

10 Burman, L., 'The Paradox of Scale', *The British Journal of Aesthetics*, Vol. 6, No. 4, October 1966.

11 Stokes, A., 'On Being Taken out of Oneself', *Int. J. Psycho-Anal.* Vol. 47, Part 4, 1967.

12 Meltzer, D., *The Psycho-Analytical Process*, London, Heinemann, 1967.

13 Clark, K., *Rembrandt and the Italian Renaissance*, London, Murray, 1966.

14 There is particularly one detail among many that may help to indicate their scope, namely a psycho-analytic view of the mother's body not only as the target for the infant's first drives but also as a medium of communication and of defence against aspects of those drives in view of the mother's capacity to receive projections 'and to return to the infant parts of itself and its internal objects divested of all persecutory qualities by means of the feeding relation to the breast', Donald Meltzer, 'The Introjective Basis of Polymorphous, Tendencies in Adult Sexuality', *The British Psycho-Analytical Society and the Institute of Psycho-Analysis. Scientific Bulletin*, 1966, No. 7.

15 Adapted from a lecture given with slides.

16 Ascribed to Raphael. One can say with certainty that the major design is his.

17 Cf. Professor Wollheim's inaugural lecture of 1964, where he argued that a mark made on paper causes not only configuration but representation in nearly all cases. *On Drawing an Object*, Richard Wollheim, London, H. K. Lewis, 1965. (Reprinted in Richard Wollheim, *On Art and the Mind*, London, Allen Lane, 1973.)

LIST OF ILLUSTRATIONS

Michelangelo

The Impact of Architecture

ILLUSTRATION CREDITS

Author's Collection, 1–24; J. Roubier, 25–37

GENERAL BIBLIOGRAPHY
and list of works by
ADRIAN STOKES

Greek Culture and the Ego

Beare, J. I., *Greek Theories of Elementary Cognition*, Oxford Univ. Press, London, 1906

Bion, W. R., 'Differentation of the Psychotic from the Non-Psychotic Personalities', *Int. J. Psycho-Anal.*, Vol. XXXVIII, 3 and 4, 1957.

Bowra, C. M., *The Greek Experience*, Weidenfeld & Nicolson, London, 1957

Braque, G., *Cahiers d'Art*, 1954; *Cahier de G. Braque*, Paris, 1952. Quoted in 'Introduction' by D. Cooper to the Catalogue' of the Arts Council Exhibition, London, 1956

Burnet, J., *Greek Philosophy*, Part I, Thales to Plato, Macmillan, London, 1914
——, *Early Greek Philosophy*, 4th ed., A. & C. Black,London, 1952

Carstairs, G. M., *The Twice-Born: the Study of a Community of High-Caste Hindus*, Hogarth Press, London, 1957

Dodds, E. R., *The Greeks and the Irrational*, Univ. of California Press, Los Angeles, 1951

Fenichel, O., *The Psycho-Analytic Theory of Neurosis*, Hogarth Press, London, 1946

Ferenczi, S., *Final Contributions to the Problem and Methods of Psycho-Analysis*, M. Balint, Hogarth Press, London, 1955

Fraenkel, E., *Rome and Greek Culture*, trans., Oxford Univ. Press, London, 1935

Freud, S., *The Ego and the Id.*, trans. J. Riviere, Hogarth Press, London, 1927
——, *Civilization and its Discontents*, trans. J. Riviere, Hogarth Press, London, 1930

Guthrie, W. K. C., *Orpheus and the Greek Religion*, Methuen, London, 1952
——, *The Greeks and their Gods*, Methuen, London, 1950
——, *In the Beginning*, Methuen, London, 1957

Harrison, J., *Themis*, Cambridge Univ. Press, 1912
Heimann, Paula, 'Functions of Introjection and Projection', *Developments in Psycho-Analysis*, ed.

Klein, M., Heimann, P., Isaacs, S., and Riviere, J., Hogarth Press, London, 1952

Hutten, E., *The Origins of Science. On the Concept of Reality*, unpublished

Jones, E., 'A Linguistic Factor in English Character-ology,' *Int. J. Psycho-Anal.*, Vol. 1; also *Essays in Applied Psycho-Analysis*, Hogarth Press, London, 1951

Kelsen, H., *Society and Nature. A Sociological Inquiry*, Cambridge Univ. Press, 1956

Kirk, G. S., and Raven, J. E., *The PreSocratic Philosophers*, Cambridge Univ. Press, 1957

Klein, Melanie, 'A Contribution to the Psycho-genesis of Manic-Depressive States', *Int. J. Psycho-Anal.*, Vol. XVI, 1935, and in *Contributions to Psycho-Analysis*, Hogarth Press, London, 1948
——, 'Mourning: its relation to manic-depressive states', *Int. J. Psycho-Anal.*, Vol. XX, Pts 3 and 4, 1939; also in *Contributions to Psycho-Analysis*, Hogarth Press, London, 1948.
——, 'Notes on some Schizoid Mechanisms', *Int. J. Psycho-Anal.*, Vol. XXVII, Pts 3 and 4, 1946; also in *Developments in Psycho-Analysis*, Hogarth Press, London, 1952
——, 'A Contribution to the Theory of Anxiety and Guilt', *Int. J. Psycho-Anal.*, Vol. XXIX, Pt 2, 1948; also in *Developments in Psycho-Analysis*, Hogarth Press, London, 1952
——, 'Some Theoretical Conclusions regarding the Emotional Life of the Infant', *Developments in Psycho-Analysis*, Hogarth Press, London, 1952
——, 'On Identification', *New Directions in Psycho-Analysis*, Tavistock Publications, London, 1956
——, 'On the Development of Mental Function-ing', *Int. J. Psycho-Anal.*, Vol. XXXIX, Pts 2–4, 1958
——, *Envy and Gratitude: a Study of Unconscious Sources*, Tavistock Publications, London, 1957

Lawrence, T. E., Translator *Odyssey*, Oxford Univ. Press, London, 1935

Lee, Vernon, *The Beautiful*, Cambridge Univ. Press, 1913

Murray, Gilbert, *Five Stages of Greek Religion*, Watts, London, 1935

Onians, R. B., *The Origins of European Thought. About the Body, the Mind, the Soul, the World, Time and Fate*, 2nd ed., Cambridge Univ. Press, 1954

Parke, H. W., *A History of the Delphic Oracle*, Oxford Univ. Press, London, 1939

Ribble, M. A., 'Infantile Experience in Relation to Personality Development', *Personality and the Behaviour Disorders*, Vol. II, Ronald Press, New York, 1944

Robin, L., *Greek Thought and the Origins of the Scientific Spirit*, trans., Kegan Paul, London, 1928

Rose, H. J., *Handbook of Greek Mythology*, Methuen, London, 1953

Rosenfeld, H., 'Notes on the Psycho-Analysis of the Super-Ego Conflict in an acute Schizophrenic Patient', *Int. J. Psycho-Anal.*, Vol. XXXIII, Pt II, 1952; also in *New Directions in Psycho-Analysis*, ed. Klein, M., Heimann, P., and Money-Kyrle, R., Tavistock Publications, London, 1956

Sachs, H., *The Creative Unconscious*, Sci-Art Publications, Cambridge, Mass., 1942

Sambursky, S., *The Physical World of the Greeks*, trans., Routledge, London, 1956

Segal, Hanna, 'A Psycho-Analytical Approach to Aesthetics', *Int. J. Psycho-Anal.*, Vol. XXXIII, Pt II, 1952; also in *New Directions in Psycho-Analysis*, ed. Klein, M., Heimann, P., and Money-Kyrle, R., Tavistock Publications, London, 1956
——, 'Notes on Symbol Formation', *Int. J. Psycho-Anal.*, Vol. XXXVIII, Pt VI, 1957

Stokes, A., *Michelangelo: a Study in the Nature of Art*, 1955
——, 'Form in Art', *New Directions in Psycho-Analysis*, 1956
——, *Smooth and Rough*, 1951
——, 'Listening to Clichés and Individual Words', *Int. J. Psycho-Anal.*, Vol. XXXVIII, Pt VI, 1957

Wisdom, J. O., 'Concept of the Phantom Body', *Actes de Congrès Philosophiques*, Brussels, 1953

The Painting of our Time

PART I

Hartigan, Grace, From the catalogue of *The New American Painting*, an Arts Council exhibition at the Tate Gallery, 1959

Klein, Melanie, *Envy and Gratitude*, London, 1957

Lewin, B. D., 'Inferences from the Dream Screen', *Int. J. Psycho-Anal.*, 1948

Stokes, A., *Michelangelo: a Study in the Nature of Art*, 1955
——, 'Form in Art', *New Directions in Psycho-Analysis*, 1955a
——, *Greek Culture and the Ego*, 1958

Wittkower, R., *Art and Architecture in Italy, 1600–1750*, Harmondsworth, 1958

PART II

Abell, W., *The Collective Dream in Art*, Cambridge, Mass., 1957

Ettlinger, L. D., *Kandinsky: 'At Rest'*, Oxford, 1961

Evans, J., & Whitehouse, J. H., *The Diaries of John Ruskin*, Vol. I, 1835–47, Vol. II, 1848–73, Vol. III, 1874–89, Oxford, 1956, 1957, 1959

Gombrich, E. H., 'Meditations on a Hobby Horse or the Roots of Artistic Form', *Aspects of Form*, ed. L. L. Whyte, London, 1951

Huxley, A., *The Doors of Perception*, London, 1954
——, *Heaven and Hell*, London, 1956

Jaques, E., 'Disturbances in the Capacity to Work', *Int. J. Psycho-Anal.*, 1960

Read, H., *A Concise History of Modern Painting*, London, 1959

Segal, H., 'Notes on Symbol Formation', *Int. J. Psycho-Anal.*, 1957

Stokes, A., *Colour and Form*, 1937 and 1946
——, 'Form in Art', *New Directions in Psycho-Analysis*, 1955
——, *Greek Culture and the Ego*, 1958

PART III

Boas, G., (ed.), *Courbet and the Naturalist Movement*, Baltimore, 1938

Goldman, B., 'Realist Iconography: Intent and Criticism'. *Journal of Aesthetics*, Vol. XVIII, Baltimore, 1959

Gowing, L., Catalogue to Arts Council Cézanne Exhibition, London, 1954

Kahnweiler, D. H., *Juan Gris, His Life and Work*, trans. D. Cooper, New York, 1947

Schapiro, M., Review of Sloane, 1951, *Art Bulletin*, June, 1954
——, 'Courbet and Popular Imagery', *Courtauld-Warburg Journal*, Vol. IV, London, 1941
——, *Vincent Van Gogh*, London, 1951
——, *Paul Cézanne*, New York, 1952

Shattuck, R., *The Banquet Years*, London, 1959

Sloane, J., *French Painting between the Past and*

Present: Artists, Critics, and Traditions, 1848–70, Princeton, 1951

Wilson, E., *Axel's Castle*, New York, 1931

Painting and the Inner World

PART I

Burke, E., *A Philosophical Enquiry into the Origin of our Ideas of the Sublime and Beautiful*, ed. J. T. Boulton, London, 1958

Diatkine, R., 'Reflections on the Genesis of Psychotic Object Relationship in the Young Child', *Int. J. Psycho-Anal.*, 1960

Gowing, L., *Vermeer*, London, 1952

Money-Kyrle, R. E., *Man's Picture of his World*, London, 1961

Read, H., 'Beauty and the Beast'. *Eranos-Jahrbuch*, xxx, Zürich, 1962

Segal, H., 'A Psycho-Analytical Approach to Aesthetics', *Int J. Psycho-Anal.*, 1952, and in *New Directions in Psycho-Analysis*, London, 1955

Stokes, A., *The Quattro Cento*, 1932
——, *Stones of Rimini*, 1935
——, *Colour and Form*, 1937 and 1950
——, *Inside Out*, 1947
——, *Art and Science*, 1949
——, *Smooth and Rough*, 1951
——, *Michelangelo*, 1955a
——, 'Form in Art', *New Directions in Psycho-Analysis*, 1955b
——, *Greek Culture and the Ego*, 1958
——, *Three Essays on the Painting of our Time*, 1961

PART II

Bion, W. R., *Thinking* (unpublished)

Klein, M., *Envy and Gratitude*, London, 1957

Meltzer, D., *The Interpretation of Tyranny* (unpublished)

Praz, M., *The Romantic Agony*, London, 1933

PART III

Binyon, L., *English Water-Colours*, London, 1933

Bell, C. F., *A List of the Works contributed to Public Exhibitions by J. M. W. Turner, R.A.*, London, 1901
——, and Girtin, T., *The Drawings and Sketches of John Robert Cozens*, Walpole Society, 1935

Burnet, J. and Cunningham, P., *Turner and his Works*, London, 1852

Butlin, M., *The Watercolours of J. M. W. Turner*, London, 1962

Clare, C., *J. M. W. Turner*, London, 1951

Clark, K., *Landscape into Art*, London, 1949
——, *Looking at Pictures*, London, 1960

Croft Murray, E., 'Pencil Outlines of Shipping at Dover of the Monro School', *B.M. Quarterly*, Vol. x

Finberg, A. J., *Complete Inventory of the Drawings of the Turner Bequest*, 2 vols, London, 1910
——, *Turner's Sketches and Drawings*, London, 1910
——, *In Venice with Turner*, London, 1930
——, *The Life of J. M. W. Turner, R. A.*, London, 1939 and 1961

Girtin, T. and Loshak, D., *The Art of Thomas Girtin*, London, 1954

Hamerton, P. G., *The Life of J. M. W. Turner, R.A.*, London, 1895

Hussey, C., *The Picturesque*, London, 1927

Livermore, A. N., 'Turner and Music', *Music and Letters*, 1957
——, 'Turner's Unknown Verse-Book', *Connoisseur Year Book*, 1957

Monk, S. H., *The Sublime. A Study of Critical Theories in 18th Century England*, Michigan, 1935 and 1960

Oppé, A. P., *Alexander and John Robert Cozens*, London, 1952

Rothenstein, J. and Butlin, M., *Turner*, London, 1963

Ruskin, J., *Notes by Mr. Ruskin on his Collection of Drawings by the late J. M. W. Turner, R.A.*, London, 1878
——, *Works*, vols 3–7, *Modern Painters*, Library Edition

Thornbury, W., *Life of J. M. W. Turner, R.A.*, 2 vols, London, 1862

Turner, J. M. W., *Verse Book MS.*, in collection of Charles M. W. Turner, Esq.

The Invitation in Art

INTRODUCTION

Klein, M., 'Some Reflections on "The Oresteia"', in *Our Adult World and Other Essays*, London, 1963

PART I

Arnheim, R. *Art and Visual Perception*, London, 1956

Freud, S., 'The Uncanny', Vol. XVII, Standard Edition, London, 1919

Milner, M. (*sub. nom.* Joanna Field), *On not being able to Paint*, London, 1950 and 1957
——, 'The Role of Illusion in Symbol Formation', *New Directions in Psycho-Analysis*, ed. M. Klein, P. Heimann and R. Money-Kyrle, London, 1955. (First published under the title 'Aspects of Symbolism in Comprehension of the Not-Self', *Int. J. Psycho-Anal.*, 1952)

White, J., *The Birth and Rebirth of Pictorial Space*, London, 1957

PART II

Bion, W. R., 'Differentiation of the Psychotic from the Non-psychotic Personalities', *Int. J. Psycho-Anal.*, 1957
——, 'The Psycho-analytic Study of Thinking', *Int. J. Psycho-Anal.*, 1962

Renoir, J., *Renoir my Father*, trans. R. & D. Weaver, London, 1962

Stokes, A., *Colour and Form*, 1937 and 1950
——, *Smooth and Rough*, 1951

——, 'Psycho-analytic Reflections on the Development of Ball Games, particularly Cricket', *Int. J. Psycho-Anal.*, 1956
——, *Monet*, 1958
——, *Three Essays on the Painting of our Time*, 1961
——, with Meltzer, D., *Painting and the Inner World*, 1963

PART III

Gombrich, E., *Meditations on a Hobby Horse*, London, 1963

Kris, E., *Psycho-analytic Explorations in Art*, London 1953

Meltzer, D., *Figure and Ground* (unpublished)

Milner, M., (*sub. nom.* Joanna Field) *On not being able to Paint*, London, 1950 and 1957

Sachs, H., *The Creative Unconscious*, Cambridge, Mass., 1942

Segal, H., 'A Psycho-analytical Approach to Aesthetics', *Int. J. Psycho-Anal.*, 1952; and in *New Directions in Psycho-analysis*, ed. M. Klein, P. Heimann & R. Money-Kyrle, London, 1955

Stokes, A., *Raphael*, 1956
——, 'The Impact of Architecture', *Brit. J. Aesthetics*, September, 1961
——, with Meltzer, D., *Painting and the Inner World*, 1963

Sylvester, D., Introduction to the Catalogue of the Art Council's Soutine exhibition at the Tate Gallery, London, 1963

Works by Adrian Stokes

The Thread of Ariadne, with an introd. by John Middleton Murry, London, Kegan Paul, Trench, Trubner, 1925

Sunrise in the West, a modern interpretation of past and present, London, Kegan Paul, Trench, Trubner, 1926

The Quattro Cento, London, Faber, 1932; New York, Schocken Books, 1968

The Stones of Rimini, London, Faber, 1934; New York, Schocken Books, 1969

Tonight the Ballet, London, Faber, 1934, 2nd (revised) edn 1935; New York, Dutton, 1935

Russian Ballets, London, Faber, 1935, 2nd (corrected) edn 1935; New York, Dutton, 1936

Colour and Form, London, Faber, 1937, new (revised) edn 1950

Venice: an aspect of art, London, Faber, 1945

Cézanne, with an introd. and notes, London, Faber, 1947 (The Faber Gallery); New York, Pitman, 1950 (The Pitman Gallery)

Inside Out, London, Faber, 1947

Art and Science, London, Faber, 1949

Smooth and Rough, London, Faber, 1951

Michelangelo, London, Tavistock Pubns, 1955; New York, Philosophical Library, 1956

Raphael, 1483–1520. with an introd. and notes, London, Faber, 1956 (The Faber Gallery)

Greek Culture and the Ego, London, Tavistock Pubns, 1958

Monet, 1840–1926, with an introd. and notes, London, Faber, 1958 (The Faber Gallery), New York, Wittenborn, 1958

Three Essays on the Painting of Our-Time, London, Tavistock Pubns, 1961

Painting and the Inner World, including a dialogue with Donald Meltzer, London, Tavistock Pubns, 1963

The Invitation in Art, Preface by Richard Wollheim, London, Tavistock Pubns, 1965; New York, Chilmark Press, 1966

Venice, Illus. by John Piper, London, Lion & Unicorn Press (ltd edn), Duckworth, 1965

Reflections on the Nude, London, Tavistock Pubns, 1967; New York, Barnes & Noble, 1967

The Image in Form, selected writings of Adrian Stokes, ed. and introd. by Richard Wollheim. Harmondsworth, Penguin Books, 1972; New York, Harper & Row, 1972

[Selected poems by], Geoffrey Grigson, Edwin Muir, Adrian Stokes, ed. by Stephen Spender. Harmondsworth, Penguin Books, 1973, (Penguin Modern Poets, 23)

A Game that Must be Lost, ed. and introd. by Eric Rhode, Cheadle, Carcanet Press, 1973

'The Sculptor Agostino di Duccio', extracted from the third of four essays on the Tempio Malatestiano at Rimini, *Criterion*, IX, 34, October 1929.

'Painting, Giorgione and Barbaro', *Criterion*, IX, 36, April 1930

'Pisanello', first of four essays on the Tempio Malatestiano at Rimini, *Hound and Horn*, IV, I, October–December 1930

'Art Today', *Spectator*, 20 October 1933

'Ben Nicholson's Painting', *Spectator*, 27 October 1933

'Miss Hepworth's Carvings', *Spectator*, 3 November 1933

'Mr. Henry Moore's Sculpture', *Spectator*, 10 November 1933

'Matisse and Picasso', *Spectator*, 24 November 1933

'The Child Artist', a review of R. R. Tomlinson's *Picture Making by Children*, 1934, *Listener*, 12, October 1934

'Leonardo's Drawings', a review of Kenneth Clark's *Catalogue of Drawings of Leonardo da Vinci in the Collection of His Majesty the King at Windsor*, 1935, *Listener*, June 1935

'Mr. Ben Nicholson at the Léfèvre Galleries', *Spectator*, March 1937

'Concerning Art and Metapsychology', *International Journal of Psychoanalysis*, 26, 1945

'Inside Out', *Polemic*, 2, January 1946, revised and reprinted in *Inside Out*, London, Faber & Faber, 1947

'Piero della Francesca – A Masterpiece', a review of Kenneth Clark's *Piero della Francesca*, 1951, *Spectator*, March 1951

'A Study of Tintoretto', a review of Eric Newton's *Tintoretto*, 1952, *Spectator*, 188, January 1952

'Form in Art: A Psycho-analytic Interpretation', in *New Directions in Psycho-Analysis*, ed., M. Klein, Paula Heimann, R. E. Money-Kyrle, Tavistock Publications, 1955; reprinted in *Journal of Aesthetics and Art Criticism*, 18, 1959 and *A Game that Must be Lost*, Cheadle, Carcanet Press, 1973

'Seeing as Action', a review of Rudolph Arnheim's *Art and Visual Perception: A Psychology of the Creative Eye*, 1956, *Encounter*, 6, March 1956

'The Impact of Architecture', *British Journal of Aesthetics*, I, 1960–1

'Coldstream and the Sitter', introduction to exhibition catalogue, *William Coldstream*, London, The Arts Council, 1962

'Living in Ticino, 1947–50', *Art and Literature*, I, March 1964

'Herbert Read', *British Journal of Aesthetics*, 4, July 1964

'Profile', a dialogue with Guy Burn, *The Arts Review*, XVII, I January–February 1965

Introduction to exhibition catalogue, *Lawrence Gowing*, London, Marlborough Fine Art, 1965

'The Image in Form', *British Journal of Aesthetics*, 4, July 1966; reprinted in *Reflections on the Nude*, Tavistock Pubns, 1967

'Reminiscences', *Ben Nicholson – A Studio International Special*, 1969

'The Future and Art', *Studio International*, 184, September 1972; reprinted in *A Game that Must be Lost*, Cheadle, Carcanet Press, 1973

'A drama of modesty: Adrian Stokes on his painting', *Studio International*, 185, April 1973 (The title was not due to Adrian Stokes)

* Monuments marked by an asterisk are those listed by Adrian Stokes in *The Quattro Cento* as being 'Quattro Cento'

Numerals in *italics* refer to plates